Advantage Books

Visual Storytelling

VIDEOGRAPHY AND POST PRODUCTION
IN THE DIGITAL AGE

FROM THE WADSWORTH SERIES IN BROADCAST AND PRODUCTION

Advantage Books

Visual Storytelling

VIDEOGRAPHY AND POST PRODUCTION IN THE DIGITAL AGE

SECOND EDITION

RONALD J. OSGOOD
Indiana University

M. JOSEPH HINSHAW
James Madison University

WADSWORTH
CENGAGE Learning·

Australia • Brazil • Japan • Korea • Mexico • Singapore • Spain • United Kingdom • United States

WADSWORTH
CENGAGE Learning

Advantage Books: Visual Storytelling, Videography and Post Production in the Digital Age, **Second Edition**
Ronald J. Osgood and M. Joseph Hinshaw

Editor in Chief: Lyn Uhl

Publisher: Michael Rosenberg

Development Editor: Megan Garvey

Assistant Editor: Erin Bosco

Editorial Assistant: Rebecca Donahue

Media Editor: Jessica Badiner

Executive Marketing Communications Manager: Jason LaChapelle

Brand Manager: Ben Rivera

Rights Acquisitions Specialist: Amanda Groszko

Manufacturing Planner: Doug Bertke

Art and Design Direction, Production Management, and Composition: PreMediaGlobal

Cover Image:

Man with camera (center photo): Ronald J. Osgood

Storyboard and Film Editing (left and right photos): Mark Mosrie

For product information and technology assistance, contact us at **Cengage Learning Customer & Sales Support, 1-800-354-9706.**
For permission to use material from this text or product, submit all requests online at **www.cengage.com/permissions.**
Further permissions questions can be e-mailed to **permissionrequest@cengage.com.**

Library of Congress Control Number: 2012956173

ISBN-13: 978-1-285-08166-3

ISBN-10: 1-285-08166-8

Wadsworth
20 Channel Center Street
Boston, MA 02210
USA

Cengage Learning is a leading provider of customized learning solutions with office locations around the globe, including Singapore, the United Kingdom, Australia, Mexico, Brazil and Japan. Locate your local office at **international.cengage.com/region**

Cengage Learning products are represented in Canada by Nelson Education, Ltd.

For your course and learning solutions, visit **www.cengage.com.**

Purchase any of our products at your local college store or at our preferred online store **www.cengagebrain.com.**

Instructors: Please visit **login.cengage.com** and log in to access instructor-specific resources.

Printed in the United States of America
1 2 3 4 5 6 7 17 16 15 14 13

Contents

PART III Post Production 217

8 The Aesthetics of Editing 219

Preface

Imagine the following scenarios and what your reaction to each might be.

Scenario 1: You are a student enrolled in your first field production class. You've spent several weeks learning about various pieces of equipment and technology and now you're ready to do your first major project. You go to see the professor to pitch the project, telling her: "First, I want to shoot everything handheld to give the piece a more authentic feel. Then, during editing, I want to desaturate everything for a grittier look. Finally, I want to use several of the new plug-ins I've got for my nonlinear editor. Some of the effects are really cool and they could add a lot to my video."

The professor replies, "Your ideas are interesting, but what story are you trying to tell?"

Bewildered, and with your enthusiasm waning, you realize that the challenge is to develop the story and then restate your ideas in a clearer way for the professor.

Scenario 2: An experienced producer is pitching an independent film with a potential investor. The businessperson is excited about the investment opportunity and compares the independent film to a blockbuster she has recently seen, saying, "The special effects were fantastic and I hope we can incorporate some of them in this film." The producer agrees that the overall effect was spectacular, but suggests, "I'm not sure how those techniques advance the narrative for this story."

Students, novices, and professionals—virtually anyone who has ever produced a video—has had the impulse to ignore the planning, conventions, and practices prevalent in video production. A new camera comes with the temptation to begin shooting before thinking about shot lists or storyboards, and a digital editing system rewards our appetite by allowing a broad range of effects that are easy to apply. While this approach may be fun, it ignores the importance of the story.

Unfortunately, the story is sometimes ignored in contemporary video production. This is the primary reason we were inspired to write this book. Anyone involved in video field production should be a visual storyteller. Like a songwriter whose lyrics weave a good ballad or an author who creates a marvelous

narrative with his words, a visual storyteller uses images, sounds, graphics, effects, and editing to create masterful stories.

Since the days of the first silent movies, visual storytelling has been paramount in any successful film or video presentation. The technology has changed greatly over the years, but storytelling and its conceptual framework have remained the same. Different styles of production and editing have come and gone in the industry, but a good foundation that takes into account the critical role of the storyteller will allow adherents to adapt to any style and any new technology. The explosion of digital technology in the video production industry has led to many productions in which style seems to matter over substance. The foundation of any production, however, must be its story and the way in which that story is told. This book will help students understand the digital environment and how it can aid them in developing their storytelling skills.

The purpose of this book is to teach and explain the fundamental concepts of field production and post production. In addition, this book serves as a reference and a resource guide for hands-on activities that help students comprehend and apply basic concepts. It provides a foundation for understanding the technologies involved in field production, as well as the processes and tools used in editing. The text stresses the aesthetics, concepts, and techniques of visual storytelling. Last, it reinforces the notion that no matter what technological tools and tricks are used, it is the story that keeps viewers focused on the production.

Each chapter in the book begins and ends with a storytelling challenge. These challenges follow the decisions that a producer, director, or other crew member may face in relation to the topic of the chapter. The decisions all involve a series of videos that a fictional production company is producing.

In addition to traditional chapters—such as those on composition, lighting, and editing—chapters on storytelling, graphics, and output are included. The chapters also contain sidebar stories that feature wisdom and advice from professionals in the field. In some cases, the stories offer an anecdote that illustrates a point in the text, or the personal narrative may provide a tip or technique that many professionals use daily.

We are especially pleased and excited about the website that accompanies this book. The website structure parallels the book and provides a great resource. It has a number of modules that illustrate concepts discussed in the text. Some examples include interactive demos on depth of field, exposure control, microphone selection, audio mixing, lighting a scene, compression, and editing sequences. Both students and instructors should find this resource valuable and informative. In addition, clips for editing exercises are available.

An undertaking such as this one is never done in a vacuum, and many people deserve our thanks and gratitude. First, the team at Cengage/Wadsworth was very helpful as we put this book together. A special thanks goes out to Editorial Assistant Rebecca Donahue, who was readily available with invaluable assistance and quick responses to all our questions. Thanks also to Prashanth K. and his team at PreMedia Global. Current and former students made numerous suggestions and contributions to the project and we thank them for their contribution. We'd also like to thank the reviewers whose feedback helped shape the book: Timothy Bajkiewicz, University of South Florida; Ward H. Bryant, Missouri Southern State University; Sonny Burnette, Georgetown College; Tony DeMars, Sam Houston State University; Samuel Edsall, Western Illinois University; Richard Gainey, Ohio Northern

University; Kevin Hager, Wichita State University; Michael Havice, Marquette University; James Henderson, University of South Carolina; Oliver Janney, Goucher College; Al Kazanfer, Jefferson Township High School; Karen Kearns, California State University, Northridge; Nancy Kerr, Champlain University; David Kintsfather, Kutztown University; Kehbuma Langmia, Bowie State University; Jacqueline Layng, University of Toledo; Marvin Marcelo, Washington State University; Denise Matthews, Eastern Connecticut State University; Tom McDonnell, Parkland College; Daniel Nearing, Governors State University; Warren Osterndorf, Eastern Connecticut State University; Jason Roche, Le Moyne College; Joseph Russomanno, Arizona State University; Lesley Salvadori, Ryerson University; Michael Schmitt, University of Wisconsin, Green Bay; Peter Seel, Colorado State University; Andrew Sharma, Salisbury University; Maura Shea, Penn State University; John Smead, University of Central Missouri; Jennifer Smith, University of Georgia; Jefferson Spurlock, Troy University; and Brian Wardyga, Lasell College.

Others that deserve recognition include the many professionals who contributed sidebar stories. The design and technical support from Yvette Shen was instrumental in authoring the companion website. Mark Mosrie deserves special recognition for the dynamic photos used throughout the book.

From Ron, thanks to the numerous individuals who listened as I talked about the project and to those who offered encouragement and suggestions. These include my colleagues in the Department of Telecommunications at Indiana University. San Francisco State Professor Emeritus Herbert Zettl provided encouragement, wisdom, and wit as the project progressed. The seeds were sown for this project years ago while Joe was completing his graduate work at Indiana University. We worked together during this time and jokingly talked about collaborating at some point in the future. It's been a good partnership and I'm grateful to call him a close friend and to have had the opportunity to work with him on this project. Personally, my son, Matt, has always been able to interject his sense of humor and keep me from getting too serious with myself. He and my daughter-in-law Molly have started their own family and one of my challenges and joys was balancing my time between grandparenting time with Luke while working on the new edition. Last, and most importantly, I must thank my wife Lilly for her love and patience during the process. I could not have completed this book without her support.

From Joe, thanks to all my colleagues in the School of Media Arts and Design at James Madison University. All offered great support, encouragement, and help in finding answers to questions that arose during the process. In addition, I'm grateful to the many current and former students who have offered suggestions and ideas for the book and website. Personally, I also want to convey thanks to Ron. He's been a great teacher and mentor to me, as well as a good friend for many years. I've enjoyed our collaboration on this and other projects. Thanks also to my father whose mantra of keeping things simple always resonates in my brain. Finally, and most importantly, thanks to my wife, DeAnne, and my children, Bethany and Carolyn. Watching the stories of their lives unfold has inspired me during the completion of this new edition. Their willingness to endure my long hours and frequent road trips were instrumental in completing the project. For the sake of this project, my family has shown great patience and love. They've helped me maintain my sense of humor and my perspective along the way.

✳

About the Authors

Ron Osgood is Professor Emeritus at Indiana University in Bloomington and a documentary filmmaker. He held positions in media management and production before beginning his teaching career. Professor Osgood has received multiple teaching awards and numerous project grants from Indiana University as well as other agencies. His work has been broadcast on network and satellite channels, selected for screening at film festivals, and distributed both nationally and internationally. His awards include an Emmy, a Telly, and a Media Communications Association (MCA-I) Silver Reel, as well as multiple Broadcast Education Association (BEA) Awards and the Pop Culture Association Documentary Award. Osgood is a Vietnam War veteran and is currently at work on an interactive storytelling project that will tell stories from the Vietnam War/American War from the perspective of the former enemies.

M. Joseph Hinshaw is a Ruth D. Bridgeforth Professor in the School of Media Arts and Design (SMAD) at James Madison University. Hinshaw also taught at the University of Oklahoma, where he won the Gaylord College Distinguished Teaching Award. Before beginning his academic career, he worked at a PBS station and a production company in the Washington, D.C., market. He edited and shot a monthly syndicated show seen on more than 100 PBS and commercial television stations that won a local Emmy for best informational program. He has also won numerous awards for his production work from organizations such as the Broadcast Education Association (BEA), the Media Communications Association (MCA-I), and the Telly and Videographer Awards. In addition, he received the prestigious Best of Festival and other awards from the BEA for his creative works related to teaching video production.

PART I

Preproduction

Visual Storytelling

We need to bring the audience back into partnership with storytelling.

STEVEN SPIELBERG, DIRECTOR

OVERVIEW

Since the days of the first silent movies, visual storytelling has been central to any film or video program. The technology has changed greatly over the years, but storytelling and its conceptual framework have remained the same. Different styles of production and editing have come and gone in the industry, but a good foundation that takes into account the critical role of the storyteller will allow adherents to adapt to any style and any new technology. The explosion of digital technology in the video production industry has led to a great many productions in which style seems to take precedence over substance. The foundation of any production, however, must be the story and the way it is told.

As the digital revolution continues, the industry may be developing a digital aesthetic. Such a transition is visible in the increased access to equipment and software at lower costs; in media-savvy individuals competing for communications jobs that did not exist a few years ago; and in an audience starving for content that is accessible on flat screen TVs, Internet sites, and personal media devices such as tablets and smart phones.

One of the most important tools a carpenter uses while building a project is a set of blueprints. Can you imagine a builder framing a new house without a materials list, simply guessing how large the family room should be? The builder relies on a vision for the project and detailed drawings that have been developed in consultation with the potential home owner. Likewise, in a video project, attention to the story precedes decisions about production technique. The most important lesson to be gleaned from this book is that the story is the most fundamental element of your project. Every creative element and technical production process must reinforce the story to ensure the project's success.

This book will cover practical techniques and technical considerations throughout each chapter. Chapters in this book include field acquisition topics such as shooting, lighting, and sound, as well as post production topics in editing, sound mixing, graphics, and outputting your work. Every topic, however, relates back to the story.

Chapter 1 covers the importance of storytelling and provides a context for the techniques you will apply as you begin your project. Gaining an understanding of story structure, point of view, character, and production design is the first step in the exciting and challenging production process. This chapter also covers program types and the process used to research and begin writing good stories.

STORYTELLING

Don't say the old lady screamed—bring her on and let her scream.
MARK TWAIN, AUTHOR

"Once upon a time" probably brings back memories of stories your parents read to you as a child. Some stories were told with picture books, while others may have been oral histories that let you visualize the images in your mind. These images and words left a visual impression that likely helped create an enjoyable experience for you. One of the biggest challenges for visual storytellers is creatively interpreting a written story in pictures and sounds. Do you remember the first time you went to see the movie version of a story you had previously read? Were the images and sounds consistent with your imagination? The experience may have been disappointing, but it is just as possible that whatever hard work you devote to your project will accomplish little if the story fails to keep the audience interested. Your challenge in creating a captivating, award-winning story is taking an interesting idea and interpreting it in a way that brings the story to life (see Figure 1.1).

Storytelling is prevalent in every culture and society. Stories passed down from generation to generation provide entertainment and information for people of all cultures, races, and socioeconomic groups. But storytelling is not necessarily easy. The campfire storyteller and ethnographer, for example, must verbally describe events in a way that others can understand. Cave paintings and art pieces have similar challenges to those of a video program in stimulating their audience's interpretation of the images. This interpretation is the challenge for the visual storyteller.

Key Personnel

It is entirely possible for an individual to create a video using today's low-cost, easily accessible equipment. On the other hand, the myriad skills and the amount of time a project requires encourages a team approach with generalized crew positions and various specialists. Some of the more critical personnel will likely have been involved from the initial development of the story.

FIGURE 1.1

Field production requires skills in shooting, audio, and lighting to complement the story development.

SOURCE: Courtesy of author, Ron Osgood.

The Writer Among the many personnel involved in the planning and production process is the writer. As the main architect of the story, the writer may have the most important role. The writer's experiences directly relate to the sophistication and the heart of a program. A writer who has driven a delivery truck through the streets of a major city could tell a more accurate story about urban culture than someone who has lived her entire life in a rural area. Conversely, a writer who grew up on a farm should be able to create a more believable story about the life of a farmer than someone who was raised in the city. Besides personal experiences, our interests and hobbies often lead us to good stories. Reading for enjoyment can often be a valuable source for ideas and background, just as watching films can help us develop an aesthetic eye.

The writer may be asked to write an original script or adapt an existing story. It is also common for a writer to rewrite rough script drafts originally written by content experts with no experience in visual storytelling. Therefore, writers must possess the skills necessary to include visualization in the writing style. While some writers focus on a particular genre or style, others broaden their opportunities by reading extensively, developing good research habits, and polishing their technical writing skills.

The Producer Producers range from business partners whose primary interest is in supporting the production financially to those who take a hands-on approach and sometimes blur the line between producer and director. Regardless, the producer is the person responsible for the success of the project. Keen business and financial skills, along with the wisdom to know what makes a good story and how to manage a diverse group of technical and creative personnel, are important traits for a producer.

The Director Another key individual in the overall production process is the director. The relationship between producer and director varies throughout the industry, from the feature film model where the director has creative control and makes most of the decisions to a variety of TV models where the director reports to a producer.

Directors work closely with the cast and production crew. A good director involves others in the process but takes responsibility and makes decisions. The director should possess experience in the production process and have a strong sense of story development.

The writer/producer, producer/director, and writer/producer/director are common job titles given to a person with responsibilities in more than one critical area. In many cases, these duties blur as the production process moves forward.

Adaptation

Engaging stories are everywhere. Many are original ideas, but just as many are adaptations of written works or other visual content. Regardless, the interpretation of the idea is the critical component in developing a good story. Shakespeare's *Romeo and Juliet* has been interpreted dozens of times in film, television, and cartoon forms. The story description—"two lovers plan to flee from their feuding families who forbid them to marry"—has been adapted in a variety of successful contemporary plots. Each adaptation interprets the same story, yet each is unique in its presentation. The challenge for the writer is to present an interesting and original story.

The novel *War of the Worlds* was written in 1898 by H. G. Wells and has been adapted numerous times, including the famous live radio drama directed by Orson Welles for *Mercury Theatre on the Air* as a Halloween special in 1938. Since then it has been re-created as a novel, a comic book, and two feature films. *Dogtown and Z Boys* (2001) is a story about the rise of skateboarding in southern California in the 1970s. It was adapted from a series of articles written in the 1970s and published in 2000 as *DogTown: The Legend of The Z-Boys*. The success of the documentary inspired one of the original Z Boys, Stacy Peralta, to write the script for the feature film *Lords of Dogtown* (2005). Some scenes in the narrative story are strikingly similar to scenes that appear in the original documentary. Comic books such as *The Avengers* and *Transformers* have also been adapted to new media forms. Visual stories are constantly interpreted and reinterpreted in new and contemporary ways (see Figure 1.2).

"*Ladies and gentleman, this is the most terrifying thing i have ever witnessed. Wait a minute! Someone's crawling out of the hollow top. Someone or something. I can see peering out of that black hole two luminous disks, are they eyes? It might be a face. It might be...*"

WAR OF THE WORLDS 1938
Radio Drama

POLICEMAN #1:

Well, there's something down here and it's moving!

AERIAL VIEW

THE CRATER HAS GROWN FROM A SMALL BOWL
IN THE ROAD TO AN ENORMOUS WEB OF CRACKS

WAR OF THE WORLDS 2005
Feature Film

© Cengage Learning

FIGURE 1.2

Various adaptations of *War of the Worlds* modify script language and style, but still tell the same story.

SOURCE: *War of the Worlds,* Mercury Theatre on the Air radio broadcast, 1938; *War of the Worlds,* film, 2005.

STORY STRUCTURE

Story structure is an integral part of both documentaries and narrative fiction. Structure is the vehicle that advances the story and attempts to hold the audience's interest. The writer must present a cause–effect pattern to advance the

story from beginning to end. In many film and television programs, the structure usually includes a situation that goes awry (cause); the rest of the story describes attempts to find a solution (effect). The structure develops through the writing of a logline and treatment.

> I had a phone call with the president of HBO. He is the kind of person who's actually going to put the video out there before an audience....
> I had all these things I planned to tell him and we were on the phone for 15 seconds but he wanted to know the story in two sentences.
> And I said, "Well...."
> And he goes, "Is that the beginning of the first sentence?" (Laughter)
> And I laughed, because I didn't have it in two sentences.
>
> KATALINA GROH, PRODUCER, GROH PRODUCTIONS

Story Genre

Many programs blur the line between fiction and nonfiction as drama may incorporate technniques borrowed from documentary style and documentaries might include re-creations. And sometimes truth is stranger than fiction.

A **narrative** story can be an original script or modified from another media source as mentioned earlier. Narrative stories are almost always produced exclusively for entertainment and are developed with a script. They may be produced using an elaborate and expensive production model, be driven by the entertainment industry, and rely on well-known actors. Independent films follow many of the same processes, but are produced with considerably smaller budgets and have more flexibility during all stages of development.

The **nonfiction** story can range from a news story to a documentary, a corporate video to a public service announcement. Such productions encompass most styles and can utilize a broad range of techniques. They may be scripted during planning and development, but it is just as likely that the script will be formed as the editing begins.

The Logline

At some point in the process, the story must be articulated through a logline and treatment. A **logline** is a short statement that describes the story in an interesting manner. This description may sound like the online program description provided by your cable or satellite company's information pop-up for a TV program, or it might include an overall objective for an informational program. Consider these two loglines:"A likeable husband's tolerance and marriage is tested by the constant intrusions of his overbearing parents and jealous insecure brother," and,"A dysfunctional family strives to cope with everyday life."

Both loglines are short, concise, and interesting. Although the stories seem to be similar, the first is for *Modern Family* and the latter for *Family Guy,* both popular TV programs. While the loglines might be similar, the stories for each show are different, and they target different demographics.

Nonfiction program stories also have loglines; for example, the one for *My Vietnam Your Iraq* is,

"A look at the pride, challenges and fears that parents and children are faced with when one is serving in a war."

The logline clearly defines what this documentary is about without giving away too much information.

The Treatment

A **treatment** uses a narrative style to flesh out and elaborate on the content in the logline. Filmmakers and video producers looking for funding realize the importance of a well-written treatment. In addition, clients requesting a production bid or not-for-profit foundations providing grant support make important funding decisions based on this critical document. It is more efficient to provide a treatment than invest time in a complete script for a **spec project**, or one that is pitched without any current funding or support.

The definition of a treatment can be confusing since some forms are industry-specific. At a minimum, treatments usually include general production information, such as location, equipment, and tentative schedule (see Figure 1.3). Some treatments use an outline, others rely on a synopsis, and still others describe the proposed story in great detail, including a thorough description of the story line using the traditional three-act structure. This narrative should contain enough details so the reader clearly understands what the story is about. Like many production documents, style is dictated by the specific industry and work environment. Consistency and clarity are essential for the treatment, regardless of format.

The Three-Act Structure

Before you shoot, it's a good idea to know that you have a
baseline story with a beginning, middle and end, so that if all
else fails, you have some kind of structure before you edit.
SHEILA CURRAN BERNARD, WRITER

The basic three-act structure for film and television includes a beginning, middle, and end. This logical and simple organizational structure has not changed through time, although styles continually evolve as new production techniques become popular. Many television programs use the traditional three-act structure of set-up, conflict, and resolution. Sometimes the story is presented using different structures, but the three main elements remain the same. While stories rely on conflict to advance toward resolution, the number of acts is not as important as solid characters, a well-developed plot, and sufficient tension to maintain audience interest. Broadcast television structure revolves around standard broadcast time slots and the placement of commercials within those time slots. This may not be the most compelling way to arrange the structure of a program, but it is a

Treatment—One Page

Logline:

Besides recreation and good health, pickup basketball promotes democracy through teamwork and competitive play.

Abstract:

Pickup basketball is democracy in action and invites cooperative competition. Players must decide teams, regulate play and compete without formal rules. Besides competition, many play for the recreation and social aspects. This half-hour documentary will follow a group of serious amateurs in Bloomington, Indiana during a several month period. The documentary touches on race, gender, generations, injuries, and aging and the social norms that keep this group together.

Themes:

1. basketball can be played by anyone
2. basketball is popular around the world
3. there is longevity amongst and within the particular group
4. friendships and business transactions result from play
5. players are diverse, crossing gender, race, age, and socio-economic borders

Production Plan:

Location Approval Confirmed

Most interviews and b-roll shot in gym

Second tier interviews to be shot away from gym

Specific game action production to be scheduled (crew, jib)

© Cengage Learning

FIGURE 1.3

The treatment takes many forms, but clarity and brevity are always key.

realistic one. The popularity of online viewing and downloading should not affect linear story structure (see Figure 1.4).

Stories told using newer technologies, such as webisodes or mobisodes, despite their short length and unconventional delivery system, still have a beginning, middle, and end. A **webisode** is an episodic video show viewed on the web and a **mobisode** is a term for television programs viewed on a cell phone.

Act One—Place Your Main Characters in a Complicated Situation The opening act introduces the characters, begins developing the story, and generally provides necessary background information for the audience. An average first act is usually around 25 percent of the overall story length. Somewhere in this initial act is the inciting incident, or hook. The **inciting incident** is the event that causes the story action to begin, introduces the main conflict, and keeps the audience interested in the story. Sometimes this event takes place before the actual program and other times it is a part of the first act. In a documentary, the event

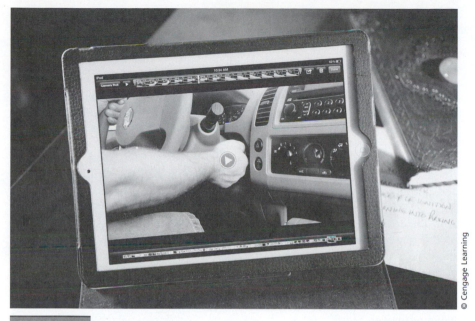

© Cengage Learning

FIGURE 1.4

Downloading and watching visual content on iPads and other mobile devices has changed the viewing habits of today's audience.

may very likely have happened before the program was conceived, while in a narrative the script could contain this important event. In the WGBH series *Nova,* a program titled "Lost on Everest" tells the story of a 1999 expedition to locate the bodies of George Mallory and Andrew Irvine, who never returned from a climbing expedition in 1924. At first glance, it would seem that the inciting incident was the 1924 expedition, but after watching the documentary, it becomes clear that the 1999 expedition was only planned after the climbers researched a story told by a Chinese climber who said he saw an "old English dead" near the peak of Mt. Everest in 1975. The inciting incident is now evident.

Backstory provides enough information to allow viewers to understand important events that occurred before the story takes place. The technique can be as simple as using dialogue to provide information, or as complex as providing clues that help us to figure it out. Without explaining the Chinese climber's story in "Lost on Everest," important clues would be missing as the tale reached its climax. Another writing technique is called **foreshadowing**. In this method, the writer drops hints about what may happen later. This technique is usually established early in the plot, as the viewer is trying to piece information together. Sometimes these story events seem out of place or cause the audience to wonder why the information is even included in the story.

Act Two—Challenge the Characters The middle of the story will be approximately half of the program's running time. This section should advance the story and introduce the twists and side stories that continue to make it interesting. In a classic model, the action continues to rise as the audience holds on to find a resolution of the conflict. During the second act, the writer must be careful to avoid creating a boring series of scenes that fails to hold audience interest or that confuses the audience with unrelated content. This is an all-too-familiar problem that results in half-interested audiences changing the channel. The writer's challenge is to build on the interest created in the setup and to keep the audience anticipating the next plot point. In "Lost on Everest," the climbers were challenged as they battled the altitude, weather, and unforeseen events.

Act Three—Resolve the Challenge The third act intensifies the action and focuses the plot to allow resolution of the conflict. An effective third act sometimes takes a twist, allowing a surprise to end the story. In "Lost on Everest," for example, the climbers uncover clues that they had not anticipated when they began. In the television series *True Blood,* the third act each week seems to be heading for a solution, but the show suddenly shifts gears and leaves the audience hanging until the next episode.

 Criminal Minds is a good example of the three-act story structure. In a typical episode, the first act introduces the crime in the first few minutes of the hour-long drama. During these opening minutes, we meet some of the central characters in the plot-driven story. As the opening act concludes, the program cuts to the opening credits and a commercial break. The second act of a *Criminal Minds* episode revolves around the work of a team of detectives and the district attorney's office. The story may move in a fairly linear progression, or move in several different and surprising directions. Regardless of format, the second act consistently ends with the arrest of the alleged criminal. Most episodes have a predictable resolution. In the third act, the story moves from the investigation to the courtroom as the audience hears testimony and then awaits the jury's ruling.

 In both narrative and documentary stories, the main story is commonly referred to as the "A" story. Within this story might be a number of smaller "B" stories. The "A" story for a weekly series like *House* gives the audience enough information to tune in each week. *House*'s "A" story logline describes the attempts of a misanthropic doctor and medical team to diagnose unusual illnesses at a New Jersey hospital. The "B" story loglines vary each week depending on the specific episode.

Point of View

Every story must embrace a point of view with which the audience can identify. **Point of view (POV)** is established through the perspective of the writer or a character. This helps the viewer immerse him or herself in the story or relate to a specific character.

First-Person POV In **first-person POV**, a character narrates the story from his or her own unique perspective and allows the audience to feel they are part of the scene instead of just an observer. This style is most easily achieved through the use of a voice-over. A classic example is *The Wonder Years,* a nostalgic coming-of-age program about growing up in the 1960s. The use of the main character's voice-over was a groundbreaking technique in television. The main character, Kevin Arnold, reflected on his childhood, and through his narration, he filled in important information from the point of view one would have with the wisdom of hindsight. In the drama *Grey's Anatomy,* the weekly stories always begin and end with a voice-over from the central character, Meredith Grey. Serial killer Dexter Morgan narrates his plans for murder while working for the Miami police department in the drama *Dexter.* During each episode of *Arrested Development,* a narrator provides key information to the audience in a voice-over. In many documentaries, someone who is actually on camera and actively involved with the story may also be providing narration about what is occurring in the visual. In the touching documentary *Be Good Smile Pretty,* filmmaker Tracy Droz Tragos presents a powerful story as she attempts to learn about her father, who was killed in Vietnam when she was a few months old. Her voice-over narrative and on-screen appearance in the film helps provide important information throughout the story.

Second-Person POV **Second-person POV** is a direct address by the actors to the audience. In this case, you are considered a direct link through the character. Television news anchors are good examples of direct address. While this technique is rare in drama, the television series *Malcolm in the Middle* is an example of its use. The technique usually produces a surprise as Malcolm turns to the camera and talks directly to the audience. Shows such as *MythBusters* and *Good Eats,* along with numerous other home improvement and cooking shows, use an on-camera host who seems to talk directly to the viewer. Some documentaries use an **on-axis** interviewing technique. This process requires the interviewee to speak directly to the camera as if conversing with the filmmaker or the audience. Television news anchors provide another example of this technique, which personalizes the story for individual viewers within a mass audience.

Third-Person POV The most common point of view is **third-person POV**. In third-person POV, we are observers of the story. We can easily feel detached from the story as we watch because we have no direct connection. Characters in sitcoms and dramas, as well as participants in some reality shows, rarely look at or talk to the camera. They simply interact with one another and we look in on their experiences.

Character POV **Character POV** is based on the character whose story is being told. In almost any program, the perspective of one character is dominant. In the TV sitcom *The Office,* weekly stories always include the branch office manager as a central figure. He sets up the episode and always finds a way to weave in and out of the storyline. *The Office* is also an example of a show with

an ensemble cast. While the manager is an important character, any number of the regular cast will be involved in the weekly episodes. Likewise, the classic sitcom *Seinfeld* may concentrate on Kramer one week and Elaine or George another. Regardless, Jerry will always be a central part of the story. Other programs with ensemble casts may concentrate on specific characters during different episodes. *Parks and Rec* revolves around a central core of characters. Individual episodes may concentrate on a specific character and other cast members are not included during the entire episode.

Conflicting POV As is the case for most topics, POV can be shifted and manipulated to suit the storyteller's desire. Numerous fiction and nonfiction stories tell the story from more than one POV. Political documentaries and advertisements are a good example, where we hear the same factual material told from dramatically different perspectives. Because of two diametrically opposed views regarding John Kerry's military duty, two distinctly different documentaries were produced during the 2004 presidential campaign. Using the same images, two opposing and conflicting accounts were presented. *Stolen Honor: Wounds That Never Heal* attempts to persuade the viewer that Kerry was not heroic in his military service and that he betrayed American servicemen during the Vietnam War, while *Going Upriver: The Long War of John Kerry* tells the story of his bravery and passion to end the war after he returned to the United States. These documentaries are excellent examples of the influence a producer or corporate sponsor can have in storytelling and editing.

An episode of the PBS series *POV* titled "Butterfly" presented two very different perspectives of an incident in which a logger climbed a 300-foot redwood tree to remove a protester who had staged a protest in the tree. In one sequence, we see a shot of the protester and then the logger as each describes what happened. The scene is intercut, continually cutting back and forth between the two of them. As you watch, you begin to wonder if they are both describing the same event.

Fact-finding and keeping an open mind are elements of most documentaries. During the preproduction process, the POV of the story will surface. In a **direct cinema** or **observational approach**, it is the perspective of the characters. *Salesman,* an observational documentary by Albert and David Maysles, is told through several Bible salesmen as they go through a normal workday. In contrast, *Supersize Me* by Morgan Spurlock is told through a first person account by the filmmaker. The film cleverly presents the filmmaker's agenda as he illustrates the firsthand effects of a fast-food diet.

I think the most important thing is to make sure you create a project that is built on a foundation of fact and on a foundation of truth. And for us from the very beginning we were doing a vast amount of research. We needed to be sure that everything was backed up by a vast amount of documented material that would show that everything that we talked about in the film is true, and that would provide very

little room for question. Once you create a film that's based in this matter, it's kind of hard to refute the truth; it's kind of hard to argue with things that you can provide documentation for.

MORGAN SPURLOCK, FILMMAKER

In some cases, POV is presented through the camera. It is as if the story is being told through the eyes of a character in a scene. Generally, the camera will present a subjective view, as if it is assuming the role of an actor in a scene. This approach is visible, for example, in a thriller or horror scene when the hero is cautiously moving through a dark building. The audience anticipates the moment when the antagonist jumps into the frame towards the main character. Along with camera placement, suspense can be highlighted through the use of lighting, music, and sound. The film *Halloween* (1978) is suspenseful in part because many shots are from the POVs of the characters in danger, interspersed occasionally with the killer's POV.

Character What keeps an audience tuned into an entire program or coming back week after week for an episodic series? Why do *Seinfeld* reruns continue to be economically successful? In many cases, it is the performance of the actors, or possibly the popularity of the actors. Because stories are categorized as **plot**- or **character-driven**, audiences may need to identify with the cast if the writer expects viewers to connect with the story. A story about the rise of rap music can be plot-driven if it is about the music. The same story can focus on rapper Kanye West and be a character-driven story.

Casting, or talent selection, must closely follow the story. In narrative structure, the characters are chosen to fit specific traits, including physical appearance and personality. Working with a talent agency or holding an audition can help in the selection of the most appropriate person for the role. Because of this, general character traits should be identified before talent selection begins. Casting for a documentary helps the filmmaker make educated choices that will impact the story. In the feature documentary *America's Heart and Soul*, filmmaker Louis Schwartzberg weaves numerous short and inspiring character pieces to tell a convincing story about

STORY 1.1 Casting

The process of casting varies from project to project. In casting the independent film *Little Big Top*, we brought our lead actor onboard sight unseen. The writer/director had written the script with horror-genre actor Sid Haig in mind. We knew going in that Mr. Haig had played only "heavies" in the past, or characters that were evil or bullies. This script was going to be a departure for Mr. Haig, as he could play a range of emotions with this lead character. This made the script appealing to him, and Mr. Haig in turn would bring name caché and a built-in audience to our small feature. It was a gamble, however, because established actors tend to only participate in independent films as "offer only," meaning they do not audition for the film. So the director and I had to best guess that although we had not seen Mr. Haig play this type of role before, he could in fact hold this feature film on his own. In this case, it paid off. Mr. Haig loved the script and said it was the role he had been waiting to play. We were able to negotiate a deal with his agent and Mr. Haig turned out to be perfectly suited for the part.

SOURCE: Annie Boedeker-Roberts, Casting Director

average individuals. These stories were selected from a large database of potential stories that he had researched and collected. Schwartzberg selected those stories or individuals that added to the overall theme of his documentary.

Character development ranges from providing background information to selecting believable names. Naming someone Bob or Bobby or Robert will influence audience perception. Would you have the same reaction to a serious question asked by a Ms. Branson as you would to the question asked by a character named Sissy? While you need to use caution to keep from stereotyping your cast, there is justification in name selection. Likewise, personality traits and props can provide additional depth to your characters. Introducing your character driving a sports car, riding a motorcycle, or horseback riding provides additional information about them. In *The West Wing,* Martin Sheen plays the role of the President. His personality fits the traits that the producer wanted for this role. He is credible, charismatic, likeable, and a positive role model. More subtle characteristics are revealed as we learn more about the character's personality as the story develops. Creating believability in your character is another critical stage in story development. Even in a fantasy, the writer must convince the audience the character is real.

Production Design

Production design includes planning the physical production space, including all the physical objects, such as the location, the set, props, wardrobe, and developing a design through the use of space, color and lighting. The French term **mise-en-scene** is sometimes used to describe this design and staging of the production space. Like a character, the production design follows the story and should enhance the original story idea. It can be a challenge to create a specific look on location. Period pieces require considerable control and attention to detail to achieve believable results. During a location site visit, the designer can look for these challenges and rectify any potential problems. It is also important to evaluate the background for opportunities or distractions. A story that takes place in a coal-mining community or an upscale urban neighborhood will be more credible if the background supports the setting. Care must be taken during documentary work to keep from altering the truth through staging. While some purists would argue that nothing can be modified or moved as shooting begins, others see no problem moving photographs or changing furniture patterns for ease of shooting.

Programs such as *Desperate Housewives* and *Gossip Girl* must concentrate on props and settings that reinforce the socioeconomic status of the cast and the time period of the setting. In the sitcom *That'70s Show,* much of the production design centers around the re-creation of a family in the 1970s. The attention to detail in the production design of *Game of Thrones* is evident as the soundstage and locations bring realism to a fantasy world. From castles and furniture to wardrobe and weapons, everything must match the time frame. Every detail can be critical in supporting the story and achieving a production look that adds realism or strengthens the story. Occasionally the use of realistic props can result in the program quickly looking dated—for example, in the case of computers and cellphones, which change from year to year with the rapid changes in technology.

Large-scale production companies may have an appointed production designer who is responsible for the aesthetic look and feel of the production. These responsibilities may include hiring and supervising carpenters, painters, gardeners, costume designers, and makeup stylists, among others. In a small-scale project, the director will supervise or attend to these issues herself.

The legality or ethics of props displaying corporate logos and product names is an important consideration in production design. **Product placement** is a phenomenon in which products appear in a scene and in return, the show earns compensation. Whether planned or unintentional, this must be considered during the production design phase of a narrative story. While it is impossible to keep products from appearing in a scene, including recognizable products can sway the audience and their perception of the story. In a nonfiction story, it is important to remain balanced and avoid influencing or biasing the program by conscientiously showing only one brand of soda, automobiles, or other product. Some programs even blur out logos on shirts to keep from providing free advertisement to specific companies.

TYPES OF VISUAL STORIES

Stories can be classified as fiction or nonfiction. Fiction stories include dramas, sitcoms, and reality shows, to name but a few examples. Nonfiction includes news, documentaries, and informational and training formats.

STORY 1.2 Narrative Fiction Story Development

When I started writing screenplays for a living, I made the mistake many new writers make. I created characters to serve the needs of my story, rather than characters who inhabited the world of the story. Both roads may satisfy the requirements of the narrative, but only the second helps create characters rich enough to bring the story truly to life.

Years later I would realize that fictional characters deserve as much respect as those of us who are lucky enough to inhabit the real world. That doesn't mean that we need to write every facet of their being any more than we can know every nuance of people we meet in life. It's a matter of judicious selection of what is revealed about a character or what we learn about a person. We simply reveal only what must be known for an audience to accept that character.

My first inkling that I might not be writing the most fully rounded characters possible came on the first episode I wrote for *Charlie's Angels*. Not the most character-driven television show, perhaps, but a good training ground for the toddler writer. My producers patiently guided me to think more about the characters than their dramatic function alone. A villain may not be a villain to his family. A villain may have a life at home where, after the villain's hat is removed, a gourmet chef's cap is revealed. The villain may be a collector of butterflies, a soccer coach, or a mother.

A few years after that—as head writer of a soap opera called *Edge of Night*—I finally understood what was meant by three-dimensional characters. *Charlie's Angels* may not have needed fully realized characters to be a hit, but soaps cannot succeed without them. The best writer cannot keep audiences riveted by plot twists alone week after week. The audience must care about the characters. Today, popular soaps on prime-time television (often disguised as other genres) like *Lost* and *24* don't rely on their stories—called in the trade their *mythologies*—to retain viewer interest. They depend on their characters and relationships.

What are the three dimensions of character? Physical, psychological, and sociological. A character's physicality will dictate how he views the world, whether he is disabled, an athlete, sad-eyed, or weathered by the outdoors. A character's state of mind—his psychology—will determine how he reacts to an insult or a kiss. And his upbringing and environment shape his ability to adapt to new challenges. Incorporating these three dimensions of character ensure an audience's interest in our stories. We sense from the glimpses we're allowed that we're not watching characters at all, but human beings just like us.

SOURCE: Lee Sheldon, Writer

Fiction

Narrative fiction stories utilize the story development process introduced earlier in this chapter. Narratives are usually generalized as entertainment and range from independent digital films to network-financed prime-time series, as well as a broad variety of programs that fall between these extremes.

Think about what captivates you while you are watching a program for the first time. If act one does not grab the audience's attention by the first commercial, chances are that the audience will not continue watching to see the end of your story. The narrative is a way of ordering events into a cohesive story that is interesting to the audience. Without a protagonist and a conflict, the story probably will not be successful. Writers need to provide interesting characters and develop a plot that advances the story while hooking the audience (see Figure 1.5).

The popularity of reality-based programs makes it challenging for storytellers to educate the audience about what is staged and what is real. In *The Real World,* MTV has developed a formula for success. While the on-screen action may be reality, the events leading up to the story are heavily controlled through auditions and coaching. In a series like *The Hills,* one must question how cameras just happened to be in two locations during an important phone call breaking up a relationship.

Nonfiction

Nonfiction stories range from news packages and documentaries to informational videos and some reality shows. While each has unique preproduction characteristics, they share some common elements that make for compelling stories. First, it is important to tell stories through people. Stories are more compelling when

© Cengage Learning

FIGURE 1.5

Sophisticated editing tools are used to bring the story to life.

they involve human connections instead of merely facts. Just as we connect with characters in a fictional story, real people in nonfiction works are individuals with whom the audience can identify. Rather than quoting statistics about homelessness or the number of adults without health insurance, tell the story of one person whom the issue has affected. Stories become more powerful if we learn about individuals and can connect with them or their situations. Some stories are naturally visual, so the visual may be developed first and the script developed later to complement those images and sounds. Other stories rely on a detailed script that has the visuals matched afterward. The key is to understand which model is appropriate for any given story. In either case, providing accurate and appropriate content is the goal. Finally, give viewers a compelling reason to watch your story. Answering the "so what" question in an effective manner will keep the audience riveted.

Documentary A number of different types of documentary styles exist and the writing for them develops in accordance with those styles. In a historical documentary, some if not all of the narration can be written before production begins. As in many of noted documentary filmmaker Ken Burns' programs, the script is written after the research is completed and while the materials are being acquired. In Burns' series *Baseball*, for example, we are presented with hours of linear historical facts about the game. Researching the various eras and developing the series around interesting topics enabled Burns to create a comprehensive story that flowed during the several hours of the finished program. Details of the visual elements of the script were included based on the writing and the potential acquisition of images and footage.

STORY 1.3 Nonfiction Story Development

Betty was an engaging 12-year-old when she was diagnosed with leukemia. She responded badly to chemotherapy and went into septic shock. In the intensive care unit for more than a month, she lost almost half her body weight, underwent several surgeries, and eventually gangrene claimed both of her legs above the knee. I was commissioned to film a documentary about the heroic medical team that saved this girl's life. "You've got to be kidding," I said. This did not sound like a story with a happy ending to me.

A great documentary employs all the conventions of a narrative film. It needs tension, conflict, surprise, and interesting characters. But documentaries have an added twist. The relationship between the filmmaker and the subject is critical. Eventually, the audience is invited to share this intimacy when they view the film. For this reason, I have learned to become a great listener, and a friend to the film's subjects. I always begin documentary production with research and phone interviews. I spoke with Betty's medical team and family. Everyone commented on her unique charisma. When I spoke with Betty, I felt this, too.

The film took an unexpected turn when I spoke to Betty's primary nurse. Concerned about Betty's deep depression after losing her legs, she discovered the remedy. Betty had stopped talking and eating. She was uncooperative and was refusing treatment. And one day as her primary nurse was changing her dressings, she noticed Betty watching the Pope on television. The nurse asked, "Betty, do you want me to take you to Easter Mass?" Betty nodded yes. When the nurse arrived that Easter Sunday, she found Betty lying in bed dressed in her Easter finest. The nurse wheeled Betty, IVs and all, to the mass in the hospital chapel. After mass, Betty looked at the nurse and smiled for first time in months. She said, "I thought God had forgotten me."

Betty recovered. She gained weight. She walks on prosthetic legs without assistance. She plans to become a doctor and help other children. This documentary is indeed a story of heroism. But I discovered this in unexpected places. The story flowed like a river, down waterfalls, over rocks, and around bends. All I had to do was listen to the current and follow its course.

SOURCE: Wendy Rosen, Writer/Director

As discussed earlier, direct cinema allows the story to develop without interference from the production crew. Frederick Wiseman is regarded as one of the most important American documentary filmmakers of the past 40 years. He emphasizes the routine of daily life with no overt attempt to interpret what happens in front of the camera. In *High School* (1968) and *High School II* (1994), Wiseman used this "fly on the wall" approach to unobtrusively film the daily routine of middle-class high-school life. Wiseman does not set up interviews, use voice-over, or music; instead, he lets the story be told as it unfolds in front of the camera. Ironically, Wiseman feels that the ratio of the film shot to the final edited piece distorts the truth because the audience does not view the real-time capture of events.

Errol Morris is another well-respected documentarian whose style is quite different from Wiseman's. Morris adds production technique to his work in the form of re-creation, music, and a unique second-person approach to interviewing his subjects. In *The Fog of War* (2004), for example, former Secretary of State Robert McNamara is interviewed through a device Morris has labeled the **interrotron**. This device is similar to a **teleprompter**, a device that mounts in front of a lens and uses a mirror and video monitor to display text for talent to read. Unlike a teleprompter that displays words, however, the interrotron image is that of Morris. The result is that the interviewee is looking directly at the audience as he is talking to Morris. Morris argues that truth exists independent of style.

© Cengage Learning

FIGURE 1.6

The interview is a main component of many documentaries.

Documentaries dealing with contemporary social issues may rely solely on content gathered during interviews. The original script should be a detailed outline containing names and contact information for the interviewees. While the outline provides the basis for the story, the actual interviews contain the story itself (see Figure 1.6). Visuals can be added after the interviews are edited into short, quotable statements called **sound bites**. The director gathers a shot list of visuals that help tell the story. If the interviewee discusses the impact that tablets have had on reading books, for example, the director could shoot footage of young people using tablets, screen shots of electronic book titles, and rows of library shelves full of books. Some documentaries try to remain flexible and combine these styles. In a feature about the construction of a new skateboard park in the community, the writer can outline the story, write voice-over, shoot the footage, and prepare specific questions for those to be interviewed.

Informational, Training, and Event Videos

My organization's board of directors regularly uses video webcasts to communicate their message. Our viewers remark about how effective this has been in making them feel a part of the company. All it took was a little effort in planning and producing interesting and informative pieces.

MORGAN ANDERSON, DIRECTOR

Most informational and training videos can be scripted during preproduction. Since these types of programs have specific goals, it can be easy to prepare the script according to the program objectives. A corporation that needs a safety video for new employees can assign a staff writer or hire an independent writer to complete the script before production begins. The format for this type of video might range from a scripted training program to a narrative scene with actors. In either case, the content does not change from the original company policies written in the employee handbook or pinned on a bulletin board in the staff lounge. The video does not change the information—just the format for delivery of the message.

Specialists, called instructional designers, are often brought in during the development stage of a training or informational video. **Instructional design** is a systematic approach to the design of a program (see Box 1.1). This process of creating objectives and selecting the appropriate means to communicate can be essential in a training or informational video. Because these types of programs are produced to help solve communications problems, many producers hire an instructional designer to assist in the writing process. An instructional designer works with content experts and production personnel by conducting a needs analysis, analyzing the audience, establishing objectives, and evaluating the completed program. Although most video producers have little training in instructional design, many use elements in the day-to-day preproduction decisions they make. Deciding on program goals and audience characteristics and selecting the best program format are all part of the process. By approaching a production

B O X 1.1 Instructional Design Model

The six steps of the ASSURE model (based on Gagne's Events of Instruction) are summarized as follows:

A	Analyze Learners	• General character • Specific entry competencies • Learning style
S	State Objectives	• Learning outcomes • Conditions of performance • Degree of acceptable performance
S	Select Methods, Media, and Materials	• Select available materials • Modify existing materials • Design new materials
U	Utilize Media and Materials	• Preview the materials • Prepare the materials, environment • Provide the learning experience
R	Require Learner Participation	• In-class and follow-up activities so learner can process the information
E	Evaluate and Revise	• Before, during, and after instruction • Assess learner, media methods

SOURCE: Heinch, Molenda, Russell, and Smaldino (1996)

with a systematic plan, producers can enter the production phase with a clearer idea of what the outcome will be.

PROCESS

Once a project has been given approval for development, both fiction and non-fiction programs undergo a process of researching and writing content. While the specifics are varied, the overall task is to understand the topic and begin the interpretation process.

Research

Everything from uncovering and confirming historic facts to finding actors and selecting locations requires some type of research. A variety of methods are used to research a story idea based on program genre (see Figure 1.7). **Genres** are

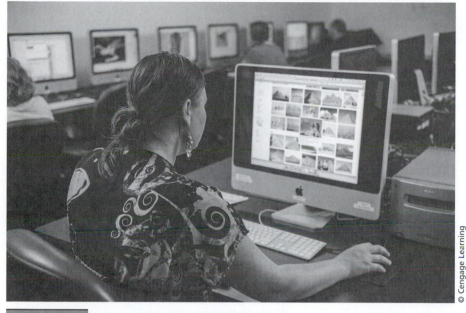

© Cengage Learning

FIGURE 1.7

Research is critical in the development of your story.

identifiers that help group programs into specific categories. Sitcoms, reality shows, and talk shows are examples of genres. For a narrative story, the writer must understand the characters and the setting, and how to advance the premise in an understandable and believable way. Researching room décor and fashion are particularly important for a period piece. A series about an urban homicide unit needs texture in character and setting to make it convincing.

A TV drama set in a hospital must be credible for audience interest, but a sitcom in the same setting may not need the same level of reality. A high-tech espionage drama needs to reflect the sense that the undercover agents or spies work in a world that most of us have never seen.

Nonfiction stories demand thorough investigation to ensure that the truth is being presented, and require writers to research the content and attempt to find the truth. In addition, certain documentary programs must present story balance and keep the content from being biased or politically motivated. While Michael Moore is a talented filmmaker, he creates controversy in his documentaries because he tends to only present highly debated issues from his own perspective. In *Fahrenheit 9/11* (2004), Moore presents a compelling argument against the war in Iraq, but the tactics he uses in interviewing and editing disenfranchise those who do not agree with his personal stance.

March of the Penguins (2005) director Luc Jacquet was keenly aware of the habits of penguins and the area where the production would take place as he followed the penguins' annual migration in Antarctica. This knowledge allowed much more control in the shooting and gave the filmmaker the luxury of a

detailed shot list. In *Sherman's March,* filmmaker Ross McElwee's story idea shifts from a historic documentary to a first-person account of growing up in the South. More often than not, however, you will not have the background that Jacquet and McElwee had when they made these films. While having a background or some knowledge on the topic can help focus the research, starting a project with no preconceived agenda and a willingness to learn can also be useful. There is an old saying that "you don't know what you don't know." This may sound simplistic, but without researching and broadening our knowledge base, we are apt to miss elements that are important to credibility.

While life experiences are an important part of research, most projects include additional inquiry. Investigation through person-to-person interviewing may make sense for one project, while another project may rely on library or Internet searches. Finding multiple sources helps reinforce the credibility of the script, as do follow-up checks to confirm the original data. The more depth in your research, the more confidence you should have in the believability of the content. Research is critical for any program. While it is not one of the most glamorous parts of the process, it is one of the most important ones. Thorough research can help uncover previously unknown facts as well as help avoid legal troubles for the program. (Legal issues are covered in Chapter 3.)

An additional level of sophistication in your story research is related to the fact that television is a visual medium. Not only does the writing need to be researched, but all visual and sound track elements must also reinforce the premise. The visual element can make the credibility of the story more difficult to achieve since the images must add to the integrity of the story.

Research is important for every genre and story format. While it may not be apparent, the casting for a reality show is a critical element in the planning of the series. Everyone who is chosen for the show has been meticulously screened to provide conflict with other characters. Likewise, an advertising agency and its production company spend an inordinate amount of time researching the audience and product so that the financial risk can be minimized during production.

Translating Thoughts into Words

Writing is the most important step in the overall process of video production. The writer plays a very important role in how the program sounds, feels, and looks. A visual writer works not only with words, but also with pictures and ideas. Writing the script usually includes all elements of the sound track, such as music, ambient sound, and sound effects. In addition, pacing, transitions, and other visual cues are all integral parts of the writing process.

The Script Narrative storytellers must focus their creative ideas and write dialogue within the framework of a believable and interesting story. Besides good technical writing skills, the writer needs to interpret culture, gender, age, and other factors in creating effective dialogue for specific characters. Life experiences certainly assist in developing stories that are credible. This is why many programs hire content consultants to assist in the writing process. A good example is *CSI,*

where the credibility of the health-related technology and medical procedures is important to the integrity of the show.

Nonfiction writing might involve using content experts who are well versed in the specifics of the content but remain novices when it comes to visualization. Even though content experts may not know how to format a script or understand how to tell the story visually, they are an integral part of understanding and articulating the content. A first draft of a script can be written by the content expert and then rewritten and adapted into a video script by the scriptwriter. Other nonfiction scripts are an outgrowth of content gathered through interviews.

The Interview One of the more common story elements of a nonfiction program is the interview. It might seem easy to set up and shoot an interview, but it can be a challenge considering everything that takes place in the process. An interview requires research, planning, coordination, and error-free technical production to achieve the best results. Numerous details are involved, ranging from the relationship with the interviewee to the calibration of proper audio recording levels. Sometimes you may be forced to cut corners in the research phase due to lack of time, or you may be nervous interviewing people because you want to avoid inconveniencing them. These issues must be addressed or the production may end up a failure. You are much better off spending the time necessary to getting everything correct and ending up happy with the results.

CONCLUSION

The most fundamental element of your production is the story. Storytelling is a combination of creative input, research, and good writing skills. Stories are usually developed with a traditional three-act structure and rely on point of view, character, and production design to advance the narrative. Stories can be categorized as either narrative fiction or nonfiction. Each has its own unique elements and style. Scripts usually follow a basic format that includes some criticism and evaluation throughout the process. The reward of working on a production lies in seeing how the story advances from an idea to a finished script.

How the Book Works: The Story Challenges

As you work through each chapter in the book, we will explore a fictional storytelling scenario. Each chapter will discuss the scenario and highlight decisions that you need to make, questions you should discuss, and challenges that you will face in terms of the chapter contents and their relation to the scenario. Think about how the contents of individual chapters will help you make those decisions, will inform your questions, and will help overcome challenges as you work to complete the productions.

In this scenario, you are a director for Pick 2 Productions. Pick 2 is a video production company that has just been hired by a nonprofit organization to

produce several video projects. You will be working with a regionally popular band that is going on tour in support of the organization's efforts to promote alternative fuel sources. Among the productions are:

1. A behind-the-scenes documentary of the tour that will air on a major cable network. It will include a historic look at alternative fuel sources, interviews with band members, and footage from the various tour stops.

2. A DVD of the live outdoor concert that the band will do as a fund-raiser for the nonprofit organization. The outdoor venue will be the last stop on the concert tour.

3. A music video of the band's latest songs that will stream on a website and be used on mobile platforms. The video will use a narrative story concept.

Preproduction

Each story is a different experience, a different learning arc professionally. It has never, ever gotten any easier. I know what's involved technically and emotionally to make one of these things happen. I have done my best to understand and utilize all of the tools at my disposal—script, camera, editing, and post production. I also learned and understand fighting my way through the executive jungle, which is an acquired skill. This is my definition of a professional: An amateur only does things he or she wants to do, and a professional does what he doesn't want to do.

JOHN FRANKENHEIMER, DIRECTOR

OVERVIEW

The most critical stage of video production takes place before much thought has been given to actual shooting or editing. The amount of time spent during this initial stage is considerable and usually far outweighs the amount of time in actual production. Poor preproduction usually results in longer and more expensive production time and increases the risk of a failed production. Attention to detail during the design and planning stage will have a significant impact on the effectiveness of the final project. It is not uncommon to hear a director state that the problems visible in a completed project relate directly to tasks that should have been planned better in preproduction. Just as a builder listens to a home owner's suggestions, uses architectural plans, creates a materials list, obtains permits, and presents a budget before picking up a hammer or saw, a video producer must also design and plan carefully. Shortchanging these important steps in preproduction would be like the builder forgetting to measure before cutting the first board.

The goal of this chapter is to make you aware of the important tasks one must consider before production begins. Bypassing the many planning activities required in this phase will certainly decrease the chances of producing an

effective program. Your chance for success is limited if shooting begins without a well-thought-out plan or if you rely on post production to try to figure out how to tell the story.

Story Challenge: Preproduction

Pick 2 Productions is about to begin development for a series of videos. The staff will be working with a regionally popular band that is going on tour in support of the nonprofit organization's efforts to promote alternative fuel sources. The challenge is to motivate an audience of young adults to seek more information about alternative fuels. Each of the three productions requires some similar design activities and project-specific planning. As the project begins, a multitude of key questions needs to be answered, some of which are listed below.

- What is known about the potential audience?
- Will the nonprofit organization develop treatments for each video?
- Is the budget at the level necessary to complete the productions with the level of quality that Pick 2 is comfortable with?
- What makes the documentary an interesting story?
- What resources are necessary to produce each of the three programs?
- Can the schedule be organized to allow current staffing to complete the work?
- Is the script going to be written by content experts and adapted for the video?
- Besides the band, will there be on-camera talent?
- Will storyboards be provided for the music video?
- What methods will be used to distribute each of the videos?

THE PREPRODUCTION PROCESS

Having a strategy to deal with the plethora of preproduction activities makes a lot of sense. Deciding on how to proceed with these tasks in a systematic manner can make the process easier to manage. Developing a preproduction model is an effective way to organize the process.

Pitches and Funding

Money is necessary to produce most stories. Programs that originate from a writer, producer, or director are probably seeking funding. Projects that are pitched through a bid environment are competing for a contract. The **pitch** is usually a face-to-face opportunity for you to sell your idea to a potential buyer or funding agency. A strong pitch should be synthesized into one sentence that clearly articulates the story. It can range from an informal exchange of ideas over lunch to a stressful business meeting with a precious few minutes to sell your

STORY 2.1 The Pitch

Making a successful pitch is an art form …. As a producer and executive, I have had the opportunity to be the "pitcher" and the "pitchee."

When walking into a room to pitch, I always take a deep breath and attempt to walk in with confidence. Executives and financiers can smell fear and most of the time, it is my belief, they want to find reasons to say no because saying no is much easier.

It is important to engage the room with your idea and feel confident enough about your subject matter that you can allow them to bounce ideas off of you and thus feel comfortable in adding their own touches, thus giving them ownership and a reason to feel empowered to champion you and your project.

As an executive, I have heard good pitches that are just not what the company is looking for; therefore, it is important to know your audience and what they are looking for so you don't waste anyone's precious time. Setting up a general meeting with a company is a good way to navigate those waters. Just remember to read the room and always, always, do your homework before you walk into the room so you can talk intelligently with the executive and make them feel special! Remember this is the movie business: movie… business….

SOURCE: Jessica Petelle, Producer

idea. Being prepared and having a passion for your project are critical in this situation. You must believe in the project and be able to convince others of the merit of your story. A good pitch doesn't get into the details of the story, but rather provides a persuasive and interesting hook that provokes additional questions. Picture yourself getting into the first floor elevator of a high-rise office building and the only other person in the elevator is someone who could finance your project. Your strategy is to interest this person in the project. You do not know if if he or she will be on the elevator all the way to the top floor, or be getting off on the next floor. You will need to be concise and convincing. Pitching "a college student discovers her boyfriend's quirky hobby" is much more interesting than "this is a story about a college student and her boyfriend. There's a shot of them walking on campus. As they pass the psychology building…." In addition to an interesting pitch, you will also want to complete your story research ahead of time so that you can confidently respond to specific questions about the plot.

Regardless of whether the project is solicited by a bid or external funding is being sought, you will need to have at least a general estimate of the production costs. For some projects, being able to articulate accurate budget figures might be impossible, while it may be required for others. Video producers understand that a number of factors influence the budget and it would be unwise to estimate costs without going through some of the steps in the preproduction process. The bottom line is that someone must pay for all direct costs to the project. It will not be easy to justify spending anyone's time or money, including your own, without the credibility that a well-thought-out plan provides. Creating a budget is covered later in this chapter.

Consultation

In most cases, someone else initiates the project idea and a producer or director executes the production based on interactions with this person. In these cases,

the initial stage usually starts with a fact-finding and brainstorming component. Regardless of whether you are a staff producer or are being hired on a contract basis, the consultation stage allows you to collect information that is necessary to bid on the project or propose a specific concept. Because this stage is so early in the development of the project, there are numerous reasons to refrain from making important decisions, offering solutions, or pitching a specific treatment of the subject. It is wise to complete this initial stage by gathering the information you will need to write a solid proposal (see Box 2.1). The audience for and potential uses of the video must be understood before any additional work can be started. After this initial meeting, you can reflect on production options before developing a goal statement that focuses on the idea and helps ensure that all those involved understand the proposal.

As a producer, you must make decisions on the feasibility of producing the project. Accepting a contract for a video project that is confusing or that does not make sense as a visual program will probably result in failure. Understanding what it takes to make a program successful is one of the most important skills of an experienced producer. Agreeing to produce a program that may potentially fail is an unwise choice for a producer trying to build a client base for future work. When a project fails, the blame usually falls on the production team. Because of this, you must learn to say "no" or modify project ideas that have little chance of success.

The Audience Knowledge of the audience is a critical factor to consider during this phase. Demographic information such as gender, age, and income can provide useful data as you develop your creative content. It is also sometimes necessary to design the program based on the viewing situation or motivation for viewing. A young adult watching videos on Internet sites like YouTube, Vimeo, or Hulu has a different motivation than a teenager told to view a training video on the first day of a new job in the fast-food industry. It is critical to research and understand your audience before moving forward.

The Viewing Environment The viewing habits of a middle-aged adult watching the Food Network on a TV in her living room are different from those of the same person watching episodes of a prime-time network drama on a smartphone during her morning commute on public transportation. The same program might be viewed by one segment of the demographic in a movie theater while another watches on a laptop. Informational videos may be viewed at a kiosk in a store or on DVDs mailed to interested consumers. Predicting the viewing environment may be impossible, but considering these potential uses assists the writer and the director in either adapting the production elements for a broad range of environments or customizing it for a specific viewing experience.

Secondary Uses and Markets Secondary audiences and other potential markets provide repurposing opportunities. With so much time and money allocated to films and national broadcast programming, producers judiciously consider

BOX 2.1 Client Questionnaire

There is considerable information to gather anytime you are producing a video project for someone else. Developing a list of possible questions can assist in the efficiency of the meeting and demonstrate preparedness and attention to detail. The following is a suggested set of questions you may want to consider.

- What is a good working title for the video?

Many clients have difficulty summarizing their project idea with a title. This short statement may eventually be the basis of a focused goal statement.

- Can you articulate or write a short description (25 words or less) based on the video's working title?

Expanding the title into a short description is another step in forcing your client to present and articulate his or her idea in a form that you and the client can understand.

- What is the goal of the video?

Every video needs a goal. It can be as simple as "to entertain a general audience" or as sophisticated as "to train electronics engineers how to troubleshoot voltage irregularities in automotive engine computers."

- What are some of the video's specific objectives (key points)?

By dissecting the goal, many projects can be broken into specific objectives. This is similar to an outline for a written paper.

- Who is the video's primary audience? Secondary?

Many programs end up being used for audiences that were not considered when the program was first produced.

- What assumptions can you make about the video's audience?

Audience demographics can be useful in preparing the script for a specific age, gender, or cultural group. Viewer motivation should also be considered.

- What's the shelf life for this video?

It is important to know if the program will be used more than once, and if so, for how long. Can you imagine the difficulty in developing a program that may be used for several years?

- Are there other potential uses for the story?

It is important to know if there are plans to post the video on a website or make it available for customers to copy to mobile devices, or to distribute it in other languages. All these pieces of information might influence the production process.

- Close your eyes and visualize the program.

Can the story be told with pictures? Since you are working with a visual medium, attention to the images is essential. Sometimes the simplest ideas are effective because of the connection between picture and sound.

- Are there any legal issues related to this video? Any ethical considerations?

Every individual must consider his or her own moral code when making decisions about a production. Ethical decisions may surface throughout the project, including everything from scriptwriting and dealing with talent to selecting locations and the use of hidden cameras. Refer to Chapter 3 for specific information regarding contracts, laws, and copyright.

- What is the deadline for the production?

Knowing the deadline for any project is critical before scheduling resources (production crew, equipment rental, and so on) and talent.

- List some dynamic scenes/shots that can capture the audience's attention.

One of your creative goals should be to hook the audience early in your production. Ask your client for ideas on how to achieve this.

- Describe the type of voice you would like for the narrator.

This is an often overlooked and critical part of many programs. Using a male friend to do your voice-over instead of the soothing female voice called for in the script may be convenient, but could do more harm to the effectiveness of your program than poor camera work or sloppy editing.

- List some possible endings that will make the audience react the way that you would like.

It is critical to end your program in such a way as to solicit the reaction you or your client intended. Just as a weekly TV series attempts to get the audience to tune in again the following week, a video soliciting funds for a local charity should have the audience motivated to write a check after viewing the program.

supplemental uses for programs. Many entertainment producers shoot alternative scenes for potential use with different audiences. A corporate producer might need longer takes of shots to adjust scenes for videos distributed in multiple languages. An independent film producer might have aspirations of reaching a general viewing audience and may consider distribution through an online service where members can download the movie. A clear understanding of these potential uses can help you adjust the project budget for any additional shoots or other elements that might need to be created for the secondary uses. Having additional uses for your program is a bonus that allows for a better return on your initial investment.

Distribution of your project will require action on a multifaceted set of issues ranging from cultural considerations to legal and contractual concerns. These types of issues are more difficult to solve when a repurposed video has not dealt with these issues early in the planning stage. Decisions on closed-captioning, inappropriate language, cultural references, and imagery require time and planning. Contract negotiations are always more complex and costly after the program has been produced. While some of these items may not seem important at the time, they should at least be considered.

Design

Preproduction design begins with the development of a short proposal, a story synopsis, or an in-depth treatment of the subject matter. This initial document may be used to secure a contract, or it may be presented to demonstrate that you understand the client's needs and have a plan that will solve his or her communications problem.

The Production Book

From the initial concept until the production has been completed and distributed, a **production book** should be compiled. This notebook, combined with electronic files, contains all pertinent information regarding the production. Some of the items include script drafts, copies of memos, printed copies of e-mails, notes from phone conversations, legal documents, site surveys, equipment lists, budgets—anything and everything that deals with the production. A companion to the production book is the project website. This site can be used internally for communications with others involved in the process and it can be employed as a promotional piece for the public to browse. Keeping all this information organized and in one location has its advantages. First, it keeps all the pertinent documents for a production in one location and facilitates organization. Second, given the potential difficulties and problems that can arise with any production, the book can become a lifesaver. If you suddenly need to produce a clearance form or show a permit to shoot in a particular location, simply go to the appropriate section of the book. When a producer is working

on several projects at the same time, keeping a good production book for each one can save time and greatly reduce stress. It makes information readily accessible. Once the production is complete, the materials can be archived. This makes it convenient to access these completed files for future modifications to the program or as resources for other projects.

The Proposal The initial proposal (see Figure 2.1) should be written in clear language so that the client can understand it. Some projects require a written logline and a brief synopsis of the program. After this abstract, pertinent information acquired during the consultation stage will be presented, which might include audience, goal, and other related information. A production plan should describe how the program will be produced. It may contain generalized information regarding personnel, facilities, and equipment. Last, a budget may be included. When the proposal is presented and accepted by the client, it becomes a contract for both parties.

PROPOSAL

PROJECT: Parrotland

A former child star is once again thrust reluctantly into the spotlight when a ruthless record executive discovers his happily obscure band of sideshow carnies.

ABSTRACT:

Parrotland is the story of Ned, a former childhood sitcom star. When we meet Ned, he is seemingly content with his obscurity, and his girl, Tracy, and a slightly demented but extremely talented band of Carnies, operators of the long-standing roadside attraction known as Parrotland. It is Stormy Huff who brings record executive Luther Gamboni to Parrotland. Luther is about to lose his job unless he comes up with something big—a hit song—and fast. Ned finds Luther a little too suggestive of the childhood memories that drove him from the spotlight. The events that follow cause Ned to question his past, and threaten to cost him his future with Tracy.

PRODUCTION PLAN:

1. There are 14 scenes with 5 locations. All locations have been cleared for production on the tentative dates requested.
2. Storyboards are complete and reviewed for continuity.
3. Talent contracts have been sent out.
4. On-location shooting is not to exceed $7,000. This will allow 7 days of location shooting.
5. The production team has been hired, consisting of a videographer, sound tech and a P.A.
6. Editing, graphics and sound will be completed in-house.

© Cengage Learning

FIGURE 2.1

The proposal includes pertinent information that clearly presents important information about the project.

The Budget

> It is often said that there is a triangle of quality in production:
> the story itself, the production schedule, and the production
> budget. Change to one of the three corners of this triangle
> affects the other two. Thus, before you can think about your
> budget, you must think about your story. What is the story
> you're trying to tell? Who are the characters? What elements
> will it require? Interviews? Archival research? Narration?
>
> ROBERT BAHAR, PRODUCER

Budgeting for any production can become a guessing game if you have not prepared your production plan thoroughly. As in any type of estimating, there is always a margin of error. Underestimating the amount of time it takes to complete a given production task is a costly mistake for a producer to make. Inexperience with estimates is the biggest cause of this problem. If the project is taking more time than originally budgeted for, the producer must try to renegotiate or simply deduct the extra costs from any potential profit. Equally problematic is a situation where the producer overestimates a job and has a budget that is out of line and unacceptable to the client. Because of the competitive nature of the bidding process, customers usually request a range of bids they can choose from. Experience with the bidding process is critical for a successful contract. A good exercise that can assist you in preparing budgets is to document how long each production activity you participate in takes to complete. Keep a log you can reference when a similar job surfaces in the future. As you gain experience, you might be surprised to discover what you have learned about how long it takes to set up and shoot each shot in a scene or how many edits you can actually complete per hour.

STORY 2.2 Budgeting

The smartest thing ever said to me when I was just starting out in the film business was by an executive producer from Columbia Pictures. He said, "There's GOOD, FAST, and CHEAP … pick two because you'll never get all three." Twenty years later, I have never been in a situation where that was not the case. When budgeting, that "saying" should be utmost in any producer's mind!

It was in *my* mind when I was commissioned to produce a new series for the Discovery Channel and given a budget. The series was about two months late in starting preproduction and the budget was minimal. I went through every line item in the budget and called every vendor I knew asking them if I could work off-hours, trade-out services, and negotiate special rates based on "spec" deals. Even working some deals based upon reputation, I wasn't able to meet the numbers in the proposed budget.

So, turn down the job or compromise the production and myself? Neither…. I went back to the production company and told them in order to do the job and make it GOOD, I needed $10,000 added to the budget. By studying the budget, working with the vendors, and then being up-front and confident about what it would take to get the project finished, I was able to sell my request. I was given the extra $10,000, managed the production with an eagle eye, and was able to bring the series in with $3000 to spare. If I had simply taken the budget I was given and not taken into account the accelerated time line or low budget, I would have passed up a great opportunity or failed in my job as producer.

SOURCE: Clare Libbing, Producer

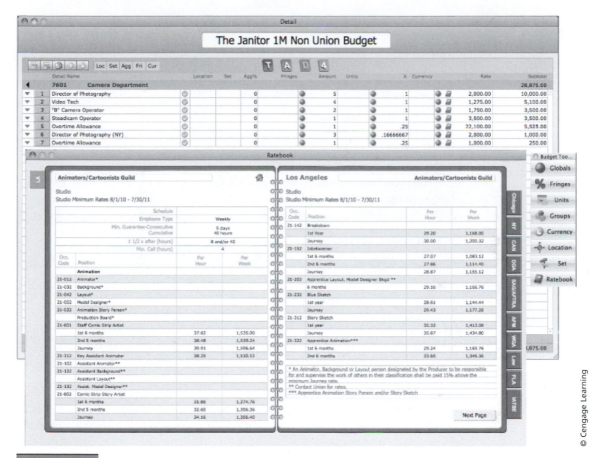

FIGURE 2.2

Budgeting can be more efficient with the use of a specialized software program designed for film and TV production.

SOURCE: Courtesy of Jungle Software.

The production budget (see Figure 2.2) contains a variety of items and costs. **Above the line** costs are those associated with the creative process. Some of these costs are writer fees, director salaries, and story rights. **Below the line** costs include such things as equipment rental, hourly production crew rates, and props. Some of these costs are fixed, while others are variable and depend on the amount of time the production takes to complete. A producer should have the ability to look at a proposal and make a good judgment as to how much time it will take to produce the program. Once the time has been established, it is a simple matter of plugging in the correct costs. For example, if a simple scene can be shot in one hour, equipment rental and personnel can be easily calculated. However, one must not forget media cards, setup time, rehearsals, licenses, or other items that are not so evident.

The **rate card** (see Figure 2.3) is an important tool for calculating costs. Most facilities list their charges on a rate card that contains detailed information

RATE CARD

1. Allow us an opportunity to bid on your multi-day projects.
2. Other service available upon request.

Camera Package

- Sony NXCAM Camera
- Miller Tripod
- Hard-Wired Lav Mics
- Arri Light Kit (4 Instruments)
- 9" LCD Battery-powered Monitor
- Wireless Microphone
- Full Day: $800, Crew costs additional

Professional Editing Services

- Avid Media Composer or Adobe Premiere
- Full Day: $1,400, 1/2 Day: $800
- Operator included

© Cengage Learning

FIGURE 2.3

The rate card lists costs associated with the services offered by a vendor.

on every service from a one-hour camera rental to a full day of editing. These prices make it easier to complete an accurate budget. It is also common for facilities to negotiate costs during slow business times, or if you are willing to use the facilities during nonpeak hours. But be aware that the rate card does not contain all of the costs associated with the production. As mentioned earlier, most productions have additional expenses, such as transportation, lodging, meals, and other crew costs.

Another budgetary consideration is the acquisition of materials from third-party vendors. These include such items as stock footage, graphic elements, sound effects, and music. Public domain and copyrighted media can be acquired through numerous sources. Some of these companies literally charge by the running time (measured in seconds), while others set their rates based on how the media will be used. It can be time-consuming to find and secure music rights if you plan on using contemporary music. That particular task might best be left to a specialist who will investigate and negotiate costs. The charges for this service are small considering the time you might spend researching and negotiating rights.

Scriptwriting

The process of writing a script is similar in many respects to any other kind of writing. The basic rules of grammar and sentence structure apply. At the same time, the scriptwriting process is different from more traditional kinds of writing,

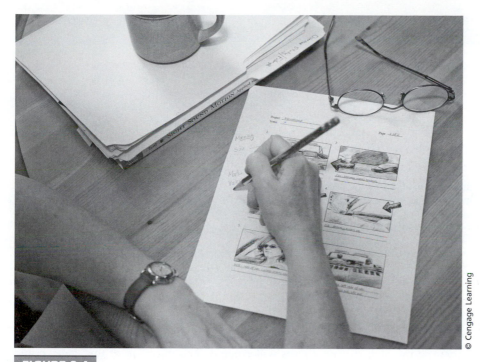

© Cengage Learning

FIGURE 2.4

Whether writing or planning visuals, the writer plays a key role in the success of any project.

since the writer needs to continually visualize what the audience will see. A brief shot showing the emotion on an actor's face can say as much as a paragraph in a novel (see Figure 2.4). It is also much easier to demonstrate visual tasks such as how to cast a fly-fishing rod or do a pirouette in a ballet by showing the process along with a simple voice-over.

Scriptwriting style is also dictated by the genre or type of project. Film scripts follow a time-tested standard with detailed lines of dialogue and specific camera directions, while a documentary might not be written until after interviews are shot and reviewed. A training video script might be heavy on voice-over work recorded after the majority of scenes are shot.

Writers may be staff employees or may work freelance. Freelance writers are usually contracted on a project-by-project basis. Some writers are unionized and only work for a union rate. Others quote a price for a specific project or work on an hourly rate. There should be a clear understanding of what the writer is responsible for when working with a freelance contract. The contract might include specific due dates, phonetic spellings of difficult-to-pronounce words, and a list of corresponding visuals or storyboard images.

The Stages of Scriptwriting The specific stages of scriptwriting are generally broken down into concept, outline, draft(s), and final script. During the concept stage, creative input and brainstorming take place. Early in this stage, the writer

STORY 2.3 Scriptwriting

Virtually any script you write without a guarantee of pay or eventual production of the material is, in Hollywood jargon, a "spec" script. Abbreviated from "speculative," it is a fitting description of what every young screenwriter must create to hone their craft and establish a reputation in a highly competitive field.

To become a screenwriter, you must write screenplays. Period. At first, no one but friends and family will care enough to read your work. But stick with it, seek out and listen to solid constructive criticism of your writing, and eventually some content-hungry producer will probably come knocking.

If you have made it to the point where a producer is asking you to write something, you have probably already put in some serious hours on the keyboard. So instead of just being thrilled that somebody is interested in your work, take a close look at the producer and what he or she wants you to write. Is this a producer you can trust? Do you believe that he or she can get your work produced, and that you will be paid and get a screen credit? Are you comfortable with the proposed content? And, ultimately, is writing this screenplay for this producer the best use of your valuable writing time?

It is always better to be writing than not, but before accepting a job on "spec," just be sure you believe enough in the project. If not, you may find yourself miserably typing away on somebody else's script for free while wishing you had time to write your own.

SOURCE: Ward Roberts, Writer/Director

should gather ideas and suggestions. As with any creative writing experience, fresh ideas sometimes evolve from other ideas. Having a writing team can greatly increase the odds that new ideas will emerge. The outcome of this stage should be a well-thought-out concept that is producible and that will conform to the story goal and target audience.

The second stage is to create an outline of the script based on the creative concept. This outline will help develop the concept and provide insight into the visualization. Sometimes an outline makes it easy to follow the flow of the story as you read it in a linear form. Story beats are added during this phase. **Story beats** are major events in the story. They can clearly explain the progression of a story without the dialogue slowing down the story comprehension. The more detail added at this juncture, the easier the transition to the next stage (see Figure 2.5).

The scriptwriter's skill can shine during the third stage by adapting written text to include visual scenes and the development of character through dialogue. This phase usually requires multiple drafts. The first draft may be written by either a scriptwriter or a content person. From this point on, the content person will act as a reviewer of the language and make certain that the script still communicates what was intended. This content expert might be a lawyer reviewing scripts for a TV program like *The Good Wife* or a scientist checking factual information for a children's science series. The final script is the culmination of all these processes. It can be quite time-consuming and expensive to change a script once the actual production work has begun, so it is important to have script approval before going into the production stage. Final approval may come from someone who has not been involved with the process, so good communication is critical throughout the scriptwriting process.

Act One
Scene 3—Bowling Alley

Laura, Chris, Peter and Sarah are trying to waste time at the bowling alley.
Although none of them bowl on a regular basis, they overcome Peter's clumsiness
and find that they are having fun and time slips by.

1. Peter is buying a soda at a vending machine.
2. Sarah is trying to untie a knot in a bowling shoelace.
3. Laura tells Chris about her relationship with Jim.
4. Chris probes for more information.
5. Sarah listens in and adds a few comments.
6. Peter puts his soda on the ground by the ball return and bowls his first frame.
7. Peter gets a strike and in his excitement kicks the soda can.
8. The soda can rolls onto another lane, angering an older couple bowling there.
9. Laura, being the diplomat she is, rushes over and eventually makes friends with
 the older couple.
10. Chris continues to throw gutter balls.
11. Sarah keeps hinting at the relationship between Laura and Jim.

© Cengage Learning

FIGURE 2.5

Story beats are another method used to organize actions or events that occur within
a scene.

Writing Conventions As with any media writing, a number of time-tested
conventions can assist in creating an interesting and effective script. For exam-
ple, most narrative dialogue should be informal and feel like a conversation
instead of having a stilted, formal style. As Mark Twain said, "I never write
metropolis for seven cents when I can get the same price for city. I never
write policeman because I can get the same money for cop." Using simple
words and sentences is recommended since the viewer of a linear program
does not have control over the flow of the program. The typical audience
member's listening vocabulary is approximately three times smaller than his or
her reading vocabulary.

Poor

"The campus had three inches of precipitation last night."

Better

"The campus had three inches of rain last night."

Poor

"Pickup basketball, which is a popular activity in college towns, is played in
the student recreation building."

Better

"A popular activity in college towns is pickup basketball. Games are played
at the student recreation building."

The pace of your script has an influence on the audience's perception of the piece. Depending on how you use writing conventions and narration recording techniques, your audience will perceive the same script differently. Slow pacing usually equates with boredom, but it can also add tension to the story. A fast pace may keep your audience from understanding the content. As with all elements of a production, trial and error are sometimes the only methods you can rely on to make these decisions.

A common writing technique used to hold audience interest and make the story more understandable is the use of active rather than passive voice. Active voice draws the viewer into the script.

Poor

"The concert was attended by college students."

Better

"College students attended the concert."

Because contractions are so common in everyday language, use them in scripts to keep from being too formal.

Poor

"Hello, what is your major?"

Better

"Hi, what's your major?"

Because video scripts cannot create cues for the audience, vocal cues can be used as an alternative. In the following sentence, many of the words can be emphasized individually to give the sentence a variety of subtly different meanings. Think of the various meanings based on the emphasis.

The *boss insisted* that *everyone* have a *good* time.

If someone must narrate the script, make certain it is readable. That means any words that might be unfamiliar to the reader should be spelled phonetically. It also means spelling out numbers instead of writing the numeric characters.

Use *three hundred and fifty-two* instead of 352.

Use *it re am* for the pronunciation of the chemical yttrium.

Always double space, or even triple space, scripts. Use uppercase letters for all directions, but use upper/lower for the body of the script. Clarity in style and use of some white space on the page makes a script easier to read. Using all uppercase letters for directions makes it easier to decipher the actual script from production-related information.

Terminology

Learn to use the specific terms and abbreviations common to video production. Terminology and abbreviations must be understood and consistently adhered to

regardless of the script format used. Abbreviations for directions and shot types can assist in keeping the script from becoming too cluttered. Some of the more common terms are listed below:

Close-up (CU)	Cuts out unnecessary images; shows detail; gains attention
Medium Shot (MS)	Shows more image, less detail; good for a variety of shots; does not have as much impact as a close-up
Wide Shot (WS)	Establishes a scene; orients the viewer
Establishing Shot	Acquaints the viewer with a subject or scene, usually a WS
Two Shot (2S)	Two people in the shot
Over the Shoulder (OS)	Shot when two people are talking that shows part of the back of the person facing away from the camera
Reaction Shot	Shot of a nonspeaking person used as an alternative shot in a scene; for example, a cut to show the reaction of a person not talking
Cut	Instantaneous change from one image to another
Fade	A gradual mix to/from black to an image
Dissolve	A gradual mix from one image to another
Wipe	A transition where one image is gradually replaced by another
Super/Key	Superimposing one image over another, usually text
Pan	Moving the camera horizontally
Tilt	Moving the camera vertically
Dolly	Moving the camera pedestal toward or away from the subject
Truck	Moving the camera pedestal laterally across the set
Zoom	Changing the focal length of the shot
SFX	Sound effects

Script Formats

A variety of script format styles exist. The two most common formats used today are the two-column and the screenplay. While there are practical reasons for

using a specific format for many projects, many scripts can be completed in a format agreeable to all those involved with the project. Seek agreement among the relevant parties about the script format before you start the project. This will help you educate your client on interpreting the script so that he or she can read it without confusion. A number of specialized software packages are available that will lay out your script into a standard format. Word processors can also be used to create templates for this purpose. Regardless of the chosen format or variation of a format, maintain consistency throughout the entire script document.

The Two-Column Script The **two-column script** is practical for live productions where the director may want to easily see production directions while directing in real time (see Figure 2.6). The left column of this format includes all the director's commands, directions, and visuals. In the corresponding right column is the actual written script. This format can be somewhat confusing for a client to understand and is not the most logical for a single-camera field shoot. On the other hand, many directors feel comfortable using this format for field production stories.

INT. CONVERTIBLE/PARKING LOT.

CAM POSITION 3

Luther Gamboni is behind the wheel of the parked car, talking on his cell phone. Stormy approaches, dressed in skin-tight jeans and slurping on a fountain drink.	SFX: Low rumble of cars on street.
CAM POSITION 1	LUTHER: Yeah. Some kind of animal act she saw when she was a kid. Yeah, I know. Look, I'll be there in . . . (LOOKS AT WATCH) twenty minutes.
CAM POSITION 2	STORMY PUNCHES HIM IN ARM
CAM POSITION 1	LUTHER: Ouch, Stormy. Right. Twenty minutes. I think it'll be good for you. LUTHER PUTS PHONE AWAY
CAM POSITION 2	STORMY: Who was that?
CAM POSITION 1	LUTHER: Big Al

© Cengage Learning

FIGURE 2.6

The two-column script is favored for live studio productions, but many TV directors use this format in fieldwork as well. Compare this format to Figure 2.7.

The Screenplay In the **screenplay format**, everything is written in a linear fashion (see Figure 2.7). This includes directions, visual information, and script. This style is based on the film industry format and is used for many broadcast entertainment programs. It allows one to follow the script in the same linear style that we use in reading most documents. This format is easy to follow if you are consistent and use techniques that separate the actual dialogue from script directions.

> We had interviewed more than 20 players over the course of
> 4 months and some of these interviews were over an hour
> long. Each interview was transcribed word for word and
> reviewed as we searched for possible sound bites. Without
> the transcripts, I would have spent much more time
> and still wouldn't have found some of the better clips
> that ended up in the final edit.
>
> JASON JIMERSON, WRITER

Sound Bite Transcriptions for Documentaries Using segments of interviews as the basis for a script requires transcribing the interviews and selecting specific segments, or **sound bites**. A word-for-word transcript of a 20-minute interview can take extensive time to transcribe, but makes the writing of a

INT. CONVERTIBLE/PARKING LOT.
Luther Gamboni is behind the wheel of the parked car, talking on his cell phone. Luther is the kind of guy who wears thousand-dollar suits and never brushes his teeth. Stormy approaches, dressed in skin-tight jeans. She is slurping on a fountain drink from a Styrofoam cup and chewing gum. She climbs into the car, and twists the rearview to fix her lipstick while she conspicuously eavesdrops on Luther.

LUTHER
 (continuing)
 Yeah. Some kind of animal act she saw
 when she was a kid. (beat) Yeah, I know. Look, I'll
 be there in . . .
 (looks at his watch)
 . . . twenty minutes.
Stormy punches him in the arm, giving him a "what" gesture.

LUTHER
 (to Stormy)
 Ouch, Stormy.
 (back to phone)
 Right. Twenty minutes. I think it'll be good for you.
 Luther hangs up the phone and puts it away.

© Cengage Learning

FIGURE 2.7

The screenplay format uses a linear progression that integrates dialogue and other production elements with production directions. Compare this format to Figure 2.6.

Tape 3

Q: Can you spell your name for me?

Sure, it's

Q: And you give me permission to use parts of this interview in the veterans project?

Yes, I do

03:00:47:25
Q: Thanks, can you talk a little bit about any interest you might have had as young girl in joining the military or what got you interested in nursing?

03:00:56:27
####### Well, nursing—my mother was a nurse, and her sister and her aunt. I loved to read and I used to read the Cherry Ames and the Sue Barton young girl series and they were nurses and I guess I just always … I liked the idea of being a nurse, so I was always, probably always, was thinking of nursing. The Army came into it for very good reasons—a couple of them, actually, but the best one was they paid my last two years of college. And I understood that I'd be going to Vietnam if I joined the Army Nurse Corp at that point in time but that was okay—I didn't have any problems with that. My father was a World War II vet, and he, he was very patriotic, and I grew up in a home where I was, I suppose I was naïve, for my age, but, you know, I believed, at 19 that if the United States Government was in a war, it had to be right— it couldn't be wrong. So I had no questions about whether I should go, in spite of the furor that I knew existed over it. But it was, it was financial as much as anything.

© Cengage Learning

FIGURE 2.8

Transcriptions should provide enough information for the writer or editor to easily read interviews and select sound bites for use in the program.

nonfiction project much easier (see Figure 2.8). While this approach might seem excessive, it may actually be one of the most useful planning elements from the editor's perspective.

Assembling a script from a word-processed file is a good method for the first draft of a documentary script that is interview-driven. But while electronic transcriptions are effective for assembling the script, sometimes a printed copy is more useful. For example, after selecting multiple sound bites from the transcripts, they can be physically cut from the printed pages and laid out on a table by story theme or historic timeline (see Figure 2.9). They can then be arranged on the table in a logical order. It is easy to see the flow of the story and move the papers around to get the best results. The quotes can be taped or glued together in the preferred order and then the original transcript files can be electronically cut and pasted using a word processing program.

Modified/Custom Scripts A number of these formats, or their variations, might work best for a given writer or project. Using these types of adaptations

SHIRTS & SKINS
SCENE 5

James 03:10:23:12

Uh this is a joke everybody knows it, I hate playing with Craig man. Craig is the one, he's always stopping the game, he's making crazy calls. I hate playing with Craig. I don't wanna play with Craig.

Connor 07:01:06:17

I don't like playing in a game where there's too many really big guys who are aggressive because um- I can get hurt. And I can think of one time in particular when Craig and- and Mike actually almost got in a fist fight. I think you might have been there that game.

Paul 02:29:20:03

Uh when Craig stops the game and uh like grabs people and calls shit to just slow the game down that'd have to be that answer

Craig 12:48:12:17

I- I'll be the bad guy that's- that's okay. Uh I'm gunna get fouled more than you because I'm gunna play inside or I'm gunna play an aggressive enough game inside that I know I'm gunna get fouled and I think a call sh- a call should be made and if I shot the ball and made the call if that stops the game I don't why because I made a call. So what happens when you make a call I don't you know I don't have an argument for that if they say I did I did it. I don't stop the game intentionally.

FIGURE 2.9

Cutting and pasting sound bites from various interviews and placing them in an order is a handy way to develop a script based on interviews.

will work well as long as all parties agree on the particular style, and the writer stays consistent throughout the script (see Figure 2.10).

Storyboards

A **storyboard** is a visual representation of each frame, possibly including transition and audio information. Storyboards are a useful tool when you must articulate the story to a client or to the production crew. Storyboards can take several forms and can serve different purposes (see Figure 2.11). On one level, a producer, writer, or director may sketch some rough storyboards to visualize how certain shots may look. A storyboard might even be presented with photographs instead of sketches. This is not possible for most projects, but it might work well for an advertisement. Indeed, for some productions, such as advertisements or music videos, a detailed storyboard is required. These frames can be taped or pinned to a wall or tack board for teams to view and discuss. In some cases, the appropriate lines from the script should be written alongside each storyboard frame. Complex scenes shot out of sequence may be easier to plan

No.	Out	Video	In	Scene	Script	Comp-Gen Words
92			x	A Representative and Customer shaking hands at the Bank	The combination of safety, reliability, and superior operation allows for a smooth, quiet, fast ride that will satisfy customers and exceed their expectations.	(Words appear as Narrator says them) 1. Safety 2. Reliability 3. Superior Operation 4. Smooth 5. Quiet and Fast
93		x		Video Scott B.		Globe
ECA "Fuzzy Logic"						
No.	**Out**	**Video**	**In**	**Scene**	**Script**	**Comp-Gen Words**
94			x	Customer from Bank in Cinci by elevator or in office	Testimonial **Questions to be generated**	
95					ECA reduces the anxiety of waiting, improves the efficiency of passenger transfer, and improves system performance.	ECA "Fuzzy Logic" 1. Reduces anxiety 2. Improves passenger transfer 3. Improves system performance
96			x	Passengers walk toward a closed door	Early Car Announcement is the early notification of the arrival of an elevator.	
97			x	Person pushing the button	When a button is pushed.	
98			x	Controller in Machine Room of factory test tower	The Fuzzy Logic dispatching will assign a car to the hall call within one second.	

© Cengage Learning

FIGURE 2.10

Script formats are modified by many organizations to meet their own internal needs.

Related Interactive Module

Storytelling > From Script to Screen

by using a storyboard to guide you through your creative choices during shooting. Successful film directors like Alfred Hitchcock and Steven Spielberg are well known for their intricate and detailed storyboards.

Production Preparation

The next stage in preproduction is preparation. This is an exciting time, as you advance toward the creative production activities. The professional producer and director keep precise and detailed information for every planning activity, from the scheduling of personnel, equipment, and facilities to keeping track of contracts and potential legal issues. Every detail should be organized and filed in the production book.

Project _Parrotland_ Page _1 of 2_
Scene _7_

1.

WS—rear of car, Luther talking
on phone, music up, sfx up

2.

cu—Stormy walks toward
car

3.

WS—Stormy opens door

4.

OS—Stormy enters car

5.

WS—rear of car, Luther starts car

6.

WS—low angle, left rear of car,
drives away, music out, sfx out

FIGURE 2.11

Besides being able to visually
interpret a scene, a storyboard
can include dialogue and shooting
directions.

© Cengage Learning

Production Scheduling One of the biggest constraints with any production
is the deadline for completing the project and whether or not you have sufficient
time to meet that deadline. Scheduling software allows links between assets,
projects, and clients. These databases provide a powerful tool in organizing indi-
vidual and multiple projects (see Figure 2.12). One proven method to track a
project is to **back-schedule** it. This is accomplished by starting with the com-
pletion date and working backward. This date may be a broadcast date, the date
your client needs to show the completed video, or an arbitrary date that is writ-
ten in your production contract. Using this date as your starting point forces you
to schedule enough time for each activity as you eventually work your way back

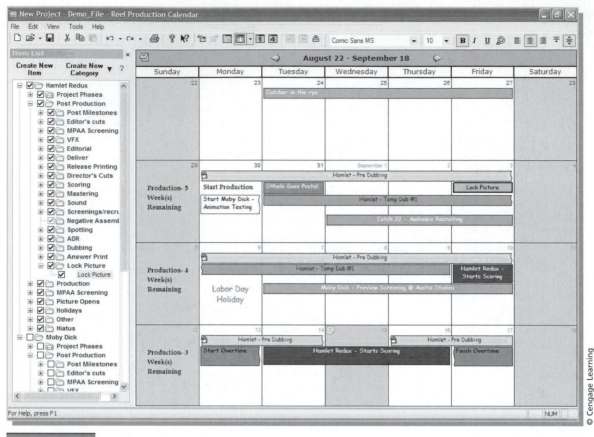

FIGURE 2.12

Computerized scheduling offers a variety of organizational tools.

SOURCE: Courtesy of Reel Logix.

to the current date. Imagine that the client wants Pick 2 Productions to complete the music video by June 1. Since the director wants to see a rough cut a week before, the schedule shows that the rough cut is due on May 24. If final editing will take a month, the edit session will be scheduled to begin on April 24, and so on. Back-scheduling can be critical in determining whether or not it is feasible to finish the program in the available time.

Working with Talent

One of the most important responsibilities of a director is working with the talent. If the talent is uncomfortable or doubts the production team's ability, it will impact the performance. The director needs to demonstrate leadership and confidence during the production. Little things, like having craft services (food) or even just bottled water, will go a long way toward making the talent comfortable. In fact, some talent will expect these extras and might have a bad attitude if

STORY 2.4 Casting

Auditions, to me, are the most exciting part of the film-making process. The screenwriter has taken great care to craft characters, and through auditions you see these characters come to life. When casting the independent feature film *LO,* conversations with the director did not lead to a definitive vision of his lead character. We knew that the character needed to be funny, sympathetic, and evil all wrapped into one likeable actor. In sifting through head-shots that were submitted online via a "breakdown," meaning a character description that is sent to agents and managers, I kept an open mind. I looked for actors whose pictures spoke to me or had something in their eyes. I selected about 40 actors of various ethnicities, ages, and body types—in other words, my picks were all over the place! On the day of auditions, as always, I was apprehensive yet hopeful that my choices would yield our lead man. After a day of seeing 40 talented actors portray their vision of our character, we had our man. Had we just settled with one description we may not have found the perfect actor for this project.

SOURCE: Annie Boedeker-Roberts, Casting Director

they are not provided. Before shooting begins, the director should make sure that the talent understands what the process will be and how he or she directs the specific type of production. During the recording, the director needs to coach the actors through each scene.

It is fairly common for a production to have either voice-over talent or actors. Productions requiring talent have two options: professional and nonprofessional.

Working with Professionals While professional talent may not need much coaching or preparation, they present unique issues to consider. A professional may be a member of a union that regulates pay rate, the number of hours of work per day, and so on. In addition, specific rules exist governing the use of children during a production. Make sure you understand these standards before the production is scheduled. Last, professional talent may request additional amenities such as wardrobe, makeup, hairstylists, and services like catering or transportation.

The director might work with talent agencies, conduct an audition, select and negotiate contract terms, and coordinate the integration of the talent into the production plan. Because of talent unions, you might be required to hire professional talent for specific projects. In other cases, small production budgets dictate the use of less-expensive actors. While this might be your only alternative, you cannot compromise the quality of the program by making poor talent choices. Ask yourself what makes good TV, and you should realize that the story and talent are far more important to the audience than the production techniques.

Working with Nonprofessional Actors Using "real" people instead of professional actors for a video production is quite common. They may be friends, co-workers, volunteers from a local theatre troupe, or just interested individuals. The advantages of using nonprofessionals include saving money on your budget and increasing the credibility of your story by using a content expert who can connect with the audience. On the other hand, sometimes nonprofessionals make poor actors and may require long hours of rehearsal and retakes. If you

B O X 2.2 Tips for Nonprofessional Talent

For those first-time nonprofessionals, the following suggestions can be helpful.

- Rehearsal time is valuable! Try recording your rehearsal and reviewing it immediately for feedback. If you will be a spokesperson talking directly to a camera or using a teleprompter, practice your presentation by talking to inanimate objects (even a doorknob!) or to yourself in the mirror.

- Dress for television. Dress in neutral tones and avoid too much contrast between items, since the camera may not be able to reproduce the contrast in a pleasing manner. Try to keep from wearing clothing with intricate patterns, as they can cause technical problems for the camera. Avoid shiny jewelry, which may be highly reflective and distracting. If you will be taping for an extended period, ask the producer if you should bring additional clothing. Many

productions will provide makeup that can be used under the heat of portable lighting. Men may want to bring shaving equipment with them.

- Visuals ranging from a book to a PowerPoint presentation should be checked and discussed ahead of time. The producer will provide guidance on their use.

- Arrive early on the day of taping. Although the production crew will be busy preparing for the taping, early arrival will give you a chance to check with the producer or director should you have any last minute questions.

- Be yourself on set. Unless you are playing a character role, it is not a good idea to change your normal style. Be conversational in your delivery, as it will be much more interesting for the audience than hearing stilted language.

© Cengage Learning

are considering using someone with little or no experience in television, offer him or her some of the suggestions in Box 2.2 before the day of production.

The Interview Finding interview sources can involve some detective work, and it might take considerable time to find the right person. Once you have identified your subject, it helps to conduct some initial background research to determine what his or her contribution is to the topic. Depending on the purpose of the interview in the context of the production, it might be wise to set up an information-gathering interview before setting a date for the actual video interview. Imagine interviewing a film director without seeing her movie, or talking with an Olympic athlete without knowing about his achievements. Such situations usually end in disappointment. This preinterview also allows you and the interviewee a chance to become familiar with one another.

Writing the interview questions ahead of time gives you a chance to prepare for the interview, but can lead to a sterile set of responses from the interviewee. A seasoned interviewer knows the focus of the interview and can lead the interviewee from one point to another. Many of the best interviews are gathered by letting the interviewee take the story in the direction he or she wants. Asking open-ended questions like "Tell me about serving as an ambassador," instead of "When did you serve as an ambassador?" or "What did you do as an ambassador?" will solicit different responses and engage your guest in different ways. Regardless of the format, the interviewer must have some questions ready and be quick enough to shift direction based on the responses received. While interviewing for a documentary on welfare and poverty in Appalachia, filmmaker Rory Kennedy found that the story was not developing in the direction she

had hoped. The answers to her questions did not reinforce the topic as she had hoped they would. She eventually decided to take the project in a new direction and ended up with *American Hollow* (1999), an award-winning documentary about one family's life in eastern Kentucky.

Scheduling the date and location of the interview occurs once the research is complete. Among the factors to consider in scheduling are the interviewee's and the crew's availability, as well as the time constraints of the program. In terms of location, the director might want to consider shooting in an area that adds to the credibility of the content. Certainly, the background should not detract from the story. If you are interviewing a restaurant cook, what better place to provide additional realism than the kitchen? On the other hand, there is always the chance that this approach will not be feasible because of the busy nature of the business or because of the uncontrolled sound and lighting. In those cases, the setting should be changed, and can be nondescript. Generally, positioning the interviewee in a location that provides a context for the interview can add interest, authenticity, and realism to both the interview and the completed program.

Planning for the Shoot While the glamour of any creative process begins with actual hands-on activity, the success or failure of the final project is most often determined by the activities that take place in the planning phase. Many of these production tasks simply require your time and a little common sense. Before heading out on a shoot, you should address several issues. What are your goals for the shoot? What needs does this shoot fulfill in the script? Have you identified all the shots you will need? What specific equipment might you need? Once you are comfortable with the decision to shoot, you will need to consider your shooting schedule, location scouting, and equipment needs, as well as a shot list.

Location Scouting Close your eyes and picture a park, a basement, and a gas station. If you ask others what they visualized, you will find as many interpretations as the number of people you ask. For example, your description of a basement is probably going to be based on your personal experiences. Perhaps it is a musty old storage room or a great family room where you have spent hours watching TV. Having a visual sense of the location you want or need makes the planning that much easier.

The only way to know what that basement actually looks like is to scout the location in advance of the shoot. When first arriving at the location for the site survey, stop and concentrate on all the environmental elements. The **site survey** includes such things as room size, window location, noise, type of lighting, scheduled events, other personnel you must work around, and gaining clearance into an area. If you are unable to get to the location yourself, hire someone else to do it for you. Request a layout drawing, digital photographs, or an uploaded video file.

Concentrate on lighting, sound, electrical outlets, and safety. Keep a notebook handy to write notes about your initial thoughts, to sketch the site plan, and to list questions that must be resolved (see Figure 2.13). Make sure to get

FIGURE 2.13

The site survey should provide enough detail for the production crew to prepare for the shoot.

local contact names and information. This might include the person who authorizes the shoot, the maintenance person or an electrician, or others who can assist in your efficiency. It is always important to know whom to contact in case you need access to a locked electrical distribution box or have a medical emergency.

Although some productions are shot with existing light, you should always evaluate the quantity and quality of lighting for any indoor scene, keeping in mind the time of day. Note the types of lighting available in the setting. Having more than one type of light source causes color temperature problems. Knowing this will enable you to prepare ahead of time. Compounding this issue can be natural light coming in through skylights and windows. (Lighting is covered in detail in Chapter 7.)

Stop reading at the end of this sentence and listen to the sounds around you for a few minutes. You should be surprised at what you might hear as you concentrate. Perhaps there is a dripping faucet, a circulating fan, or a neighbor mowing the lawn. Sound considerations include noises within the space and external noises, both of which may be picked up by your microphone. These may be mechanical sounds like heating and air-conditioning fans, motors, or office equipment. The sounds may also be environmental sounds like wind and water flowing. In addition, the sounds from people in the area can be

problematic. Identifying these sounds should assist you in developing a plan to control the sound during the actual recording. (Sound is covered in detail in Chapter 6.)

Be sure to check the placement of electrical power outlets throughout the room. For complex shoots, find out how many amps and different circuits are available, as well as where the electrical boxes are located. The power distribution in most buildings is wired with different circuits in different rooms or areas. In most apartments and homes, the kitchen has its own circuit, but all bedrooms may be on the same one. Industrial buildings may have multiple circuits in the same room. This information can be very valuable when setting up lights and other equipment that may be plugged into wall outlets during the shoot.

Safety Safety should always be the first concern during the production process. During the location scouting visit, you will want to make sure that you observe the site for potential dangers to your crew or talent. You will also want to make sure you have the local contact's cell phone number, as well as that of a backup person, in case of emergency. You should always check for multiple exits from buildings and make sure the entire crew knows where they are. Because you are probably plugging lights and other gear into electrical outlets, you must check cables for worn ends or loose wires before leaving for the production. At some locations, like hospitals, you will probably need clearance from a staff electrician who will check your equipment for potential problems that could affect the electrical system. It is also important to develop a lighting plan that allows the extension cables and light stands to be set up to keep crew and talent from tripping. Use caution if your lights are extended near the fire sprinkler systems mounted in ceilings. Placing cables around the perimeter of a room or under carpets, or taping them down, are ways of preventing people from tripping. You might also need to consider crowd control if you are shooting in a public space.

> I'm a big believer in the shot list, which is very old-school directing. Show up with your shot list, and the shot list should contain everything. Basically, I walk in with a game plan.
> JAY JOHNSON, DIRECTOR

The Shot List An extremely important step in the preproduction stage for a field shoot is to complete a shot list. A **shot list** (see Figure 2.14) is a description of all the shots you wish to capture at a given location. This advanced organizer should be designed to take advantage of the most convenient sequence for taping. One possible method of developing a shot list is to convert script scenes into a linear shooting list. While some directors find producing a shot list to be too time-consuming, you only need to miss one required shot and then have to return to shoot at another time to realize how important this list can be. Shot lists must contain enough detail so the videographer can understand your

Shot List

Parrotland Scene 7

Shooting Order	Shot #	Description
1	6	Extreme WS, From behind car, Luther drives off-screen
2	1	WS, Behind car, Luther talking on cell phone
3	3	WS, rear left side of car, Luther on phone, Stormy enters frame and gets in car
4	4	OS, Luther talking on cell phone, Stormy enters frame and gets in car
5	5	CU, Stormy enters frame and gets in car, talks to Luther
6	2	CU, Stormy feet walk through frame

© Cengage Learning

FIGURE 2.14

A shot list is an advanced organizer that helps ensure all shots are completed.

requirements. If the shot list corresponds to a script or storyboard, the shooter will find the shots easier to understand; it will allow him or her more time to work on composition instead of trying to figure out what you want.

Equipment Checklists Selection of equipment may not seem to be much of a consideration for some production work, but this may be shortsighted. The selection of a microphone and the choice of a rental camera package are just two situations when this is important. These decisions might add additional cost to the project, but the costs can be built into the budget if you prepare in advance.

Once the equipment is selected, an often-overlooked procedure is using an **equipment checklist** to ensure everything has been packed and is ready to go. This type of list is simple to construct and use. Many production companies have prepared forms that list their specific equipment and supplies. Utilizing a list like this may keep you from forgetting something critical to the shoot. Besides listing equipment and supplies, some forms include routine tasks that must be checked before leaving for the production location. This might include reminders about prelabeling memory cards or tapes, checking battery levels, and reconfirming the shoot with the client.

The Crew Along with equipment selection, crew size depends on the budget and scale of the project. While many projects can be shot individually, a second

STORY 2.5 Traveling with Equipment

If you are a professional in the video business, you will eventually have to rely on an airline to get yourself and your gear from one place to another. When I travel, I still follow a practice I started when I was shooting for *CBS News*: hand-carry the camera, battery, tape or media cards, and a microphone. That way, if the checked equipment is misdirected, you can still make pictures. You are allowed two carry-on items on the plane and, if it will fit in the overhead or under the seat, your camera bag can be one of them. TSA policy says the camera must be taken out of any carrier at the checkpoint and x-rayed. You should also carry a battery to make it work if asked. Baggage tags can get lost, so put a note inside each case with your name, cell phone, and destination address. Your office address could result in the bag going home rather than where you need it. If

possible, combine extra pieces before you depart or you may be hit with an additional baggage fee for every excess piece. Just be careful of exceeding the single-item weight limit. I pack my long stuff (tripod and light stands) in a hard side golf club case because many airlines don't consider them to be oversized. The golf case doesn't roll off a baggage cart and it has wheels that make it easier to move. Some airlines may have a lower "Professional Photographer" or "Media" rate for excess baggage, but you will only get it if you remember to ask. If you're traveling with a lot of stuff, the various fees can make it cheaper to ship the cases as cargo on the same flight or via an outside next-day delivery company such as FedEx or UPS.

SOURCE: Dick Reizner, Director

or third person can be beneficial. The assistant may provide technical support or just act as a production assistant and help move equipment or offer a second opinion. During a typical shoot, someone may be engineering the audio in addition to the videographer and director. Typical crew positions for more complex scenes may also include a data wrangler, lighting director, and production assistant. A **data wrangler** works on location to ensure digital files are properly recorded, stored, and backed up.

Permissions Many municipalities require written permission before allowing your crew to shoot on public property. In most instances, this is easy to obtain, but be prepared to wait for approval once the paperwork has been submitted. This can take several days from the time of submission. Private property may not be an issue if your client has permission, but places like shopping malls and schoolyards must also be cleared. For most projects, property owners will be reluctant to let you shoot because of liability reasons. If you think about it, why would someone let you use their property without the proper insurance against lawsuits and a guarantee that your crew will not disturb the normal use of the property? This is especially true of large national companies as opposed to local stores and businesses.

Last, be sure to bring talent release forms with you. You cannot assume that you have permission from those who appear in your footage. A **release form** is used to inform the talent of their rights and of how the recorded video will be used. It is also used to secure an individual's permission to use their image and voice. The release is a contract that protects the talent and the producer by detailing the specific use(s) of the footage. When working with minors, the parent or legal guardian must sign the release form. If you forget your forms, begin recording and ask the talent to give their names and contact information and have them make a statement that they agree to be recorded. Follow up by

getting a release form sent to them. If you mail it, make sure to include a self-addressed stamped envelope for its return. (Release forms are covered in detail in Chapter 3.)

Approaching the Shoot

Before the actual day of taping, it may be useful to set up a time to rehearse or talk to those who will perform in your production. Certainly, this may not be the case in a news story or in some documentary work, but for other programs it may be essential. Novice talent and interview subjects may not understand what will happen at the shoot, what is expected of them, or what they should wear. This meeting may help alleviate some of these potential problems.

Estimating the amount of time required for an individual shoot becomes easier with experience, but it is always a challenge. Many factors must be considered when budgeting time. For example, have you thought about the weather, the time of day, and the season? Have you included enough time to travel to the location, set up your gear, make a test recording, and make any necessary adjustments? Do you have enough experience to understand how long an individual shot takes to set up, shoot, reshoot, and strike? Without a systematic plan that details every shot and an estimated time frame, you may find yourself hurrying to complete your work.

You do not always have the privilege, budget, or crew to modify locations for the optimum setting. Many times, rearranging furniture in a room or making other cosmetic changes to a space can enhance the visual aesthetic of a location and result in better video. If the owner prohibits you from doing this or if some ethical staging questions arise, you must work under existing circumstances. Advanced knowledge and understanding of this situation can help make the shoot successful.

On the day of shooting, keep in mind travel time, parking, transporting equipment, and meeting locations and specific times. Try to leave extra time for the inevitable delays caused by traffic or other setbacks. Be sure to provide a map and directions for crew and talent. If no arrangements have been made for parking, it is advisable to park close to the location to unload the gear and then move the vehicle to a legal space. Try to keep your gear out of the way and send someone to establish contact.

When setting up your equipment, get a sense of the location and decide where the optimum position will be for the camera. This should be easy if a site survey was completed and the camera positions plotted. Unfortunately, many situations arise where a site survey was not done and the director or videographer needs to make decisions based on the shot list and/or storyboard. Think about the look of the shot. What focal length will give you the aesthetic you want? What will the audio sound like from this location? Depending on your arrangements, you might need permission to block off an area. It is important to keep safety concerns paramount as you run cables across hallway floors,

set up lights on portable stands, and stack your equipment boxes and supplies out of the way.

If you have a crew of more than one, everyone should know their specific jobs during setup. The goal is to quickly get set up so that you can make a test recording. The test will confirm that your equipment is operating properly and that your visuals and sound will create the feel that you are trying to establish. Test recordings are of little value if you do not play back the test and watch and listen to that playback.

Once everything is in place and working, you can use the downtime to give the crew a break and go over last-minute details one more time.

As production begins, you will be faced with numerous decisions involving technical, aesthetic, communication, and talent issues. Proper planning and the ability to stay cool under pressure will help make the shoot go smoothly. With a script or shot list in hand, you can go about the business of capturing the shots you need. It is always important to think about how the shots will work once the editing session begins. A good field producer understands the importance of shooting for the edit. This might mean shooting additional shots, multiple takes, and/or changing camera positions. The ratio of actual footage shot to edited-project running time may end up exceeding your preconceived idea. A ratio of 10:1 means 10 minutes of video were shot and 1 minute was actually used.

CONCLUSION

A good producer or director will receive little praise for excellent work in planning a project. Preproduction activities, however, are critical to the success of any video project. Nearly all-successful productions can point directly to the work done during preproduction as a reason for success. You will never hear anyone say, "Hey, nice job planning that shot," but there is a good chance the reason a viewer likes your program is because of the planning.

Story Challenge: Preproduction

Pick 2 Productions spent considerable time designing and planning the three contracted videos. A number of questions were raised during the initial consultation.

While assessing the potential audiences, the producer realized that the concert DVD would be of interest to a young audience, many of them being followers of the particular band being featured. This realization helped make decisions on what DVD extras to prepare. The music video audience paralleled this audience closely, but had the potential to be a larger audience since it would stream from a few websites. It was decided that the music video would be included as an extra on the DVD. The documentary was more difficult to assess since much of the content would be about alternative fuels. The initial thought

was that it would attract a splinter audience from those interested in the band, but there is also the potential for a totally different demographic for this program.

Initial financial figures were close to what was required, but a few items had to be cut in order to keep within budget. One cost-saving measure was to use only five cameras for the concert instead of six. The producer would not budge on craft services since the crew would be working so hard.

A script and storyboard were provided for the music video, and a detailed outline of important themes as well as interview questions were available for collecting documentary footage. Several key people with a vested interest in the project approved these documents.

Legal and Ethical Issues

While shooting documentaries, I've witnessed subjects told to turn off the music playing in the background that they were listening to, or asked to change what they're wearing because of brands and logos on their clothing. That would have never happened 20 years ago. To navigate around legal concerns, today's filmmakers can feel compelled to alter reality.

ROBERT M. GOODMAN, FILMMAKER AND WRITER

OVERVIEW

Like many of the preproduction tasks in this section, understanding legal and ethical issues related to video production is not the most glamorous part of the storytelling process. Nonetheless, steering clear of legal and ethical hurdles is just as important as your site survey, footage log, or any other planning document. A firm grasp on the legal issues that affect the video production process can help you achieve that goal. You would not want a great story to go untold because you failed to pursue the appropriate legal protections.

This chapter is not intended to replace or supplant qualified legal advice. Although it will help you understand some of the legal and ethical issues at stake in the production process, you should always remember that if you have questions or concerns about something in your production, you must consult a qualified legal professional. In addition, legal matters are inherently complex and diverse. Any video producer needs to learn more about the law and its application to video than this chapter could possibly cover. Here, we will discuss some common legal issues and examine them in a very general context. In addition, we will review contracts, defamation, and privacy as well as intellectual property laws. Issues that arise from audio and video streaming are integrated throughout this discussion.

A number of legal issues have the potential to impact your production. You may have to sign contracts for equipment rentals or secure permission from a scriptwriter to use her script or draw up contracts to employ actors. In addition,

you may have to agree to union contracts when hiring engineers or other union workers. During production, you may need to consider issues regarding defamation or privacy. You will need to seek permission if you use another person's music, photos, text, or trademarked items. Digital technologies, such as streaming your video on the Internet or via mobile devices, can compound the relevant legal issues. Having some basic knowledge of common issues and an understanding of how to handle them should keep you out of legal trouble and allow you to focus on the artistic and aesthetic elements of telling your visual story.

Story Challenge: Legal Issues

The legal concerns for the three videos you are directing for Pick 2 Productions are numerous. As you work on each piece, you will have to avoid any defamation or privacy issues that might arise from the story. The largest issues, however, will deal with intellectual property. Specifically:

- Will Pick 2 Productions need permission to use certain still photos or videos for the documentary?
- How will music permissions and licensing be handled?
- Of all the relevant intellectual property and location agreement issues, which ones will Pick 2 have to handle and which ones will the band's management handle?
- What release agreements are most appropriate for each of the three videos?
- Who will own the copyrights on the three finished videos?

CONTRACTS

A **contract** is an agreement by two or more parties that is legally enforceable. The parties involved agree on a set of mutual promises. These commitments define the rights and responsibilities for each party involved in the contract. While a contract can be an oral agreement, a written contract offers more protection and is better for all the parties involved. Contracts are enforceable in court. If Party A meets its obligations under the terms of the contract and Party B does not, then Party B is in **breach**, or violation, of the contract and Party A is entitled to relief through the courts. For example, suppose you enter a contract with a local business to produce a commercial. Under the terms of the contract, you promise to create the video, and the business promises to pay you for the work. If you complete the video and the business does not pay you, you can go to court to seek justice, or payment. On the other hand, if you accept payment and then do not deliver the video, the business can sue you.

Developing a contract often involves a series of offers and counteroffers. The process begins with an offer from one party to another. The contract is formed only when the second party accepts the offer. Imagine that you initiate a contract offering a musician $1,000 to use some of her original music for the documentary

that you are producing, and the musician says she wants to think about it for a few days. Only after the musician agrees to the offer do you have a valid contract. If you believed that the musician was going to agree and started to use the music before the formation of the contract, you could be in violation of copyright law. To prevent such delays from holding up a work indefinitely, a person making the offer for a contract can impose a time limit for the offer. If the second party fails to respond by the deadline, then the offer is void and there is no contract.

In addition to monetary and time considerations, all of the terms and responsibilities of a contract are negotiable. A good document will spell out each party's responsibilities as well as the remedies available for any party in the event of a breach. Several questions should be considered when preparing or signing a contract. Are you comfortable with the obligations you will have to fulfill? Is the deadline for production reasonable? Will distribution be on DVD, broadcast over the Internet, or both? Which party will cover production costs such as equipment rental or travel to locations? What constitutes a finished product and how many revisions can a client request? Many other questions must be tackled as well, but the important point is that your responsibilities should be clearly delineated and you should be very comfortable that you can deliver on those promises. Make sure the client's responsibilities are also clear. For example, will the client require final script approval or provide artwork for a logo she wants in the video? To what standards and format should that artwork conform? Who makes the final judgment on the script approval? In some cases, you will need to clear up ambiguous or unclear language. If you are signing an agreement for equipment rental and the agreement states that you are liable for loss or damage beyond reasonable wear and tear, you should be clear on what "reasonable wear and tear" means. Be sure to consider secondary markets and repurposing for the video. For example, you will want to check if your contract allows streaming on the Internet or any merchandising rights for the production. If you signed a contract with an actor or a musician for his or her performance rights and these rights are limited to distribution on DVD, you will need to renegotiate for Internet and merchandising rights. Include these issues at the outset to avoid such renegotiations.

Location Agreements

A **location agreement** is a contract that gives you the right to shoot on private property. It also generally conveys rights to shoot any trademarks or architectural copyrights you may encounter. A **trademark** is a word or symbol that is legally registered to represent a company or product. Generally, trademark and architectural copyrights are not a problem. The pertinent laws allow you to show such features in your production if they are readily visible to the general pubic. However, if your production disparages a trademark, you could be liable for diluting the value of the trademark. The biggest issue with a location agreement is to ensure that the person granting the permission is authorized to do so. For example, suppose you are shooting inside a store that is located within a shopping mall. You have a location agreement with the store owner, but you may also need a location agreement with the mall owner.

Shooting in public areas has grown somewhat more difficult in an era of increased national security interests. Typically, you are allowed to shoot video in public locations. In addition, you may shoot video of public facilities such as bridges or commuter trains. In some instances, the local governing authority may require a permit to shoot, but they cannot deny your right to shoot in a public location. A permit is typically required in order to prevent traffic congestion or other municipal issues that arise from your shooting. The combination of heightened security since 9/11 and the desire of videographers and filmmakers to have access to public areas in which to shoot has led to a number of confrontations between filmmakers and law enforcement. In some cases, amateur photographers were detained and their images confiscated. Public transit authorities in several communities, including New York City, have considered bans on photography. Many public transportation organizations, for example the Seattle Metro Transit Authority, require commercial photographers to have an approved permit. Proposals that require permits or notification, however, are counter to the historical practice of allowing unlimited videography or photography in a public place. First amendment issues also come into play with such restrictions. It is important for videographers to understand and be able to articulate their rights when shooting in a public location. A local or state film office may help you resolve any issues related to shooting at certain locations.

DEFAMATION

Defamation is a communication that damages or harms the reputation of an individual. It may cause hatred, ridicule, scorn, or contempt. Defamation is almost always considered an issue for the states to adjudicate. As a video producer or videographer, you should be familiar with the laws that govern the state in which you are shooting. Defamation is the most common legal action faced by those working in the mass media.

Despite being covered by state law, many elements of defamation are common to statutes in all states. Such commonalities are useful in understanding defamation. In a lawsuit, the person bringing the suit is called the plaintiff and the person being sued is the defendant. To prevail in a defamation suit, the plaintiff must prove that the defendant published a defamatory statement concerning the plaintiff. A defamatory statement is a false utterance that harms the character of an individual. For example, the suggestion that John Doe is a criminal is potentially defamatory. The statement must clearly identify the plaintiff. The identification can happen in many ways. The most obvious means is by name. However, showing a photo or video footage of the person or making a reference to personal information such as using the title "Mayor of Smallville" instead of the mayor's name are sufficient means for identification in a defamation suit.

Public officials and public figures have an additional burden of proof in defamation suits. **Public officials** are people who serve in elected or appointed governmental positions. **Public figures** are generally people who are in the public eye, such as a sports star or Hollywood celebrities. These individuals must also show the defamatory statement was made with "actual malice." This term comes from the Supreme Court case *New York Times v. Sullivan*. **Actual malice**

means the plaintiff must prove that the defendant published the statement knowing it was false, or prove that it was published with reckless disregard for the truth. Because of this additional burden of proof, it is very difficult for public figures to prevail in defamation lawsuits.

You can employ a few defenses if sued for defamation. Truth is an absolute defense. If you can prove the statement is true, you cannot be liable for defamation. A couple of inherent problems come with the truth defense, however. First, it can be costly to prove that the statement is true. It is likely that you will end up in court and have to pay an attorney to defend you. Second, some statements cannot be proven true. For example, the statement, "This is the worst video ever created" cannot be proven true or false because there is no objective standard by which you can judge the quality of videos.

A second defense to a defamation suit centers on privilege. This means that the defamatory statement was published in an environment in which it is not possible to sue for the infraction. A member of Congress making a speech on the floor of the House is privileged. Any defamatory statements that come out of the speech are not actionable. Privilege exists for most legislative bodies, both local and national, as well as for executive branch members. In addition, lawyers and judges in the conduct of official business have privilege. To assert privilege as a defense, the publication of the defamation must happen in the context for which the privilege exists. A senator making a floor speech is privileged, but when the same senator is writing a letter to the editor of a newspaper, she does not necessarily have privilege. The privileges described previously are absolute. Members of the media have a qualified privilege when they report or further publish defamatory material. As long as the report is about the proceeding or document and it is a fair and accurate summary, then the media can report or broadcast defamatory remarks. A third defense involves opinion. Traditionally, statements found to be opinions are not subject to lawsuits. Opinions in the media are thought to be a fundamental part of political and social discourse and as such should be exempt from lawsuits. This area of law is not as absolute as something like truth, but in some cases opinion can provide a viable defense to defamation. Three minor defenses can be used: the expiration of the statute of limitations; the claim that the plaintiff was given an opportunity to reply to the defamatory statement; and the claim that the plaintiff consented to the publication of the defamatory material.

INVASION OF PRIVACY

Like defamation, privacy actions are a state matter. Unlike defamation, however, what constitutes a violation of privacy in some states may not be a violation in other states. In fact, some of the reasons, or causes for action, of a privacy lawsuit are not recognized by some states. Be sure you understand the specific privacy laws in the states where you will be working. Through the years, several actions have emerged that fall under the umbrella of invasion of privacy. Those actions are the appropriation of name or likeness for trade purposes, intrusion upon a person's solitude, and false light. Each of these areas is explored in the following. A fourth

action, publication of private information about a person, is a common privacy claim, but it is not very relevant in a video context and is not covered below.

Appropriation

When you appropriate a person's name or likeness and try to use it for commercial gain without the person's consent, you have invaded that person's privacy. The appropriation action consists of two somewhat different legal causes of action. One action is the right of privacy and the other is the right of publicity. The **right of privacy** is designed to protect individuals from any emotional harm that may come from commercial exploitation of a name or likeness. The **right of publicity** is designed to protect those who may suffer economic harm from an appropriation of their names or likenesses. This applies to those persons, like professional athletes or other public figures, whose endorsement of a product can boost its sales. In those cases, the name or likeness has some commercial value. For example, you are not likely to be persuaded to buy a sports drink because your professor endorses it. However, if Hope Solo or LeBron James endorses that drink, you might be persuaded to buy it. The names and likenesses of these athletes, as well as those of celebrities, have commercial value.

The appropriation of a person's name is pretty clear, but what about that same person's likeness? A drawing, a photograph, a painting, or anything that might make the audience believe the plaintiff is identified can qualify as a likeness for an invasion of privacy suit. Even the use of a celebrity look- or sound-alike can qualify for action. In many cases, the courts have sided with the celebrities who were imitated in the commercial exploitation of their name, voice, or likeness.

Consent Forms Cases involving sports figures or celebrities can be a confusing and unsettled area of law, but one way to avoid any of those issues is to obtain the celebrity's consent to use his or her image or likeness. A **consent form** is generally signed by anyone who appears or is heard in your footage. Consent forms can vary in the ways in which footage can be used and how widely you may distribute the material. Examples of consent forms are pictured in Figures 3.1 and 3.2. Figure 3.1 is considered a limited consent form, while Figure 3.2 is an unlimited consent form. Examine the forms for differences in language. A limited release form typically restricts your use to those specified on the release form, while an unlimited release gives you blanket permission to use the footage in all forms of media, including those not yet invented.

Shooting Video of Children Videographers must exercise great caution when any shooting involves children or minors. Here it is useful to distinguish news and non-news videography. In a news situation, if the children are in a public area, such as a city park, and the videographer is on public property, then there are no special rights for children or their parents. Public schools, though, often have strict policies requiring permission before shooting on school property. In non-news situations, the best course of action is to seek permissions before any shooting. You should have written releases signed by the parent or legal guardian of any minor who will appear in the video.

Limited Release Form

Program title: _____

Production dates: _____

Participant: _____
(please print full name)

Grant of rights

In consideration of my appearance, I hereby grant _Pick 2 Productions_ permission to record my name, likeness, image, voice and performance on videotape. Further, I grant the right to use that recording for the following purposes:_____ in the following regions or territories _____ for a period of _____ year(s).

I grant the right to use the recording in all forms of media including composite or edited representations.

Payment (check if necessary)

[] _Pick 2 Productions_ will pay participant $ _____ for the rights granted herein.

Renewal (check if necessary)

[] _Pick 2 Productions_ may renew this agreement with the same terms and conditions for _____ year(s). The renewal fee of $_____ shall be paid at the time of the renewal.

Release

I agree to indemnify and hold harmless _Pick 2 Productions_ from and against all losses, expenses and liabilities of every kind including reasonable attorney's fees, arising out of the use of my name, likeness, image, voice and performance. I also agree that, without obligation, _Pick 2 Productions_ may use my name as a credit in conjunction with my image.

This agreement represents the entire understanding of the parties and may not be amended unless mutually agreed to by both parties in writing. My signature below indicates that I have reviewed and understood this agreement.

Signature:_____ Date: _____

Address: _____

- -

Parent/Guardian consent (if participant is under the age of 18)

I represent that I am the parent or guardian of the minor who has signed above or is a participant in the Program. Further, I agree that the participant shall be bound by this Agreement.

Parent signature: _____

Print parent name:_____

Parent address: _____

FIGURE 3.1

This release form limits the ways in which the producer may use the video. In addition, it contains sections for payment and renewal.

Unlimited Release Form

Program title: _____

Production dates: _____

Participant: _____

(please print full name)

Grant of rights

In consideration of my appearance, I hereby grant *Pick 2 Productions* permission to record my name, likeness, image, voice and performance on videotape. Further, I irrevocably grant the right to use that recording in all forms of media including composite or edited representations for informational, advertising or any other commercial purposes in perpetuity.

Release

I agree to indemnify and hold harmless *Pick 2 Productions* from and against all losses, expenses and liabilities of every kind including reasonable attorney's fees, arising out of the use of my name, likeness, image, voice and performance. I also agree that, without obligation, *Pick 2 Productions* may use my name as a credit in conjunction with my image.

This agreement represents the entire understanding of the parties and may not be amended unless mutually agreed to by both parties in writing. My signature below indicates that I have reviewed and understood this agreement.

Signature: _____ Date:_____

Address: _____

Parent/Guardian consent (if participant is under the age of 18)

I represent that I am the parent or guardian of the minor who has signed above or is a participant in the Program. Further, I agree that the participant shall be bound by this Agreement.

Parent signature: _____

Print parent name: _____

Parent address: _____

© Cengage Learning

FIGURE 3.2

This release form provides a very broad consent to use the video. A form like this one gives a producer or director the most flexibility.

Intrusion

A second cause of action for a privacy lawsuit is **intrusion**. It is a privacy violation when you intrude upon the solitude or seclusion of an individual. Intrusion is primarily concerned with how you acquire the information you publicize. The method used to gather material is the sole consideration. It goes hand-in-hand with the phrase "reasonable expectation of privacy." In other

words, where individuals have a reasonable expectation of privacy and you use extraordinary means to acquire material from that location, you can be guilty of intrusion. Typically, this action is associated with things like hidden cameras and microphones. Indeed, those are a part of the issue, but the question of where the offending information was acquired is equally important. There are a number of ways in which you can intrude on other people. For example, you might overhear a conversation in a grocery store. There is no intrusion in this case because the grocery store is considered a public place for purposes of privacy law and people do not have a reasonable expectation of privacy there. However, if you overhear that same conversation in someone's home, you may be guilty of intrusion, since individuals have a basic expectation of privacy in private locations. This can be complicated. For example, in one case, a producer talked with a person at her front door. The producer had instructed the camera crew, set up across the street, to shoot the scene and record the audio. It is likely that the producer was wearing a wireless microphone. When the footage was used in a program, the home owner sued for intrusion. The courts, however, ruled that because the conversation took place in plain sight of anyone who passed by on the public street, there was no expectation of privacy.

As the size of audio and video equipment gets smaller and smaller, the media can increasingly rely on hidden camera techniques for news gathering. In addition, reality TV and other types of productions are utilizing tiny recording devices. At what point do these tactics cross the line? The answer is anything but clear. Rulings in the courts have gone both ways. In some cases, the interests of the public in having the information in question have been important. In other cases, the privacy that someone can expect in his or her own home has been critical. Because controversy exists on the issue, journalists are trying to police themselves. Some media organizations have drafted guidelines for the use of hidden cameras and microphones. Generally, these guidelines try to balance the importance of getting the story against the harm such intrusive techniques can cause. In addition, the guidelines also consider if there are other methods for obtaining the information. With reality TV, however, no real guidelines exist for the use of hidden cameras and microphones. Participants in these shows generally sign very broad and unlimited release forms that protect the producers of the show.

As a case study, consider the following fictional scenario. You are a producer for Slime Productions. You are hired by E! Entertainment to produce a show about the new unknown love interest in the life of Hollywood's latest star hunk, Jay Cook. You decide to hire and equip Cook's full-time housekeeper with hidden cameras and microphones. In addition, you equip a landscaper working on the neighbor's yard with a camera and shotgun microphone. Footage and sound obtained by the housekeeper is all likely to be found intrusive when the lawsuit is heard. It took place in the house and both Cook and his love interest have a reasonable expectation of privacy in the house. Footage from the landscaper might be a different story, though. If the footage comes from a location in public view, then there is no reasonable expectation of

privacy. If the yard has a tall fence to protect privacy, then all the footage may be an intrusion. A court, however, may find that the public interest in Cook's life trumps any reasonable expectation of privacy.

Another intrusion issue concerns the use of material obtained illegally. Consider this scenario as it relates to the documentary on alternative fuels that Pick 2 is producing. The program profiles several environmentally friendly companies that make extensive daily use of alternative fuels for their energy supplies. Suppose someone approaches the producer with documents showing that one of these exemplary companies is actually responsible for a terrible environmental disaster. This fact, however, has never been revealed. After checking the veracity of the documents, the producer also learns that the person who acquired these documents did so by burglarizing the company's offices. Such illegally obtained information could be problematic for Pick 2. Generally, if you have used illegal means to obtain the information, the courts will not look favorably on your case. However, if someone else with no connection to you had obtained the records and then given them to you, the courts may take a more favorable view of your intrusion case. Either way, the law is still unsettled in this area.

B O X 3.1 An Overview of Codes of Ethics

Groups as diverse as *The Los Angeles Times* and the Wedding and Event Videographers Association have codes of ethics that relate to video production. Many of the codes come from news-gathering organizations and are geared more toward information collection than standard production. Nonetheless, an examination of a variety of codes can produce a list of good practices that apply to many areas of, and topics within, video production.

Although primarily concerned with news, the Radio–Television News Directors Association (RTNDA) code of ethics offers several key points for all videographers. In the section on integrity, the RTNDA code addresses the issue of hidden cameras, saying that such methods should only be used "if there is no other way to obtain stories of significant public importance and only if the technique is explained to the audience."

The National Press Photographers Association (NPPA) is an organization for videographers as well as still photographers. The NPPA is another organization that is primarily interested in news gathering. The NPPA code advocates for pictures that are objective, truthful, and honest. In addition, the code states, "Do not manipulate images or add or alter sound in any way that can mislead viewers or misrepresent subjects."

In an increasing era of convergence, many traditional print journalism organizations are involved in video production. *The Los Angeles Times* code of ethics has a section concerning other media that states, "Video is governed by the same ethical principles as still photography. Distortion of any type is improper. In editing video, do not insert words or splice together statements made at different times so as to suggest that they were uttered at the same time. Excerpts of an interview or address generally should be presented in the order that they occurred."

The National Professional Videographers Association (NPVA) is a regional organization located in the northeast United States. Its code of ethics is more concerned with business matters, but does contain some production-related items. For example, the NPVA calls on its members to "not represent other individual's work as my own." In a point that NPVA shares with the Wedding and Event Videographers Association (WEVA), the groups incorporate responsibility for sharing knowledge into the code of ethics. According to both codes, "I will share my knowledge with fellow videographers, students, and others who aspire to become professional videographers, so as to attempt to raise the standards of this industry."

False Light

This privacy action can plague video production personnel and is an issue around which producers must be extremely cautious. The action of false light states that you may not publicize material that places a person in a **false light** if that information would be offensive to a reasonable person and if the person who publicized the material was at fault. The plaintiff in such cases must also show that the material was false. A good example of false light and the ease with which it occurs in video production comes from a case that involved WJLA-TV in Washington, D.C. The station aired a story about a new medical treatment for genital herpes. The story appeared during the 6 P.M. newscast and again at 11 P.M. Both stories began with video of many pedestrians on a busy street. Then it focused on one woman, Linda Duncan, standing on a corner. She looked directly at the camera and was clearly recognizable. During the 6 P.M. newscast, there was no audio over the opening footage. The story then cut to a shot of the reporter, who said, "[F]or 20 million Americans who have herpes, it's not a cure." The rest of the story flowed from there. During the 11 P.M. newscast, a studio anchor read the reporter's opening sentence while the opening video played and showed the close-up of Duncan. She sued, claiming that the 11 P.M. news portrayed her in a false light. In other words, according to the 11 P.M. newscast, she had genital herpes. The combination of the camera shot, Duncan's look, the pacing of the editing, and the words caused Duncan to be shown in this false light. Duncan sued the TV station and won. Anytime generic video is used to cover potentially controversial statements, you should be certain that individual people are not identifiable from the footage. Be cautious about this throughout the production process as any changes to the video, voice track, or both can cause a new problem to arise.

Imagine that you are working on a newsmagazine story about crime and punishment. In one section, you are providing some statistics about crime. The voice-over states that one in three men will be arrested at some time during his life. During that voice-over, you show a shot of three young black college students as they walk to class. The implication is that one of those three college students will be arrested during his life. Another implication is that the statistic refers only to black men. Your choice of that shot demonstrates a lack of sensitivity to stereotypes of ethnicity and represents a poor ethical decision. In addition, if none of the three had been arrested, you have placed each of them in a false light and you could face a privacy lawsuit. As an alternative to that footage, you could have shown shots of a prison, a wide shot of a large group of students walking through campus or on a street, or even police cars with flashing lights. In any of those shots, no person should be readily identifiable. Also, you could have used any of those shots and then blurred the image a bit to provide a backdrop for a graphic to help illustrate the voice-over.

INTELLECTUAL PROPERTY

The protection and proper licensing of intellectual property is also likely to have a significant impact on your video production work. Laws governing intellectual property protect the creation and dissemination of creative and artistic works.

There are two primary areas of importance for video producers and directors: copyright and trademark law. A **copyright** is the exclusive legal right to a piece of intellectual property. **Intellectual property** is property that derives from original, creative thought and has commercial value.

Copyright law provides incentives for the creation of intellectual property. Copyright protection exists for literary works, dramatic works, musical works, computer programs, pantomimes and choreographic works, pictorial graphic and sculptural works, motion pictures and other audiovisual works, and sound recordings. The incentives are provided through an exclusive bundle of rights for the copyright holder. Those rights include the right to reproduce the work, the right to create derivative works, the right to publicly perform or display the work, the right to distribute the work, and the right to control public digital performances of a sound recording. Examples of digital public performances include streaming over the Internet, satellite radio, and music channels on digital cable and satellite. Copyright law protects the expression of ideas and not the ideas themselves. For example, in a medical genre TV show like *House* or *Grey's Anatomy,* the idea for the show is not copyrightable, but the expression of that idea as detailed in the weekly episodes of each show is copyrightable. Works are protected under copyright as soon as they are created. For U.S. works, the copyright must be registered before the producer can file a lawsuit to protect and enforce the copyright. For example, suppose you produce an informational video and do not register the copyright. Soon after your work airs, you start seeing unauthorized copies. You file a lawsuit for copyright infringement. Because you have not registered the work with the U.S. Copyright Office, a court will not hear your lawsuit. Having the copyright certificate acts as evidence that you hold a valid copyright. Although all works are protected from the date of creation, you need to have the copyright certificate before you can sue to protect your copyright.

A trademark can be any word, symbol, or device used to brand a company or service. For example, McDonalds, the Golden Arches, and Ronald McDonald are all associated with the famous fast-food restaurant. These icons, symbols, and words all have value to the business. As such, they can be trademarked. Unlike other areas of intellectual property law, a trademark can theoretically last forever. As long as it is used to distinguish a business or brand, it remains valid. In some cases, rights can be terminated if the trademarked item or phrase has become so ubiquitous that the public believes the trademark is the generic term. "Kleenex" is a good example of this. Although it is a facial tissue made by Kimberly-Clarke, the word "Kleenex" has come to equal "facial tissue." For years, the manufacturer Avid had its product mentioned when people in the industry talked about nonlinear editing. In this case, the advent of alternative nonlinear editing systems has led to the demise of this term being used generically. (In such cases, the trademark cannot be protected because its value has been diluted.) Video producers need to be concerned with clearing trademark issues when the video includes trademarked elements. In addition, if the trademark item also has copyrightable elements, the issue becomes more difficult. For example, Microsoft owns a trademark for its animated spinning globe and letter "E," part of the

Internet Explorer application. Those graphic elements and animation are also copyrightable. Characters like Mr. Peanut and the Pillsbury Doughboy also qualify as trademarks that have copyrightable elements.

The Work-for-Hire Doctrine

If you create intellectual property as a part of your job, that work may be covered by the work-for-hire doctrine. Under this part of copyright law, the owner of that intellectual property is the company that hired you. In addition to work prepared in the scope of employment, a work for hire may fit into a broader category of specially commissioned material that includes motion pictures or other audiovisual works. Whether a work is considered a work for hire can affect the copyright term as well as the ownership rights of the creator. In some cases, a company may require you to sign a form acknowledging that any intellectual property you develop in your time as an intern or employee is a work for hire. Suppose you are interning and you develop a screenplay that turns into a big hit. If the company claimed it was a work for hire, you would not have the ownership rights. In the case of the productions you are directing for Pick 2 Productions, it will be important to know whether Pick 2 or the nonprofit company that hired you will own the copyrights on the work. If the nonprofit will have those rights, perhaps you could negotiate some usage rights as part of the contract.

Using Intellectual Property

In order to use copyrighted material in your production, you must first determine if you need to obtain a license or clearance to use the material. If the material is in the **public domain**, you will not need to get permission to use it. Besides materials that never had a copyright, the public domain includes items whose copyrights have expired or have not been renewed. In addition, most works produced by federal agencies are in the public domain. For example, the National Aeronautics and Space Administration (NASA) has many images of space and the earth that are freely available to producers. Moreover, you may not need permission to use a copyrighted element because your use is covered by fair use. Fair use is a provision in copyright law that allows certain uses of material without having to obtain permission. It is covered later in this chapter.

Although the process of obtaining a license to use protected material in your production can vary by the type of material you are using, five basic steps should be followed: determine if permission is needed; identify the owner; determine the rights you need; contact the owner and determine if payment is required; and get the owner's permission in writing. If you determine you need clearance, the methods for obtaining a license can also vary depending on the type of material you are trying to clear. The most common items to clear for video production include photographs, music, and tv/film clips.

Public Domain and Fair Use As noted earlier, a work may now be in the public domain for several reasons. Anything published prior to 1923 has entered

the public domain because any copyright on those items has expired. The term "published" means that it was either made available to the public or it was registered with the U.S. Copyright Office. Because of a 1998 law, no work published after 1923 will enter the public domain until 2019. In 2020, work published in 1924 will enter the public domain; in 2021, work from 1925 will enter the public domain, and so on. Another way works can enter the public domain is through the failure to properly renew a copyright. Under an older version of the copyright law, owners were given a 28-year term of protection and then had to renew for an additional term of protection. Many works published between 1922 and 1964 have fallen into the public domain because the copyright owners failed to renew their work. The current law does not require renewal. Finally, some authors and creators publish works strictly for the public domain. Those individuals assert no copyright over the work. Alternatively, they may claim a copyright for some period of time and then bequeath it to the public domain.

Fair use is a section of the copyright law that may allow you to forgo obtaining permission to use someone else's work. Some uses of copyrighted works may be permitted if those uses meet certain conditions. In evaluating a fair use claim, courts will examine four factors: the purpose and character of the use; the nature of the copyrighted work; the amount and substantiality of the portion used in relation to the copyrighted work as a whole; and the effect of the use on the potential market for, or value of, the copyrighted work. In addition to those factors, the fair use section of law has a preamble. In that section, the use of copyrighted works is allowed if it is utilized for criticism, comment, news reporting, scholarship, teaching, or research. Some issues also arise with fair use. First, fair use can only be evaluated in a court. If you believe the use of copyrighted works in your production falls under fair use, you may have to defend that belief in court. Such a defense would be costly and time-consuming. In addition, as a student, your use of materials may be covered by fair use for class projects or other assignments, but if you take the work and use it in another context, like an entry in a film festival, it may no longer be fair use. If you want to avoid any legal entanglements with copyrighted materials, your best course of action is to obtain permission to use the work in your production. The following are some guidelines for securing those clearances for photos, music, and audiovisual clips.

Because of their commercial intent, the three productions that Pick 2 is currently completing will not be able to claim fair use. On the other hand, a newsmagazine review of the completed productions, which includes several clips from the shows, could likely claim a fair use exemption.

Photographs

It is not unusual for a video production to utilize still photographs in telling a story. Ken Burns has made extensive use of still photos in his documentaries such as *The Civil War*, *Baseball*, and *Jazz*. The reality show that traces the family history of celebrities, *Who Do You Think You Are*, uses both current and older

photos to tell its stories. Still photos can be obtained in several ways for use in your work. The first option is to hire a photographer or take your own photos. A second choice is to use an image bank or stock photo agency. An image bank has an array of photos available for licensing. Many of these companies specialize in certain genres of photos from celebrity to sports to nature to current events. If you find a photo and it is not licensed through an image bank, you need to find the person or organization that holds the rights. Typically, this will be the photographer or the publisher of the photo.

Once you have determined the rights holder, you need to make contact to arrange permission. This will typically involve paying a fee. With many image banks, you can check the fee online. With others, you may have to negotiate. Regardless of how you find the fee, a number of factors impact how much it will cost to use the photo. Fees can range from as low as a few dollars up to several thousand dollars. Even if the photo is a "royalty-free" photo, a high-quality version may still require an acquisition fee. Many factors determine the rights fees for a photo: how you plan to use the photo; the degree of national or international exposure; the technical quality you need; and whether or not you will also use it on a website. Requesting a nonexclusive right can lower the fee, but it means others will also be allowed to pay a fee and use the same photo. In addition, some organizations charge a reuse fee. If you are producing a documentary to air on PBS and you secure the rights to use a photo in that program, the fee may be higher if you will reuse that program for other purposes, such as DVD distribution.

A written agreement for permission to use a photo should include proof that the grantor owns the photo and is able to license it; a statement indemnifying you if the grantor is not able to the license the photo; a clear description of the photo; the length and nature of the use; payment arrangements; and any information about a courtesy credit for the photo. **Indemnity** is a legal term to guarantee against losses suffered by someone else. In the context of a photo, indemnity means that if the grantor gets sued because he is not the real copyright holder, you will not suffer losses.

A list of image banks, search engines, photographers, and photo researchers is included in the reference section of this chapter.

Music

Music is the most common asset for which producers seek clearance because it plays such an important role in many narrative, documentary, informational, corporate, and advertising videos (see Figure 3.3). Unfortunately, clearing music can be one of the most complicated and confusing procedures you will face. The complications arise from the different types of licenses you may need for your production. Every piece of music contains two separate copyrights. There is a copyright for the song itself, which protects the words, music, and arrangement of notes. Though a songwriter typically creates this work, he or she often assigns the copyright to a music publisher who will enforce the copyright and pay royalties to the songwriter. The second copyright on a piece of music is for the sound recording.

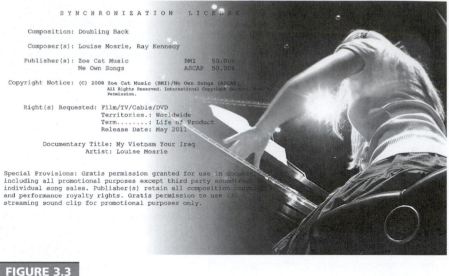

SYNCHRONIZATION LICENSE

Composition: Doubling Back

Composer(s): Louise Mosrie, Ray Kennedy

Publisher(s): Zoe Cat Music BMI 50.00%
 Me Own Songs ASCAP 50.00%

Copyright Notice: (C) 2008 Zoe Cat Music (BMI)/Me Own Songs (ASCAP).
 All Rights Reserved. International Copyright Secured. [...]
 Permission.

Right(s) Requested: Film/TV/Cable/DVD
 Territories.: Worldwide
 Term........: Life of Product
 Release Date: May 2011

Documentary Title: My Vietnam Your Iraq
 Artist: Louise Mosrie

Special Provisions: Gratis permission granted for use in documen[...]
including all promotional purposes except third party soundtrac[...]
individual song sales. Publisher(s) retain all composition copyri[...]
and performance royalty rights. Gratis permission to use :30
streaming sound clip for promotional purposes only.

© Cengage Learning

FIGURE 3.3

It is important to secure the proper licenses for any music used in your production.

When a song is performed and a recording of it is made, the sound recording copyright protects that particular performance and the actual sound of the song. A record company typically holds this copyright. The record company will enforce the copyright and collect the royalties. Having two copyrights for every piece of music makes it difficult to determine what licenses you need to obtain for your particular production. Consider the holiday classic "White Christmas" as an example. Irving Berlin wrote the music and lyrics in 1942.

His company, Irving Berlin Music, is the publisher and owns the copyright to the song. Over the years, this famous song has been covered by performers including the Andrew Sisters, the Zavala Brothers with Bing Crosby, Elvis Presley, Frank Sinatra, and many others. If you wanted to use the Bing Crosby version in your video, for example, you would have to secure the rights to the song from Berlin's music company and then get permission to use the Crosby sound recording. That sound recording permission would come from Universal Music Group, since it currently owns the rights to the sound recording of Bing Crosby's initial performance of "White Christmas." Table 3.1 shows the various fees and licenses you may have to pay to either the music publisher or the record company.

Royalty-Free Music Production music libraries provide a variety of sources for copyright-free music. The term **royalty-free music** does not mean that such libraries are free. Rather, you pay a fee to acquire the music and have few, if any, restrictions on the way you can then use the music. Like image banks, music libraries can vary by genre and type of music. Numerous music libraries are available to the video production community. A partial list is included at the end of the chapter.

TABLE 3.1 Overview of the Fees Paid When Licensing Music for a Production

Licensing Fees Paid To	
Music Publisher	**Record Company**
Mechanical Royalty	Master Use License
Performance Royalty	Digital Use Rights
Synchronization License	
Videogram License	
Digital Broadcast Rights	

© Cengage Learning

Two main methods are used to pay for music from a production library. A renewable **blanket license** gives you unlimited use of music for a specific period of time. Fees for a blanket license can range from several hundred dollars up to several thousand dollars per year. The second method is a **per-use agreement**. With this method, you pay each time you use a particular piece of music from the library. This type of payment method is also known as a "**needle drop fee**." That language comes from the days when music was recorded on a vinyl album and you paid each time the needle was dropped on the record. Fees for a per-use agreement can run from less than 100 to several hundred dollars.

Using Other Music Several different types of permissions may apply in your production situation. Not all license types are required for every production.

A **mechanical license** is paid to a music publisher for the right to record and sell a song that the publisher owns. Congress sets the rate for a mechanical license and provides regular increases for inflation. It is considered a compulsory license because anyone who wishes to record a protected song may get the license for the same fee. In 2012, for example, the rate for a song was 9.1 cents per copy or 1.75 cents per minute, whichever was larger. It is possible to negotiate and receive a rate that is lower than the compulsory fee. The Harry Fox Agency (www.harryfox.com) handles mechanical licenses for most music publishers and is the first stop for acquiring such permissions.

A **performance royalty** is a fee paid to a music publisher when one of its songs is performed or played publicly. The performance can be categorized as either nondramatic or dramatic. Nondramatic performances are unrelated to any larger plot structure in a video production. If you hear a song at a restaurant, in the shopping mall, on an elevator, over the radio, or on television, the companies and organizations who are playing the song have paid a performance royalty. For television, the songs that the contestants sing on *American Idol* are considered nondramatic performances. For these nondramatic performances, the fee does not go to the publisher directly. Rather, the music publisher uses a **performing rights society** to collect fees and enforce the copyright. There are two main performing rights societies, BMI or Broadcast Music, Inc., and ASCAP, the American Society of Composers, Authors, and Publishers. These nonprofit organizations collect

performance fees and distribute them to their members. A third, and smaller, private organization is called SESAC. A songwriter generally belongs to only one of these organizations. Radio and television stations, as well as retail outlets, can purchase blanket licenses from the performing rights societies and use any song in their libraries. A dramatic performance is one in which the music helps advance or develop a story line in the production. The performance royalty for a dramatic production must be negotiated directly with the music publisher.

A **synchronization license** is needed if you use a song or part of a song in a video program or other media format. Synchronization means that the music will be recorded along with visual images. Typically, you will have to negotiate fees for the synchronization license with the music publisher. Although the terms for most synchronization licenses are the same, each one can be tailored for specific needs like a theatrical motion picture, a corporate informational video, a student project, or a film festival. The fee structure depends on whether the song is used in the background or foreground, or in a special manner. For major productions, the fees can be quite large for a synchronization license. A major motion picture, for example, might cost tens of thousands of dollars per song. The fee for an independent documentary that uses the song in the background could be several hundred dollars.

A **videogram license** will allow you to sell copies of your production on DVD or video. Any production that contains copyrighted music and that will be distributed on DVD or video requires a videogram license. It doesn't matter if the work previously aired on a television outlet; the videogram license covers the sale of the work to the public. For major productions, the fees can run up to several thousand dollars. Alternatively, the fee might be tied to sales of the DVD. For a corporate video, you may only have to pay a more modest flat fee tied to the number of copies you sell.

Digital use rights may be necessary if you plan to have your video production available on the Internet. Under the copyright law, webcasting and audio streaming are considered **digital audio transmissions**. The law divides those transmissions into interactive and noninteractive. An **interactive digital transmission** occurs when the website user clicks on a particular song and the music plays. In addition to a blanket license from a performing rights society, you will also need a mechanical license for the digital copy that will be created through the streaming process. In addition, you will need permission from the sound recording owner to transmit the sound. That permission is negotiated directly with the record company. **Noninteractive transmissions** are generally known as webcasts. A user can tune the music in or out at any given time. This is the same principle as channel surfing through your TV channels, since you do not control what you see and hear when you visit the site. Noninteractive digital transmissions require a blanket license from the performing rights society. Most video productions streamed over the Internet or to mobile devices are considered interactive digital transmissions.

Another fee you may have to pay to a record company is a master use license. Recall that record companies own the copyrights on sound recordings. A **master use license** is a fee to use the "master" version of a particular

recording. The master version is the highest quality recording that exists for a particular song. If you have decided that your narrative production needs the version of "White Christmas" that Bing Crosby sang, you will have to obtain, among other permissions, a master use license to use that particular recording of the song.

It can be difficult to sort and identify which licenses you will need for your production. The scenarios that follow may be helpful in understanding these issues. Regardless of the level of experience with music licensing, many professionals rely on a **music clearance company** to navigate the legal complexities. These companies allow for peace of mind since they specialize in securing the correct licenses and rights for your particular production. A list of some music clearance companies is included at the end of the chapter.

Errors and Omissions (E&O) insurance can provide additional protection from lawsuits arising out of licensing issues. An E&O policy is similar to a malpractice insurance policy that a doctor or lawyer might purchase. E&O insurance will protect you if you infringe a copyright, invade someone's privacy, defame a trademark, or make other general types of legal mistakes during your production. This type of insurance is typically reserved for large budget productions. Rates for an independent film production can cost several thousands of dollars for a 3-year policy with a $1 million per claim limit and a total limit of $3 million. The deductible under such a policy is generally around $10,000.

Music Clearance Scenario I—A Fictional Narrative Production Suppose you are producing a sweeping narrative coming-of-age story that covers a broad range of time. It will be shown as a 2-hour movie event on a network or cable television outlet. The music needs are quite varied. You require some stirring orchestral movements to set the overall theme, as well as some contemporary popular music that will provide the background for some montage sequences. In addition, more subtle instrumental music is needed throughout the piece. Besides the television broadcast, you will release the story on DVD and market a stand-alone soundtrack CD. To begin, you decide you will hire an orchestra to perform the theme music. The orchestra could also perform some of the background instrumental music. Even though the orchestra is performing the music, it still may need to be cleared. If you determine that the music is in the public domain, you are permitted to use the music without further licensing steps. While the music is clear, however, the arrangement may need to be licensed from the music publisher. If the songs are not in the public domain, you must obtain several licenses for each song that the orchestra will perform. You will need to pay a performance royalty for each piece as well as acquire a synchronization and videogram license. Because this is a narrative piece, it is likely that even the background music will be viewed as playing a role in the drama and therefore be a dramatic performance. The synchronization license will allow you to use pictures with the music, while the videogram license is necessary for the DVD distribution. Since the contemporary popular music is already published and recorded, you will have to pay the publishers performance royalties and

purchase synchronization and videogram licenses. In addition, you will have to acquire a master use license from the record company. Finally, you will need to pay mechanical royalties for the rights to take all the songs from your story and produce them on the soundtrack CD.

Music Clearance Scenario II—A PBS Documentary In this scenario, imagine that you are producing a documentary that will air on public television. In addition to the television broadcast, you will sell DVDs of the show and stream the program on the Internet. Your music needs are fairly modest. You require some background music to help with the pacing of some sections, and one popular song is needed for the documentary. As in the previous scenario, you will have to pay performance royalties and purchase synchronization and videogram licenses. In addition, you must also pay digital rights fees for the streaming version. The record company will require a master use license and a digital broadcast license. As for the background music, the best alternative may be a production library.

Music Clearance Scenario III—A Commercial You have been hired to produce a commercial for Acme, a computer software company. The company wants you to create a spot to help launch its new web browser. In addition to the television commercial, Acme will use your video during presentations at various corporate events and trade shows. Because their theme is surfing the Internet, they want to use the song "Surfin' Safari" by the Beach Boys. A synchronization license from the publisher is required, as well as the rights to use the performance of the song. You will also need a master use license.

Music Clearance Scenario IV—Informational Video Your production company has been hired by a local church, which wants you to produce a short informational video to help it raise funds. The video will be played when church members visit other members to introduce them to the capital campaign. You determine that the video needs some generic music that will play in the background. You will use a variety of different musical selections to help with the pacing of the piece. Even though this is a not-for-profit organization, rights are required. Therefore, you decide to use music from your production music library. Fortunately, you have a blanket license from the music library company. You can use any cut in the library. This flexibility will offer the client a number of choices for the video.

Use of Trademarks in Your Production Like copyright clearance, there might be instances when you need to clear the use of a trademark in your video program. The use of a trademark is permitted without clearance for informational or editorial uses. If the video was produced to inform, educate, or express opinions, the use is protected under the law. You can even use a trademark in an advertisement that uses comparisons to sell a competing product. The stipulation with advertising is that your comparison must use accurate statements; otherwise, you could be liable for trademark dilution. In ads or

promotional or marketing videos that do not compare products, you will need to clear the use of the trademark. The procedures to do so are the same as those previously described. Find the owner of the trademark, determine the fee, and get the permission in writing. Large corporations, such as Federal Express and McDonalds, have departments that handle licensing issues. To locate more obscure trademark owners, you can use the U.S. Patent and Trademark Office (USPTO) database.

Narrative video works may present an opportunity with regard to the use of trademarks. Owners are likely to desire placement in your story and will often be willing to pay **product placement fees** for using their trademarks. This happens frequently in movies but can be more difficult for television productions. Whenever a product placement occurs in a television show, the FCC (Federal Communications Commission) requires an acknowledgment that the company has paid for that placement. This is typically done during the credits for the show. The acknowledgment must state the name of the company and the fact that it paid for the sponsorship. Payment, of course, can come in the form of prizes for people in the show and products for members of the production crew, among other incentives. For example, on *American Idol,* the judges sip drinks from the red Coca-Cola cups prominently placed on the table while contestants wait in the Coca-Cola lounge and viewers are urges to use their AT&T phones to call and text. Although reality shows like *The Amazing Race* and *Born Loser* are the most popular outlets for product placements, a number of other shows are increasingly using the practice. Product placement is becoming so widespread on television that some consumer groups have started complaining to the FCC about these advertisements that, to consumers, may not look like advertisements. Nonetheless, product placement is a routine occurrence in theatrical movies and other nonbroadcast programs not regulated by the FCC. As an example of negotiating a product placement deal, consider that you are doing a coming-of-age story about a group of teenagers. Among the many gathering places for this group are several fast-food restaurants like McDonalds, Burger King, and Wendy's. As the producer, you could approach each company and offer them an exclusive product placement deal. In return for them paying you, the story would only show the group gathering at their chain. In return, a product placement agreement could generate revenue for the production.

Clearing Audiovisual Material Like other copyrighted material, audiovisual clips from movies or television shows need clearance. The procedure is the same as with other media assets: find the owner, negotiate the fee, and get the permission in writing. Like photos and music, stock footage companies can be used to obtain video footage for your project. Many companies have a variety of offerings. Make sure any agreement with a stock footage company includes an assurance that the company does in fact own the rights associated with the clip. It may seem obvious, but a stock footage company cannot grant you rights it does not own. Despite such assurances, your licensing agreement should include language that indemnifies you. A list of stock footage companies is included at the end of this chapter.

In some cases, additional fees may be charged to cover contracts with union workers such as writers, directors, and actors. If a union is involved, you will likely have to pay additional "reuse" fees on top of the standard licensing fee. The theory behind a **reuse fee** is that if you did not use a specific clip, you would have to create original material. Creating that material would presumably involve writers, directors, and actors. By using the clip, then, you are displacing these writers, directors, or actors from working and earning money. To compensate for that, you pay a reuse fee. If the clips contain music, you may need to license the music as well.

Risks of Not Obtaining Permission Beyond the obvious ethical issues associated with violating copyright law in your production, some practical issues should also be considered. You are still responsible for licensing intellectual property even if your production is too small to warrant attention from copyright holders or if you do not anticipate making a profit. Generally, a copyright holder will send you a letter asking that you either stop using the material or request permission to use it. If you do neither, you are likely to face a lawsuit. For example, imagine that you have one piece of music that is critical to your production. You have spent countless hours editing the pictures to this particular clip. The copyright holder may sue if you did not obtain the proper licenses for the clip. You could probably avoid a lawsuit by not using that particular piece of music, but that would mean re-editing your piece. If you try to seek the licenses after you have received a letter from the copyright holder, your attempt to skirt the law may mean higher licensing fees, or worse, a denial of your license request.

Securing Your Own Copyrights It is a remarkably straightforward process to obtain a copyright on your own video production work. Once you have created the piece, you simply fill out the correct form, pay the fee, and mail the form and a copy of your work to the U.S. Copyright Office. Video productions are considered audiovisual works under the copyright law. To secure a copyright on an audiovisual work, you complete FORM PA, which you can download from the Copyright Office website (www.copyright.gov). Assuming that you correctly followed all the directions on the form, you will receive a copyright certificate. The copyright protects the work for the life of the author plus 70 years.

CONCLUSION

You must consider legal issues throughout the production process. The exact laws that govern your production will vary from state to state. You should consult a qualified legal professional if you are confused or have questions about the legal aspects of your work. You must follow all the relevant contract, defamation, privacy, and intellectual property laws. You may have a great story to tell and you may be telling it in the most compelling way, but if you run afoul of the legal issues at stake, audiences may never see it.

This chapter has introduced you to the basic legal matters of video production. In addition, it has given you some guidance about licensing the use of protected intellectual property as well as details about protecting your own work. Like the other activities involved in the preproduction stage, managing the legal matters related to your story are critical to the success of your production.

Story Challenge: Legal Issues

Successfully navigating through all the legal concerns for Pick 2 Productions' three projects was a difficult challenge, but it was successful because the director considered the issues during the preproduction phase. That forethought made it very easy to get signed release forms from every participant in the videos. In addition, finding a number of public domain photos and video clips for the historical documentary kept the permissions costs low for the overall production. Because Pick 2 knew before production began that there would be licensing rights for cable, DVD, and Internet distribution, the producer was able to easily negotiate those fees from the start and did not have to renegotiate later because something had been overlooked. Moreover, the communication with the band and its management helped make the location agreement and music licensing go very smoothly. Finally, because the work fell under the work-for-hire doctrine, the nonprofit company that hired Pick 2 Productions secured all the copyrights for the three videos.

SUGGESTED READINGS/REFERENCES

Unions
- International Alliance of Theatrical and Stage Employees (www.iatse-intl.org)
- American Federation of Musicians (www.afm.org)
- Screen Actors Guild–American Federation of Television and Radio Artists (www.sagaftra.org)
- National Writers Union (www.nwu.org)
- Writers Guild East (www.wgaeast.org)
- Writers Guild West (www.wga.org)
- Graphic Artist Guild (www.gag.org)

Photo Image Banks
- AP/Wide World Photos (www.apwideworld.com)
- Jupiter Images (www.jupiterimages.com)
- Corbis (www.corbis.com)
- Getty Images (www.gettyimages.com)
- Stock.XCHNG (http://www.sxc.hu/)

Finding Photographers

- The American Society of Media Photograhers (www.asmp.org)
- Professional Photographers of America (www.ppa.com)
- National Press Photographers Association (www.nppa.org)

Photo Researchers

- American Society of Picture Professionals (www.aspp.com)

Production Music Libraries

- Smartsound (www.smartsound.com/music)
- Music Bakery (www.musicbakery.com)
- Killer Tracks Production Music (www.killertracks.com)
- Video Helper (www.videohelper.com)

Music Clearance Companies

- Arlene Fishbach Enterprises (arlenefishbach.com)
- BZ Rights and Permissions, Inc. (www.bzrights.com)
- Clearance Consultants (clearanceconsultants.com)
- Parker Music Group (musicclearance.com)

Mechanical Rights Society

- The Harry Fox Agency (www.harryfox.com)

Performing Rights Societies

- ASCAP (www.ascap.com)
- BMI (www.bmi.com)
- SESAC (www.sesac.com)

Record Company Resources

The big four record companies own the rights to about 85 percent of the sound recordings in the United States:

- Universal Music Group (www.umusic.com)
- Sony Music Entertainment (www.sonymusic.com)
- EMI (www.emimusic.com)
- Warner Music Group (www.wmg.com)

Stock Video Footage

- National Archives (www.archives.gov)
- Archive.Org (www.archive.org)
- Airboss Military Stock Footage (www.airbossstockfootage.com)

- All Stock (www.all-stock.com)
- BBC Motion Gallery (www.bbcmotiongallery.com)
- Historic Films Stock Footage Library (www.historicfilms.com)
- NBC Universal Archives (www.nbcuniversalarchives.com)
- Producers Library (www.producerslibrary.com)
- Streamline Stock Footage (www.streamlinefilms.com)

Useful Copyright Resources

- U.S. Copyright Office (www.copyright.gov)
- Public Domain Music (www.pdinfo.com)
- Creative Commons (www.creativecommons.org)

PART II

Shooting/Acquisition

From Light to Electrical Energy: Creating and Storing Media

Sufficiently advanced technology is indistinguishable from magic.

ARTHUR C. CLARKE, SCIENCE FICTION AUTHOR

OVERVIEW

The seemingly simple technology of today's cameras and intuitive video-editing software makes it appear easy for even the most novice user to start producing video. Professional results, however, require an understanding of the capabilities and limitations of the technology. This chapter will demystify that technology and explain how cameras work.

The purpose of a video camera is to convert light into electrical energy. That energy can then be manipulated, stored, and eventually reconverted into images that an audience can view on a television receiver or monitor. This chapter begins with a description of how video/television images are created and how humans process visual information. It then provides an overview of technical production standards. Finally, the chapter discusses how video cameras create and store images.

Story Challenge: Technical Issues

Although technical background may not seem to have much impact on storytelling, equipment choices can affect how the story is told. Among the questions and issues facing you as you work on the three videos for Pick 2 Productions are:

- How does the choice in camera technology impact the images in the videos?

- Which recording formats will give you the best results for the chroma key interview segments that you want to use in the historical documentary?

- What features of tapeless media can you use to make editing all the videos more efficient?

DIGITAL TELEVISION STANDARDS

The first U.S. television system came about in the 1930s. The National Television Systems Committee created the NTSC standard. It was later modified for color television and stereo sound. In the late 1990s, the government mandated that all broadcasters must begin transmitting signals for digital television (DTV). Unlike the single NTSC standard, the government approved 18 separate digital standards (Table 4.1) and declared that the market should determine the best standard. The standards allow for different frame rates, different levels of resolution, and different methods of scanning the image.

TABLE 4.1 ATSC Table 3 of Digital Television Transmission Standards

Vertical Size	Horizontal Size	Aspect Ratio	Frame Rate and Scan
1,080	1,920	16:9	24 progressive
1,080	1,920	16:9	30 progressive
1,080	1,920	16:9	30 interlaced
720	1,280	16:9	24 progressive
720	1,280	16:9	30 progressive
720	1,280	16:9	60 progressive
480	704	4:3	24 progressive
480	704	4:3	30 progressive
480	704	4:3	60 progressive
480	704	4:3	60 interlaced
480	704	16:9	24 progressive
480	704	16:9	30 progressive
480	704	16:9	60 progressive
480	704	16:9	60 interlaced
480	640	4:3	24 progressive
480	640	4:3	30 progressive
480	640	4:3	30 interlaced
480	640	4:3	60 progressive

© Cengage Learning

Before exploring the technical aspects of the television system, it is important to understand how humans perceive the images shown on the television screen. The basics of color and scanning in television are also important.

Humans perceive motion from a series of rapidly sequenced still frames. The mechanics of how the eyes and brain work together to accomplish this are complex. Early research demonstrated that humans could discern motion at 16 frames per second. A series of still images typically has subtle variations in the brightness or darkness of each individual frame. Human eyes are very sensitive to these differences.

Higher frame rates can help compensate and hide the variations in the brightness of images. Because of these brightness issues and other factors, the frame rates for film and television were set at 24 and 30 frames per second, respectively. Modern rates for digital video include 24, 30, and 60 frames per second. If you slow down a video signal by changing the frame rate to 12 or 14 frames per second, for example, you can easily see the strobe-like effect of the motion and understand the reasoning behind the standard frame rates.

In much the same way that you read this book from left to right, line-by-line, the television set draws or scans the color image on your screen. Three electron guns—one each for red, green, and blue—scan your TV screen from left to right to draw images one line at a time. The exact method of line drawing is discussed later in this chapter. These lines combine to create a full-screen image, and these full-screen images generate a series of still frames on your television.

Color Television uses the **additive color** model to create color pictures. The video image consists of three primary colors: red, green, and blue. When you mix the full strength of each of the primary colors, you get the color white. Imagine a red spotlight, a green spotlight, and a blue spotlight. If you were to shine all three at full intensity on the same spot on a wall, you would see the color white. When you add two of the primary colors, you get the secondary color of cyan (blue and green), magenta (blue and red), or yellow (red and green).

Color has three attributes: hue, saturation, and brightness. **Hue** is the actual color itself, such as a red shirt, a blue ball, or green grass. **Saturation** is the richness or strength of the color. The bright rich colors of flowers in the spring are highly saturated, while those of old faded blue jeans are less saturated. Highly saturated colors are those that have little or no white mixed in. As more white is added to a color, it becomes desaturated. **Lightness**, or **brightness**, affects the luminance of a color. **Luminance** is the black and white information in a video signal. In other words, lightness is a gray-scale representation of color.

Lines, Frames per Second, and Scanning The image is drawn, line by line, onto the television screen. The method and frequency by which those lines are drawn can vary according to the specific television system.

The resolution of a video image is determined by the number of vertical lines in the signal. More lines means better resolution. The number of lines in video images ranges from 480 up to 1,080. Furthermore, with some systems, each video frame is divided into two fields. With **interlaced scanning**, the TV set draws the odd-numbered lines until it reaches the end of the first field. Then, it returns to draw the even-numbered lines for the second field (see Figure 4.1). **Progressive scanning** is an alternative to interlaced scanning and is used in some digital television systems (see Figure 4.2). Starting with line 1, the electron beam sequentially scans the image line by line. The beam then returns to the top of the screen to draw the next frame of video. In addition to these digital television systems, computer monitors use progressive scanning.

(A) In interlaced scanning, the electron beam first scans all the odd-numbered lines, from left to right and from top to bottom. This first scanning cycle produces one field.

(B) The electron beam jumps back to the top and scans all the even-numbered lines. This second scanning cycle produces a second field.

(C) The two fields make up a complete television picture, called a frame.

© Cengage Learning

FIGURE 4.1

With interlaced scanning, the television first scans all the odd-numbered lines, then returns and scans all the even-numbered lines.

During this scanning process, there is both horizontal and vertical blanking. **Blanking** is a process that turns off the electron beams at the end of each line and at the end of the first field. In an interlaced, 30-frame-per-second format, each field of video is updated every 1/60th of a second and each complete frame is updated every 1/30th of a second. With progressive scanning, the full frame is also updated every 1/30th of a second. You can calculate similar math for other frame rates.

FIGURE 4.2

With progressive scanning, the television scans each line sequentially until it draws each line onto the screen.

ANALOG AND DIGITAL SIGNALS

An **analog signal** is one that varies according to the stimulus that creates it. A whisper and a scream provide a good analogy. The soft sound of a whisper is a low point on a loudness scale. A scream is a high point on that scale. The analog signal to record those sounds would smoothly and continuously change to reflect both values. An analog signal is often represented as a sine wave, as shown in Figure 4.3. In the example, the wave would start low and move higher to represent the louder signal. The movement of the analog signal would be smooth and continuous. Re-creating data between values in this way may seem like the best method of reproduction. Unfortunately, interference and noise that can disrupt audio and video signals are also represented as a sine wave. It is difficult for electronic equipment to separate the video and audio from the interference in order to present clear pictures and sounds.

FIGURE 4.3

An analog signal is usually represented as a sine wave.

Rather than a continuously variable wave, **digital signals** are composed of data using binary code, which is made up of 0s and 1s. **Binary code** is the language of the digital world. Every bit of information is represented by a series of numbers using only the digits 1 and 0. For example, in binary code, the letter "A" is "01000001," while a lower-case letter "a" is "01100001." In other words, every value becomes a concrete piece of data. The process used to convert analog waves to a binary code is called digitizing. This is accomplished by sampling the analog signal and re-creating it in a digital form. **Sampling** is a process by which analog information is measured, often millions of times per second, in order to convert the signal to digital. Because the wave is constantly changing, the more times we sample it, the better our re-creation of it. Consider Figures 4.4 and 4.5. Figure 4.4 shows only 10 samples of the wave. The digital signal is not nearly as close to the analog wave as it is in Figure 4.5, with its

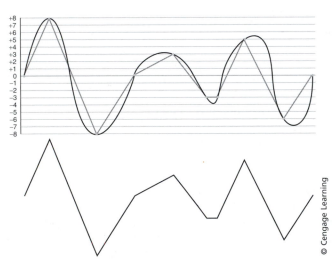

© Cengage Learning

FIGURE 4.4

The original analog sine wave, in the upper part of the figure, has been digitally reproduced with 10 samples. Compare the accuracy of the digital wave, in the lower part of the figure, with the one in Figure 4.5.

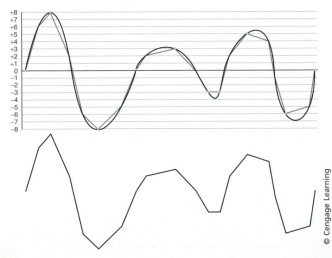

© Cengage Learning

FIGURE 4.5

The original wave, shown in the upper part of the figure, has been digitally reproduced with 20 samples. Compare the accuracy of the digital wave, shown in the lower part of the figure, with the one in Figure 4.4.

20 samples. Higher sampling rates produce more authentic replications of the analog wave. Each of the samples refers to a specific number. What gets recorded in digital video is not the constantly changing analog wave, but rather a series of numbers to re-create that wave. A digital video signal is typically created from over 14 million samples a second. The sampling rate is not the only consideration when converting a signal to digital. The precision of the samples also affects the final results. **Quantization** is the term that describes how precise your samples are. Consider Figures 4.6 and 4.7. In Figure 4.6, notice that the sample can be recorded at only six levels. Because of that limitation, the samples will not be as accurate as they are in Figure 4.7. In that figure, the samples may be recorded at 16 different levels. We speak of quantizing in terms of bits. Using 8-bit quantizing, the sample may be recorded at 256 levels. The standard bit depth for professional video is 16, which results in more than 65,000 separate levels.

© Cengage Learning

FIGURE 4.6

With only six levels at which the digital sample may be recorded, the reproduction of the analog wave is not as accurate as the one in Figure 4.7.

© Cengage Learning

FIGURE 4.7

With 16 levels at which the digital sample may be recorded, the reproduction of the analog wave is more accurate than the one in Figure 4.6.

Aspect Ratio

Aspect ratio is the ratio of screen width to screen height. Most production work today uses the 16:9 aspect ratio (16 units wide by 9 units high), which is standard for high definition television. It is common to describe the ratio in terms of pixels. A 16:9 aspect ratio can be any number of pixels divisible by this ratio, for example 1280 by 720 or 1920 by 1080. Standard definition has an aspect ratio of 4:3 (4 units wide by 3 units high). The most common is 640 by 480 pixels.

As you saw in Table 4.1, eight of the digital standards use the 4:3 aspect ratio, but all those categorized as HDTV use a 16:9 aspect ratio. An alternative way to say this is that the 16:9 aspect ratio is 1.78 times as wide as it is tall. Consequently, a 16:9 aspect ratio is also referred to as 1.78:1.

Some common aspect ratios from the film industry are 1.85:1 and 2.35:1. Because of these ratios and the fact that more than 50 years of archived programming has been shot in the 4:3 aspect ratio, mixing different aspect ratios to be used in the same production requires creative solutions.

When placing 4:3 images in a 16:9 aspect ratio, you have several choices. The image could appear in the center of the screen and have vertical black bars on the left and right. This is called **pillarboxing**. Another popular method is sometimes called **blurry wings**. This method uses two layers of the 4:3 video. The background video is stretched to fit the 16:9 screen and blurred. The original 4:3 is then put on the foreground layer. When played back, it looks like a larger, blurry version of the video is playing in background (Figure 4.8). The entire 16:9 frame is filled with the blurry wings acting like the black bars in the pillarboxing method.

FIGURE 4.8

Blurry wings are one way to fit a 4:3 image into a 16:9 screen.
SOURCE: Courtesy of author, Joe Hinshaw

Another challenge is fitting the wider aspect ratios normally used for a feature film into a 16:9 frame. There are some technical options that producers might consider to rectify this incompatibility. One choice is to **letterbox** the video. In this case, the wider image is proportionally shrunk to fit the smaller dimensions. That shrinking leaves black bars at the top and bottom of the screen. This method enables the viewer to see the whole width of the wide screen frame. Another method is the **pan and scan** technique. With this method, wide screen images are cropped to fit a 16:9 frame. Before being released for distribution, films are converted using a special camera that pans back and forth across the entire width of the image. This technique ensures that the important action in the wide screen can be viewed in 16:9. With this method, however, the process may insert apparent camera movement that was not there originally.

THROUGH THE LENS: LIGHT INTO ENERGY

The lens and the camera imaging device are the two most significant technological differences between professional and consumer camcorders. To create an image, light travels through the lens, strikes an imaging device in the camera, and is converted into electrical energy. There are two primary types of imaging devices used in today's cameras, CCDs and CMOS. A CCD is a **charged coupled device**, while CMOS are **complementary metal oxide semiconductors**. Although both types of sensors will work well to capture images, there are some differences between these devices. CCDs require a special manufacturing process, while the CMOS sensor is manufactured the same way that many other computer chips are made. Because of that process, a CMOS sensor can include other technological features. For example, image stabilization technology can be integrated into a CMOS sensor, while a camera using CCDs requires an additional circuit. In addition, CMOS sensors require less power and cost less than CCDs. On the other hand, CMOS sensors are not as sensitive in low-light situations and are subject to rolling shutter artifacts. **Rolling shutter** can cause the image to smear or wobble if the shot has rapid movement.

Regardless of the chip technology, there are a number of differences between consumer and professional camera imaging devices. First is the number of chips. Professional cameras almost always have three chips, one each for red, green, and blue, while consumer camcorders usually have one chip. A second difference is the physical size of the chips. Chips range in size from two-thirds of an inch to one-sixth of an inch. The bigger the chip, the better the image quality. Finally, the chips will differ as to their ability to work in low-light environments. More expensive chips will have better low-light sensitivity.

Light entering the lens hits the imaging device and is then converted into electrical energy. The surface of the chips is covered with photosites. A **photosite** is a light sensitive container on a CCD or CMOS chip. Think of it as a bucket that collects photons of light. These photons are then used to create the

Red CCD

Green CCD

Blue CCD

© Cengage Learning

FIGURE 4.9

The beam splitter takes the light from the lens and separates it into red, green, and blue light. It then sends it to the target for conversion into electrical energy.

digital image. Since photosites see light but not color, an additional circuit must be included. The process used to create a color image is different depending on whether the camera has three chips or one chip. In a three-chip camera, the light entering the camera is focused onto a beam splitter or dichroic filter (see Figure 4.9). This device separates the light into its three primary colors—red, green, and blue—and directs the appropriate light to the imaging device or target. In a single chip camera, the light entering the camera passes through a filter that separates the light into its component colors. With this method, each photosite collects only one color of light. The most widely used filter is known as a Bayer filter. Imagine a checkerboard pattern where every other square is green. Then on alternating rows there are blue squares and red squares (Figure 4.10).

Once the light has been filtered and collected, the electrical energy is converted from an analog to a digital signal that creates the pixels. A **pixel** is the smallest unit of visual information. The term "pixel" is a combination of the words "picture" and "element." This process of converting the light from photosites into pixels continues for each frame of video. The next stage of the process is to encode and record the signal. Before it can be encoded, though, the signal must be amplified to achieve a sufficient voltage.

Encoding

Once the signal has been amplified, it must be encoded before it can be stored on memory cards, hard drives, videotape, or another storage device. Encoding is the process of taking all parts of a signal, combining them, and then eliminating

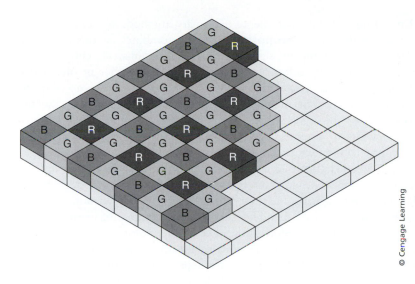

FIGURE 4.10

With the Bayer filter, only certain colors of light reach each individual photosite on the imaging device. Notice that there are twice as many green squares as there are red or blue. Human eyes are more sensitive changes in luminance, therefore more of that signal is required.

redundant information. Composite and component are the two different methods of encoding video signals. These two methods work for both analog and digital signals.

Video signals are composed of chrominance and luminance. **Chrominance** refers to the color part of the video signal, and **luminance** is the black and white or brightness part of the signal. The energy from each of the three chips contributes some luminance and chrominance to the overall picture (see Table 4.2). When combined, they create one luminance signal and two color signals. The letter "Y" represents the luminance part of the video signal. A black and white television receiver would only use the Y signal from the transmission. Chrominance can be represented by the letter "C," but color information is more complex than luminance and therefore requires two separate signals. These are known as color difference signals. The color information minus the luminance gives us the color difference signals. The abbreviation for these signals is R–Y (read as r minus y or red minus luminance) and B–Y (blue minus luminance). A complete set of signals that represent luminance and chrominance is Y, R–Y, and B–Y. Equipment using this configuration requires three separate cables and connections to distribute video to a recording device.

TABLE 4.2 Percent of Luminance and Chrominance in Red, Green, and Blue Camera Signals

Chip	Percent Luminance	Percent Chrominance
Red	30	70
Green	59	41
Blue	11	89

SOURCE: Jon Dilling, Editor

Analog Encoding Recall that the two primary methods for encoding are composite and component. **Composite** encoding combines all the individual video signals into one complete signal. That means luminance, chrominance, synchronizing, and blanking information are all bundled together in one signal. Combining and encoding these signals reduces the amount of data necessary to carry all the information. The drawback is that the composite signal is also the lowest quality. Once the signal is encoded, it must be decoded for additional recording or viewing on a home receiver. In the process of getting a signal from a camera to your television set, there could be several instances in which the signal is encoded and decoded. With each iteration, the signal is subject to errors and extraneous information. The constant encoding and decoding can degrade the picture. The composite signal is the most susceptible to this degradation.

A **component** system of encoding keeps the luminance information separate from the chrominance information. Using the color difference signals described earlier, three separate connections or signals are used for component encoding. The Y, R–Y, and B–Y signals are kept separate during the process. Because they are not combined, the signals have a greater degree of integrity and do not degrade as easily as composite signals. A variation on the color difference signals is Y–C. Under that scheme, all of the chrominance information is compiled, but kept separate from the luminance information.

Digital Encoding The goal of digital encoding is to reduce the necessary bandwidth required to transmit and record the signal. In fact, digital encoding is similar to analog encoding except that data are stored as bits instead of analog waves. Digital encoding also allows the machines in the system to process the data at a higher rate of speed than analog machines. This means more data and information can be processed. Digital composite encoding is the same as analog encoding. All of the signals–luminance, chrominance, synchronizing, and blanking information–are encoded into one digital signal.

The digital component signal also consists of one luminance channel and two color difference channels. The letter Y still refers to luminance but there can be two different designations for the color difference channels. Instead of R–Y, you can have Pr or Cr. Likewise, with B–Y you can have Pb or Cb. The difference between the P and the C is that P was encoded as an analog signal and then converted to digital, while C refers to signals that have never been analog. A complete set of digitally encoded component video would read as YPrPb or YCrCb.

The amount of compression applied to the signal and available data rate both affect the quality of a digital signal. Because of these factors, there are varying levels of quality. As the term implies, **compression** is a means of reducing the amount of information in a video signal. There are several methods used to compress video. **Compression rate** is the amount of reduction applied to the original data. For example, a 5 to 1 compression rate means that the reduced data will occupy five times less space than the original data. Generally, the lower the compression ratio, the higher the video quality. That quality comes at the price of larger files; hence, more required storage space.

The term "**data rate**" refers to the speed at which information can be moved or transported. Data rates are expressed in terms of bits per second; in other words, how many bits of data can be moved in one second. Some digital formats may have a set rate such as 25 megabits (Mbs) per second while others have variable bit rates. Higher bit rates generally mean higher-quality video signals.

Each method of sampling digital video signals can be described with a series of numbers. Popular choices include 4:4:4, 4:2:2, 4:1:1, and 4:2:0. These numbers describe the sampling rate for the conversion to digital video. A rate of 4:4:4 (see Figure 4.11) means the luminance and each color difference signal are sampled the same number of times per second, around 14 million. On each line of the video, for every four samples of luminance, there are four samples for each color difference channel. The 4:2:2 scheme (see Figure 4.12) means that for every four samples of luminance information, there are only two samples of each of the color difference channels. This means that there is far less information to handle. However, the sample may not be as reliable as a 4:4:4 sample. The 4:1:1 (see Figure 4.13) rate provides only one sample of each of the color difference channels.

The 4:2:0 rate (see Figure 4.14) is a current option used for the AVCHD format. This does not mean that only one color difference channel is sampled. With 4:2:0, each color difference channel is sampled on every other line of

Line 1	Y Cr Cb	Y Cr Cb	Y Cr Cb	Y Cr Cb	Y Cr Cb	Y Cr Cb	Y Cr Cb	Y Cr Cb
Line 2	Y Cr Cb	Y Cr Cb	Y Cr Cb	Y Cr Cb	Y Cr Cb	Y Cr Cb	Y Cr Cb	Y Cr Cb

© Cengage Learning

FIGURE 4.11

The 4:4:4 sampling scheme. Cr is the Red minus luminance color difference signal, and Cb is the Blue minus luminance color difference signal. For every sample of the luminance signal, there is a sample for each color difference signal.

Line 1	Y Cr Cb	Y	Y Cr Cb	Y	Y Cr Cb	Y	Y Cr Cb	Y
Line 2	Y Cr Cb	Y	Y Cr Cb	Y	Y Cr Cb	Y	Y Cr Cb	Y

© Cengage Learning

FIGURE 4.12

The 4:2:2 sampling scheme. Cr is the Red minus luminance color difference signal, and Cb is the Blue minus luminance color difference signal. For every four luminance samples, there are two samples of the color difference channels.

Line 1	Y Cr Cb	Y	Y	Y	Y Cr Cb	Y	Y	Y
Line 2	Y Cr Cb	Y	Y	Y	Y Cr Cb	Y	Y	Y

© Cengage Learning

FIGURE 4.13

The 4:1:1 sampling scheme. Cr is the Red minus luminance color difference signal, and Cb is the Blue minus luminance color difference signal. For every four samples of the luminance signal, there is one sample of each color difference channel.

Line 1	Y Cr	Y	Y Cr	Y	Y Cr	Y	Y Cr	Y
Line 2	Y Cb	Y	Y Cb	Y	Y Cb	Y	Y Cb	Y

© Cengage Learning

FIGURE 4.14

The 4:2:0 sampling scheme. Cr is the Red minus luminance color difference signal, and Cb is the Blue minus luminance color difference signal. Rather than no sampling of one color difference channel, this scheme merely samples each color difference channel on every other line.

video. For example, in line 1, perhaps the Cr channel is sampled. In line 2, the Cb channel would then be sampled. There are two color samples for every four luminance samples. These systems with reduced color information work because the human brain is much more receptive to changes in the luminance information than in the chrominance information. It also means, though, that this recording format is less accurate than others.

Having a grasp of the sample rates of different digital formats can be important during production. For example, if you are shooting a chroma key shot (detailed in Chapter 7), the recording format has an impact on the quality of the final shot. A **chroma key** is an electronic effect in which a specific image replaces a colored background in a shot. The result is a combination of a foreground shot and a background shot. Typically in post production, the color background is removed and replaced with new video or graphics. A good example of this effect is the weather during your local newscast. The weather person is not standing in front of those maps and other graphics you see. The weather person is standing in front of a blue or green screen and electronic graphics fill in where the background color was. The most critical information in creating the effect is the color. A recording format that has fewer samples of the color difference channels, such as 4:1:1, will make it more difficult to create the chroma key. However, using a format that can record a 4:2:2 signal means the editor will have twice as much color information to efficiently create the chroma key effect.

Other Acquisition Technology

Digital Cinema A growing trend in the feature film industry is to create movies using digital technology from acquisition to movie theatre projection. *Slumdog Millionare* was the first digital cinema work to win an Academy Award for best picture. Though the process is digital, the look of traditional film production is retained. Unlike traditional video cameras, resolution for digital cinema cameras (Figure 4.15) is measured in terms of the number of horizontal pixels in the image. Resolution standards are 2K and 4K. This means that an image is either 2048 or 4096 pixels wide. Another characteristic of 2K and 4K production is the ability to crop the vertical dimension of the image for different aspect ratios.

While not all digital cinema cameras shoot at these high resolutions, they offer features used in the film industry, such as the ability to change lenses, add film-style rigs, and mimic the production techniques developed for the film industry. A **rig** is a device used to mount or hold a camera, such as a shoulder mount or a jib arm. (Alternative mounts are discussed in Chapter 5). Some digital cinema cameras, like the Red, use sensors that are 5120 by 2700. Using these cameras can be difficult to manage because of the enormous file sizes generated while shooting.

DSLR Using a Digital Single Lens Reflex camera to shoot video is a way to combine the look of digital cinema cameras. DSLR cameras were traditionally used for still photography but have become attractive, low-cost alternatives for independent filmmakers trying to achieve the cinema look (Figure 4.16). Interchangeable lenses and a single large image sensor allow for shallow depth of field (discussed Chapter 5), rich colors, and increased contrast. One of the drawbacks to working with DSLRs is the audio. These issues are discussed in Chapter 6.

FIGURE 4.15

This digital cinema camera shoots at a resolution of 2.5K. Notice that some metadata has already been entered for the upcoming shot.

SOURCE: Courtesy of Blackmagic Design

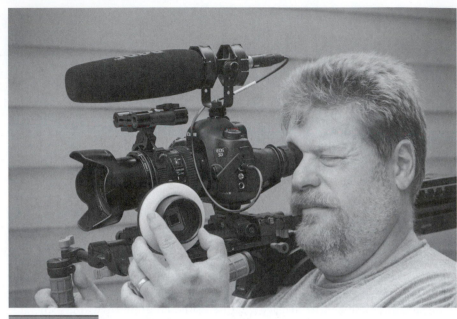

FIGURE 4.16

A Digital Single Lens Reflex or DSLR provides an alternative to filmmakers looking to achieve the same look that digital cinema provides.

STORY 4.1 Stereoscopic 3D Acquisition

Producing a stereoscopic 3D movie is a little more complicated than merely bolting a second camera to the tripod. Technically, a stereoscopic 3D movie is actually two nearly identical flat 2D movies presented at the same time. Stereoscopic 3D must be planned and produced with an understanding of what makes a 3D movie work. Having a crew that is 3D aware and a trained stereographer on the set goes a long way toward making a technically good stereoscopic 3D movie. Of course, a bad movie will always be a bad movie, regardless of whether it's in 3D or 2D.

Stereopsis is what happens in the brain when most people look at the world around them. We perceive the world in stereoscopic 3D because we have two eyes about 65mm apart that each view the world from a slightly different perspective. This difference in perspective is analyzed as horizontal disparity via a process defined as stereopsis by Sir Charles Wheatstone in the mid 1830s.

A stereoscopic 3D camera rig allows the filmmaker to capture digital images from two slightly different perspectives (just like your eyes) and record the two 2D video streams that will be edited into a 3D movie. Stereoscopic 3D camera rigs come in three basic configurations: dual-camera beamsplitter rigs, dual-camera side-by-side rigs, and unibody cameras. Each type has certain advantages and disadvantages that help the filmmaker achieve his or her vision for the movie. Currently, the beamsplitter design is the most used configuration due to its versatility (Figure 4.17).

The 3D camera rig records two synchronized video streams. It is critical that the recordings be in temporal phase, meaning that both sensors are capturing the scene at exactly the same time and the recorders are recording the imagery at exactly the same time.

Once the stereography (3D photography) is complete, the production will have two nearly identical sets of raw recordings to store, transport, edit, grade, render, and deliver.

SOURCE: Chris Eller, Team Lead, Advanced Visualization Lab

FIGURE 4.17

The 3D rig in use on location. The rig weighs about 42 pounds. This is an underslung beam splitter configuration with the right camera on top and the left camera underneath.

SOURCE: Photo Courtesy Chris Eller

STORING THE IMAGE

Once images have been created and encoded, they are stored for editing, viewing, or archiving. It is common for today's cameras to include a built-in or docked recording device, hence the name **camcorder**, a camera and recorder in one unit.

Storage Options

During shooting, media is recorded and stored on an internal or external device. While older camcorders may use tape, today's cameras use one of a number of tapeless options.

Memory Cards A growing number of cameras use either secure digital (SD) or compact flash (CF) cards to record media (Figure 4.18). When using this type of storage, it is important to ensure that your cards have sufficient write speed to handle the demands of video. Many manufacturers require a class 10 or higher

STORY 4.2 The King Is Dead

The first 20 years of my career in video production I pledged my allegiance to one king, videotape.

The entire infrastructure of television was built around tape. Tape was the way to shoot, view, edit, master, duplicate, deliver, transmit, and archive video production.

As computers got faster and storage capacity increased, the ability to deliver final video from an edit suite using disk-based computer editing systems became more viable. My producers used to scoff at video compression, questioning any and all compression even after digital resolutions matched and then surpassed those of videotape.

Storage capabilities have gone from megabytes to gigabytes to terabytes and they keep expanding toward "what's-next-a-bytes." Cameras, which once recorded to film and tape, now record to disks and cards. Control rooms in television stations, which once relied solely on tape machines, now playback content from streaming servers.

Trust in tape and skepticism in computer files has now inverted. Producers now favor the speed, cost, and flexibility of hard drives and servers over videotape. Where videotape was once viewed as reliable, robust, and enduring, it is now viewed as rigid, clunky, and outdated.

So the question arises, has the era of videotape come and gone? Cameras no longer shoot to tape, editors no longer edit with tape, and now television stations are playing back not from tape but files. Changing the infrastructure of an entire industry has taken many years. Videotape carried the industry for decades. But as its use and usefulness diminishes, videotape will take its place with other technologies that once served a great purpose, only to be displaced by better technology that inevitably comes along. "The king is dead, long live the king."

SOURCE: Jon Dilling, Editor

speed card. Class 10 means that the card is capable of writing data at 10 megabytes per second. Once the material has been shot, the media can be copied to the computer and used with the nonlinear editing software. This can be a slow process depending on the connection method and type of card. Although this

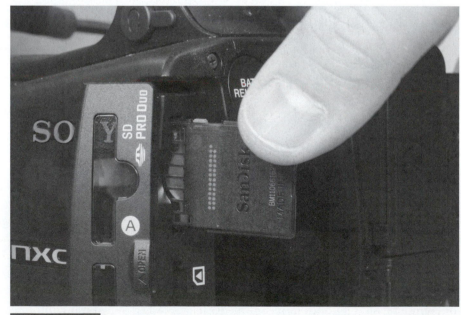

FIGURE 4.18

Flash memory, like the SD card shown here, is a popular choice for tapeless recording.

topic is covered in Chapter 9, it is worth mentioning that having a backup for each card is a critical step in the production process.

An early professional version of a memory card recording system is Panasonic's P2 recording technology (Figure 4.19), which uses a PCMCIA card. A **PCMCIA** card is a credit card–sized computer card commonly used to expand the capabilities of many laptop computers. Recording times vary depending on card capacity, compression settings, and data rates. One of the unique features of flash memory is that it is a **solid state** device with no mechanical moving parts and should provide excellent durability and reliability. In addition, because there are multiple slots in the cameras and decks, you can redundantly record or continuously record from one card to the other. As cards fill up, you can remove them and immediately replace them with another card. Cards are said to be "hot swappable" because you do not need to stop the recording to insert or remove cards.

© 2014 Mark Mosrie, Cengage Learning

FIGURE 4.19

The P2 system uses flash memory on a credit card-sized device to record video and other data.

Hard Drives Hard drives offer another tapeless option. Hard drives provide high transfer rates so that material can transfer quickly to and from the drive. Depending on drive size and compression settings, they can store as much as several hours of video and audio material. Like memory cards, the media must be copied to another location before deleting the files for the next project. Many hard drives have multiple methods for transferring material, including

Thunderbolt, **Firewire** (IEEE 1394), and **USB** (Universal Serial Bus). In saddition, some drives have an Ethernet connection. While some drives are self-contained, others include a housing that saves cost as they allow raw drives to be inserted as needed. Hard drives can be either solid state (Figure 4.20) or traditional spinning platter design.

FIGURE 4.20

This unit enables recording on a solid state hard drive. There are connections for the camera on the back. The slot accepts 2.5-inch drives. It can also mount on your tripod.

SOURCE: Courtesy of Blackmagic Design

Another advantage of a hard drive system is the ability to transcode the material in real time. Transcoding is the conversion of a digital file to another format. DSLRs are a good example since they record video in a proprietary format. This requires the use of additional software inside the nonlinear editor to transcode the clips so they are recognizable in your editing software. Since transcoding every clip can be time consuming, many hard drive manufacturers have units that will transcode from the proprietary format into a common file format such as Apple Pro Res or Avid DNxHD (Figure 4.21). This workflow is also useful with 2K and 4K production work. (Chapter 9 covers this topic in detail.)

FIGURE 4.21

This recording unit has numerous connections for the camera, audio, and computer. The slots on top are for solid state hard drives. In addition to recording, this unit can transcode the media for greater efficiency in editing.

SOURCE: Courtesy of AJA Video Systems

Optical Disk XDCAM, a Sony format, is a system that uses an optical disc to record images and sounds. An **optical disc** looks like a CD or DVD, but has a greater storage capacity. Using blue laser technology, an optical disc can hold up to 50 gigabytes (GB) of data, depending on user-chosen compression, data rate, and format.

Recording with tapeless media enables other beneficial features for the videographer. Those features include metadata, proxies, and caching.

Metadata

Metadata is best described as "data about data." It is not the data itself but information about that data. DSLR production provides a good example. The metadata for a DSLR shot could include the aperture, the shutter, the ISO, the focal length of the lens, and even the camera model (see Figure 4.22). In addition, the data wrangler could add metadata such as the location of the shoot or specific camera settings. A few different standards are used to format the metadata. The Advanced Authoring Format (AAF) is a multimedia format that aims to provide a seamless exchange of digital data. For example, there may be technical problems if you begin editing on one brand of nonlinear editor and then switch to

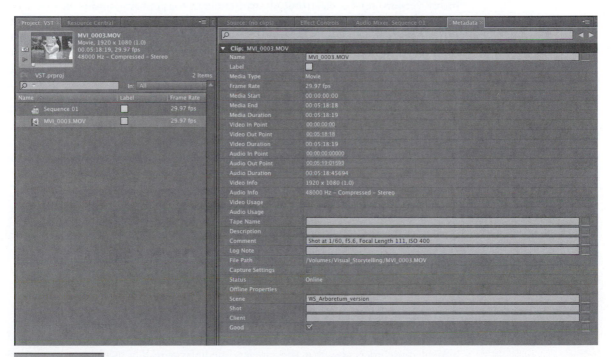

FIGURE 4.22

DSLR metadata includes information about camera specific settings, such as focal length, color temperature, gain and ISO. These settings, along with video specific settings, provide important information that may be useful for future acquisition or during editing.

SOURCE: Courtesy of author, Joe Hinshaw.

another brand. AAF metadata can eliminate these potential problems and make the switch seamless. Another standard is the Material Exchange Format (MXF). MXF is a file format for the exchange of program information between different servers, archives, and other sources of information. MXF files may contain a completed program or different parts of a program. The MXF format mixes video, audio, and program data all together in what is called "essence." Increasingly, manufacturers have camcorder settings that allow a videographer to record in the MXF format. This feature allows for additional flexibility in post production.

Proxies

Storage of digital media can be a significant expense for video professionals. **Proxies** are low-resolution versions of your video clips that occupy substantially less storage space than the high-resolution versions. With some systems, you can record a low-resolution proxy that is stored along with the higher-resolution images. When you load the low-resolution proxy into your nonlinear editor, it occupies significantly less storage space than its higher-resolution counterpart. Similar to a traditional offline/online edit workflow, an editor can create a proxy version, send it electronically to the client for approval, and then load the higher-resolution clips to complete the project. This process is particularly appealing for post production houses that deal with a number of clients and go through many rounds of revision before finalizing a project.

Caching

With a **caching** feature, the camera is constantly caching or storing video data. Although the caching is continually happening, the recorded files will contain approximately 10 seconds prior to when the record button is pressed. At a press conference, for example, a camera operator likes to begin rolling tape when the participant enters the room. It can be tricky if there is no announcement of when that person will enter. With caching, you can roll when you see the person and know you will have recorded the previous 10 seconds, which should be enough to get the entire entrance into the room.

Hybrid recording

The current practice of shooting tapeless was preceded by a hybrid system offered by many camera manufacturers. The hybrid systems allowed redundant recording on tape and some form of memory card. An advantage to these transitional camcorders was that the tapeless media was readily available for editing and the tape backup could be stored for archival or backup purposes.

Videotape Long before tapeless options were common in the industry, most camcorders recorded on some type of videotape in either an analog or

a digital format. Table 4.3 reviews the major analog tape formats. Table 4.4 reviews digital tape formats. Though some of these formats are not appropriate for field recording, they are included in the table for purposes of comparison. Although the use of tapeless recording is dominant in the industry, there are facilities that have not yet converted to these newer methods, especially in their archives. It is likely that you will encounter a tape format at some point in your career.

TABLE 4.3 Selected Analog Tape Formats

Format	Year	Signal	Comment
2-inch Quadruplex	1956	Composite	First successful format
¾-inch Umatic	1970	Composite	Revolutionized TV news
1-inch Type C	1976	Composite high-end reel-to-reel format	
VHS	1976	Composite	Video Home System revolutionized home viewing
Betacam	1982	Component	½-inch cassette format
MII	1985	Component	Lower-priced alternative to Betacam
S-VHS	1987	Y/C	Separates luminance and chrominance
HI-8	1989	Y/C	8-millimeter cassette

© Cengage Learning

TABLE 4.4 Selected Digital Tape Formats

Format	Signal	Sample rate
D1	Component	4:2:2
D2	Composite	4FSC
D3	Composite	4FSC
D5	Component	4:2:2
Digital Betacam	Component	4:2:2
DV	Component	4:1:1
DVCPro	Component	4:1:1
DVCam	Component	4:1:1
DVCPro 50	Component	4:2:2
HDV	Component	4:2:0
XDCAM EX	Component	4:2:0
HDCam	Component	4:2:2

© Cengage Learning

STORY 4.3 What a Difference a Decade Makes

When I first started out as a freelance tape operator for sporting events, my first assignment was to operate a one-inch videotape deck by hand. I would record a given camera angle, and when the time came for the all-important replay, I was instructed to "wait a beat" after stopping the record mode before rewinding. If I didn't, the tape went into auto-shutdown mode and took at least 6 seconds to restart. It didn't take the producer that long to express displeasure when that happened.

If you wanted half-time highlights, you had to wait until the end of the half to give the tape operators time to rewind the tapes, find the four plays (two for each team), and then assemble them onto a separate reel.

That was then. This is now.

The "tape" room now relies most heavily on hard-disc-based recording. The advent of these drives has truly revolutionized the playback of all elements within sports production. These boxes have a minimum of two record channels, or trains, and quite often four. My first experience operating this technology was for NASCAR's Coca-Cola 600 in Charlotte, North Carolina. No less than six of these units were on the truck. And all of them were on a common Ethernet network. Now, any moment from the event could be instantly replayed.

Two of the operators were responsible for assembling montages as the race progressed. With the network in place, they could search any drive and pull clips to use in their packages. If I had a particularly good shot I knew they could use, I could "push" that clip to their machine. It was truly amazing how the events of the game could be chronicled fully and instantly, greatly enhancing the ability of the producer and director to tell the story of the event.

There are still plenty of tape machines in sports trucks, but the handwriting is on the wall for all tape operators. Embrace the new technology or get left behind.

SOURCE: John Hodges, Freelance Videotape Operator

CONCLUSION

This chapter has reviewed technical issues related to production in today's world. In addition, it has explained how a video camera converts light into electrical energy. This very fundamental principle of physics underlies the creation of most of the pictures and sounds in video production. Having a good understanding of this process, as well as encoding, color theory, and recording options will enhance your aesthetic abilities when shooting in the field. Once you have a thorough comprehension of the video equipment and how it functions, you will have an easier time utilizing your creative energies to focus on storytelling.

Story Challenge: Technical Issues

The link between the technology of how video works and the storytelling needs of the director and Pick 2 Productions regarding the three videos may not be obvious. However, an understanding of imaging and recording technology can inform the choice of equipment for the productions. A key decision that the director made was to use a recording format that samples color at a higher rate. That allowed the post production on the historical documentary to go much more smoothly. The higher color sampling made it much easier to achieve a clean chroma key for the interview segments in that piece. In addition, the decision to use a tapeless alternative was very wise for several reasons. It saved time in

the editing of all the pieces. The director was able to create rough-cut edits very quickly using the low-resolution proxy recordings. In addition, after creatively manipulating the camera settings, the videographer was able to save those settings as part of the metadata with each recording. This enabled the videographer to accurately re-create those same settings and provide a uniform look to all the elements of the three productions.

CHAPTER 5

Composition

The camera makes everyone a tourist in other people's reality, and eventually in one's own.

SUSAN SONTAG, AUTHOR

OVERVIEW

Now that you have a solid understanding of how a camera converts light into pictures, we can shift our focus to the content of images. In this chapter, we will examine techniques, elements, and rules of composition. The decision of what to include and exclude from every shot is an important one. The information in this chapter will help guide you through that process. We will begin by examining some of the elements you read about in Chapter 4, this time from a content perspective. We will also review various elements of composition—items that videographers must account for when framing shots. Afterward, we will discuss some common rules of composition used in video production. Finally, we will examine dynamic composition, which accounts for movement in the frame.

Creating and capturing good images requires a combination of skills. A videographer needs to have a good photographic eye as well as the ability to manipulate the various camera and lens controls to bring about the desired visualization of a particular shot or scene. It also helps to have good timing to make sure that you are in the right place at the right time to capture the perfect shot. It does not hurt to be a little lucky as well. Understanding the elements and rules of composition will help train your eye. After reading this chapter, you should practice with your equipment to increase your knowledge of the camera controls so that you can use them to achieve the look you want, rather than allowing the controls to dictate how the shot will appear. Finally, getting experience will improve your timing and make it possible to create your own aesthetic.

Story Challenge: Composition and Visualization

This is the stage where an understanding of the technology and functions of the camera provides the knowledge required to create the visuals that will tell the story in the most compelling way. For the three videos that Pick 2 Productions is producing, several compositional issues must be considered before shooting:

- What techniques can be used to manipulate depth of field during both the music video and the documentary to keep the audience engaged?
- What strategies will be used to shoot effective sequences for the documentary and music video?
- What composition rules must be strictly followed and which ones can be broken to aid the storytelling process?
- What camera mounting devices will be most helpful during the production of the live concert?

The information in this chapter will help answer these questions and will provide a basis for basic shots and rules of composition.

Composition and Storytelling

The lens is a critical part of the camera. The optics of the lens have the most significant impact on the quality of your images. The lens controls of focus, zoom, and iris (see Figure 5.1) are responsible for helping you frame the shots the way that you want them to look. For example, do you want the background in a shot to be in focus or blurred? Do you want to shift the emphasis from the background to the foreground in the middle of the shot? These sorts of decisions are important to the practice of telling good visual stories, and skilled operators can use these controls to shape the story for viewers. Perhaps the most important decision that you face when you shoot is where to place the camera and tripod. Opting for the easiest or most convenient spot may not yield the best results, since camera placement has a huge impact on shot framing. Depending on placement, the lens may need to be zoomed one way or another and the resulting shot may communicate different meanings than intended. Think carefully about camera placement, and make decisions based on storytelling and content rather than ease and convenience.

LENS FUNCTIONS

Noticeable differences exist between professional lenses and lenses for consumer cameras. The single biggest difference is the quality of the optics, or the glass, used to make the lens. A more noticeable difference is the myriad numbers stamped on the outside of the professional lens. These numbers are not found on most consumer lenses. Professional lenses also allow precise manual control over lens attributes that are necessary for professional production. In this chapter,

FIGURE 5.1

The professional lens allows the videographer to manually adjust the focus, focal length, and aperture.

we will be explaining the main functions of focus, aperture, and focal length of a professional lens (as shown in Figure 5.1).

Focus

Every scene has a central object or subject that must be in focus. Such an object or person is often known as the **point of critical focus** in the scene. The focus ring on a professional camera has a series of numbers (see Figure 5.1). When the focus ring is on a particular number, say 8 feet, any object 8 feet away from the lens will be in focus. To properly focus a shot with a professional camera, zoom all the way in until the lens will not zoom anymore. Now, focus the shot by turning the focus ring until the image appears sharp in the viewfinder. If you are focusing on a person, focus on their eyes. The focus must be readjusted if the camera position changes or the talent moves in the scene. This procedure may seem more complicated and difficult than simply using an auto-focus, but professionals prefer this method. An auto-focus lens is always searching for the sharpest focus. Any slight movement in the scene could cause the focus to change. Because the mechanism for manual focusing on a professional lens is more precise, camera operators must pay close attention to the scene while shooting.

Imagine shooting an interview for the alternative fuel documentary. There is a street in the background of the shot, and as cars drive past, the auto-focus shifts to the cars, causing the interview subject to lose focus momentarily. If the lens has both a manual and auto-focus mechanism, the videographer can use

auto-focus to set the shot up and switch to manual after the focus has been set. Another reason manual focus is preferred is that it allows the camera operator to make subtle adjustments more quickly and smoothly.

Because focus is based on the distance of the desired object to the front of lens, it is possible to use a tape measure to determine where the focus should be at any point in the shot. Consider the host in a reality program walking through his home and stopping occasionally to talk about his big screen TV, bedroom suite, and garage. Through preproduction blocking, the talent can be staged to stop at a specific distance each time. These distances can be measured and marked ahead of time. **Blocking** is a procedure in which the director, videographer, and other relevant personnel resolve camera positions, movement in the frame, and other issues prior to shooting a scene. During the shot, the videographer—or another person known as a **focus puller**—can ensure that the numbers on the focus ring are matched up to the measurements at the specific points. At each critical juncture in the shot, the person would be in sharp focus.

Another operational characteristic of the focus control on a lens is the minimum distance for an object to be in focus. All lenses have a minimal focus distance and objects must be at least this distance in order to get a sharp focus. That distance is generally 3 to 4 feet. If something is closer to the lens than that minimum distance, the lens will not be able to focus on it. Some lenses include an optical device known as a **macro lens** that allows focus on objects closer than the minimum distance.

On consumer lenses, there are no numbers for focus and sometimes not even a focus ring. Often there is a knob on the side of the camera that allows you to change the focus. Regardless of whether you have a knob control or an actual ring, there are no positive stops at either end of the focus range. On a professional lens, you can only turn the focus ring so far in a given direction. On the consumer, a slip ring is associated with the focus mechanism, which allows the external adjuster to continue turning endlessly. You may or may not be moving the focusing mechanism inside the lens, but the manual adjustment continues to turn.

Because of the increased resolution of HD video, focusing is even more critical. Many HD cameras have a **focus assist** system. These systems help the videographer more easily achieve critical focus. One system will slightly enlarge a portion of the image in the viewfinder to make it easier to focus. Other methods provide an overlay that outlines the principle portions in the frame. This outline makes it easier for the operator to focus the camera. With cameras that have color viewfinders, the focus assist will also turn the color image to black and white. Because all of the information a videographer needs to focus an image is contained in the luminance portion of the image, this viewfinder conversion is helpful when shooting in high definition.

Iris

The **iris** is the device that controls the amount of light entering the camera (see Figure 5.2). On a professional lens, the iris is a mechanical device composed of a set of metal blades that the videographer can open and close to dictate the

Front view of aperture

f/2 f/16

© Cengage Learning

The iris is the set of metal blades that open or close to change the size of the aperture, thus allowing more or less light to enter the camera.

amount of light that is allowed to enter the camera. On most consumer lenses, the iris is an electronic adjustment. The electronics in the camera, rather than metal blades, change the amount of light let in through the camera. Regardless of the mechanism, the opening that allows the light through the lens is called an **aperture**.

An **f-stop** is the number used to indicate how much light is coming through the aperture. Some typical f-stop numbers are f/2.8, f/4, f/5.6, f/8, f/11, and f/16. Higher numbers like f/16 indicate a smaller opening and less light entering the camera. When you move from a large number (f/16) to a smaller number (f/11), you are opening up the iris. That is, you are creating a larger opening for light to pass through. The change in the amount of light allowed to enter the camera is an exponential change. Each time you open the iris one stop, you double the amount of light passing through the lens. Opening up four stops on the iris does not amount to eight times more light. Rather, it amounts to 2 × 2 × 2 × 2, or 16 times more light coming through the lens. Closing down the iris is the opposite of opening it up and results in the same exponential decrease in the amount of light coming in. The f/stop numbers indicated here come from professional lenses that use the mechanical device of metal blades to form the aperture.

Most lenses allow for automatic and manual control of the iris. In the auto position, this control will automatically adjust the iris for changing lighting conditions. It does this by averaging the amount of light in the entire frame and adjusting accordingly. One advantage of the automatic control is that it is possible to achieve proper exposure in a variety of lighting conditions. Professionals might use an automatic iris to set up the initial exposure level and then switch to

a manual iris. Like auto-focus, automatic iris controls can be easily fooled. If the sun goes in and out of the clouds, or if you are shooting a scene in which a white vehicle moves through the background of the shot, you will see changes in the automatic iris setting, changes that can distract the viewer.

Another method used to manually calibrate aperture settings is a waveform monitor or the camera's zebra function. A **waveform monitor** (see Figure 5.3) shows an electronic representation of the video image. It is used to determine if the video meets legal broadcast specifications. A digital waveform monitor shows active video on a scale that goes from 0 to 700 hundred millivolts (or .7). When viewing the luminance signal of the video, the brightest parts should not exceed the .7 mark, and the darkest parts should not go below 0. The scale on an analog waveform goes from 0 to 100. The bright parts of the image should not exceed 100, while the darkest parts of the image should not dip below 7.5. Although portable waveform monitors are available for field use, it is not a common practice to use one because of their expense and the burden of carrying additional equipment. Some higher-end cameras have built-in waveform monitors, an others may provide a histogram for checking brightness levels. A **histogram** is a graphical representation of the brightness in an image (Figure 5.4). Most professional cameras also have a function called zebras that helps with exposure

Related Interactive Module

Exposure > Waveform Monitor

Related Interactive Module

Exposure > Histogram

FIGURE 5.3

This multi-monitor can create several displays. The lower right display shows a waveform representation of the color bars displayed above. The brightest parts of the image should not exceed the .7 mark, and the darkest parts should not go below 0.

SOURCE: Courtesy of Leader Instruments.

FIGURE 5.4

The histogram is another way to check the luminance values in your image. The higher the graph, the more pixels in the image at that particular value.

control. **Zebras** are a diagonal overlay that can be displayed in the viewfinder when the image you are shooting is brighter than a preset waveform level. Cameras equipped with a zebra function have a switch to select the level at which the zebras will appear. Typically, these switches can be set at increments between 60 and 100 percent. Adjusting the exposure is a subjective action for the videographer, but the government has set legal limits for the video level. In addition, videographers want to avoid over- or under-exposed images. There is no universal rule for how a videographer should use zebras, but there are some general guidelines. With a setting of 100 percent, adjust the exposure until the zebras disappear. Another method is to use a lower number, like 70 percent, and try to adjust the exposure on a person's face so that the zebras begin to appear.

Related Interactive Module	CENGAGE brain .com
	Exposure > Zebras

Related Interactive Module	CENGAGE brain .com
	Exposure

Focal Length

Measured in millimeters, **focal length** is the distance between the optical center of the lens to the plane where the image is focused, or the target (see Figure 5.5). The zoom control changes the focal length. A long focal length has a narrow field of view with large magnification, and is referred to as a "telephoto lens." A telephoto lens is characterized by larger numbers such as 90 or 120 millimeters. A short focal length has the opposite attributes and is called a wide-angle lens. The focal length for a wide-angle lens would be a smaller number, like 7.5 millimeters. Video cameras usually have a variable focal length, or a zoom lens that can be set for any focal length within its range. While zoom lenses are widely used, some productions rely on **prime**, or fixed focal-length, lenses. A prime

Optical Center

Target

Millimeters

© Cengage Learning

FIGURE 5.5

Focal length is the distance from the optical center, or node, of a lens to the image target. It is measured in millimeters. Longer focal lengths produce narrow-angle telephoto shots, while shorter focal lengths produce wide-angle shots.

lens does not have an adjustable focal length capability, so zooming is not a possibility. A director may select a prime lens like a long telephoto or super wide-angle lens because of its specialized application. In addition, some directors believe that a prime lens delivers more predictable results than zoom lenses.

STORY 5.1 The Limitations of Auto Iris

I was once asked to tape the announcement of a new college basketball coach. This always seems to be a "big deal" in the life of a university, and the Sports Information Office was doing everything it could think of to make the announcement dramatic. The event was taking place on a stage in an auditorium. On the stage were three individuals seated in chairs and a podium that was center stage. The auditorium was dark except for strong back lights on the three individuals in the chairs on stage. The audience knew people were on stage, it just didn't know who they were. This certainly added to the anticipation of "who's the new coach" but all the darkness made the exposure from the auto-iris worthless. I had to manually close the iris to get the proper exposure for the back lights.

Finally, one of the silhouetted figures walked to the podium. A very bright follow-spot from the back of the

auditorium suddenly lit up the face of the standing speaker. He squinted uncomfortably into the light and the auto-iris on my lens bounced as it tried to adjust to the extreme conditions. When the lens finally settled, my shot was still overexposed. I couldn't zoom in enough to fill my shot with the face of the athletic director. This would have eliminated the black background and allowed the auto-iris to give me a better exposure. Once again, I had to manually adjust the lens.

It is important to remember that the exposure you get from your auto-iris is an overall average of the light coming into your camera. Extreme conditions of light and dark in the same scene will have an adverse effect on your exposure, no matter how dramatic they may seem.

SOURCE: Ron Prickel, Videographer

Focal length adjustments can have an important impact in a scene. A medium shot of a subject from 6 feet away will be significantly different from the same medium shot of that subject from 20 feet away. Examine the medium shots in Figures 5.6A and 5.6B. Figure 5.6A was composed using a wide-angle lens, while Figure 5.6B was composed using a telephoto lens. Compare how much of the background you can see in the two shots. These shots were created by using the zoom control to change the focal length and by changing the distance between the camera and the object. While the medium shot composition is quite similar, they are really two very different shots. Long focal-length shots compress the background. In other words, they appear to show less of the background than the same shot would show if it were done with the camera closer to the subject and a shorter focal length.

Depth of Field

When I watch a film, I don't really want to notice the depth of field. I would hope the story and the craft of the film would be a little bit more engaging than that.

JAMES LONGLEY, TWO-TIME ACADEMY AWARD NOMINEE

Once you have mastered each of these functions (focus, iris, focal length) individually, you can begin exploring how the manipulation of each factor in combination with the other factors can be used to compose the type of shots you want. One of the most important concepts that relates to these factors is **depth of field**. Depth of field is the range of distance over which objects in a picture will remain in critical focus. The standard terms to characterize depth of

Related Interactive Module

CENGAGE brain .com

Depth of Field

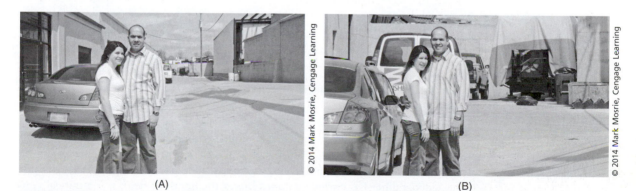

(A) (B)

© 2014 Mark Mosrie, Cengage Learning

FIGURE 5.6

(A) Contrast this image with the one in image B. Although the framing on the couple is the same, the amount of information in the background of the image is much greater in this shot. It was composed with a shorter focal length and the camera closer to the couple than the image in B. (B) Notice that even though the framing of the couple is nearly the same, there is far less background information in this image. This shot was composed with a long focal length, which appears to compress the background.

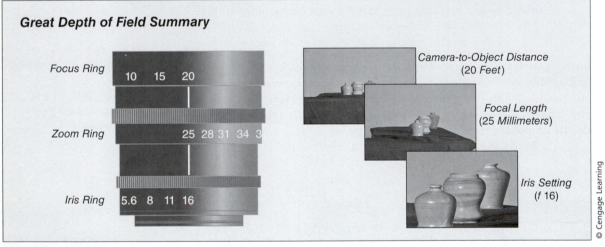

Shallow Depth of Field Summary

Focus Ring 5 7 10

Zoom Ring 25 50 75 90

Iris Ring 2 2.8 4 5.6

Camera-to-Object Distance
(4 Feet)

Focal Length
(102 Millimeters)

Iris Setting
(f 2)

Great Depth of Field Summary

Focus Ring 10 15 20

Zoom Ring 25 28 31 34 3

Iris Ring 5.6 8 11 16

Camera-to-Object Distance
(20 Feet)

Focal Length
(25 Millimeters)

Iris Setting
(f 16)

© Cengage Learning

FIGURE 5.7

The videographer can manipulate iris, focal length, and the camera-to-object distance to achieve either a shallow or a great depth of field in the frame.

field are shallow (where there is not a long range of objects in focus) and great (where there is a long range of objects in focus). Depth of field is affected by iris or aperture, focal length and camera-to-object distance (see Figure 5.7). Because the videographer has complete control over the depth of field, it is a critical concept to understand. Manipulating the depth of field for any shot can communicate dramatically different feelings. Consider Figures 5.8A and 5.8B. In one shot (see Figure 5.8A), the background is out of focus and the viewer's attention is on the person. The other shot (see Figure 5.8B), has a greater depth of field because both the subject and the background are in focus, suggesting that there may be something of interest in the background.

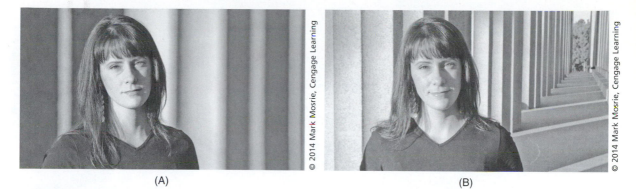

(A) (B)

FIGURE 5.8

(A) Notice how the shallow depth of field in this image draws the attention to the person in the frame rather than the background. Contrast this image with the one in image B. (B) Notice that the great depth of field in this image focuses the audience's attention on both the person and the background.

Aperture As the iris closes, you get a greater depth of field. An f/stop of 16 would have a great depth of field, while 2.8 would yield a shallow depth of field.

Focal Length A wide angle or short focal length provides a greater depth of field. A setting of 7.5 millimeters has great depth, while 90 millimeters, or a telephoto shot, has shallow depth.

Camera-to-Subject Distance The farther away the camera is from the subject, the greater the depth of field.

Depth of Field in the Story

If the lens is the most important part of composition from an equipment perspective, the placement of the camera in the scene is the most important aesthetic decision in composition. Regardless of whether a production location survey was conducted or a storyboard was drawn, it is imperative that the camera be positioned for the best composition. Although a shot of the talent can be composed regardless of camera placement, the focal length to achieve that shot can change everything else in the frame. Depth of field (as shown in Figures 5.9A and 5.9B) and compression of the background can be dramatically different, and the results might not be what you had in mind. Understanding and learning to manipulate depth of field can greatly enhance your images and will have an impact on your story.

During preproduction, the director for Pick 2 Productions conducted preinterviews. One subject was so passionate about the topic that every word she said drew viewers into the story. The director suggested to the videographer that she

(A) (B)

FIGURE 5.9

(A) In this image, the great depth of field allows the viewer to focus on all the bottles in the frame. The hand helps guide the viewer to one bottle, but the depth of field suggests that all elements of the frame are important. Contrast this image with the one in B. (B) The combination of the hand and the shallow depth of field really draw the viewer's attention to one particular bottle.

STORY 5.2 Camera Placement Is Everything

Most of the interviews I shoot do not take place in a studio, so setting up on location can become an activity of troubleshooting: identifying the problems and finding a solution.

On a recent shoot, we were asked to interview an executive that would be included in the company's corporate image video. Most of the time, people think that the "exec" will give their words of wisdom while sitting behind an impressive desk. While this may be good for the executive's image (or ego), it can be a real bottleneck for the production schedule. The challenge comes from trying to "dress the set" so the elements that show up in the frame next to, and behind, the exec aren't distracting to the viewer. Trying to arrange all the items to the satisfaction of

the exec (or more often, their assistants) can become a time-consuming exercise.

My solution to this was to have the exec sit casually on the front edge of the desk and move the camera as far back as possible, then zoom in to get the composition. By increasing focal length, I narrowed the depth of field so the background went soft. This puts the viewer's attention squarely on the subject without any distractions in the background. The set-up time gets reduced, too….In fact, all the small details get blurred out and you have a much smaller area behind the exec to deal with.

SOURCE: Gary Stone, Director/Videographer

use a very shallow depth of field during her interview. This would help focus the audience's attention on the speaker and what she was saying, rather than on anything else in the frame. The director also needed to be mindful of how the use of this technique would contrast with other interviews in the documentary.

Lens Attachments

A camera attachment that can provide additional visual enhancements is a **matte box** (Figure 5.10). A matte box provides a hood for the camera lens to reduce glare and is capable of holding lens filters. A **filter** is an optical device that mounts in front of the lens and alters the look of an image. Filters can either screw onto the lens or be mounted in a matte box. Some common filters include

FIGURE 5.10

The matte box on the front of this camera can reduce the glare from outside light, as well as hold filters.

neutral density, polarizing, and fog filters. A **neutral density filter** will reduce the amount of light entering the camera without affecting the color temperature of that light. Neutral density filters are also used to reduce depth of field since they cut down the amount of light striking the image sensors. Although many cameras have a switch to use a neutral density filter, you can also use a stand-alone glass filter that fits in a matte box. A **polarizing filter** is designed to reduce glare. Suppose you are shooting into the window of a neighborhood shop, but there is too much glare reflecting off the window. A polarizing filter will reduce or eliminate the glare and help you get the shot your story needs. A **fog filter** will soften the contrast and sharpness of your image and add a misty or fog-like quality to the image.

COMPOSITION

Think about the word "frame" and apply it to an image. If you are photographing with a still camera, how do you decide where you want to frame the shot? It is intuitive to think of the frame with all four sides, always considering what is contained in the entire image. Regardless of the scene, the videographer selects what to show the audience. In selecting some parts of a scene to show and not selecting other parts, you are exercising editorial and content control over what your viewers will see. Because of this high degree of control, it is essential to understand the basic shots used in video production as well as some factors and rules that affect composition.

Shot Types

Camera shots are identified with a series of logical abbreviations. For example, a **wide shot (WS)** usually refers to a shot where the lens is zoomed out to a wide angle (or short focal length). Conversely, an **extreme close-up (ECU)** indicates that the lens is zoomed to a very tight shot of the subject (long focal length). While this is basic and easy to understand, the relationship between these shots can be confusing. For example, an individual director or videographer usually makes the decision as to what constitutes a wide shot. Once that is established, all the other shots should fit into a logical progression. Should another videographer be shown any of those shots individually, she might call it something different. In other words, although everyone can identify the difference between a WS, a medium shot (MS), and a close-up shot (CU), the actual definitions of what constitutes each shot are somewhat ambiguous. It is generally best to judge the type of shot in the context of other shots in the same scene or sequence (see Figures 5.11A through 5.11D).

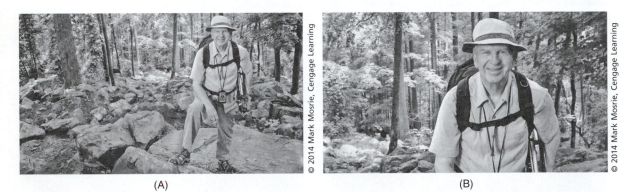

(A) (B)

(C) (D)

© 2014 Mark Mosrie, Cengage Learning

FIGURE 5.11

(A) This image illustrates a wide shot (WS) of the person. Contrast it with the images in B, C, and D. (B) This image illustrates a medium shot (MS) of the person. (C) This image illustrates a close-up shot (CU) of the person. (D) This image illustrates an extreme close-up shot (ECU) of the person.

Visual Aesthetics

The term "visual aesthetics" refers to guidelines and factors that influence shot composition. These basic visual conventions must be considered during the creative process.

TV as a Close-Up Medium A correlation exists between emotion and production technique. One of the ways emotion is effectively communicated is through the use of close-up shots. It is common practice for scenes to begin with a master shot of the entire setting, followed by **medium shots (MS)** and eventually **close-ups (CU)**. This technique draws the viewer into the scene and helps us identify with the character. While TV receivers are getting larger today, screening videos over the Internet or on personal devices such as smart phones is increasing. Close-up shots of eyes and facial expressions are effective in communicating talent characteristics. Consider a furtive glance or a penetrating stare from one character toward another. In order for the audience to see such a subtle communication, the shot will probably need to be a close-up. Along with writing techniques, these types of close-ups help an audience identify with a particular character.

The increased resolution of high-definition images means viewers may be able to discern more detail from wider shots, but that doesn't mean that there is less of a need for close-ups. Regardless of the resolution or clarity of the images, close-ups are still effective in providing detail and emotion.

Aspect Ratio As introduced in Chapter 4, aspect ratio is the ratio of screen width to screen height. Because the orientation of the screen is horizontal, care must be taken to utilize screen space effectively. For example, skylines or landscape shots are effective, while vertical images like skyscrapers do not work as well. The videographer is forced to select only part of a skyscraper to show in the frame.

Working with different aspect ratios poses a challenge for the video storyteller trying to design sets, compose images, and produce graphics.

> **Related Interactive Module**
> CENGAGE brain.com
> Aspect Ratio

Shoot and Protect Widescreen video may also be viewed on standard definition monitors. Because of this, videographers can simultaneously frame for both different aspect ratios with a technique called **shoot and protect**. While shooting, the videographer looks through a regular viewfinder. Inside the viewfinder will be a smaller overlay, called a **graticule** (see Figure 5.12). The videographer will then frame the critical action so it takes place in the smaller graticule, and make sure that there is nothing distracting in the rest of the frame. When the larger images are shown on a smaller screen, the picture will be cropped. With **pan and scan**, the widescreen picture is cropped to fit the smaller screen and then digitally moved from side to side to show all the content. While shoot and protect is a good compromise, the framing does not take advantage of the wider screen. Rather than framing for the space, the videographer merely ensures that there is nothing distracting in the picture. In this sense, it represents an artistic compromise, or the lowest-common-denominator approach to framing.

> **Related Interactive Module**
> CENGAGE brain.com
> Aspect Ratio > Shoot and Protect

(A) (B)

© 2014 Mark Mosrie, Cengage Learning

These two images illustrate the concept of "shoot and protect." Image A is the full 16:9 frame, while B shows the 16:9 frame with a 4:3 aspect ratio graticule overlay.

Essential Area/Safe Action Area There is a difference between what is shown in the picture on a camera viewfinder or computer screen and that same image on a television. Televisions overscan images, with the result that not all of the original picture is seen by the audience. During production, the videographer must account for overscanning because the process generally results in 10 to 15 percent of your video being lost in transmission to the home television set. The **essential**, or **safe action**, **area** is the area in the frame that will be accurately portrayed on the home television set (see Figure 5.13).

The Frame as an Element of Composition The frame itself can exert force on the images inside the frame. In this sense, the edge of the frame acts like a magnet and tries to draw images and elements within the frame to the edges. A skilled videographer can take advantage of this idea with careful composition. To make sure that the frame does not overpower subjects or objects in the frame, it is important to maintain proper headroom, chin room, and nose or look room.

(A) (B)

© 2014 Mark Mosrie, Cengage Learning

These two images illustrate the action safe or essential area of the frame. Image A shows the full 16:9 frame while B shows the essential area overlay. The areas outside the graticule may get cut off by the home TV set.

Headroom is the space between the top of a person's head and the top of the frame. **Chin room** is the space from that person's chin to the bottom of the frame. **Nose room**, also known as **lead room** or **look room**, is space left in the frame for a person to talk or look in a particular direction. Figures 5.14 through 5.16 visually demonstrate both the correct amount of headroom, chin room, and lead room.

(A) (B)

FIGURE 5.14

These two images illustrate the proper amount of headroom (A) and an improper composition in which the head is cut off in the frame (B).

(A) (B)

FIGURE 5.15

These two images illustrate proper chin room (A) and a composition with the chin cut off (B).

FIGURE 5.16

This image has enough lead room or nose room into which the subject can talk.

Off-Axis and On-Axis When shooting an interview, the interviewer should be positioned as close to the side of the camera as possible so that the interviewee is looking just slightly off the camera axis. This **off-axis camera shot** creates a more natural shot with less of a profile shot that allows the audience to see both eyes. If the interviewer moves further away from the camera the interviewee will look further off-axis and the seperation creates a situation where the audience will be more detached from the interview content. (See Figure 5.17).

On-Axis As discussed in Chapter One, an **on-axis** interview (See Figure 5.18) or monologue has the effect of the person talking directly to the audience. This second person composition is commonly used in TV news, stage performances and to a lesser extent in narrative and documentary work.

Camera Angle Besides camera placement in the scene, the relationship between the height of the camera and the camera angle is very important. There is a psychology in the resulting shot if a decision is made to raise or lower the camera. Most normal shots are composed with the lens at approximately the same height as the talent's eyes when the camera is perpendicular to the floor. Lowering the camera forces you to tilt the camera up, thus creating a **low angle shot** (Figure 5.19A). Conversely, a **high angle shot**, created by moving the camera higher and tilting down, creates the opposite effect (see Figure 5.19B). A low angle shot can inspire awe or create excitement. It can increase the height of a person in the frame and tends to separate people or objects in the frame. In addition, a low angle shot can eliminate unwanted foreground material and drop the horizon. Finally, it can distort compositional lines and create a more forceful composition that can amplify the dramatic impact of a scene. A high angle shot of a person has the effect of seeming to belittle that person or making the audience feel superior to the character. A high angle shot can also

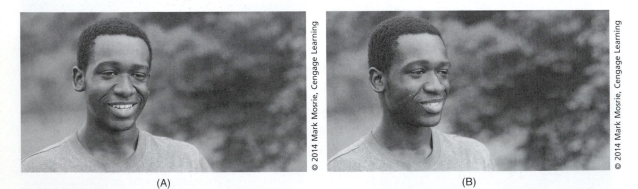

(A) (B)

© 2014 Mark Mosrie, Cengage Learning

FIGURE 5.17

Positioning the interviewer close to the camera (A) creates a more intimate image. Contrast this with image B where the interviewer has moved further away from the camera.

FIGURE 5.18

Having the on-screen actor or character look directly at the camera creates direct address with the audience.

give the opposite feeling, and might provide greater depth and understanding. Consider a high angle looking down on a line of traffic. By seeing it from above, the viewer has a sense of context—that is, how long the line of traffic might be. Similarly, gardens with complex flowerbeds or paths that run through a group of hedges might look better from a high angle. In addition, a high angle is helpful in scenes where action occurs in depth, such as a sporting event or marching soldiers. Overall, high angle shots can add context to the story, reveal aesthetic beauty, and influence the way in which the audience perceives a character. A good example of the effects of high angle shots can be found in *The Rainmaker*

(A)

(B)

FIGURE 5.19

(A) The low angle shot puts the person in the image in a position of power or superiority. Contrast this image with the one in B. (B) This high angle shot puts the subject in a powerless or weak position.

(1997), a film based on the John Grisham book about an inexperienced lawyer who sues an insurance company and wins the biggest settlement in history. During the early courtroom scenes, the rookie attorney is shot from a high angle to show his inexperience and reduced stature. The opposing attorney, with many years of experience representing the insurance company, is always shot from a low angle to reinforce his superiority over the other lawyer. In addition, the director had the ceiling of the courtroom lowered for the shots of the experienced attorney to further reinforce the effect.

In addition to high and low angles, you can use a canted or **dutch angle** for a shot (see Figure 5.20). With a canted angle, the frame is tilted a bit and portrays a dynamic feel, or the idea that all is not right with the world. In addition, the angle can show madness or disorientation on the part of a character. Canted angles are used frequently in horror, suspense, or science fiction genres.

Vectors and Lines Another element of composition involves the use of vectors and lines in the frame. **Vectors** are elements that can lead the viewer's eye to certain parts of the frame. They can be as simple as architectural shapes and people pointing, or more complex, such as the converging lines of a set of railroad tracks. Vectors provide a path for the viewer to visually navigate across the frame. Because of this, vectors are referred to as **leading lines.** There are three principal types of vectors: graphic, index, and motion. **Graphic vectors** are created by stationary objects or elements that guide the viewer's eyes in a particular direction, such as the vertical line of a tall building shot from a low angle camera position. **Index vectors** are created by people or objects that point in a particular

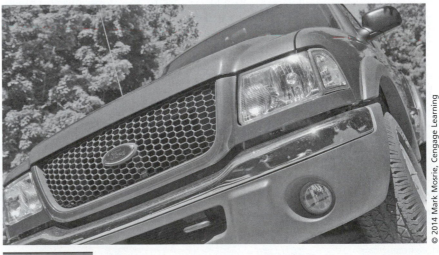

© 2014 Mark Mosrie, Cengage Learning

FIGURE 5.20

The canted or dutch angle can connote a sense of dynamic action. It can also be used to convey confusion or bewilderment.

direction, such as a person looking off-screen or pointing (see Figure 5.21). **Motion vectors** involve movement in the frame, such as a bicycle rider moving from left to right across the frame.

Besides vectors, the use of line has an impact on composition. A vertical line, for example, generally implies strength, dignity, or power (see Figure 5.22). Horizontal lines imply stability and openness (see Figure 5.23). Diagonal lines,

© 2014 Mark Mosrie, Cengage Learning

FIGURE 5.21

The strong index vector leads the viewer through the frame.

© 2014 Mark Mosrie, Cengage Learning

FIGURE 5.22

The vertical lines created by the columns in this image show strength and power.

on the other hand, are associated with action and excitement. Curved lines connote calmness, grace, elegance, and sometimes movement (see Figure 5.24). In print ads or television commercials, sports cars generally follow diagonal lines in the frame to show how exciting the car is. Minivans will usually be shown on a horizontal line to show how stable they are for a family.

FIGURE 5.23

The strong horizontal lines in this image show openness and stability.

FIGURE 5.24

The curving line of the stairs connotes grace, elegance, and calmness.

The Rule of Thirds Though the word "rule" has formal connotations, it does not necessarily mean formal balance or a symmetrical image. Creative photography includes the use of a technique called the **rule of thirds**. The design principle works on the theory that an unbalanced composition will be more dynamic and interesting (see Figures 5.25 and 5.26). The rule suggests that videographers construct an imaginary tic-tac-toe board on their viewfinder. Using the imaginary lines, you should place important actions in the frame on the intersections of the tic-tac-toe board. Another variation on the rule of thirds is that dominant horizontal and vertical elements should follow the horizontal and vertical lines in the tic-tac-toe board. The rule of thirds can be traced back to Greek and Roman architecture as well as to Renaissance artworks. The rule derives from the "divine proportion" as well as the "golden rectangle." The divine proportion is 1.618 to 1. Constructing a rectangle from that ratio creates

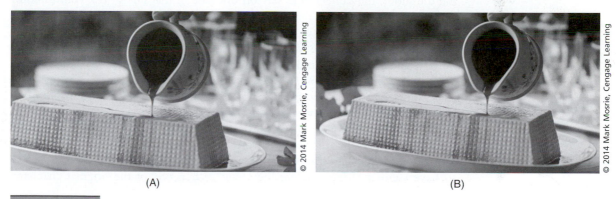

(A) (B)

© 2014 Mark Mosrie, Cengage Learning

FIGURE 5.25

In image A, the rule of thirds has not been applied correctly. Image B follows the rule of thirds. Look at Figure 5.26 to see an overlay showing the rule of thirds for these photos.

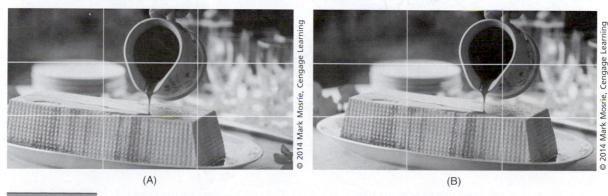

(A) (B)

© 2014 Mark Mosrie, Cengage Learning

FIGURE 5.26

The rule of thirds overlay demonstrates how image A does not follow the rule, while image B does. Look at Figure 5.25 to see the images without the grid.

the golden rectangle. The ratio has since been found throughout nature, from the way petals and leaves form on flowers to the shape of a nautilus shell. In addition, much research has shown that the golden rectangle is the most pleasing shape for humans to observe. The Parthenon in Greece used the golden rectangle for its shape. While the 16:9 aspect ratio of television is not a golden rectangle, dividing that shape by thirds produces one.

Related Interactive Module

Axis of Action

The Axis of Action or the 180-Degree Rule The **180-degree rule** dictates camera placement during a scene to ensure consistent screen direction. It is perhaps best understood in the context of an interview. When shooting an interview, it is important for the audience to perceive that the interviewer and interviewee are talking to each other. When you cross or break the axis of action, it will appear that they are not looking at each other. The axis of action is an imaginary line that the videographer establishes for a particular scene. During the shoot, the camera must stay on one side of that line or risk confusing the audience. In Figure 5.27, the camera stays on the same side of the axis of action for all the shots, and the two people in the interview are looking at each other, while in Figure 5.28, the videographer crossed the axis, causing the talent to both be looking in the same direction.

The overall purpose of the 180-degree rule is to preserve consistent screen direction. Consider the example in Figure 5.29. The scene shows a simple set with two people sitting on a couch. Notice that when the shot is taken from either camera position A, B, or C, the direction in which the person looks is consistent. When the shot is taken from camera position D, however, the direction in which the actors look is reversed from the original shots. One remedy is to have another character enter the scene. When one of the original characters

(A) (B) (C)

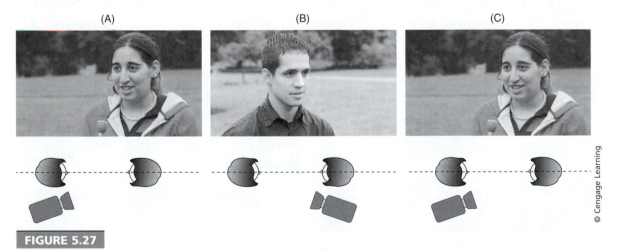

© Cengage Learning

FIGURE 5.27

The videographer followed the 180-degree rule in this series. The camera stays on the same side of the axis of action and the interview is presented as if the two people are speaking to each other. Contrast this image with the one in Figure 5.28.

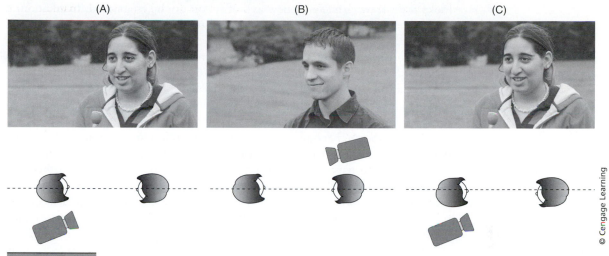

FIGURE 5.28

The videographer did not follow the 180-degree rule in this series. The camera moved to the other side of the axis of action in image B. That flips the screen direction and potentially confuses the audience. Contrast this image with the one in Figure 5.27.

FIGURE 5.29

This illustration shows screen direction for a narrative scene. If the director chooses a shot from camera A, B, or C, she will maintain proper screen direction. A shot from camera D, however, will flip the axis of action and change screen direction. The result may disorient the viewer.

© Cengage Learning

looks at the new character, a new axis of action can be established. In addition, if one of the original characters were to stand up and walk across the original axis of action, a new line could be established. Another acceptable way to break the axis of action rule in your shots is to show the camera moving as it crosses the line. In this way, the audience will see that the camera has crossed the line and will understand why the screen direction has suddenly flipped. When shooting moving action, like a chase scene, the line or axis of action generally follows the direction of the motion in the scene.

Audiences are becoming increasingly sophisticated in their viewing and understanding of visual media and can generally follow the story when screen direction has been reversed. Nonetheless, breaking this rule or any other rule of composition should come only with a thorough understanding of these conventions and a good reason for breaking them. In the case of the 180-degree rule, crossing the line may help build energy and conflict in a scene, or raise the level of tension in a particular shot.

The Z-Axis and the Creation of Depth Television is a two-dimensional medium with no physical depth. However, several techniques can help create the illusion of depth through the use of the z-axis. The **z-axis** is an imaginary line that extends from the front of the camera lens to the horizon. Techniques such as overlapping planes, linear perspective, and selective or rack focus all use the z-axis to create depth in the frame. Combining these techniques with a consideration of the foreground, midground, and background in each shot will add to the illusion.

An **overlapping plane** uses the foreground of the frame to force the viewer to focus on something in the background (see Figures 5.30 and 5.31). Because

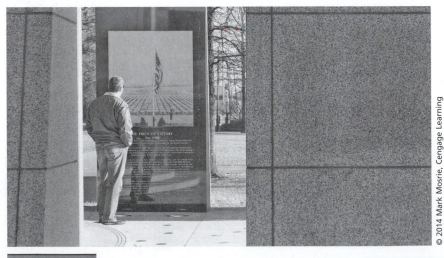

© 2014 Mark Mosrie, Cengage Learning

FIGURE 5.30

Notice how the granite pillars in the foreground create a frame for viewing the background. The overlapping planes in this image help show depth in the frame.

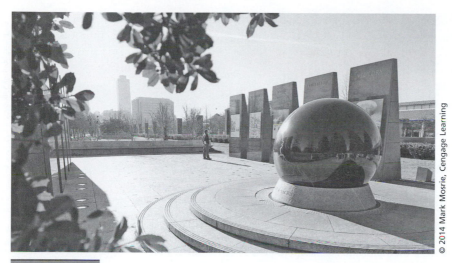

© 2014 Mark Mosrie, Cengage Learning

FIGURE 5.31

This is the classic application of overlapping planes. A tree branch or leaves in the foreground help frame other objects in the background. The framing gives the image the perception of depth.

the viewer is clearly able to distinguish the foreground from the background in the frame, there is the perception that the frame has depth. An example of this concept is to have a small tree branch with a few colorful leaves in the foreground helping to frame a building in the background.

Using **linear perspective** to create depth in a scene is fairly simple. Instead of shooting an object like a bench or fence straight on, move the camera so that the bench or fence is on a 30-degree or 45-degree angle from the front of the camera. When you do this, the length of the bench or the fence sits on the z-axis of the shot and creates the illusion of depth in your frame (see Figures 5.32A and 5.32B).

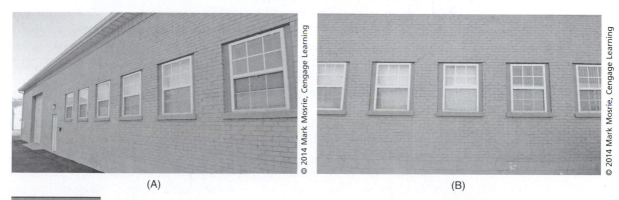

(A) (B)

© 2014 Mark Mosrie, Cengage Learning

FIGURE 5.32

(A) By placing the line of the building on the z-axis, a linear perspective is created and the image has a sense of depth. Contrast this image to the one in B. (B) Here, the long edge of the building is flat in the image. No sense of depth is created.

(A) (B)

© 2014 Mark Mosrie, Cengage Learning

FIGURE 5.33

These two images illustrate the beginning and ending frames of a rack focus shot. In shot A, the woman is in focus, looking through the binoculars. The videographer then racks the focus to shot B to show what the woman is observing. Note that if either of the shots were used individually, it would be a selective focus shot.

Selective focus is a technique used to change the focus on objects at different distances along the z-axis (Figure 5.33). When one object in either the foreground or background is out of focus, the viewer will infer that there must be some depth in the scene because one of the objects in the scene is not clearly focused. Taking that concept one step farther, the videographer can manipulate the focus and show the audience that manipulation, known as a **rack focus**. During a rack focus, the focus shifts from one object to another. For the effect to work well, a long focal length must be used to create a shallow depth of field, or you may rack through the entire focus ring and not see a change on screen.

Z-Axis, Long Focal Lengths, and Perception Recall that long focal lengths appear to compress the background in a particular scene. Another strange phenomenon occurs along the z-axis when long focal lengths are being used. The telephoto shot appears to compress the spacing of items arranged on the z-axis (see Figures 5.34A and 5.34B). A famous example of this phenomenon occurs in a particular shot in Washington, D.C. When shooting the length of the national mall with a long focal length, the Lincoln Memorial, Washington Monument, and U.S. Capitol appear to be right on top of each other (Figure 5.35). The reality is that two miles of mall separate the Lincoln Memorial and the Capitol. The long focal length is what creates this compressed perception.

Another artifact of this apparent compressed perception affects objects in motion along the z-axis. With a long focal length, people or objects moving along the z-axis will appear to be moving very slowly and making no progress toward the camera. A famous scene in the movie *The Graduate* (1967) uses this technique. In the film, the main character, played by Dustin Hoffman, is running to get to a church before the girl of his dreams marries someone else. The

(A) (B)

FIGURE 5.34

(A) Notice the spacing between the fence posts in this image. The shot was composed using a wide-angle lens. The z-axis does not compress with a short focal length and the spacing between the posts looks normal. Contrast this image with the one in B. (B) The long focal length used in this shot compresses the z-axis and makes the spacing between the fence posts appear smaller.

SOURCE: Courtesy of author, Joe Hinshaw.

FIGURE 5.35

This photo dramatically shows how a long focal length shot can compress the z-axis. The three monuments appear to be right on top of each other, but in truth, two miles separate the Lincoln Memorial and the U.S. Capitol.

SOURCE: Courtesy of author, Joe Hinshaw.

director selected a long focal length lens for the running shot to make it look as if Hoffman's character is making no progress as he runs. It helps to show hopelessness and futility on the part of the character in the movie. When you use a short focal length, objects on the z-axis move quickly. To show how fast traffic moves, use a short focal length to accentuate the fast movement of the cars.

SHOOTING FOR SEQUENCES

A **sequence** is a series of related shots that helps add interest to the scene. A sequence of shots is designed to tell a story or convey an idea. Sequences can help make stories more dynamic and interesting. Figures 5.36A through 5.36D represent a sequence of shots of a man putting a suitcase in a car. While this scene could be shot with a master wide shot similar to Figure 5.36A, the addition of the other shots will add interest, help with pacing, and allow for manipulation

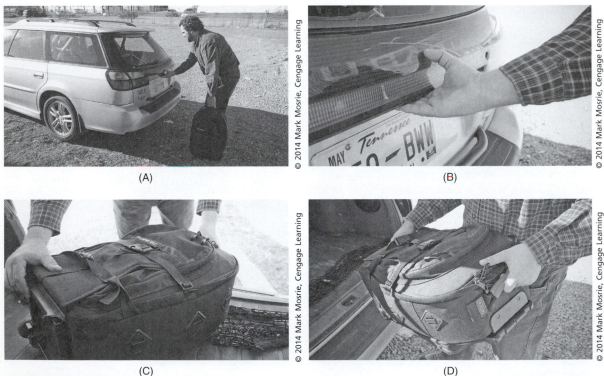

(A) (B)

(C) (D)

© 2014 Mark Mosrie, Cengage Learning

FIGURE 5.36

(A) This is the master shot. The addition of images B, C, and D create the sequence. Remember to overlap the action across the shots to ensure easy editing.

of time. Several shooting techniques can be used when creating sequences for editing. The basic rules are to shoot a wide shot, a medium shot, and a close-up of every action in a scene; overlap the action in the shots; move people in and out of the frame; record the same action from different angles and with different types of shots; and anticipate action. In the suitcase example, when shooting the wide shot, have the actor go through all the actions in the scene: open the hatch-back, pick up the suitcase, set it in the car, close the hatchback. Then have the actor repeat those exact actions with a medium shot and again with a close-up shot. There is now overlapping action in your shots. After getting the basic shots, experiment a bit. Try shooting from inside the car, or perhaps from an extreme low angle at the bumper of the car.

DYNAMIC COMPOSITION

Shots can be classified as either static or dynamic. A **static** shot does not have any camera moves or movement in the frame, while a **dynamic** shot does.

Camera Movement

The goal of any camera movement is to enhance the story. These moves are broken down into those caused by using the lens, the camera, or the camera support.

Lens movements are almost always the result of zooming, but rack focus or use of the macro lens can also be considered movement. Some of the most basic camera moves are a **pan** (side-to-side movement on a fixed axis); a **tilt** (up and down movement on a fixed axis); a **dolly** (movement of the camera mount toward or away from the subject); and a **truck** (side-to-side movement of the entire camera mount). In considering these various methods of moving the camera, it is useful to distinguish which parts of the camera and the device on which it is mounted are moving. In the case of a zoom, the lens is moving. With a pan or tilt, the pan and tilt head on the tripod is moving. With a dolly or truck, the entire tripod or camera support is moving. From this basic description, we can derive three basic types of shots that involve movement: simple shots, complex shots, and developing shots. The **simple shot** involves only the talent in the frame moving, and nothing on the camera moving. The **complex shot** includes subject movements, lens movement, and movement of the pan and tilt head. Finally, the **developing shot** involves subject movement, lens movement, pan and tilt head movement, and movement of the entire camera support.

Camera movements are used to follow or reveal action, to show landscape or other objects too big for the frame, to relate events, and to induce action. Camera movement might be an efficient alternative to shooting multiple shots that would be edited together.

One of the most natural and least obvious camera movements is the **pan** or **tilt** to follow action. A runner moves across the frame from left to right and the

videographer pans to follow the runner. The camera might also move to the front of the runner to reveal a large hole in the street that the runner is approaching. Tilting up from the entrance to a company's main building to reveal an imposing skyscraper adds strength to the corporate image. A close-up shot of a person's worried look that then pans to reveal a dentist with a drill shows the relationship between the patient and dentist without the need for an edit. A camera placed on the north rim of the Grand Canyon pans to show the incredible size of the canyon in one continuous shot. Starting that shot with a close-up of a postcard of the Grand Canyon in someone's hand adds another dimension if the camera zooms out to reveal the canyon in the background.

Camera movement might also be used to relate events that might not otherwise seem related in a scene, or to draw attention to detail. The audience may see a shot of a crumpled piece of paper on the ground; the camera tilts up to reveal a police officer looking down at the paper as if it were significant evidence. In one of the shots for the documentary that Pick 2 is producing, the videographer pans from the tail of an airplane past the front as it sits on the runway. Such a camera move induces action that the audience might equate with flight.

To the untrained eye, a zoom and a dolly may look similar. There are, however, aesthetic differences between the two moves. Notably, the human eye does not zoom, so such a move is unnatural. With a zoom, objects on the z-axis appear to move quickly from the foreground to the background on a zoom in. On a zoom out, the objects recede along the z-axis. The faster the zoom happens, the more quickly we perceive this action. No change in perspective occurs during the zoom, however. The camera remains stationary. Because of that, the objects in the frame seem stuck together and do not move during the zoom. With a dolly, the entire camera and its support are moving. Physical relationships change as the movement of the camera support reveals something new or establishes a relationship between objects. We perceive this motion the same way that we perceive motion when walking toward an object. The perspective of the camera and the relationship between the camera and the objects change as we move through the scene.

Camera Mounts A camera can be mounted in a number of ways. This section will discuss some of the more common camera mounts used to achieve a stable platform with smooth pan and tilt functions.

The tripod (see Figure 5.37) provides a very portable way to create professional looking, stable shots in virtually any location. It sets up quickly and can make a dramatic difference in the quality of your shots. A tripod support plate makes moving the tripod to different locations very easy. The plate mounts to your camera and then simply slides on and off the tripod (see Figure 5.38). When its time to relocate, slide the camera and plate off, move to the new location, and then slide the camera back on. Tripods will use one of three types of heads to create smooth motion. A **fluid head** is composed of a sealed system that contains a viscous liquid between the moving and nonmoving parts of the head. This helps create smooth movements. Fluid heads are the most popular

FIGURE 5.37

The tripod is the most common mount that the videographer uses.

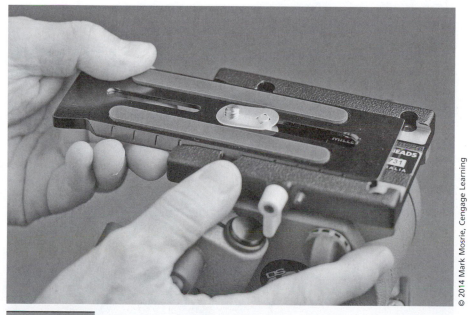

FIGURE 5.38

The use of the tripod plate makes it very easy to quickly remove and remount the camera on the tripod.

tripod head for video work. **Friction heads** use grease to perform the same job as the liquid in a fluid head. Finally, **geared heads** rely on gears and handwheels to smoothly move the camera. Regardless of the mechanism, the head will use some counterbalancing system to balance the weight of the camera as it tilts. The counterbalance should work in such a way that the operator does not have to fight the weight of the camera when performing a tilt.

For successful dolly or trucking shots, attaching wheels to the camera tripod will work for some applications. A more sophisticated device is a dolly on a track (Figure 5.39). With this method, a car that contains the camera tripod or other method of attachment rides on a track. The camera can be moved along the track to produce a very smooth and fluid motion.

Another mounting system is the Steadicam (see Figure 5.40). The **Steadicam** is a harness with a series of counterbalances that provides smooth and fluid movement. Because a Steadicam is very expensive, it is typically used only in higher-end productions. A number of lower-cost alternatives are available, although none functions with the same sophistication as the Steadicam.

There are a number of **rigs** for mounting a DSLR. These rigs help overcome the challenge of hand-holding the camera by providing a balanced and ergonomic device that can eliminate jerky camera movements (Figure 5.41).

Most specialized camera mounts combine a fluid head with some unique way of attaching the mount to an object. For example, attach the fluid head to a series of suction cups and you have a car mount. Another type of camera mount is a **jib** arm (see Figure 5.42). This crane-like device suspends the camera

FIGURE 5.39

A jib arm is riding on a dolly track, providing flexibility for a variety of dynamic movements.

SOURCE: Courtesy of author, Joe Hinshaw.

FIGURE 5.40

The Steadicam mount consists of a vest that the operator wears and an articulating arm to balance the camera. For the videographer, it provides the portability of a handheld camera with the stability of a strong platform. The result is a fluid, smooth camera movement.

SOURCE: Steadicam® Clipper 324, Courtesy of The Tiffen Company.

from the end of the arm and allows for shots with a smooth movement that gives the illusion that the camera is flying through the air.

Through creative experimentation, some sophisticated moves can be accomplished with relatively simple alternatives. One creative method is to use a wheelchair or garden cart as a dolly for smooth movements. The large rear wheels allow for an inexpensive method for dolly shots.

Implications of Camera Movement Camera movement is an important compositional element. In addition to the aesthetic principles already discussed, camera movement creates a psychological opportunity, or barrier, for the audience. Horizontal movement can suggest travel or momentum. Movement from left to right across the screen is natural for Western culture, but audiences perceive this movement as weaker than right-to-left movement. Moving right to left has a stronger, more dramatic opposition in the frame. Generally, you should use left-to-right movement for more common shots such as routine pans of a landscape. Move right to left to make a stronger statement. Vertical camera movement can suggest growth and freedom. Tilting a camera up to follow a rocket as it launches skyward is an example. Because upward vertical movement

FIGURE 5.41

A rig can be a useful tool for creating better camera shots. In addition, extras such as battery and monitor support as well as focus controls can increase the efficiency of the videographer.

FIGURE 5.42

The camera mounted on a jib arm gives the videographer and director a number of creative choices for dynamic movement in the image.

STORY 5.3 Patience in the "Field"

Early one summer day I was tasked to transport and assemble a jib in order to film an antique car moving along a country road. Knowing it would take some time to get all 30 feet assembled, I arrived early in the morning and with some initial help I was ready for the scheduled shoot. In the meantime, I double-checked the connections and balance. An hour later, I thought, "Well, it's hurry up and wait. I can do this. I did it for years in the military." At noon, the only people I'd seen were two farmers wondering what the heck I was guarding along the cornfield. Finally, around 3 p.m., the producer contacted me by radio, "We're having problems with the car." I was to disassemble the jib and he'd call back on where to set it up next. An hour later and with the jib nearly stowed, the radio came alive. "The car is working again. We'll be there in 45 minutes." Another time I might have told the producer it'd take a little longer to set up, but having spent the day in the hot sun and after reading the assembly instructions cover to cover five times, it was a challenge I couldn't pass up. I was done when they arrived and the DP (director of photography) got his shots before rushing to the next location, but I had to laugh when I saw the final production and the jib shot lasted only 8 seconds.

SOURCE: Jeff Post, Production Assistant

is seen as uplifting, a tilt up can also be used to reinforce that message. Tilting down can suggest danger or overwhelming power. The videographer can tilt down on a burned-out building to reinforce the message of destruction. Diagonal movements, which can be produced with a jib arm, can be strong and dramatic. When the jib moves the camera on a diagonal, it suggests opposing forces, or, depending on the direction of the move, ascent or descent. Using a Steadicam to move the camera in a curved motion may suggest fear even though a circular movement generally connotes happiness and cheerfulness.

CONCLUSION

Shooting video is more than just setting up a camera and recording a scene. Camera placement, focal length, and iris setting all impact depth of field in the scene. In addition, the restrictions of the screen aspect ratio and considering the essential area are important to your framing. Visual aesthetics such as the rule of thirds, vectors, the use of the z-axis, and creation of depth in the frame are critical to telling the story according to the vision developed during preproduction. Shooting a compelling sequence will also enhance the production. Finally, using different camera mounts can help achieve solid dynamic and static composition.

Story Challenge: Composition and Visualization

The storyboards the director created during the preproduction phase really helped in shooting the music video. Keeping a great depth of field, accomplished mostly by short focal lengths during several b-roll shots, really took the viewers into the environments where the shots were done. Also, the use of shallow depth of field during selected interviews was a great tool for focusing attention on the interviewee. Storyboards were also helpful for a few planned sequences in

the documentary. It was important to understand the director's intent from the storyboard so that the videographer could adapt to the different conditions in the field. That adaptability enabled the videographer to shoot sufficient video for the editor to create good sequences. Many of the scenes were shot multiple times from different angles to ensure smooth editing. During the music video, the director was able to break the axis of action rule and create a very jarring sequence that will help to draw in the audience and that really added to the overall story line. Finally, the use of both a Steadicam and a camera mounted on a jib arm were very useful tools in capturing the live concert. Both cameras were able to provide some intimate and different angles showing great audience interaction with the band.

Audio in the Field

Sound is messy stuff. It spreads out, bends around corners, and bounces off objects.

JAY ROSE, AUDIO ENGINEER

OVERVIEW

Although we think of television as a visual medium, the sound track must not be treated as an afterthought. In fact, the audio is essential to the program's success, and an interesting sound track can change a lifeless video into an exciting story.

During the preproduction stage, most directors spend considerable time developing storyboards and shot lists to enhance the visual elements of their story. Meticulous detail may be given to composition, sequencing, and editing since each contributes to the overall story. While some directors also shoot their own video, others will hire a professional videographer. Unfortunately, in many instances, sound recording is given only cursory attention. It is rare that small crews will add an additional person to engineer the audio. Regardless of the production, however, it is critical to go into the acquisition stage of production with the intent of getting optimum sound.

When it comes to collecting audio in the field, you must understand and consider several technical and aesthetic elements. On the technical side, you need to understand microphones and how they collect sound. Choosing the correct microphone for a given situation is critical for getting good audio. Aesthetic decisions are also important since they too influence your overall story. During the acquisition stage, you may be recording narration, voice-over, interviews, dialogue, and natural sounds. Simultaneously, you might be negotiating music rights and acquiring other audio elements. This chapter begins with a discussion of the technical elements of sound and microphones. Next, it reviews the aesthetic decisions you face when recording audio in the field.

Story Challenge: Audio

During the planning and development for the three videos you will direct for Pick 2 Productions (documentary, concert, music video), several questions have been raised in relationship to audio acquisition.

- How will the storyline for the documentary be created through the interviews that will be conducted?
- What types of microphones and techniques will be used to capture clear audio?
- What role will natural sound play in the documentary? How will optimum sound be acquired?
- How can sound be used to enhance the storyline?
- Will music be recorded live?

Paying attention to these considerations and other audio elements is just as important as the camera work in producing a compelling story. As a director for Pick 2 Productions, you have an opportunity and responsibility to demonstrate the power of sound in the three videos.

TECHNICAL CONSIDERATIONS FOR AUDIO

It is helpful to understand how sound works and how it relates to audio signal flow, audio connections, microphones, and microphone placement.

How Sound Works

Sound is produced when matter vibrates and travels in waves. Vibrations are produced when pressure is exerted on the air molecules that constantly surround us. These vibrations create acoustical energy that human ears and microphones translate into discernable sounds. The behavior of sound waves is difficult to predict, given that they can spread out and bounce around. Understanding how sound behaves, however, will enable you to do a better job when you are in the field recording sound. Frequency and amplitude are two important characteristics of sound.

Frequency **Frequency** or **pitch** refers to the relative tonal quality of an audio signal measured by the number of waves, or hertz (Hz), that occur per second. Each complete cycle of a sound wave is one hertz (see Figure 6.1). Humans can generally hear sounds between 20 and 20,000 Hz. Lower frequencies are called **bass** and produce a deep low sound, while high frequencies produce higher notes, referred to as **treble**.

Amplitude **Amplitude** is a measure of volume or loudness. In the sound wave shown in Figure 6.1, the amplitude corresponds to the height of the wave. Also, the more molecules that vibrate, the greater the sound's amplitude.

Frequency →

Amplitude

© Cengage Learning

FIGURE 6.1

This sound wave shows frequency (number of cycles) and amplitude (loudness).

The **decibel (dB)** is used to measure the loudness of a sound. The mathematical equation is complex, but the standard used to describe sound is based on a scale with zero as the reference. Human breathing is 10 dB, while a jet engine that is 100 feet away is measured at 150 dB. Sustained levels of over 85 dB are harmful to your hearing. Careful attention to adjusting record levels is an important detail to remember during production. A change of just 6 dB doubles the amplitude of the sound signal.

Audio Signals

All audio signals, whether they come from microphones, digital files, CD players, a satellite feed, or a video tape recorder (VTR) create voltage based on the type of signal. There are three different levels of voltage. Microphones (mics) produce signals with low voltage. These signals are commonly referred to as **mic level** signals. Other equipment, such as VCRs and CD players, produce higher amounts of voltage that are called **line level** signals. Speakers/monitoring equipment requires the most voltage in what is called speaker or **PA level** signals. The signal produced to drive a speaker/monitor is considerably larger since it is amplified so that the speakers can project the sound. Because of these voltage differences, the higher-level signals will distort the audio if plugged into an incorrect jack. Conversely, lower-level signals will not have enough voltage to reproduce an audible signal when plugged into a jack requiring the larger signals. Most professional camcorders have audio inputs that are switchable between mic and line level (see Figure 6.2). Understanding signal level and how to modify these signals can be advantageous in production situations. For example, at many live events (press conferences, concerts) there is often a **mult box** (see Figure 6.3) that offers a direct feed from a mixer or other audio equipment. The mult box allows the crew to connect to an audio signal from the event's in-house sound system. Generally, the box will have outputs for both mic and line levels. Using such distributed audio often gives you cleaner audio and saves set-up time since you do not need your own microphone. Knowing which output to use and how to modify it for your input may not only provide you with a better signal, but may also prevent you from damaging equipment by sending too much signal into your input.

FIGURE 6.2

Some professional cameras have a switch that allows the audio input to be changed from mic to line level.

FIGURE 6.3

A mult box provides an audio feed to which multiple users can connect. The box commonly provides mic and line level signals.

SOURCE: Courtesy of author, Joe Hinshaw.

Matching Levels On occasion, various pieces of equipment will need to be patched to allow additional inputs to a mixer or to send the signal to another source. **Patching** is the process of connecting two pieces of equipment together—in this case, you connect cables from the output of one device to the input of another. It is a simple task, with one caveat. The signal levels must match. As previously discussed, a microphone signal voltage is extremely low, while a speaker/monitor level is large. Line level signal voltage is somewhere in between. As an analogy, think of the water system in your house. A large pipe runs down the street and branches off to smaller lines that enter the home. Once inside the house, the water lines branch again and connect to faucets. As you might imagine, the pipe outside the house is much larger than the pipe running to your shower or kitchen sink. If you were able to actually connect the street pipe to your shower, there would be far too much water and the shower head would explode! You would get the opposite effect if you ran the water from the shower line back to the street. The amount of water would look more like a trickle as it made its way through the larger pipe.

Impedance Another consideration is matching the impedance between two devices. **Impedance (Z)**, measured in **ohms**, is the resistance to signal flow. With an improper match of impedance, signal flow may be unusable. In the water pipe example, consider impedance as corrosion or sludge in the pipes that causes the water flow to slow down. The most common way a production team deals with impedance is through the use of microphones. Low impedance microphones are less than 600 ohms, while high impedance mics are over 10,000 ohms. Professional mics are normally in the low impedance category.

Balanced or Unbalanced Microphones are connected to system components as a balanced or unbalanced signal. A **balanced** connection has two wires for the audio signal and one wire for the ground. An **unbalanced** connection uses only one wire for the signal and one for the ground. Because of this, part of the audio signal is included with the ground wire. This situation makes it more likely that interference will occur. Therefore, balanced connections are preferred; they do a better job of rejecting possible hum and other electrical interference.

Sampling The sampling rate of a digital sound file impacts your project through quality and file size. **Sampling** is the process of changing a continuous signal (analog) to a digital signal that has a specific number of samples per second. The audio portion of digital video normally uses 48 kilohertz (kHz), while an audio CD uses 44.1 kHz. This means 48,000 or 44,100 samples per second. The more samples you take, the more accurately you reproduce the analog signal. An MP3 file has more compression and might be 44.1 kHz or 32 kHz. A variety of software applications allows you to change a sampling rate for the desired use. Higher sampling rates, while they are more accurate, also occupy more space on a hard drive.

Mono, Stereo, or Surround Audio signals may be mono, stereo, or surround signals. **Mono** audio, also known as monophonic or monaural, is a single audio signal. It is primarily characterized by the fact that, when played back, it imparts no information about the direction of the sound. When a recording is done in **stereo**, the audio has a separate left and right channel. This mimics the way humans hear sounds. Because our ears are on the sides of our heads, sounds do not arrive at each ear at exactly the same time. The time difference allows our brain to figure out the source and direction of the sound. This allows for a more natural method of reproducing sound and helps add depth and reality to the sound. The term "depth" refers to an understanding of the environment in which the sound was recorded. For example, recording audio in a concert hall sounds much different than recording audio in a room with concrete walls. Surround sound takes stereo and depth a step further. In a typical **surround sound** system, at least six separate signals of audio are used—those for the left and right front and the left and right rear; a center channel; and a subwoofer for reproducing the bass, or low, frequencies. The addition of rear speakers

allows for greater depth in the audio. A film or video that is mixed in 5.1 surround sound takes advantage of the additional sound perspective.

Signal Flow

Audio signals flow through a field recording system in a simple linear fashion. Sound is transferred from a microphone directly to the input connection on the camcorder's recording device or passes through a microphone mixer before being plugged into the audio jacks for the recorder. The signal can be monitored at the mixer or camcorder by listening to the sound or observing a reference on a metering system. Usually, the monitored signal is the input going to the recorder, but with the proper equipment you can monitor a return feed from the camcorder. In addition, once a signal has been recorded and stopped, an amplified signal can be played back through headphones or speakers.

Record Levels

Recording an optimal audio signal is a fundamental objective for the production crew. Some camcorders are limited with a system that can only record using an **automatic gain control (AGC)** circuit. AGC (see Figure 6.4) will average out the input levels during the recording. This functions in much the same way as the auto iris does for exposure. This might seem like an acceptable procedure, but there is a tendency during quiet times for the signal to increase background noise and to artificially cut off the signal during times of peak audio. In order to have better control of the audio, more advanced camcorders include the flexibility of recording automatically or manually. Professionals prefer to adjust most sound manually to eliminate the annoying results of an automatic circuit. This requires close attention to the audio levels during recording. Another automatic circuit is called a limiter. A **limiter** circuit cuts off all extremely high-level sounds. This can be useful in situations when audio levels vary greatly, and occasionally an extremely loud sound occurs.

© 2014 Mark Mosrie, Cengage Learning

FIGURE 6.4

The auto/manual switch on a professional camcorder lets the user control audio levels manually or through an automatic circuit.

© 2014 Mark Mosrie, Cengage Learning

The analog audio meter measures analog audio levels.

An **audio meter** measures signal strength in voltage units (VU). Meters are critical in order to make optimum manual adjustments of signal amplitude. The two types of meters are analog and digital. While both serve the same purpose, the settings are different for each. With a traditional analog meter (see Figure 6.5), the scale has negative numbers leading up to 0, and positive numbers to the right of the 0 indication. To adjust the audio level on an analog meter, adjust the record level (or mixer control) while watching the VU meter. The needle or indicator should bounce to the right, near the 0 reading on the audio meter. Some sounds may occasionally go into the far right zone. If they consistently bounce too high, it will cause the signal to be distorted. On the other hand, if the needle hardly moves at all, the signal will be very weak and hard to hear. During playback, the volume will have to be turned up high and this will induce noise into the signal.

Digital audio meters (see Figure 6.6) only go to 0 and anything beyond this will be distorted. Some digital meters have two scales that compare the analog and digital readings. The digital equivalent of 0 on an analog meter can vary, but is usually between –20 and –12. The variation is a result of equipment manufacturers

© 2014 Mark Mosrie, Cengage Learning

The digital audio meter measures digital audio levels.

using different standards. If you look carefully at Figure 6.6, you will notice that −20 on the digital scale equals 0 on the VU scale. Digital meters can also display peak and average readings. A peak reading marks a line on the scale for the loudest signal, while the average meter reading continually shows the current level.

Audio Connections

Several different types of connectors are used to connect audio equipment. It is preferable to keep a balanced signal throughout the path. This does not necessarily mean you will not get good audio with unbalanced connections, but there is a greater likelihood of an electrical hum or other noise being introduced into the audio signal. Professional microphones with low impedance allow longer cable runs between the mic and recorder.

Among the most popular and frequently used connectors are the XLR or Cannon (see Figure 6.7A), a 1/4-inch (in) phone (see Figure 6.7B), an 1/8-in mini-phone (see Figure 6.7C), and a phono connector (see Figure 6.7D). The XLR is the preferred professional connector. It is a balanced connection and provides the best audio. XLR connections are preferred for situations with longer distances between the microphone and recorder. XLR connectors are also used to connect an audio mixer or a mult box to a recorder. The 1/4-in phone jack is another popular connector. In addition to connecting musical instruments to amplifiers, the 1/4-in plug is used for some microphones. The 1/4-in connector can be balanced or unbalanced. Generally, they are unbalanced connections, but in some situations they do provide balanced connections (see Figure 6.7E). The primary use of the 1/8-in connector is for headphones or consumer-level high-impedance microphones. Most professional camcorders have headphone jacks that will accept the 1/8-in plug for monitoring the audio. On consumer camcorders, the microphone input is typically an 1/8-in unbalanced connection. Most DSLR's have an 1/8-in mic jack, but some use a sub-mini connector. Another common use for the 1/8-in plug is the audio in and out of a computer. Phono, or RCA, connectors are typically used with consumer audio equipment such as CD players, tape decks, and receivers. The use of this connector in digital video is rare.

Special DSLR Considerations

DSLRs present unique challenges in recording sound. Some of these cameras do not have manual sound level adjustment, and it is rare for them to have headphone monitoring. An alternative is to use a dual system recording technique that includes an independent audio recorder (Figure 6.8) and syncing the sound back to the video during post production. This is a technique that has been used in film production for many years. In addition, there are software products that make it easy to synchronize the video and audio in post production. Besides external recorders for DSLR cameras, some software companies have developed "hacks" to permit camera users to change the native software and have some control over the audio levels. In terms of monitoring the audio, there are some solutions that use a splitter to divide the audio feed. The audio is sent to the

© 2014 Mark Mosrie, Cengage Learning

(A)

(B)

(C)

(D)

(E)

FIGURE 6.7

(A) The XLR connector is a three-pin balanced audio connector used with professional microphones. (B) The 1/4-in phone plug connector is found on a variety of audio equipment. (C) The 1/8-in audio connector is used for headphones and consumer-grade microphones. (D) The phono or RCA plug connector is used for line level audio and some video connections. (E) The three-conductor 1/4-in phone plug is an alternative balanced connector and is used for some headphones.

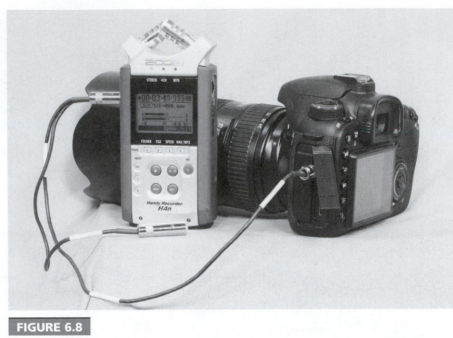

FIGURE 6.8

An external audio recorder can help capture better sound when using a DSLR camera.

camera and to a headphone connection. One drawback to this method is that you are monitoring the input signal and not the actual output from the recording device. Some newer cameras include an option for real time output.

Microphones

Microphones are **transducers**, devices that convert one form of energy into another. Microphones convert acoustic energy into electrical energy. The electrical energy flows through the system as voltage and is subject to resistance or impedance. Microphones can be classified by construction, pick-up pattern, or operational use. All three factors should be considered for a specific field shoot.

Construction Construction refers to the method by which a microphone converts energy into electrical signals. Following are the three main types:

- **Dynamic microphones** are rugged in construction and capable of producing very good sound. The mics can take a great deal of abuse and serve as a good all-purpose choice. When sound enters a dynamic mic, a small cone wrapped with wires moves within a magnet. That movement results in voltage (see Figure 6.9A). The voltage from a dynamic mic is typically quite low and requires sufficient amplification to produce good sound.

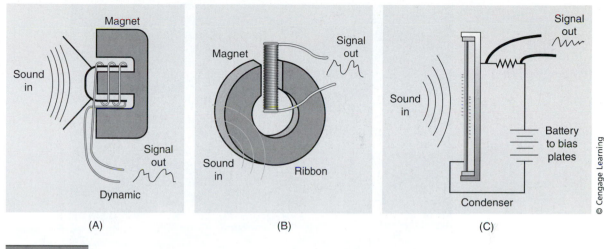

FIGURE 6.9

(A) The dynamic microphone has a small cone wrapped with wires that moves within a magnet. (B) The ribbon microphone uses a small metallic ribbon within a magnetic field that moves and generates voltage. (C) A condenser microphone works when sound waves move past a charged diaphragm and plate.

- **Ribbon microphones** produce rich warm tones and are generally used for sound studio applications. They also make great voice-over microphones in video applications. A ribbon microphone operates much like a dynamic microphone. When sound enters a ribbon microphone (see Figure 6.9B), a small metallic ribbon within a magnetic field moves and generates voltage. Many ribbon mics are large, expensive, and fragile, and they are rarely used in video field production. Newer ribbon mics may have an internal shock-mount system that makes them more practical for some additional situations.

- **Condenser microphones** have a greater sensitivity to sound than dynamic microphones. That makes them an excellent choice for most production situations. The condenser mic features a charged diaphragm that is mounted very close to a rigid plate. The plate is charged. As the sound waves move the diaphragm, a stream of electronic signals is created (see Figure 6.9C). Condenser mics require a power source, either an internal battery or an external source. **Phantom power** is an external power source supplied through camcorders and audio mixers (see Figure 6.10). It is usually identified by a switch labeled "+48 volts."

Pickup Patterns Another microphone classification is the pickup pattern. The **pickup pattern** is the direction from which the microphone will pick up sounds. Think of a mic pickup pattern as describing the way in which a microphone hears. The pickup pattern is one of the most common criteria used when selecting a microphone. Following are three common patterns:

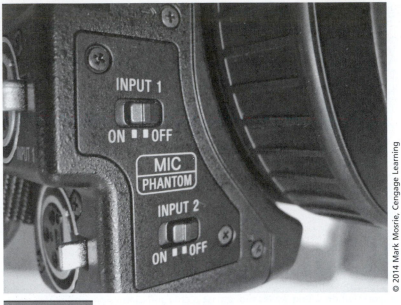

© 2014 Mark Mosrie, Cengage Learning

The phantom power switch lets you power certain microphones from the camera or audio board.

- **Omni-Directional** Microphones with this pattern are designed to be sensitive to sounds from all directions (see Figure 6.11A). This pattern is a good choice when all sounds are desirable. An omni-directional microphone works well in an interview situation if you want to pick up sound from more than one person with one microphone. It is important to consider the potential problem that you may have isolating sounds from a specific direction.

- **Cardioid** This pattern is sensitive to sounds in a heart-shaped area (see Figure 6.11B). This is a good all-purpose pattern that can help reject sounds

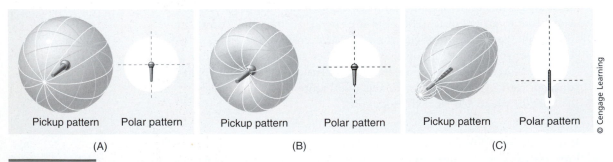

© Cengage Learning

(A) Omni-directional mics are designed to be sensitive to sounds from all directions. (B) Mics with a cardioid pickup pattern are designed to be sensitive to sounds from a heart-shaped pattern. (C) A mic with a hyper-cardioid pickup pattern is designed to be sensitive to sounds from a specific direction.

coming from unwanted areas. A cardioid mic is a good choice when you need to isolate sounds from most directions but need some flexibility if the talent moves slightly.

- **Uni-Directional** Microphones with this pickup pattern are sensitive to sounds from a specific direction and reduce or reject sounds from other directions. Several specific patterns are classified as uni-directional, such as hyper-cardioid (see Figure 6.11C) and ultra-cardioid. **Uni-directional** mics are also sometimes referred to as shotgun mics. **Shotgun** mics are very sensitive and do a better job of picking up sound from farther away than other mics.

Operational Type A final characteristic of microphones is how they are used. The following describes various microphone types and their use.

- **Lavaliere (lav) microphones** (see Figure 6.12) are attached to the talent using a clip. They are an excellent choice for live talent as long as there will be minimal movement. Lavaliere mics are the *de facto* choice for interviews, reporter stand-ups, and talk shows. A side benefit of a lavaliere is that it does not create shadows like those a microphone stand or boom can cause. In a number of professional situations, you may notice that a person appears to be wearing two lavaliere microphones. This redundant, or double-miking provides a backup if the main mic breaks or loses power.

- **Wireless microphone** (see Figure 6.13) systems require a transmitter and a receiver. A wireless is practical for setups where cables may be a problem or in situations where the talent needs the freedom to move. A plug in transmitter (see Figure 6.14) can turn any mic into a wireless one with the correct receiver.

 Certain etiquette should be followed when a wireless mic is used. Sometimes talent can forget the mic is on when they leave the set. If a person wearing a wireless mic needs to engage in some sensitive conversation with another person, he or she should be warned to turn off the

© 2014 Mark Mosrie, Cengage Learning

FIGURE 6.12

Lavaliere microphones are small clip-on mics that are an excellent choice for voice pickup.

FIGURE 6.13

Wireless mics are a good choice when the talent must move on the set.

FIGURE 6.14

The wireless transmitter is a device that sends the signal to the receiver. It can be used with most types of mics.

microphone. It is a good practice for production personnel to turn the power switch off when the talent is not on camera.

A **handheld** or stick microphone (see Figure 6.15) can be useful for production situations when the mic does not need to be hidden and an interviewer or on-camera spokesperson is involved. The mic can also be mounted on a table stand to pick up audio from a presentation or a panel discussion. A dynamic handheld mic is excellent as a backup on almost all shoots. Its flexibility and the fact it requires no external power ensure that it will work well for a variety of applications.

- **Shotguns** (see Figure 6.16) are highly directional microphones. These types of microphones are commonly mounted on a microphone stand or are handheld using a device called a fish pole (see Figure 6.17) or boom. Although shotgun microphones can pick up sounds from longer distances than most microphone types, it is still critical to get the mic positioned as close to the scene as possible. It is also common to use a shotgun mic mounted on a camera to collect natural sound.

© 2014 Mark Mosrie, Cengage Learning

FIGURE 6.15

A general-purpose handheld mic can be used in situations where the mic does not have to be hidden.

© 2014 Mark Mosrie, Cengage Learning

FIGURE 6.16

A shotgun mic is a directional microphone that can pick up sounds from further away than other types of mics.

© 2014 Mark Mosrie, Cengage Learning

FIGURE 6.17

A shotgun mic can be attached to a boom pole for situations where the mic needs to be extended to get closer to a scene. This particular unit also includes a windsock, sometimes referred to as a dead cat.

© 2014 Mark Mosrie, Cengage Learning

FIGURE 6.18

The boundary microphone is a low-profile mic that can be hidden in a scene. Its omni-directional pickup pattern makes it useful for collecting sound from all directions.

- **Boundary microphones**, also commonly called **PZM** (Pressure Zone Microphone) typically feature an omni-directional element that is mounted slightly above a metal plate (see Figure 6.18). That metal plate can sit on a table or the floor, or be mounted on the wall. It provides a very low profile mic that can be easily hidden in a scene. The PZM is effective for miking a panel discussion or a group of people sitting at a table. A potential problem is the amount of noise that the PZM can pick up from its placement on a table or the floor. Any tapping on the surface will generate noise that may be picked up by the microphone. It is possible to minimize this problem by cushioning the mic with a soft material, such as a mouse pad, to provide a barrier between the table surface and the mic.

Microphone Selection

Microphone selection is usually dependent on what specific microphones you have available. As you plan your production, be sure to include some discussion of microphone selection along with the shot list, composition, and lighting. Determining if the mic needs to be hidden, clipped to the talent, wireless, or selective in the direction it picks sounds up are critical questions to answer before the day of shooting. What might work well in one situation may be problematic in another.

An audio engineer will consider type, construction, pickup pattern, and the requirements of the shoot in selecting a microphone. For example, a wireless lavaliere with an omni-directional pickup pattern is a good choice for on–camera narration. A uni-directional shotgun mic might be a good choice for a narrative scene with talent walking across the set. Understanding and considering these criteria for each shoot will help you make better choices for sound collection in the field.

Microphone Placement

When placing the microphone for every shot or scene, certain technical factors should be considered. The mic must be close enough to the talent to record

good audio. The story also dictates where you place a mic in a scene. Pick 2 Productions will use lavaliere mics for any formal interviews and make a last-minute decision regarding any informal interviews. If possible, the lavs will be used, but the shotgun will be available if the situation warrants it. For the dramatic scene, shotguns will be used, since it is not appropriate to have lavaliere mics clipped on the talent. Such a microphone would be incongruous with the nature of the scene. In thinking about mic placement, you should balance the needs of the story with the technical requirements.

After determining whether a visible microphone is acceptable, you can decide on proper placement techniques. Common sense dictates that the talent must be facing the microphone and be within the pickup pattern and range of the mic.

While placing mics in a scene, it is important to remember that as the distance from the mic to talent doubles, the sound level reduces to one-quarter of its intensity. This is known as the **inverse square law**, and it can dramatically alter the sound level. Keeping the microphone as close as possible is essential, and not paying attention to this almost always causes problems during post production. **Perspective** is another factor to consider for each scene. For example, if you have an extreme long shot of two people who are far from the camera, the sound should reinforce the distant feeling. If you cut to a closer shot of them, follow the impact of the visual with an appropriate change to the audio. Finally, tonal quality will not be the same in different environments. Because sound reflects differently off hard surfaces than it does in rooms treated for sound acoustics, the placement of the mic must be considered. Matching tonal quality between shots can sometimes be controlled during recording. In other cases, it must be tweaked during the post production process.

Positioning of the mic either assists or detracts from the story. In a handheld interview situation, the mic should be 12 to 18 inches from the talent, and just slightly below the mouth. Placing the mic too close will probably cause popping *P*s and sibilant *S*s at the very least, and distortion at worst. Moving the microphone too far away results in hollow-sounding recordings with low signal levels. If you try to boost those levels in post production, you will also increase the amount of background noise in the signal. The mic pickup pattern will dictate whether the mic needs to be pointed directly at the talent or not. For example, with an omni-directional pattern, the mic can be positioned so that it can collect sounds from multiple directions.

Framing of the camera shot will influence lav mic placement. If a medium or medium close-up shot is being used, it is possible that the mic can be placed just out of frame. If this is not possible, carefully placing the cable inside the talent's shirt, blouse, or sports coat should be considered. Unless you have a mic that is designed for hidden applications, do not try to hide the mic underneath clothing. This will muffle the sound and induce unintended noise such as clothing rubbing against the mic. It is both acceptable and preferable to have the talent run the mic cable inside their clothing themselves. As a production professional, provide verbal guidance to the talent as they run the mic cable. As Figure 6.19A shows, clipping the mic on someone's shirt can be done in a neat

© 2014 Mark Mosrie, Cengage Learning for (A), (B), (C)

(A) (B) (C)

FIGURE 6.19

(A) Notice how the lav mic is properly attached and dressed off. (B) This lav has the clip reversed so it can attach to a woman's blouse. (C) Always place the mic clip on the side of the coat that the talent will talk toward.

and effective manner. Carefully looking at how the actual clip attaches to the mic reveals that the clip can be detached and turned 180 degrees (Figure 6.19B). This places the clip in the opposite direction depending on whether the talent is male or female, since shirts and blouses have the opposite side (left or right) overlaying the other. It is also important when placing the mic on the lapel of a sports coat to put it on the side that faces the direction in which the talent will be talking (see Figure 6.19C). This will ensure optimum sound, since the talent will be facing the microphone. Even with a high-quality mic, if the talent speaks away from—rather than across—the mic, there will be a noticeable difference in the audio quality. If the talent is wearing a t-shirt, consider clipping the mic on the outside of the shirt, about chest high, and then framing the shot so the cable and the mic are out of the shot. Another choice would be to run the cable under the shirt and use a vertical clip (see Figure 6.20). Using a wireless microphone allows for great freedom in those cases where the talent must move within the scene.

© 2014 Mark Mosrie, Cengage Learning

FIGURE 6.20

Lav clips come in horizontal and vertical orientations, and can be changed for specific situations.

Use of a shotgun microphone does not mean that mic placement is not important. Videographers and sound engineers try to position the mic so that it is slightly out of the frame. When using a fish pole, it is easy to position the head of the mic just out of camera sight. The crew member holding the fish pole can slowly move the mic closer to the talent until the videographer sees the mic in the frame. At that time, the mic can be pulled back slightly. This is not difficult with careful planning and continual observation during the shoot. In addition to distance, you must carefully monitor the direction the tip of the microphone is facing and understand how directional and sensitive the specific mic is. Visualize pointing and extending the mic towards the talent's mouth. This should help you as you attempt to point the mic in the correct direction. It is common to mount a shotgun mic on a fish pole (see Figure 6.21) for better control and reach. Holding the fish pole for an extended period of time can be difficult if you have your arms stretched out and are trying to avoid getting in the shot or having a shadow from the pole cross through the frame. Try positioning yourself so that you can keep your arms in a comfortable position. Likewise, even the smallest tapping on the pole can cause vibrations that affect the actual sound being recorded.

While use of a camera mic is almost always discouraged, this mic can be used on certain occasions. Most built-in mics are designed to pick up sounds within several feet. Action that takes place further than several feet causes sound levels to be low, requiring levels to be boosted. This boost may induce additional noise.

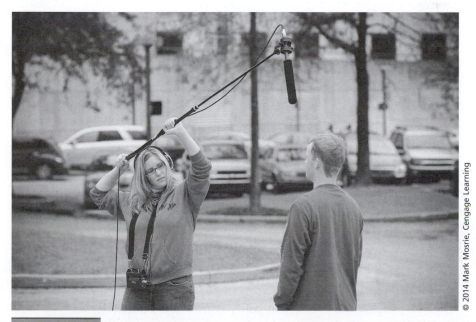

© 2014 Mark Mosrie, Cengage Learning

FIGURE 6.21

The boom/fish-pole operator must move the mic as close to the scene as possible. It should be held in a comfortable and steady position.

© 2014 Mark Mosrie, Cengage Learning

FIGURE 6.22

While most camcorders have a built-in mic, some allow an external shotgun mic to be attached for better sound.

Good mic placement requires a much smaller distance between the mic and the talent than the camera mic can provide.

Most cameras have a built-in mini or XLR mic jack that allows the option of placing a high-quality shotgun mic on the camera (see Figure 6.22). Even with this setup, the same basic issue persists with microphone-to-talent distance. Therefore, most professional videographers only use this type of mic placement to pick up natural sound.

Being an on-location sound engineer is challenging, as you must select the appropriate microphones, position the microphones effectively, and adjust recording levels during the actual recording. It is absolutely critical that the person in charge of the sound wear good quality headphones. MP3 player ear buds may be good as an emergency backup, but they do little in isolating extraneous sounds when important audio is required. Monitoring the recording includes getting proper recording levels as well as eliminating unwanted sounds.

Related Interactive Module

Microphones

AESTHETIC CONSIDERATIONS FOR AUDIO

Audio is the thing that kills you the most. People can sit through anything visual but they can't sit through bad audio— they squirm in their seats. You cannot sacrifice audio.

JAY JOHNSON, DIRECTOR

Dialogue/Narration

Dialogue and narration are the most utilized elements of the sound track. They can be recorded simultaneously with the video, prerecorded, or added during post production. Dialogue is most commonly recorded simultaneously with the picture, while narration can be written and recorded as a voice-over or with on-camera talent. In all instances, microphone selection is an important consideration. Effective technical procedures should not be your only concern during the recording of dialogue, narration, or other sound-track elements. Careful consideration of the type of voice you would like for narration may be one of the most important elements of the production. Is it a male or female voice? Is it a young or old voice? Once you know the type of voice and have the person to provide that voice you can turn to your script preparation.

Recording Dialogue Dialogue recording is one of the most challenging aspects of a field shoot. Microphone placement requires constant attention since the audio engineer is usually working around the camera shots that are being composed. This means moving further away for wide shots and trying to match the sound characteristics and proper perspective within a scene. The audio should be recorded for each camera angle with an emphasis on getting consistency with each take.

The use of a field mixer (see Figure 6.23) allows multiple microphones to be plugged into the camcorder and offers individual level adjustment for each

© 2014 Mark Mosrie, Cengage Learning

FIGURE 6.23

Using a portable battery-operated field mixer lets an audio operator control the levels of multiple microphones at the same time.

mic input. In addition, the audio engineer can easily monitor and adjust levels at the mixer and not have to continually worry about the audio levels at the camera. This is accomplished by calibrating the audio levels on the camera to a 0 VU tone sent from the mixer before the recording begins. Once the camera audio levels are matched to the tone, the audio person can be assured that the sound level at the camera is reacting the same as at the mixer. One potential drawback to using a mixer is that some mixers combine all the incoming signals into one outgoing signal. This can limit your choices in post production as the different mic signals will be combined into a monaural track.

Recording Narration Have a typed, double-spaced script with a minimum 12-point simple font using upper- and lowercase letters. Be sure to include the pronunciation of difficult or unusual words as well as technical terms. For example, Staunton is a small town in the Shenandoah Valley of Virginia. The name of the town is pronounced STAN-ton, not STAUN-ton. In addition to the pronunciation guidelines, have someone on the crew follow along during the taping. This person should be either the writer or content expert. This technique will help catch problems that the producer or the director may miss. Decide ahead of time if narrator errors will be edited live or after completion of the entire recording session. Editing live means that if the narrator makes mistakes or the director would like a second take, you interrupt the flow of the narration to record a new version of that particular track. The alternative is to read through the entire script and then go back to make any changes. If possible, edit live. This will make the next phase of post production go more smoothly. You might consider making exceptions to editing live if the talent has limited time, continues to make frequent mistakes, or is a professional being paid by the hour. When recording the voice-over, remember to consider the pacing of the program. It is generally possible to change the pace of the delivery during post production, but your job is easier if you get the pacing right when the voice-over talent is delivering the lines.

A test recording should always be completed before your talent arrives. This can ease your concerns and ensure a smooth production. Schedule at least twice as much time as the length of the script. If you have a 30-minute script, you will probably need an hour or two to finish the recording. Always isolate live recording sections. In other words, record the narration as a separate, independent audio signal. Do not try to mix music or other audio with that narration while you are recording. Save all the mixing for post production. Consider recording a narration directly to your video camera. Plug a good quality mic into the camera and point the lens toward the narrator so you can see the lip movement of the narrator while editing. Another good choice if you have an isolated voice-over booth is to record to a digital audio recording system or directly into your nonlinear editing system.

Interviewing Interviewing is one of the more common elements of a video documentary or news story. Recording the interview is the ultimate balancing act of story and technical concerns. You may get the greatest content in the world in an interview, but it may be useless without good audio, proper shot composition, and good

lighting. Conversely, you may have the greatest lighting, audio, and shot composition in the world, but the interview is useless without good content. Interviewing might seem like a simple task, but it can be one of the more difficult setups for the novice. An interview requires research, planning, coordination, and error-free technical production to achieve the best results. Care must be taken with numerous details, ranging from the relationship with the interviewee to the proper audio recording levels. Chapter 1 covered the nontechnical aspects of an interview. In addition, a number of other tasks and procedures must be completed by the production crew.

Scheduling an interview can be complex as you juggle production crew and talent schedules. Adequate time should be budgeted for proper set-up and final testing. You do not necessarily need access to the interviewee during this time, but you *will* need access to the interview location. This should be clearly communicated when you schedule the interview. Location surveys and equipment checklists will help ensure that you arrive with the appropriate equipment and that you have a plan if the location needs additional set-up time for lighting, arranging furniture, or other tasks specific to the interview.

While some crews make a test recording before leaving their facility, others set up early and test before conducting the interview (see Figure 6.24). If you are doing the latter, it is important to know whether you can react and adjust if you have a problem. Test recordings should certainly include playback of the

The sound technician should check all equipment before the production begins.
SOURCE: Courtesy of author, Ron Osgood.

test to ensure that everything is working. In keeping with the adage "hurry up and wait," it is sometimes a nice idea to have everything prepared, and to allow your crew some downtime before the interview begins. It is a better feeling to know that everything is working before the subject shows up than to rush around completing the setup while the subject waits.

You will get the best interviews when the subject is relaxed and at ease. You can facilitate this by introducing the interviewee to the crew and providing the person with some bottled water. Just before beginning, check the talent's physical appearance and make sure his hair looks acceptable, his tie is straight, his posture is good, and anything else the crew might observe that would be awkward for the talent to see during replay. If you are suggesting that the talent brush his hair or adjust his clothing, you can explain that you want him to look his best on the video. Have a release form available for those programs where one is required. If you have forgotten one, get an address to send one to afterward. It is also a good idea to ask him to state his verbal permission once the recording has started.

As the time approaches for the actual interview, the crew should make some last-minute checks. Besides logical camera tests, always check audio levels at the meter, and monitor the recording with headphones. Make sure you have enough blank tape or media cards for the entire interview. Consider the physical environment in which you are recording to avoid or control potential distractions like a ringing telephone, a noisy air conditioner, or a computer monitor with a screensaver that is visible in the frame. You might consider turning appliances or electronics off to control unwanted sounds. It is critical to conduct a sound/mic check by asking the talent a question. Avoid the technique of asking the talent to "count to ten." This might ensure that the mic is working, but this artificial test won't get the talent talking at the same level that he or she will actually speak during the interview.

Take advantage of the multichannel audio feature found on many cameras by recoding the interview on separate tracks. Perhaps set the audio levels slightly differently so that you have options if the person gets quieter or louder during the interview. You might also mic a sit-down interview with a lavaliere on one channel and a hidden boom on another. Two different mics may give you choices in tonal quality.

After the interview is complete, the crew should confirm that the sound and picture are technically acceptable. The director should be sure all pertinent information was communicated through the question and answers. It is always a good idea to review part of the interview before you leave the location. Don't be afraid to ask the talent to redo parts of the interview that might be unusable due to content or technical difficulty. In addition, make sure to label the media and write down any notes and reminders you might forget after leaving the location.

Any field shoot is made more difficult by working alone. If you are the only person on the shoot and you must set the lighting, operate the camera, monitor the audio, and ask the questions, it can be difficult to get a good interview. This "one-man band" concept occurs quite frequently in small-market television news. If you find yourself the only person on an interview shoot, the following tips might prove helpful. First, frame your shot a little looser than normal. This will allow the interview subject a bit of space in which to move during his or her answers. Obviously, such movement would have to be small, so as not to require

an adjustment of the camera, but you can also ask the person to sit still as he or she answers. Wear headphones to monitor the audio, just as if you were only the videographer on the shoot. Because you are the interviewer, it is important to focus on the content of the interview as well as the technical side. You might want to sit as you normally would during an interview if you had additional crew. With the looser framing, the interviewee sitting still, and you wearing the headphones, you should be able to get a good interview.

Natural Sounds and Sound Effects

Listen to the sounds around you for a minute. Is it quiet? Is it silent? What seems like silence is really the ambience of the environment. These sounds represent a powerful element of the sound track. Using studio-recorded narration or dialogue without this ambience will certainly give the program a hollow, sterile feeling. While it might seem that having no competing sound underneath a voice-over is best, the lack of natural sound is conspicuous in its absence.

A well-produced sound track should contain the subtle sounds that match the visuals. An image of ocean waves hitting the shore will have much more impact when the viewer can actually hear those sounds. The intensity of a city scene will be heightened with the sounds of that exciting and busy environment. Such natural sounds add an element of realism to your story. If you were standing in that location, you would hear those sounds. Therefore, when you take the viewer to that location, the viewer should also hear those sounds. With this in mind, the method used to record the sound is important to consider.

When sound is recorded, the volume may not be the same as if it was heard directly by the human ear. Because of this, it is important to control the levels and quality of the natural sound. For example, if the babbling brook in the background cannot be heard, an additional recording should be made. This recording can be added to the sound track during post production. If you are recording a scene with busy city street traffic in the background, it might be difficult to control the background sound in relation to the foreground dialogue. It is usually not possible to control real-world sounds, so tough decisions might need to be made. Perhaps you can change the location, use a different microphone pickup, or shoot at a less busy time. Regardless of your decision, the background sound is essential for the mood and setting of the scene. Because you can control both the foreground and background sound in post production, you will be able to direct the viewer's focus in the way you mix these elements together.

Another sound issue during field production is the actual change in ambience from cut to cut within a scene. In the traffic example, when the scene is edited, different truck and automobile sounds continually pop in and out. Hearing an ambulance siren on every piece of dialogue from one person and none on the reverse angles of the second person can be a challenge to the editor. Recording ambient sound at every location can help alleviate this potential problem. Having a piece of sound without the dialogue that can be inserted on additional audio tracks during post production will help mask the changes between cuts. This practice is known as recording room tone. It is a good idea to record

approximately one minute of room tone at each location. This process will give the editor some raw material to build sound loops or cover up any artifacts that may occur as a result of editing the piece together.

But what do you do if you need the sound of a rocket being launched or a charging herd of wild buffalo? Those types of sounds might be impossible for you to personally collect. One possibility is to use production sound-effects libraries. Generally, the same companies that provide music libraries (discussed in the following section) also provide sound effects. Having a sound-effects library can be a quick and effective method to give your story a little edge in quality. A second method is to re-create the necessary sounds. Close your eyes and crinkle a piece of paper. What does it sound like besides paper being crinkled? Or pull apart a piece of Velcro. Does it bring a picture to mind? How about re-creating the sound of someone walking on a gravel path? A small box of gravel can easily be kept in a studio and free you from the task of actually finding the proper location for this simple sound. Natural sounds and sound effects can be created through a process called **Foley**. This technique is named after Jack Foley, who was a sound editor for almost four decades at Universal Pictures. This technique can help control the sound and provide a safe setting for dangerous actions. Unnatural sounds, like aliens or spaceships, can also be creatively added through this process.

Music

Music serves a variety of purposes in a video program. The more common uses include creating a mood, setting the pace of the program, transitioning between scenes, and as background.

The process of adding music to the sound track should be considered before the production process begins. Will the music be mixed with narration as part of a documentary? Will theme music for an episodic series be added during the post production process? Are the visuals matched to the beat of the music? As you can tell from these basic questions, the process of music selection must be considered during the preproduction phase.

The goal in the music selection process is to determine the mood or effect desired and then to locate music that fits these criteria. Instrumentation and beat are key elements in the selection process. While an audio clip with heavy percussion has a definite and driving beat, a piece of music based on string instruments has a totally different feeling. Adding light classical music to an automobile chase scene creates a psychological barrier that may confuse the viewer, since the action and sound track seem to contradict one another. On the other hand, this might be exactly what the director wants to happen since it may promote thought and awareness of an issue or concept. Finally, adding a piece of music with vocals is certainly appropriate for a music video or as the main sound source during a montage, but for general purposes the vocals can detract from the effectiveness of the scene.

It can be time-consuming to identify and acquire music for a production. While style and theme are obviously important, obtaining legal rights to the

music is critical. If copyrighted music is selected, a license must be obtained from the copyright holder. (Music licenses were covered in Chapter 3.) An alternative is to create original music or to contract with one of the numerous companies that provide royalty-free music. Numerous companies provide music in every style and format you can imagine. While some companies provide a buyout option, many provide a lease or are licensed through a pay-per-use option.

Recording Music in the Field When the producer and director for Pick 2 Productions agreed to shoot the live performance, they realized that there would be some potentially difficult situations to manage. If you are recording live music in the field, you have several choices and questions to answer. The main question to consider is how you will be using the music in your finished program. If the music is mostly for background and is not a featured element in the production, you can probably use a shotgun mic to collect the natural sound of the music. The key to this type of recording is getting decent sound from the band without a lot of crowd noise. Staying close to the stage will help with that. Also, record at least one entire song without stopping. That will give you a longer segment of natural sound to use to make the scene edit together more smoothly. If you constantly start and stop the recording, it will be difficult to make the background sound match up correctly from shot to shot. Having an entire song recorded will alleviate that worry. If you will be featuring the live music in the production, such as a documentary on the band, you should consider getting a feed from the house audio system. All the band's instruments and vocal mics will likely run to a mixer. Getting a feed from that mixer will give you the best quality audio.

Several issues are related to a feed from the house audio system. First, you will have to address the issue of a mic-level or line-level feed from the board.

STORY 6.1 Recording Live Band Audio for Video

My primary audio production and engineering experience involves recording and mixing albums in a controlled audio production facility, but I love the challenge of a live recording.

I was hired by John Mellencamp to record and mix the audio portion of a live video session to be used in a documentary DVD about the making of his *Trouble No More* CD. This CD has a particular vintage sound quality. My job was to make the live performance sound like the CD. I decided to bring in additional audio equipment to capture the live performance in a way that provided me with enough sonic options for post production mixing.

When dealing with an audio for video session, there are several considerations. During live taping I record to multitrack so that I can later sweeten the tracks in the studio to make the audio feel more like a finished album.

I must also consider the way the setup looks, as well as the way it sounds. For example, I use fewer microphones and smaller profile mics than normal. This helps to avoid cluttering the visual space. Also, any time you are recording audio that will later be synced back to video, it is important to make sure to capture a time code track. In the Mellencamp session, we took a time code signal from the main video deck to run the clock inside the multitrack recorder.

After the shoot, I took the tracks back to the recording studio and used vintage compressors and equalizers to sweeten the sounds to match the sonic quality of the *Trouble No More* CD. Once the tracks were mixed, I was able to provide the video editor with a stereo audio track that sounded as good as the video looked.

SOURCE: Paul Mahern, Audio Producer/Engineer

More than likely it will be a line-level, but you will need to make sure when you connect your cables. Second, the location of the board and the cable requirements might be less than desirable. You could try running a longer cord to get into the best shooting location. That may be difficult if there will be a live audience at the show. Another option is to use a wireless transmitter to send the feed from the board to your camera. That will give you the freedom to move about and still collect good audio. The house audio feed typically is designed to get the sound to the speakers, and is geared more for that sort of output rather than clean sound for a video production. If the feed you get has already been amplified, there will be more noise in it. It is sometimes possible to get a pre-amplified feed. That means your signal is coming out of the audio mixer before it moves to the amplification stage of the process. This gives you a cleaner feed with much less noise than other feeds.

CONCLUSION

Successful audio begins in the preproduction stage. After careful planning, you can begin to make the basic technical and aesthetic decisions necessary to recording good audio in the field. Understanding how sound works and the various audio signals will help you make good decisions. Many factors impact microphone selection: impedance, pickup pattern, construction, and operation type. After deciding on the proper microphone, the placement of the microphone in the scene is important. Once you have made your technical decisions, you can turn to the aesthetic aspects of the audio. The integration of all the sound elements, including dialogue, interviews, natural sound, sound effects, and music, are all important for a successful program.

Even with the best-laid plans, the audio will always be a challenge during your field shoot. Being able to think quickly and troubleshoot problems in a systematic manner will greatly aid in the resolution of the problem.

Story Challenge: Audio

Pick 2 Productions had several important decisions to make regarding audio acquisition. The decision to shoot formal interviews using lavalieres was a good idea since the sound quality was clear and recorded at a consistent level. Several interviews were shot in an informal setting using a shotgun mic. This worked well because it allowed band members and stage crew to continue setting up while talking. The shots had realism to them because of the visual interest, and a variety of natural sounds was collected along with b-roll. In addition, several shots were completed to acquire a room tone so ambience sounds would be available. A few takes of the songs were also recorded all the way through so the music would be available. Some of these were taken from a line level output through a mult box. All in all, the director was pleased with the results under some demanding conditions.

The following list covers the procedure Pick 2 Productions used before recording began:

- Carefully choose a microphone for the shoot. If you want to pick up all the natural sounds in the area, use an omni-directional. If you want to suppress extraneous sounds, try using a uni-directional. Use a fish pole to get the mic as close to the source as possible.

- Listen to the environment before recording. You will be surprised at what you hear if you listen for a few seconds.

- Stage your action to keep wind noises and other distractions at a minimum.

- Always make a test recording and listen to the playback.

- Always monitor the sound through headphones during the shoot.

- Always record natural sound while recording b-roll. Use the built-in microphone or attach an external microphone.

- Record a few minutes of ambience, or room tone, to assist the editor during sound mixing.

- Start interviews with some conversation. Once recording begins, ask the guest to spell his or her name.

Lighting in the Field

Lighting is okay until it hits something.

E. CARLTON WINKLER, LIGHTING DIRECTOR

OVERVIEW

As with any of the crafts of television, lighting technique should be transparent to the viewer. Unless an attempt is made to draw attention to the lighting, viewers usually only notice it when it is done poorly or not considered at all. Using light is both a science and an art. In terms of the science, there must be enough illumination for the camera to see. In terms of the art, you can use lighting to create interesting space, control shadows, and sculpt a scene. The decision to supplement existing lighting with lighting tools is an important step in the process. It can be tempting to get by with available light, since today's cameras are very sensitive and can technically reproduce an image with very little light. Because of this, the production crew must analyze the situation, consider the quality of the existing light, and plan accordingly. Before considering the techniques of lighting, it is important to understand why we use supplemental lighting. Then we will discuss lighting tools, basic rules, and specific lighting challenges.

Story Challenge: Lighting

Lighting presents many challenges, but also great opportunities to enhance storytelling. The Pick 2 production team has several issues ahead of it as the director and others consider some of the lighting issues. Among the questions they need to answer:

- What lighting style or styles will be used in each of the three programs?
- How will various videographers maintain a consistent lighting style through each production?

- Will the standard concert lighting package that the band normally uses for its stage show provide sufficient light for the video production of the DVD?
- What is the best way to light the chroma key shots that will be used in the documentary?
- How can the crew create the kinds of dramatic lighting effects indicated in the storyboards for the music video?

PROVIDING ENOUGH LIGHT

One might assume that the lighting is acceptable when casually looking through the viewfinder of a video camera. Because some cameras perform so well under low-light conditions, it is easy to consider the image acceptable. Even though every camera has specifications for the optimum and minimal amount of light required, the quality and direction of the light is just as critical. Consider that most office lighting comes from lights that shine down directly from above. This light may be bright, but it does not flatter facial features and it creates distracting shadows. Additional lighting will add to the richness of the image, allow better manipulation of depth of field, and provide greater flexibility in the production of your story.

Modern High Definition (HD) and DSLR cameras, present some unique challenges and opportunities to the lighting director. The lighting requirements differ from older cameras and are much more critical with regard to color. Higher-resolution images offer more latitude in manipulating the depth of field as well as permitting a wide range of contrast. **Contrast** is the difference between the darkest and brightest part of the video image.

Measuring Light

The amount of light is measured in **foot-candles**. Using a scientific standard, one foot-candle is the amount of light a candle emits as measured from a distance of one foot. Another term for measuring light is lux. **Lux** is the metric term, and is equivalent to approximately 11 foot-candles.

A light meter is used to measure the number of foot-candles in a scene (see Figure 7.1). Two distinct types of measurement are common using the light meter. Pointing the light meter from the scene toward the lights results in an **incident reading**. It tells how much light is falling on a scene (see Figure 7.2). This measurement should coincide with the specifications for the camera and for the lighting look you hope to achieve. The second type of measurement is used for reflected light. Pointing the meter from the camera's perspective toward the scene and checking the reading will indicate **reflected light** (see Figure 7.3). The reflected reading will be much lower than the incident reading, and will vary greatly depending on the colors and reflectivity of the materials at which it is pointed. A reflected reading is used to ensure consistent base light or to

FIGURE 7.1

The light meter measures the amount of light in foot-candles.

check the contrast level of the scene. Knowing the contrast level is important because television has a limited contrast ratio. The camera has a hard time reproducing a full contrast range on the luminance channel if your shot has high and low reflective elements within the frame. Highly reflective elements cause the

FIGURE 7.2

Holding the light meter near the subject and pointing it toward the lights creates an incident light meter reading, which determines the number of foot-candles falling on the subject.

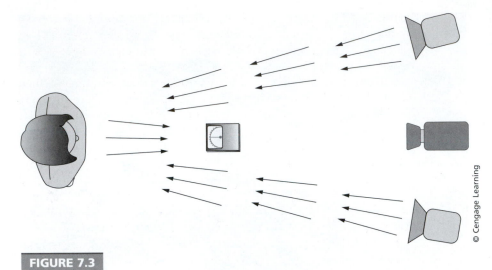

FIGURE 7.3

Holding the light meter away from the subject and pointing it at the subject creates a reflected light meter reading. This helps determine the contrast ratio and the amount of light bouncing back from the scene.

iris to close, rendering the black elements too dark. Low reflective elements cause the iris to open, making the brighter areas overexposed. After checking the scene with the meter, you can adjust the lighting accordingly.

Color Temperature

Color is the result of a specific frequency of visible light. Isaac Newton demonstrated that when you combine all the colors that make up sunlight, it appears to be white to human eyes. White light has equal parts of all colors. When there is a rainbow, you can see many of the colors that make up this light. Water drops refract the light and allow us to see white light broken down into some of its component parts. Video cameras do not interpret color the way the human eye perceives it. Most artificial lights look red to the camera, while the sun looks blue. **Color temperature** is the relative redness or blueness of light as measured in degrees Kelvin (°K). The higher the color temperature, the bluer the light (see Table 7.1). Color temperature is rated using a scale developed by a nineteenth-century British physicist named Lord William Thomson Kelvin.

TABLE 7.1 Common Color Temperatures

Incandescent—2800 °K
Quartz—3200 °K
Fluorescent—4500–6500 °K
Daylight—5600 (average) °K

White Balance Video cameras must be calibrated in order to accurately reproduce color. This is accomplished through the use of color filters and an electronic circuit that "white-balances" the camera to the type of light it sees. Some professional cameras have a filter wheel adjustment that can be set for different types of lighting. The knob can be rotated to the proper position and then the process of setting the white balance can be completed. The procedure requires the videographer to point the camera at a white object under the exact lighting conditions being used for the shoot and press the white balance switch on the camera (see Figure 7.4). This procedure tells the camera how white should look under the given lighting conditions. Once the camera has that information, it can create all the other colors accurately. The white balance will remain correct as long as the lighting does not change. If the lighting changes, a new white balance must be performed. Consumer camcorders have either a switch that can be set for indoor or outdoor lighting or an automatic circuit that attempts to set the proper white balance when the camera is turned on. While this system is convenient, it is not always precise.

Shooting Outdoors The sun may seem to provide an excellent source of light, but in fact it can create a number of difficult situations. The sun is always moving in the sky and the color temperature changes throughout the day. This requires constant attention to the white balance throughout a long day of outdoor production. The brightness of the midday sun is another challenge. It tends to wash out the image and causes harsh shadows that require additional time to control. Therefore, filmmakers prefer shooting at a time known as the magic, or golden, hour. This is the brief 30- to 60-minute time frame that surrounds sunrise and sunset. The quality of light during these times produces beautiful images. Besides the magic hour, cloudy days are another good time to shoot outdoors. The clouds diffuse the light to provide soft, even lighting.

© 2014 Mark Mosrie, Cengage Learning

FIGURE 7.4

After selecting the correct filter and pointing the camera at a white object in the exact lighting conditions as the shot, the videographer can complete the white balance.

Shadows

Controlling shadows is another objective of a lighting plan. Some shots call for controlled shadows, while others necessitate the use of shadows in support of the story. When controlled properly, shadows can help create depth, add texture, or define shapes. If you are trying to control shadows, try to keep the subject at least 6 feet away from walls. On a sunny day, moving the talent into a shaded area can be a good idea, but be careful that streaks of light don't cause shadows on the face (Figure 7.5). Remember the field of view (video space). If a shadow falls outside the field of view, it doesn't matter, since the audience will not see the shadow.

Falloff is the change from light to shadow. Objects with a gradual change from light to dark have slow falloff (see Figure 7.6A), while objects with a

(A) (B)

© 2014 Mark Mosrie, Cengage Learning

FIGURE 7.5

(A) Moving the talent into a shaded area on a sunny day can be a good idea that will help produce even lighting. (B) Be careful that streaks of light do not create shadows on the talent's face.

(A) (B)

© 2014 Mark Mosrie, Cengage Learning

FIGURE 7.6

(A) A diffused light source produced the soft light and slow falloff seen in this image. (B) A spotlight with no diffusion produced the hard light and fast falloff seen in this image.

sudden change have fast falloff (see Figure 7.6B). Fast falloff is used for a suspenseful or dramatic shot. Slow falloff produces a more subtle change and softens the light. The type of lighting instrument influences the amount of falloff.

Evaluating Light

A light meter registers the amount of light in a scene. The only way to truly evaluate the quality of the light or determine if it "looks" the way the story demands is to check it on a video monitor. Once the camera and lights are set up, the director and videographer can review the lighting by using a monitor. The LCD panels that are part of most consumer and prosumer cameras are adequate for this practice; however, this type of LCD monitor does not have high resolution and the reflectivity from the sun can make them difficult to see outdoors. Using the viewfinder or an external video monitor will display the most accurate reproduction of the image.

LIGHTING TOOLS

A variety of tools are available to supplement existing lighting. In addition to lighting instruments, there are accessories for diffusing, shaping or blocking light, adding or changing color or effect, and mounting/attaching the lights. Before discussing those tools, however, it is important to understand the main differences between hard light and soft light.

Light Quality

A **soft light** produces a diffused beam of light, creating subtle shadows and slow falloff (see Figure 7.6A). Soft light provides excellent lighting for interviews and offers a good solution in situations where sharp shadows may not fit with the story aesthetic. A **hard light** is one that produces a distinct beam of light with very sharp shadows. It is typically transmitted from a focused light source and creates fast falloff (see Figure 7.6B). A cloudy day diffuses the light, producing few shadows. On the other hand, the sun on a cloudless day produces a very hard light, which creates distinct crisp shadows. The dichotomy of hard and soft light is often used as a description for many of the lighting instruments and tools discussed next.

Lamp Type

The three main types of lamps used for portable lighting fixtures include a quartz globe with a tungsten filament, a light-emitting diode (LED), and a fluorescent bulb. These lamps can vary in intensity from less than 100 watts of output to well over 1000 watts. The tungsten lamps used in video production have a color temperature of 3200 °K, which matches one of the standard color temperature settings on a camera. Fluorescent lamps designed for

television have color temperatures of either 3200 or 5600 °K. In addition, special fluorescent lamps are available with color temperatures of 2900 or 3000 °K to create lighting with a bit more warmth. The output from a fluorescent fixture is typically lower than a tungsten lamp. This makes the light more energy efficient, but requires that the light be closer to the set than the tungsten instrument.

Lighting Instruments

The type of lighting instrument dictates whether it will produce hard or soft light. Some instruments are used in very specific situations while others are more general in their use. Most professional lighting directors use a mixture of instruments to allow for flexibility in a variety of lighting situations.

Spotlights One of the more common types of lighting instruments is a **spotlight** (see Figure 7.7A). These instruments usually have a **Fresnel lens** in front of the lamp. The lens causes the light beams to focus and makes the light more directional.

Spotlights usually have the ability to adjust the width and intensity of the light output. Typically, this is done with a slider or knob on the back of the lighting instrument (see Figure 7.7B). When the beam is at its narrowest and most intense position, it is said to be **spotted**, or in the spot position. When the beam is at it widest and least intense position, it is said to be **flooded**, or in the flood position. A common lighting procedure is to spot the light, aim it where it is needed, and then flood it out a bit. Fixed spotlights do not have a variable beam. Most spotlights can use lamps of different wattages. Higher-wattage lamps produce brighter light, but they also use more electricity.

(A) (B)

© 2014 Mark Mosrie, Cengage Learning

FIGURE 7.7

(A) A spotlight produces a hard light with fast falloff. (B) This knob will adjust the spotlight between a more focused, or spotted, beam of light and a more diffused, or flooded, beam of light.

Softlights Lights classified as **softlights** have slow falloff and a more diffused light. Softlights provide some of the best and most attractive lighting for interviews and product shots. A variety of lights can be classified as softlights. These include instruments designed to reflect light and those that use an accessory to soften a hard light. A **softbox** (see Figure 7.8) consists of a spotlight with a fabric enclosure. The fabric is highly reflective on the back and sides, but the front is made of diffusion material. The instrument produces a very soft, diffused light. These units typically fold up into a small package but expand and set up quickly as a very effective light source.

Fluorescent Lights Fluorescent fixtures (see Figure 7.9) require very little power, can work in both 3200 and 5600 °K environments, do not get too hot, and come in many different sizes. To help focus and control the spill from these softlights, some instruments come with a plastic focusing lens to generate a harder light that will allow for more sculpting in a scene. Another solution is

© 2014 Mark Mosrie, Cengage Learning

FIGURE 7.8

This softlight produces a very diffused light with slow falloff. It is excellent for lighting interviews.

© 2014 Mark Mosrie, Cengage Learning

FIGURE 7.9

The egg crate on the front of this fluorescent fixture helps diffuse the light.

the use of plastic or metal louvers, sometimes known as an egg crate. These resemble a honeycomb and help control the spill light from the fixture.

Light Emitting Diodes LED panels (see Figure 7.10) have all the benefits of a fluorescent light in a much smaller and lighter size. **LEDs** produce a consistent color temperature from the moment they are turned on. Models range from small units that fit on a camera cold shoe to large studio type fixtures. Some models include color temperature dials to assist in balancing for a variety of conditions. In addition, because of their low power consumption, many LED panels can be battery operated. This allows for greater portability for those productions requiring travel.

© 2014 Mark Mosrie, Cengage Learning

FIGURE 7.10
LED light panels are energy efficient and highly portable.

HMI Lights Halogen Metal Iodide (HMI) lights are designed for use outdoors and have a color temperature matched to daylight. They work well when shooting indoors and trying to match outdoor lighting coming in through a window, or to supplement the sun when shooting outdoors. One of the major benefits of using HMI lights is that they produce a much brighter light than standard quartz light. This means it takes fewer watts of light to get the same amount of brightness.

Camera–Mounted Lights Although not a specific instrument type, camera-mounted lights (see Figure 7.11) come in spotlight, fluorescent, and LED varieties. These lights are effective for close-up shots of talent in situations where a stand light cannot be used or there is no electric outlet to power a light. A spotlight provides the most light, but may cause your subject to be overlit and to squint as he or she looks toward the camera. The fluorescent provides a very soft light. LED lights are energy-efficient. Some models have an adjustment to lower the intensity. This makes a camera-mounted light effective for close-up shots of talent. In addition, most of these fixtures can switch between 3200 and 5600 °K. This ability to color match with indoor and outdoor light sources increases the flexibility of the instrument.

© 2014 Mark Mosrie, Cengage Learning

FIGURE 7.11

This camera-mounted spotlight has a softbox on the front to diffuse the light and reduce both the harshness and shadowing that a camera-mounted light sometimes produces.

Lighting Accessories

The videographer or lighting director has a number of tools to control light. Such tools include methods for reflecting the light, diffusing the light, blocking the light, and changing the color or color temperature of the light. Many of these accessories are often included as part of a professional lighting kit (see Figure 7.12).

© 2014 Mark Mosrie, Cengage Learning

FIGURE 7.12

A lighting kit typically contains stands, instruments, diffusion materials, and other accessories.

Reflectors A **reflector** is a device that bounces light from a light source toward the subject. Reflectors are useful when shooting outdoors to bounce sunlight off the reflector and back on the subject to even out the light. While professional reflectors have a white side and a gold or silver side, others can be created from a variety of materials, such as a piece of foam core, a sheet of aluminum foil, or a stretched white bed sheet. Silver reflects more light than white and gold is a good choice when reflecting light on a person with a dark complexion. Although typically used outdoors on sunny days to help control the harsh light from the sun (see Figure 7.13), some indoor scenes can also be enhanced with a reflector. It can bounce the light from a window or other light source onto the subject. It requires patience to reflect the light properly. Care must be taken, as sudden movement of the reflector can cause noticeable changes in the lighting.

(A) (B) (C)

© 2014 Mark Mosrie, Cengage Learning for (A), (B), (C)

In A, there is no reflector to bounce the light and soften the dark shadows. In B, the reflector has been added and the light is much more even across the talent. Image C shows the position of the reflector in the scene.

Umbrellas An **umbrella** (see Figure 7.14) is a reflective device that can be attached to a spotlight to diffuse and reflect the light in a scene. The instrument is pointed away from the scene and toward the underside of the open umbrella. The umbrella reflects the light back toward the area to be lit. The effect produces a very soft and diffused light that can be flattering in an interview setting.

Diffusion Several different methods can be used to **diffuse** or soften light. Tough spun, frosts, and grid cloth can diffuse the light. **Tough spun** is made from retardant polyester, **frosted gel** is another polyester-based product, and **grid cloth** is a white translucent material that is usually stretched in frames or attached to the front of a soft box. These products can be easily mounted in a frame or attached to the lighting instrument with clothespins. One of the simplest diffusion methods is to use a metal screen (see Figure 7.15) that is attached to the front of the lighting instrument housing. This screen is sometimes referred to as a **metal scrim**. Although these diffusion methods soften and reduce light, they do not change its color temperature. A variety of different types of diffusion can be purchased inexpensively, and are easy to carry on a shoot. Safety is

FIGURE 7.14

An umbrella attaches to the light and reflects light onto the scene. It produces a very soft light with slow falloff.

FIGURE 7.15

The metal scrim or screen in front of the spotlight diffuses the light.

paramount when mounting these items in front of a light since the heat of the light can ignite the material if it is too close to the lamp.

Diffusion is usually not a good choice when modeling and fast falloff are desired. Most scenes shot with diffusion have limited shadows and a potential lack of depth that contradicts the need for fast falloff.

Barn Doors and Flags Sometimes it is necessary to prevent or block light from reaching specific areas within a scene. **Barn doors** (see Figure 7.16) are metal flaps that attach to an instrument and prevent light from hitting certain parts of a scene. If the barn doors are not sufficient, a flag provides greater precision in blocking the light (see Figure 7.17). A **flag** can attach to a stand or any object that can hold it steady. Flags may be used like a barn door to shape the light or to block the light from hitting an area that is reflective or too bright. A commercial for a new automobile may utilize flags to block the light from hitting a chrome bumper. Flags are useless for most shots with camera or product movement because the area you are trying to block is moving in the frame.

© 2014 Mark Mosrie, Cengage Learning

FIGURE 7.16

The barn doors, or metal flaps, on the front of the instrument effectively block the light from hitting some parts of a scene.

© 2014 Mark Mosrie, Cengage Learning

FIGURE 7.17

Flags come in many shapes and sizes. They allow the lighting director to block the light and keep it off certain parts of a scene.

FIGURE 7.18

Clothespins are used to attach a gel to the front of a light. Besides clothespins, many lighting instruments will accept a frame that will hold a gel or diffusion material.

Gels A **gel** is a polyester-based material that comes in a wide range of colors. Gels are used to cast a certain color, to match color temperatures, or to reduce light intensity. Most gels are attached to a frame or to barn doors in the same way as diffusion material (see Figure 7.18). Even though a gel can have many uses, it is important to note that most gels will reduce light intensity, regardless of purpose.

Placing an orange gel on a light can be used to create the illusion of a sunrise or sunset. If a window will be visible, this light can be placed outside the window with the orange light shining through. A gel can also be used to splash a color wash on the background of a shot. For example, a maroon streak of light across a bookcase can make a nice background for an interview, particularly if you combine this effect with a shallow depth of field. Green and blue gels can provide the high-tech feel of a laboratory or other scientific setting. To achieve the effect created by the colored gel, the camera must be white-balanced with the gelled light off. After white-balancing is completed, the gelled light can be turned on.

Lighting a scene that has a mixture of color temperatures is perhaps the biggest challenge facing a lighting director. Many indoor field shoots must deal with this issue. It is really quite simple in theory: all lights must be balanced to the same color temperature. Using the correct color gel can help match a lighting source to other lighting in the scene. The practicality of this, however, is another story. The color temperatures of different lighting types (desk lamp, ceiling fan light, fluorescent fixture, and so on) are different from each other and all are different from the standard camera settings for 3200 and 5600 °K. The classic example of this occurs when adding quartz lighting to a location that has sunlight in the scene. When shooting an interview in an office, it is usually wise to take advantage of any light coming in a window. Adding other lights to the scene requires matching those new lights to the color temperature of the sun. Adding a blue gel to quartz lights makes them match the sun. Similar to a blue gel, a **dichroic filter** (see Figure 7.19) is a blue-colored glass that mounts in front of a light. This procedure

© 2014 Mark Mosrie, Cengage Learning

FIGURE 7.19

A dichroic filter is inserted into the light fixture to match the color temperature of the tungsten instrument to the color temperature of sunlight.

can be reversed if the goal is to color correct the sunlight to match the quartz light. In this case, an orange gel is placed over the window to convert the sunlight to 3200 °K.

The use of a gray or **neutral density gel** will reduce the intensity of the light. A neutral density gel placed in front of a light can be used in conjunction with a color-correcting gel. The gray gel is different from a scrim in that it does not change the hardness of the light. A scrim will diffuse and soften a light, while a gray gel will simply reduce the amount of light coming from the instrument.

Light Mounts Devices for mounting lights include simple tripod stands and a variety of cleverly fabricated clamps that allow a light to be attached to almost any surface. Many light kits come with a portable stand with legs that can be spread for support and adjustable sections to increase the height. Most stands can be set at least 8 feet high so that they can be placed at the proper angle to the scene. As an added precaution, sandbags or weights can be placed on the leg spreader to help stabilize the stand and keep the stand and light from a potentially dangerous crash. Other specialized mounts include such devices as a drop ceiling mount, a door hanger (see Figure 7.20A), and a clamp (see Figure 7.20B), among others.

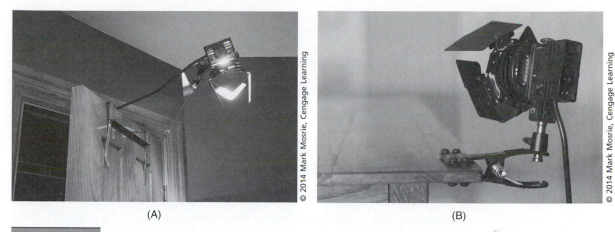

(A) (B)

FIGURE 7.20

(A) This mount allows the light to be mounted on the top of a door. (B) The clamp allows the light to be mounted to many flat surfaces, such as tables and bookshelves. Notice the rubber bumpers on the clamp that protect the furniture.

PLANNING

Having a lighting plan is no different than any other planning activity in the production process. The more prepared the production team is, the more predictable the task will be. One of the important tasks of the location survey is to provide adequate information about the existing lighting and the potential for adding supplemental light. Knowing about the existing lighting and options for controlling the light is just as important as having a shot list or the proper microphones during the shoot. Besides the specific lighting requirements, it is important to collect information about the electrical system at the location. Such information should include the number and location of electrical outlets as well as data about circuits and breakers. Having the name and contact information for someone who can access electrical circuit boxes is essential. This lighting information may not be critical for a simple interview, but it is one of the more important issues to address in a complex scene that includes blocking of talent and the use of larger sets. After gathering this information, the videographer can prepare by selecting the proper instruments and accessories.

Another helpful task is to sketch the details for the placement of supplemental lights. While this initial design may change during the actual setup for the production, it can be a good starting point. Besides the suggested lighting placement, the sketch should indicate talent positions and movements, as well as camera positions.

Safety

It should not be necessary to stress the importance of common sense and safety when working with mechanical and electrical equipment. Safety should always be the first priority in setting up for the shoot. It is important to continually

consider the possibility of a light stand falling or an electrical shock being caused by a worn or frayed power cord or improper connections.

In the early 1990s, the CBS newsmagazine *60 Minutes* conducted an interview with presidential candidate Bill Clinton and his wife, Hillary. At one point during the interview, Mrs. Clinton was answering a question when the TV lights came crashing down. The lights nearly hit the Clintons in the head. Fortunately, no one was hurt, but the story helps illustrate the necessity of good safety when using lighting equipment.

Physical Safety Once lighting stands are secured, check the path that cables are run. A cable should not be stretched so tightly that it hangs off the ground. Add an extension cord if necessary. Cables that run on the ground should be covered by a carpet or pad in those areas where talent and crew may be walking. Tripping over a light can cause the stand to topple and the lamp to implode or injure someone. Make sure light stands are secure, with the base stable and each locking knob tightened. Adding a sandbag to anchor the base is a good practice.

Electrical Safety Knowing the amount of electrical power required for a lighting instrument is also important. The amount of amperage running through a lighting circuit is significant, and overloading a circuit can be dangerous. Paying attention to this fact during setup can alleviate potential problems (see Table 7.2).

All power outlets in homes and businesses have a limit on how much electrical current the circuit can handle. If too much current is applied, the circuit breaker will trip. In an older building, a fuse may blow. If this happens, it could take precious time to restore power before continuing the shoot.

A look at the home electrical system will make this easier to understand. The power arriving in the house is divided into several circuits. Each circuit is designed to handle the average amount of power used. While several bedrooms might be on one 20-amp circuit, the kitchen probably has its own circuit. This is because kitchens typically contain a number of power-hungry appliances, such as refrigerators and microwaves. Using three 600-watt lights in a 20-amp kitchen circuit that also powers a 600-watt refrigerator will probably shut the circuit down when the refrigerator condenser comes on. There would be 2400 watts and almost 22-amps going through the wires, which would cause the circuit breaker to blow. Spreading the load by using outlets in different rooms for the lights will help avoid this problem.

TABLE 7.2

amps (A) = watts (W) divided by volts (V)

For example, three 600-W lamps plugged into a single 110-V wall outlet would be:

A = (600 × 3) divided by 110

A = 1800 divided by 110

A = 16.4

© Cengage Learning

STORY 7.1 White Balance, or How I Learned to Stop Worrying and Love Natural Light

In the world of independent documentary, you are often forced to shoot in less than ideal situations. Typically, you need to create more than one unique "look" in a single location. One useful technique in accomplishing this task is utilizing and manipulating any natural light that might be entering the room through windows.

On a particular shoot, I was faced with composing and lighting three different interview shots in one office conference room. One wall of the room also happened to be full of floor-to-ceiling windows. I decided to include the windows in each shot as part of the background, but to change the color of light that the camera would be seeing for each successive interview.

For the first shot, I left both the windows and set lights alone. In other words, I didn't use any color correcting gels to attempt to equalize the higher color temperature of daylight and the lower temp of the tungsten lights that I was using to light the subject. I then set the white balance at the normal tungsten temp of 3200 °K, so the result was that the subject looked normal under the set lights but the background had a much bluer look to it.

For the second interview, I covered the windows with a full CTO (color temp orange) gel. Then I used a full CTB (color temp blue) on the set lights and set the white balance to 5600 °K. The light from the windows suddenly seemed much warmer, creating a feel of sunset.

On the final interview, I removed the gel from the window but left the full CTB on the set lights as well as the white balance set to 5600 °K. Now the window light and the subject light were the same temperature, providing another distinct combination of color for subject and back light.

One potential risk of shooting with natural light is its tendency to change quickly. The light level can quickly drop several stops when the sun goes behind a cloud or moves behind a building. To allow for quick compensation, I usually attach a dimmer to all of my set lights and keep the dimmers within arms reach of me as I'm operating. That way, when the natural light fluctuates, I can quickly compensate by raising or lowering the intensity of my set lights accordingly—all without stopping the interview or seriously marring the shot.

SOURCE: Matt Bockelman, Freelance Videographer

CREATING A MOOD

While providing enough light and controlling shadows are important considerations for a lighting plan, the aesthetic decisions used to create a mood or illusion are equally important. Providing realism in a scene can be as critical as proper camera framing and microphone selection. Watching a low-budget television show reinforces the point. Shows that have multiple episodes have little time to adjust the lighting for each episode. The same situation can occur in a series of field interviews if the camera is fixed and the lighting is set for several consecutive individuals to appear before camera. Not only will the background be similar if the camera positioning is not changed, but the lighting is probably set for the first interview. If it is not adjusted for each person's height and the contrast of their complexion and clothing, you will likely get mixed results.

The relationship of light placement to talent is another consideration. When blocking a scene where an actor stops and talks to another person, it is important that the lighting be set to accommodate the movement and highlight the specific area where the conversation takes place. Just as the actor needs to know where to hit the mark to stop walking, the crew needs to know where to set the lights for that same position.

A well-produced TV drama illustrates attention to detail and use of lighting to create a specific mood. In the classic television series *ER*, the lighting gives the feel of the location with the proper mix of lighting instruments and techniques to give the set a realistic feel. The sense that the viewer is really in the emergency room is enhanced by all the production elements, including the lighting. A program like

CSI takes advantage of the use of color gels to give different scenes a different look. For example, a scene with a blue tint might indicate a lab setting.

The lighting style can provide continuity between episodes and make a program identifiable. In the award-winning series *SportsCentury*, ESPN used a slightly yellow-cast lighting technique during interviews. The result was a nostalgic feel that added to these historical documentaries about great athletes.

Another use of color is to create a colored theme for the set or background. A common and easy technique is to set the lighting and white balance as usual. After this has been checked, add a splash of color to the background by placing a color gel on a light and pointing it towards the background. While it can provide beautiful results, make sure the lighting does not distract from the story.

Establishing the motivation for any supplemental lighting should always be a goal of the lighting director. Suppose someone enters a room and turns on a light switch. The direction of the light and the shadows it creates will allow the audience to understand where the light is located. Likewise, a shadow of miniblinds suggests that the room has a window.

Backgrounds can also be framed to emphasize shadows for stylistic reasons or to help create realism. It is quite simple to give the illusion of a window just out of the field of view. This is accomplished by placing a pattern of a window frame or miniblinds in front of a light pointed towards a wall on the set. The result is a simple and inexpensive way to achieve realism through the use of lighting and controlling shadows. These patterns are created with a **cucalorus**, or **cookie**, and can be used to create a variety of different images and shapes, including abstract designs.

The angle of a light is normally 30° to 45° above the subject (see Figure 7.21). This usually results in the light being at least a few feet higher than the talent.

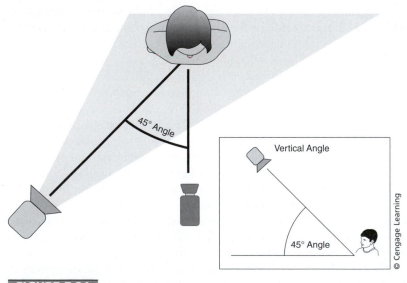

FIGURE 7.21

Ideally, the light is placed 45° up from the talent and at a 45° angle from the line between the camera and the talent.

As the light is raised or lowered, shadows will move accordingly. If the light is moved to the left or right of the subject, the falloff changes accordingly. If the light is lowered so much that the light is now tilted up, shadows are directed upward. This creates unnatural shadows and is a technique used to create tension, uneasiness, or supense.

Cameo lighting is a technique that isolates the talent from the rest of the frame. This causes the viewer to ignore the screen space and concentrate on the talent. In most cases, the background will be very dark and have no light on it at all. Directional lighting is used to light the talent (see Figure 7.22).

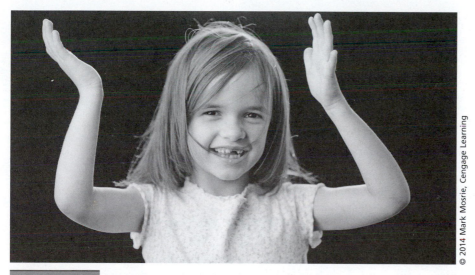

FIGURE 7.22

The cameo lighting and dark background help make the little girl stand out in this image.

Lighting the subject only from the back creates a **silhouette**. This technique keeps the foreground dark and all the audience sees is an outline of the subject (see Figure 7.23). This is a popular technique to hide the identity of the talent, such as in undercover police reality shows. Another way to create a silhouette is to evenly light the background and provide no lighting on the subject. This method creates a somewhat flatter look.

Because television is two-dimensional, lighting techniques can be used to add depth to the scene. Careful lighting tricks can add to this illusion. Strategically placing pools of light to highlight the foreground and background can help accentuate this effect. This can be accomplished effectively by using spotlights and possibly adding color gels to specific elements of the set. The falloff from light sources and accompanying shadows creates the illusion of depth on a two-dimensional surface.

© 2014 Mark Mosrie, Cengage Learning

FIGURE 7.23

The silhouette lighting in this scene keeps the audience from knowing the identity of the subject.

LIGHTING SETUPS

The lighting requirements for each scene should be evaluated, and specific plans implemented to help achieve a certain look. Because of the number of instruments that a scene may require and the amount of space needed, the videographer may end up moving the lighting instruments for each shot. In a scene with a conversation between two people, there will probably be a minimum of two camera positions. The overall look of the scene will be much more realistic if the lighting for each angle retains a comparable look. In addition, the motivation and direction for the light as well as shadow placement should be appropriate. A common technical continuity error occurs when the lighting changes from different camera shots within the same scene.

Three-Point Lighting

Triangle, or **three-point lighting** is the basic configuration used for television lighting (see Figure 7.24). The name comes from the triangular positioning

© Cengage Learning

FIGURE 7.24

The photo shows all three lights in the three-point lighting scheme. The diagram illustrates the position of the three lights.

of three individual lights used to illuminate the subject. This basic rule is a good starting point for most lighting, but will likely undergo modifications during the setup.

> **Related Interactive Module**
>
> CENGAGE brain .com
>
> Field Lighting > 3-point

Key Light The **key light** provides the main light source of illumination (see Figure 7.25). It should be directed towards the subject with the motivating light in mind. A motivated light is a light that the audience believes is coming from a source within the set. If the audience knows that there is a window on the wall towards the left side of the screen, place the key light to the left to assist in the illusion. Using a spotlight helps to focus the light and avoids having too much light spill onto the set. When lighting a person, the key light is typically placed on a 45° angle off of the axis between the camera and the person.

Fill Light The second light is called the **fill light** and is used to add light to the side opposite the key light (see Figure 7.26). Besides adding some illumination, the fill light reduces the shadows caused by the key light. It is important to note that the fill light should not eliminate all shadows. Some shadows are natural and can add to the illusion of depth in a scene. The fill light is normally about half the intensity of the key light. If all the lights in a kit are of equal intensity, the instrument can be placed further away, or some form of diffusion or gray gel can be added. This allows for some texture and slight shadow, which in turn has a more natural look to it.

FIGURE 7.25

Only the key light is on in this scene. The key light provides the primary source of illumination. Diffused light with slow falloff was used for this key light.

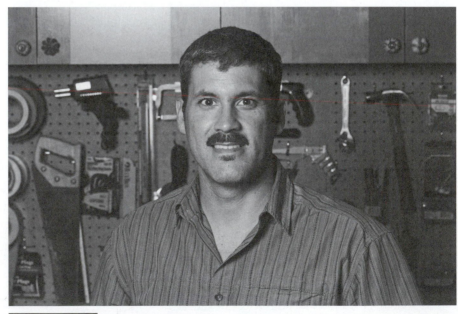

FIGURE 7.26

Only the fill light is turned on in this scene. The fill light minimizes the shadows caused by the key light and helps provide even lighting on the face.

© 2014 Mark Mosrie, Cengage Learning

FIGURE 7.27

The back light is the only light turned on in this scene. Notice how it separates the subject from the background and provides depth.

Back light The third light is the **back light** (see Figure 7.27). It is used to create the illusion of depth by separating the subject from the background. Because it is positioned at a steeper angle than the key and fill lights, it causes light to shine directly on the talent's shoulders and the top of his or her head. When done properly, it creates a flattering glow around the hair and shoulders and creates depth between the foreground and background.

Additional Lights Some additional uses for lights may be practical for the story. A **kicker** (see Figure 7.28) can be used in conjunction with a back light to add

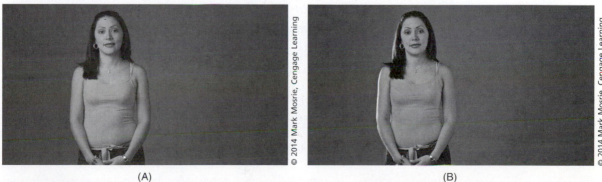

(A) (B)

FIGURE 7.28

There is no kicker light in image A. A kicker has been added to image B on the left side of the talent. The light helps the talent stand out from the background.

FIGURE 7.29

A fourth, or background, light has been added to the scene to illuminate the backdrop.

additional light directly opposite the key light. This adds to a modeling effect with the back light more dominant on that side. It is a good choice for dramatic shots.

A **background light** (see Figure 7.29) can add some depth to a scene and is particularly effective in an interview shot. It is placed so that it casts light in the area behind the subject. Sometimes it is placed low to the ground and aimed upward on the backdrop. A gel can be added on the background light to help with the illusion of depth. The tendency to overlight a background is a common mistake. Too much light on a background can distract the viewer by creating a bright area that is not important to the scene.

Variations on Three-Point Lighting

Using multiple lights may be required for a shoot, but it is not always practical or efficient to include the number of instruments that the design calls for. One of the challenges in location lighting is getting optimum results under less-than-optimum conditions. Learning to make do with a smaller number of instruments is a skill every lighting director and videographer must perfect. Lighting an interview subject with only one light is really quite easy. The setup can begin after deciding if there should be slow or fast falloff. For slow falloff, diffuse the light to create a soft look. This is easily accomplished by using an umbrella, softbox, or other diffusion material. Moving the light closer or further away will affect the brightness levels. Like audio, light follows the **inverse square law**. If the distance doubles between the subject and the light, the

intensity of the light will drop to one-quarter of its original value. If the light registers 100 foot-candles 10 feet from the talent, there will be 25 foot-candles with the light 20 feet from the subject. Moving the light to the left or right of the camera will cause the light and shadow to move accordingly. Putting diffusion material in front of a hard light source will provide results similar to the umbrella, but the light will come from a straight line as opposed to the curved light from the umbrella.

Fill light can be added without using additional instruments. Using a reflector or positioning the talent so that a white wall acts as the reflector may help achieve this. This technique provides a soft lighting effect and is a good choice when a second light cannot easily be positioned as a fill light.

If a second light is added, it can be placed on the opposite side of the camera to act as a fill light, or it can be positioned as a back light. With a little creativity, it may be able to provide a little of both (see Figure 7.30). As mentioned earlier, it is important to keep the intensity of the fill light around 50 percent of the key light to allow for some slight modeling and shadows. This technique also keeps the image from being flat and two-dimensional.

If the second light is used as a back light, position it to provide a pool of light that hits the talent from a high angle on the top of the head and shoulders. The use of a back light is sometimes more critical than a fill light because it adds dimension to the scene. As mentioned earlier, the back light can be moved directly opposite the key light to create more modeling.

(A)

(B)

FIGURE 7.30

In this four-point lighting scheme, light 1 serves as the back light for person A, and as the fill light for person B. Lights 2 and 3 are the key lights for B and A, respectively. Light 4 is the back light for B, and the fill light for A.

© Cengage Learning

An effective method to light a scene with minimal lighting is to consider the possibility of using the light coming into the space through a window or glass doorway. Beautiful results are possible by using the window as a fill and/or back light. It is critical that the window does not appear in the field of view and that the lights are all matched for color temperature.

Although three-point (or triangle) lighting is the basic rule, it is consistently broken or modified for specific lighting situations. For example, when two people are talking to each other in a scene or interview, it is not necessary to use six instruments. A setup called **four-point lighting** (see Figure 7.30) allows the crew to minimize the number of lighting instruments and retain the characteristics of the traditional three-point setup. Each light serves two purposes in this configuration.

Regardless of the lighting scheme, avoid continually adding instruments to try to correct lighting problems. In many cases, the additional lights just add to the problem. It is better to eliminate some lights and work backward to solve the problem. Isolating the issue and working from that point takes time, but it is time well spent, and the lighting will benefit from this attention.

LIGHTING IN PRACTICE

Understanding the fundamentals of lighting and the operation of the equipment is important, but it takes the practice of actually lighting a scene to gain proficiency. Every situation is different and presents its own challenges. This section presents several common field lighting situations and some suggested solutions for them.

Interview Scenario

You have been asked to set the lighting for an interview that will take place in an office. During the location survey, you notice that the room has fluorescent lighting, track lighting that highlights some artwork on one wall, and a table lamp in a corner. There is also a window on the western wall with miniblinds. The interviewee's desk is positioned so that the window is to the left side of the desk.

Once you understand the challenges of this shoot, you can decide the optimum way to light the interview. Arriving with the proper tools, including diffusion and color correction items, should make the job easier. Understanding which current lights must be kept on and which can be turned off is the first decision. Multiple methods can work for almost every situation. The general rule is that you must balance the color temperature as best you can. Some options are simpler than others. For example, if daylight is present in the room, it is much easier to convert 3200 °K to 5600 °K than the opposite.

Upon entering the office for the shoot, you glance at your wristwatch and see that it is 3 P.M. From the window, plenty of sunlight is streaming in, while track lighting is distributing light along the wall opposite the desk. The table lamp is positioned over the shoulder of where the interviewee is going to be

sitting during the interview, and the overhead fluorescent lighting makes the room appear bright. In the next several minutes, you will make a decision on how to light this interview. Systematically, you begin your work. First, you let the demands of the story dictate camera position. Once you know that, you can move on to the lighting. One obvious solution is to turn off the track lighting. You consider leaving the table light on as a background element. What to do with the fluorescent light and window will be the tough decision. Because you plan to use supplemental lighting, you consider turning the fluorescent lighting off. The window is positioned in such a way that it can be used as a logical light source. It makes sense to consider using the window as either the main light source or as a back/fill light combination. Once the camera is set for the position, you elect to use the window as a key light and use a soft light source as the fill light and a diffused spotlight for the back light. Adding a blue gel or dichroic filter to the TV lights allows you to balance all the lights for 5600 °K. Of course, you must remember to turn off the fluorescent lights in the room (see Figure 7.31).

Another way to handle this scene is shown in Figure 7.32. Here, you elect to close the blinds to block the sunlight, then position the interviewee so that the artwork will be visible in the background during the interview. Turn off all the

FIGURE 7.31

This illustration shows one solution to the interview scenario. The light coming in from the windows is providing the key light. Lights 1 and 2 are color-corrected to match daylight. Light 1 serves as the fill light, while light 2 is the back light.

Light 3

Track lights

Windows (blinds closed)

Fluorescent light

Light 2

Light 1

Fluorescent light

© Cengage Learning

FIGURE 7.32

Another solution to the interview scenario is presented in this image. The windows have been covered to block daylight. Lights 1, 2, and 3 are a standard three-point setup. White-balance the camera with the track lights off, and then turn the lights on to warm-up the artwork on the wall behind the interview subject.

Related Interactive Module

CENGAGE **brain** .com

> Working with Windows

room lights, including the track lights, table lamp, and overhead fluorescents. Set up a traditional three-point lighting scheme on your interviewee. Once you have white-balanced the camera, turn on the track lighting. These lights are likely rated between 2000 and 2500 °K. They will provide a warm glow on the artwork during the interview. If you left the lights on during the white balance, you might lose the warmth of the glow. If you find that the glow is too distracting, you can turn off the track lighting and add your own background light.

Narrative Scene

During the planning of a narrative scene that will be shot in the living room of an apartment, you notice that the room is rather dark and only has a few stand lights and table lamps. The room is painted white and there is a sliding glass door covered with a light-colored curtain at one end of the room. The scene takes place at night and begins with one person entering through a doorway from a hallway lit by wall sconces. The action follows the actors as they sit on the couch and overstuffed chair with some of the stand and table lights in view when an establishing shot is composed.

Many factors need to be planned in advance in order to create a lighting scheme that adds to the narrative realism. It is a wise decision to consider the lighting during the blocking rehearsal so that you can evaluate the actors' positions and any on-screen movement. This particular scenario is common and poses a variety of challenges. First, the hallway must be bright enough to see the talent before they enter the apartment. The sconces give enough light, unless you want the hallway to be slightly dark. There is also the issue of color temperature with the light bulbs in the sconces. In the apartment, you must figure out a way to add enough light without causing the room to be overlit, creating back lighting problems from the white walls. You also have to consider the movement in the scene.

Because this is a narrative scene, it is likely that you will tweak the lights every time you change the camera position. Use caution, however, when tweaking to make sure that you maintain continuity in the lighting. To handle the hallway, you can bounce a light off the ceiling to provide additional lighting for the scene. When properly white-balanced, the sconces will make the scene a little warmer. The instrument providing the bounced light would not be seen by the camera. You can use the same bounced-light technique for the wide shots in the apartment. The white walls are a very reflective surface for bouncing light. When you move to medium and close-up shots, try setting your TV lights so that the light they create appears to come from the lamps in the room. Check for "hot" spots as well as slight color or tone shifts as you move locations. White-balance with only the TV lights on. When you are ready to shoot the scene, consider turning on the table lamps to provide a warmer glow to the scene (see Figure 7.33).

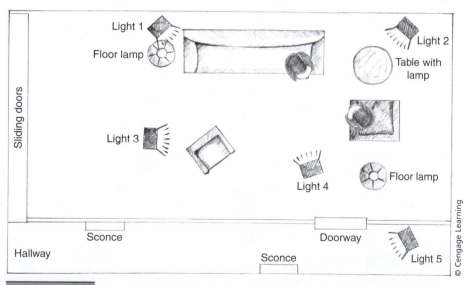

FIGURE 7.33

For this narrative scene, light 5 is positioned to bounce light off the hallway ceiling to provide enough base light. Once inside the room, lights 1, 2, 3, and 4 provide the necessary illumination for the various shots during the scene. Each light may be tweaked between shots, but maintaining the continuity of the lighting is important.

Blue Screen

The historical program you are working on will have an interview shot against a blue screen, so some old photographs can be layered as a background during post production. During editing, a **chroma key** effect will remove the blue color in the screen and replace it with the old photographs. Although it is possible to chroma key with any color, this technique commonly uses either blue or green as the background.

The lighting for a chroma key is fairly straightforward (see Figure 7.34). You should consider the lighting as two separate scenes. The first scene is the blue screen or background of the image. The second scene is the foreground, which

Background light Background light

FIGURE 7.34

Successful lighting for a chroma key shot begins with even lighting on the colored backdrop. Here, two fluorescent lights have been used as background lights for the screen. The subject is then lit with a traditional three-point set up. A side light can be added to help create a clean key. Finally, if the subject's hair presents any difficulty with the key, a colored gel can be added to the back light. The gel should be the opposite color of the backdrop.

in this case is the interview subject. For the background, it is important to light the blue screen evenly throughout the frame. Using a few soft lights that spread the beam across the entire surface is a good choice. Fluorescent stand lights would make another excellent choice for even illumination on the screen. Placed close to the screen, they can provide a very even source of light. In terms of light levels on the blue screen, you want the background to be one f-stop lower than the f-stop setting for the foreground. If you have the ability to check the signal on a waveform monitor, try to get the blue screen to fall between .3 and .4 on the digital scope when you have the iris adjusted for the foreground video.

For the foreground lighting, a few tricks can really help you get a good chroma key. First, you can use a standard three-point scheme on the foreground. Place the subject 6 to 8 feet away from the blue screen. This distance is helpful for a few reasons. First, it helps to ensure that the light you use for the subject will not also light the blue screen and create bright spots on it. Second, the distance will keep shadows from the subject off the blue screen. These shadows would cause dark spots on the screen that would make it harder to achieve a clean effect. Finally, the distance will help minimize spill light from the blue screen onto the subject. As the subject gets closer to the blue screen, the color from the screen will reflect back on the subject. This spill light will create a blue line around the subject that will make it harder to create a clean effect. Another helpful tool for eliminating this spill is the use of a side light. As you might imagine, this light is placed to the side of the scene and lights the person from the side. In some ways, it acts like a back light, in that it will help keep the shoulders and upper body of the subject set off from the background. More importantly, though, it will help minimize the spill light. Finally, if you are having difficulty getting a person's hair to key effectively, you can add a colored gel to the back light. The color you add should be the opposite of the color of the screen. So, for a blue screen shot, you would use a yellow gel. For a green screen, you would use a magenta gel. It may look a bit odd to your eye, but to the electronics that will create the actual key, it will help create a cleaner effect.

Products and Tabletops

You are assisting the lighting director for a television commercial. The shots will be of a new e-reader that the client is marketing. The e-reader has a sleek look to it, but reflections from the silver back create hot spots on the device.

The challenge in working with tabletop items or products is controlling the shadows. The last thing an advertising agency or client wants is lighting that causes glare or shadows on its product. It is usually advisable to use lower wattage instruments and add flags to block light from hitting those areas that cause reflections. Another approach is shown in Figure 7.35. First, it might help the shot if you devised a mechanism that would allow you to tilt and/or rotate the e-reader during the shot. In either case, this lighting setup should work well. Use soft lights with lots of diffusion positioned above the e-reader. The soft lights will provide nice, even illumination and avoid any harsh glare as

© Cengage Learning

FIGURE 7.35

For the product shot, lights 1 and 2 are softboxes. Light 3 provides the back light. Light 4 has a green gel for the background. Finally, light 5 is a spotlight with barn doors to produce the specular highlight.

well as minimize shadows. Think about adding some colored gels in the background to help create a high-tech mood. Finally, consider adding a small hard light to create a specular reflection that can enhance the high-tech mood that you are already creating with the colored gels. In addition, the highlight will add some visual interest to the shot. You must be careful with this highlight, however, since it can easily become a distraction in the shot.

Outdoors

Related Interactive Module

Field Lighting > Lighting Outdoors

It is midday and you are going to shoot several person-on-the-street sound bites in a nearby park. A winding path in the park passes through open areas as well as sections covered in shade.

Shooting outdoors poses some challenges. The sun is usually too bright, especially at midday. Think about it: when you are out in the sun, you are probably wearing sunglasses because of the brightness. Not only is the brightness a problem, but the midday sun causes terrible shadows. The angle of the shadows is almost straight down since the sun is so high in the sky. If your talent has glasses, you will see large shadows on her face. You will also see harsh chin shadows and a prominent shadow on the ground in a wide shot.

The most logical advice would be to move the location or change the time of the shoot. Shooting during the magic hour would be ideal. The sky has a

© Cengage Learning

FIGURE 7.36

Using a reflector in the sunny part of the park helps balance the harsh shadows that a cloudless sunny day can produce. Another option is to shoot in the shade.

softness that makes images look beautiful. The apparent problem is that the magic hour may last only 30 to 60 minutes, which does not give you much time to shoot. Shooting on an overcast day is another solution since the light is also soft and the colors vibrant. Moving out of the sun into a shady section of the park is another option. You must watch carefully to make sure that the sun is not streaking through the canopy, causing light and dark streaks on the talent. If you must shoot in the harsh light, try to position the talent to minimize the shadows. Adding a reflector is an easy and inexpensive alternative that may also help substantially (see Figure 7.36).

CONCLUSION

Lighting is one of the elements in video production that can elevate the professionalism of the production and dramatically enhance the story. The technical objective of having the correct amount of light, the correct white balance, and proper control of shadows is critical for achieving good exposure and viewable

images. A variety of tools and instruments are available for the videographer to use in lighting a scene. Basic lighting begins with the three-point lighting scheme, but many variations exist on that model. Having a systematic approach with enough set-up time can greatly improve the chances of completing a successful and well-lit production.

Story Challenge: Lighting

The lighting that Pick 2 produced was successful for all three productions. The director, working with a lighting director and several videographers, was able to create a very systematic plan for the lighting in each production. The discussions with the band's stage manager proved very fruitful since he was able to boost the light levels to provide enough illumination for good shots of the live concert. In addition, the use of a side light during the chroma key interview segments helped create a very clean effect. The decision to alter the traditional three-point lighting plan during the shooting of the music video was a smart one because the director was able to achieve a dramatic and effective look through the use of lighting.

PART III

Post Production

Meenachie n...

The Aesthetics of Editing

Editing is now something almost everyone can do at a simple level and enjoy it, but to take it to a higher level requires the same dedication and persistence that any art form does.

WALTER MURCH, DIRECTOR/EDITOR

OVERVIEW

Many stories come together during post production as the editor organizes and manipulates footage and other assets into a memorable story. If a program is created during the preproduction phase and developed into a solid story during production, then post production defines the story and brings it to life.

During the typical post-production stage, footage is reviewed, shortened, and arranged. In addition, sound track elements are modified and mixed, graphics and animations composed, effects added, and all video color-corrected. These tasks should follow basic conventions and traditional, time-tested work habits in an effort to increase the efficiency of the process, which enhances the effectiveness of the original story.

Technical competence is important since audiences should not be distracted by technical mishaps caused by poor editing practices. While the technical craft of editing is fairly easy to master, the ability to use editing tools to bring the story to life can be a much greater challenge (see Figure 8.1). Aesthetic skills and techniques are far more difficult to master. Understanding and using the psychology of the edit is central in telling the story in a logical, compelling, entertaining, or persuasive manner.

Most editors will tell you that having enough good footage and spending sufficient time preparing before the edit session can save time and money once the session begins. In fact, it is not uncommon for an editor to mention limited footage, nonexistent natural sound, or a lack of continuity options as potential setbacks to a productive session. Likewise, having a producer deliver several unlogged tapes, media cards, or hard drives to the edit bay and telling the editor

FIGURE 8.1

An editor considers the story before making an edit decision.

to make the story flow is another pet peeve. Even the most skilled editor can find these obstacles difficult, but the challenge of putting a story together is a great motivator. While stories are sometimes cut exactly as they are scripted, most require additional creative decisions and technical expertise to fine-tune the narrative. Because of this, the role of the editor varies from technician to problem solver, from button pusher to creative director. You can easily imagine the enthusiasm or frustration that an editor may experience under these various circumstances.

This chapter will cover historical editing conventions and how the psychology behind these conventions is still used today in visual storytelling. Technical and aesthetic considerations, as well as the role of the editor, are also covered.

Story Challenge: The Aesthetics of Editing

Pick 2 Productions hopes to create a dynamic series of videos that will appeal to viewers and motivate them to consider alternative fuels. Although the editing team has a vested interest in the planning and shooting stages, they cannot be on location during the shoots. Because of this, several key questions must be articulated.

- What shooting techniques did the production crew use to ensure continuity for the narrative story line in the music video?

- Have themes been developed that allow the production team to link potential footage to specific interviews?

- Were the interviews that were shot with green screen technically acceptable and is there footage to use for the background layer?

- Will historic photos, home movies, and so on be provided? And if so, are there any quality issues with these assets?

- Considering the diverse audience and the need to create multiple videos, what editing style or styles will be used?

- Were techniques used to provide clear natural sound with the footage?

Good communication between the production crew and the editing team should help minimize potential problems. A sit-down meeting between these two groups to brainstorm ideas will make the editor's job easier.

STORY 8.1 When It All Comes Together

One of the reasons that I love editing so much is because it's where everything comes together—the footage, the graphics, the music, the sound design, and ultimately, the story. One of the things that might not be that apparent is that it is a very collaborative process. It's not just the editor, in a dark room, doing it all by him- or herself. I generally work directly with a team of three people—the producer, writer, and art director. While it's up to me to edit the original rough cut, we then work as a team to revise and rework it until the spot is just right. Then we bring in the music, sound design, mix, graphics, color enhancement, and finishing teams to polish it. Every one of these teams has a role in making the finished piece. I also have to be able to work with all these people, acting as a manager in a way, to get them to give me their best. I have to be able to communicate exactly what I think will be best for the piece and get them to execute that.

SOURCE: Craig Lewandowski, Editor

HISTORICAL CONVENTIONS

A number of filmmakers have contributed to our editing knowledge. In the early twentieth century, American film director Edwin Porter discovered that individual shots could be assembled together to create a more interesting story. He also realized that cutting two disparate images together can produce a believable result. In *The Life of an American Fireman* (1903), Porter demonstrated this by cutting between actual footage of fires and fire engines to a dramatized scene of a mother and child in a burning building. While Porter showed the linkage between the two, he did not vary the shot type or cut to influence the pacing of the story. Later in 1903, Porter continued his technique in *The Great Train Robbery*. In this film, he cut interior and exterior shots of the robbery and the attempted getaway.

D. W. Griffith is recognized as the father of film editing. His work included parallel editing and flashbacks. **Parallel editing** is a technique that cuts back and forth between two different stories, while a **flashback** manipulates time as the story moves from the present to the past. His film *The Birth of a Nation* (1915), at over 2 hours, tells the story of a northern and southern family during the Civil

War. Griffith's use of parallel editing to tell both stories was a significant innovation that demonstrated the power of editing. His technique of cutting from a character in the film to an unrelated shot helped develop the theory of shot order.

In the 1920s, Russian filmmaker Sergei Eisenstein developed the theory of **montage** that defined editing as combining unrelated shots to create new meaning. Eisenstein's idea was that two unrelated shots cut together create a new meaning. In his writings, Eisenstein discusses several types of montage incorporated into cinema. He defined a **metric montage** as a series of shots that are varied by the length of time that they are on-screen. **Rhythmic montage** relates to the placement and movement of content within the frame. A **tonal montage** refers to the emotions of the shot, while an **overtonal montage** is a combination of the metric, rhythmic, and tonal montages. Finally, an **intellectual montage** forces the audience to interpret a connection between ideas and camera shots. In each of these categories, Eisenstein builds on his theory that the combination of shots reveals a new meaning.

Lev Kuleshov and V. I. Pudovkin were two other Russian filmmakers who took Griffith's style and Eisenstein's theories one step further to create a new meaning when two shots were cut together. In a well-known experiment, they intercut a shot of actor Ivan Mosjukhin with shots of a bowl of soup, a coffin, and a little girl playing. Audiences viewed a shot of Mosjukhin and the soup, then with the coffin, and finally with the little girl. The experiment clearly demonstrated the power of the cut as audiences reacted to the hungry man, the sad husband, and the proud father. In this form of montage, two unrelated shots are cut together to reveal a new meaning.

Moving into the age of television, crude videotape editing in the 1960s challenged editors to develop creative methods to work with the medium. *Laugh-In,* a 1960s skit comedy program, challenged the medium with its fast-paced and heavily cut style. This series was innovative in the use of a tape-splicing process whereby the videotape signal was viewed under a microscope and physical cuts were made with a razor-like tool to keep the sync signals aligned.

In the 1970s, *M*A*S*H* used a technique that relied on wide shots and a tracking camera with action occurring as characters moved through the frame. With creative editing, these shots were used to transition from one story to another. The techniques helped support the idea of ensemble characters and the central theme of the series, which was the absurdity of war.

One of the more prominent influences on contemporary editing was the 1980s advancement of music videos, most notably on MTV. Styles ranged from short narrative stories designed with continuous scenes to fast-paced montages with a flair for the artistic. These early music videos allowed the editor freedom to experiment with new forms and style.

Television commercials are another segment of the production industry that allows unique opportunities for editors to test new techniques and try new things. It is easy to comprehend the sophistication involved if you consider that advertising agencies spend millions of clients' dollars promoting their product with 20- or 30-second advertisements. In these cases, each frame is critical in

engaging the audience and understanding the message. With the volume of commercials broadcast every hour and the audience scanning through them, many innovative and contemporary techniques are utilized.

Throughout the past 100 years, these pioneering efforts paved the way for contemporary editing styles. Their methods can be found in everything from feature films and TV commercials to documentaries and music videos. Their practices provide a lexicon of techniques that bridge early film and television techniques with contemporary digital storytelling.

GETTING INSIDE THE VIEWER'S MIND

I keep telling my editors, if you win an award for editing,
I won't work with you anymore. Your editing shows.
LOUIS MALLE, DIRECTOR

As discussed previously, Kuleshov, Pudovkin, and other early filmmakers proved that cutting disparate images together could produce a new meaning for the audience. While some cuts establish continuity between images, others break from this tradition and force the audience to critically think about the message. But does an audience think about this while viewing a film or TV show? Naturally, the audience probably isn't thinking about production techniques unless there are technical problems, there is a misuse of technique, or the edit has been created to draw attention to the technique. Editors should approach the task to ensure that every cut in a program has a purpose, with the goal of keeping the edit transparent to the viewer.

The Psychology of Editing

Like the decision a director makes regarding where to physically place the camera for a shot, an editor must decide when each edit should occur. There is no magic formula that dictates how long a shot should be on-screen before a cut. Editors might say that an average of every 3 to 5 seconds is common, but that it is really difficult to label the length without some factual parameters. During some programs, a shot may be on-screen for several minutes, while in others, there may be a cut every few frames. The digital film *Timecode* was 90 minutes long and was shot in real time. The film consists of four 90-minute long shots, with each shot being on-screen the entire time in one of four equally sized video windows. It is common for the PBS series *This Old House* to use one continual camera shot to cover scenes that can run several minutes long. On the other hand, fast-paced montages in music videos, commercials, and program promos might be cut every few frames. Combining this fast pace with multiple layers of on-screen images and sophisticated sound-track elements can provide content at a rapid pace, requiring hundreds of edits per minute.

The director or editor must be able to justify each cut within a scene, and there should be a motive for each cut in the program. The most logical cut is to

allow the viewer to see the content from a different perspective or to present something new. In narrative stories, the camera shots are usually of the person talking. Occasionally, the cut will be modified and we see a **reaction shot** of the person listening. In *CSI,* there may be a cut from a wide shot of a lab technician discussing the DNA report she has in her hands to a close-up of the actual report. A common technique in a news story is to cut from the picture of the reporter describing an event to a series of shots that visually enhance the story. This use of **b-roll**, footage that visually describes the story, is very common in nonfiction storytelling. In many programs, edits are used to compress or expand time. Regardless of style or pacing, your program should be validated by the effectiveness of the cutting.

Image and Sound　As more information is provided to the audience, the story's focus becomes clearer. The old adage that "a picture is worth a thousand words" might make a stronger statement if sound is added. An image of a dog wagging its tail becomes more prominent if we hear another dog off-screen or a person talking to the dog.

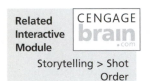

Related Interactive Module

Storytelling > Shot Order

Shot Order　The scene begins with a person pointing a still camera and clicking the shutter. The next shot shows another individual looking towards the camera in surprise. The audience interpretation is that a person hears the camera click and turns to see that the photographer has already taken the shot. But what happens if we reverse the order of the shots, starting with the person looking towards the camera and cutting to the photographer before clicking the shutter (see Figure 8.2)? The audience would then assume that the person knew the photographer was going to take her picture.

While most programs have logic in the order shots are presented, in some cases, the decision is not so clear. Picture a scene that begins with a wide shot of a building followed by a close-up of the doorway. This approach establishes the

(A)　　　　　　　　　　　　　　　　(B)

FIGURE 8.2

How does the story change if these shots are placed in reverse order?

SOURCE: Courtesy of author, Ron Osgood.

location before any details are presented. Conversely, the close-up of the door can be shown first. This creates suspense while the audience tries to figure out where the scene takes place.

Shot Relationship An editor can alter believability by using patience and attention to detail in the edit. Like Kuleshov's experiment, the relationship of two unrelated shots can be believable or it can confuse the audience. Cutting from a wide shot of a building to a medium shot of someone sitting at a desk is a logical progression that provides the audience with enough information to assume that the person is in that particular building. With planning and attention to physical continuity issues, these shots could have been shot in Chicago and London months apart. It is the edit that joins them together.

Related Interactive Module CENGAGE **brain**.com

Storytelling > Shot Relationship

Time Manipulating time is a primary reason for editing. Compressing time is the most common form of time manipulation. This storytelling convention includes everything from a simple scene where the talent walks to a counter and buys a cup of coffee to a historical documentary covering hundreds of years during the Middle Ages. In each case, the editor must cut to retain credibility with the audience by presenting a cohesive story that fits the director's allotted time for the scene.

Program length is also dictated by distribution requirements. A half-hour PBS show has a time slot that is slightly less than 27 minutes. TV commercials must hit a specific time to the frame. Because of these guidelines, the editor must continually consider the length of each shot, each scene, and each program.

Compressing time is almost always a consideration in sitcoms and dramas. This presents an artistic and technical challenge to the production crew and eventually to the editor. A common scenario is having talent move from one location to another. If the talent needs to move from a second floor bedroom to the first floor kitchen, the cutting will in all likelihood include techniques used to compress time. This can be accomplished by starting with a shot of the person walking towards the bedroom door. The next shot could be a shot of the kitchen with the person entering the kitchen. These two shots can easily be positioned to shorten the time and distance as well as to maintain believability with the audience.

In *Parrotland,* the project mentioned in Figures 2.1 and 2.14 of Chapter 2, the director wanted a shot of Stormy as she walked to the car. To maintain continuity, it was critical to keep the car out of the shot and have proper screen direction (see Figure 8.3). In order to create the sense of time it took for her to walk to the car, a low angle shot of Stormy's shoes was used. If the director shot with editing in mind, the editor can compress long scenes by cutting out the unimportant parts. While the process can be effective, problems occur when the camera pans with the talent, or the recording is stopped before the talent exits the frame. The result is an editor's nightmare.

Related Interactive Module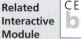

Storytelling > From Script to Screen

This same technique was used by Pick 2 Productions to show the band leaving a hotel, flying to the next city, and walking into their new hotel. The whole process contained six shots. While the whole scene was just under 23 seconds,

© Cengage Learning

The storyboard helps the director visualize a scene and provide the necessary shots for the editor. The cut to the woman's shoes allows the editor to cut away from the shots of the car and allow time to be compressed.

the sequence was still time-consuming to shoot and edit since the crew needed shots from each location.

A documentary may use a voice track to drive the edit points and allow for jumping through time and space. In the documentary *Dogtown and Z Boys*, a sound bite from one of the skateboarders about competitions they participated in over several months was the cue for editing different competitions from different locations and times. In an informational video for Habitat for Humanity, a voice-over narrator discussed the rebuilding of a home, while the audience saw a series of shots showing construction of the home.

Rhythm and Pacing A number of factors are important in deciding the length of each edited shot in a story. We have all watched programs that advanced too slowly, and others that were cut so fast that they were too hard to comprehend. The editor has an important job deciding on the pacing and

STORY 8.2 The Challenge

One of the most difficult things about editing commercials is trying to tell a story in 30 seconds. A good director will almost always overshoot in order to give the editor as much coverage as possible. I normally receive a minimum of 2 hours of footage for a 30-second spot and will occasionally get as much as 6 to 7 hours. My job is not so much about whittling this footage down to the best 30 seconds, but rather choosing the scenes that tell the best story.

I find dialogue spots to be among the trickiest in this respect. I will usually start by cutting the best spot, regardless of time, and see where I end up. The last dialogue commercial I edited started out at 39 seconds. Breaking it down to 30 was not easy. I started by trimming as much "dead" space as possible. The establishing shot (no dialogue yet) got cut in half, from three seconds to one and a half. Then I trimmed as much as I could in-between takes without compromising the flow. I was down to 36 seconds.

Next, I swapped out two of the original lines I chose with faster reads. That bought me another two seconds. I was down to 34. It was obvious I would have to cut a scene. I hated doing that, but if I tried to keep everything, it would have been way too rushed. Because the dialogue was between two people, it did not work to just cut one person's line entirely, so instead I was able to trim the middle part of a line by cutting from a close-up to a wide shot of the same person. That saved me two more seconds, leaving me at 32. Next, I sped up some of the scenes where the talent was not talking. I couldn't speed up the whole scene because then their mouths would be out of synch with their audio. This trimmed up a little more than a second. For the final 15 frames I did the easy, but dangerous, thing to do—I trimmed the product logo at the end.

SOURCE: Craig Lewandowski, Editor

rhythm to the cuts. The easy answer is that an image should be on-screen as long as necessary to transfer the information to the viewer. The hard part is deciding how long that time is.

Pacing can be likened to beat in that it sets up a defined rhythm for the audience. When editing to music, the beat suffices, but when editing with dialogue, the rhythm is based on the character. While not always the case, some scenes are written for a controlled rhythm of the cuts. With montage, the pace can be based on the amount of time a shot needs to be seen or cut to the tempo of the audio track. Sometimes it is refreshing to have the rhythm broken during a predictable series of cuts.

The faster the pacing, the more specific the cut must be. As an editor listens for the point to edit, it is a simple process to carefully look at the audio wave-form and mark the edit point directly on the part of the waveform that identifies the specific reference in time. It is amazing how different the cut can appear by being a few frames off the beat.

TURNING THEORY INTO PRACTICE

The challenges for an editor are to maintain believability, keep the story interesting, and develop techniques to advance the story. Think of how you would plan a scene of a young mother driving from home to drop her kids off at school. How would you shoot and edit the scene? Would you create a subjective point-of-view shot and complete the scene in one long take, or would you use a series of shots with cuts of an automobile pulling out of a garage, the garage door closing, and the car moving across the frame as it goes down the street and eventually parks. Both versions tell the same story, but they use entirely different techniques.

Continuity

Continuity refers to maintaining story consistency from shot to shot and within scenes. This convention helps add to the believability of the scene and maintains realism. A **jump cut** is a series of two shots that lack continuity.

Physical continuity relates to all the items used in the production. These items include everything from the sunglasses that the talent is wearing to the time displayed on clocks in the background. For example, if the talent is wearing sunglasses in one shot, all subsequent shots in the scene must include the sunglasses. This type of continuity can be checked before shooting begins and someone on the crew can be given the responsibility of checking props, clothing, and other physical items visible throughout the shooting.

Technical continuity problems refer to technical inconsistency from shot to shot. This inconsistency can be caused by changes in lighting, audio levels, or quality of the image. The crew must ensure that cameras are white-balanced and natural sounds match from shot to shot.

A third type of error occurs when there is a spatial jump from one shot to another. A **spatial jump** cut (Figure 8.4) occurs when the cut between two

images is not sufficiently different from the previous shot. If camera position changes, it should be at least 30 degrees off axis from the previous position. In an extreme case, the camera only moves slightly from the original position and the cut from one camera shot to another barely shows a change except for a slight shift in the on-screen image. This will be easily be apparent to an audience. A cut that includes the same subject but with different focal lengths should usually be cut on movement or action. The action carries the movement and makes the change in frame size less evident. In these cases, the focal length is usually cut from a wide to medium or close-up to medium, rather than being a dramatic cut from a wide shot to a close-up. A good editor can make a cut on action so transparent that the cut is not noticed and the audience focuses on the information contained in the second shot. In a law enforcement genre, a detective may reach towards a desk drawer in a wide shot, and a seamless cut to a medium shot of the drawer opening reveals the evidence that is necessary to solve the case. When done properly, the cut is not noticed and the audience sees what the detective sees.

Continuity is also broken when screen direction is reversed. Figure 8.5 shows an example of this continuity error. In the first shot, the man is looking to the right. In the second shot, he is looking left because the videographer reversed screen direction.

Most dramatic stories are planned, shot, and edited for continuity. In *True Blood,* care is taken to ensure that the audience understands the story and can follow the series through time and space. When an actor looks left in a shot, the following shot should be what he was looking at. When an actor reaches to pick up an item from the ground, a cut on action from a wide shot to a close-up is seamless, as the cut always shows the talent as if the scene was happening in real time. A **cut on action** is a series of two edited shots that flow in a continuous and realistic fashion.

While the editing style for most narrative stories is based on classic continuity, some shows borrow techniques from **cinéma vérité**, a genre popularized in French cinema during the 1950s. In cinéma vérité, attention is placed on truth in the shot instead of on the control usually dictated by the camera crew. The techniques exploit jump cuts and might, if not used with common sense, distract the viewer and make the story seem amateurish. This style is popular in observational,

(A) (B) (C)

FIGURE 8.4

Image B creates a spatial jump cut as the camera has moved less than 30 degrees from the axis established in image A. Image C does not create a spatial jump cut as the camera has moved more than 30 degrees.

© 2014 Mark Mosrie, Cengage Learning

© 2014 Mark Mosrie, Cengage Learning

FIGURE 8.5

The editor is forced to find a way to maintain continuity for these shots because the camera broke the 180-degree line and caused a screen direction problem.

"fly on the wall" documentaries, and a number of reality TV shows. Sometimes the content carries the story, while other times, the technique distracts the audience.

Some programs take liberties in the interpretation of continuity. The critically acclaimed series *Homicide,* based on David Simon's book *Homicide: A Year on the Killing Streets,* used a number of cinéma vérité techniques that challenged the standards we normally see on television. While the overall editing of each *Homicide* episode was based on continuity, it was also common to see jump cuts and other techniques that broke the axis of action or otherwise forced audience members to think about what they were watching. In one episode, a shot of a door being slammed shut in three consecutive shots to emphasize that the door had been closed. Each of the three cuts revealed a slightly different shot because of the use of larger focal lengths that were edited rapidly in succession.

Errol Morris used continual jump cuts while editing the interview with former Secretary of State Robert McNamara in his documentary *The Fog of War* (2003). McNamara's is the only interview in the entire 2-hour film. While graphics and historic b-roll footage cover much of the film, Morris uses numerous jump cuts of McNamara. It might be assumed that these jump cuts are the result of a much-edited interview, but it is more likely that Morris intentionally left them in to heighten the tension and intensity of the interview.

Confusing the tradition of continuity is the technique, or mistake, of having jump cuts between shots. This is evident in many TV commercials and music videos. A cut from a medium shot of a person holding a cell phone to a cut of the same person with his arms crossed and no cell phone may be purposely edited to tell a quick story for a commercial, but that same series of shots in a dramatic program shows lack of proper planning during the shoot or edit session. While this technique might be dynamic and interesting for some stories, it is important to learn how to properly sequence the shots in a scene before experimenting and breaking the rules. Given the proper video clips, an editor almost always considers continuity when editing a scene together. Today's audiences are sophisticated and can usually understand the role of a jump cut. When a jump cut is partially disguised, the viewer psychologically senses something out of the ordinary but may not be able to identify what it is. This may help advance a suspenseful scene or it might confuse the story line.

Related Interactive Module

CENGAGE brain.com

Axis of Action >
Changing the Axis

Continuity Conventions Editors rely on a number of conventions to make the story believable through continuity. One of the most basic rules is maintaining screen direction. An imaginary axis should be drawn bisecting the scene, and all shots should be from the same side of this axis. Without proper screen direction, the editor must rely on seasoned tricks to mask the problem. One technique is to find an appropriate cutaway shot to distract the viewer before cutting back to the shot that crossed the axis of action. Another idea is to use a filter to reverse or flop the image as if you are looking at it in a mirror. This can only work if backgrounds, text, or props do not give away the fact that the image is reversed. Problems can be as obvious as a car in the background driving on the wrong side of the street or a logo on someone's shirt being backwards.

Maintaining screen direction is quite simple in a scene with two actors and limited movement. Adding additional talent and having talent movement within a scene can considerably elevate the complexity. Imagine that three actors are in a room, and one actor moves from screen left to screen right and turns around towards the other actors. At this point, any shots of this actor should show her looking the opposite direction from the direction we saw before the movement. Such scenarios are common in narrative productions and can create confusion for the director when shooting. Using a storyboard can help the videographer maintain continuity throughout the shoot.

When shooting a scene in which characters are supposedly looking at each other, talent eye lines should match. A common problem occurs during an interview if the interviewee is sitting and the interviewer chooses to stand. During the sound bites, the interviewee will be looking up. Another situation occurs in a dramatic scene when a conversation between two actors is shot with only one of the actors present. Care must be taken to ensure that the talent looks at the proper angle for the height of the other actor. Of course, there are times when a scene has two people that are different heights, or you have a scene where one person is standing and another sitting. You must remember that if you change the camera angles, the audience will perceive the change.

Director and editor Walter Murch has said that "editing is a dance of eyes." What Murch meant was that when a character glances off-screen, the following shot should reveal what the character sees. This is an easy method of joining two unrelated clips together, as the actor's look provides the catalyst for the cut. If an actor hears a sound and looks off-screen, a cut to what made the sound is the logical shot. This use of a cutaway is very common and helps the editor maintain continuity. A **vector** that leads the viewer's eyes through the frame can also be used as a lead-in to the next shot. An actor pointing off-screen or a sign with an arrow pointing to the right are simple mechanisms to help the audience connect two consecutive shots (see Figure 8.6).

Clearing the frame is a common technique the videographer should include in applicable scenes. This is critical when talent moves through a series of shots such as in a chase scene. In a classic chase scene, a vehicle might drive off-screen left and the cut can be to a shot of the vehicle entering the frame from the right. It is helpful if the vehicle is out of the frame in the second shot, as the scene can be shortened and valuable screen time can be saved.

(A) (B)

The man pointing (A) creates motivation for the cut and creates a link to the next shot (B).

When cutting to the first shot of a new scene, a cue should be provided indicating the location of the new scene. This may be an **establishing shot** or a line in the dialogue letting the viewer know where the scene takes place. Many times, transitional music slowly fades in during the end of one scene and continues through to the next. This is a common technique used in *The Bold and the Beautiful* and other daytime dramas. In *Seinfeld,* the familiar audio riff is heard several times during each episode as the scene moves from Jerry's apartment to the cafe and other locations.

The Montage

> The hour's approaching, just give it your best. You've got to reach your prime. That's when you need to put yourself to the test, and show us a passage of time. We're gonna need a montage.
> TREY PARKER, FROM *TEAM AMERICA*

Contemporary techniques challenge the basic conventions of production in a number of exciting ways, including editing style. While most narrative and non-fiction films and television programs utilize traditions of continuity, directors and editors continually look for fresh ideas to get their stories noticed—perhaps through the use of jump cuts or montage.

As described earlier, a montage is the grouping of unrelated images to produce a new meaning. This might be a series of shots relating to the same topic, but sometimes the shots are only related because the editor chose to place them together. A good example is episodic TV program openings that use a series of shots cut to theme music. Producers hope this technique will keep you tuned in until the plot or characters can hook you.

At its simplest form, a montage is a series of images cut to the beat or lyrics of a song or voice-over script. A classic example is the training scene in the feature film *Rocky* (1976). Through a series of cuts, the audience gets a strong sense of and feel for the main character's training.

Related Interactive Module

CENGAGE brain.com

Editing > Styles > Montage

Episodic series occasionally use montages to condense extremely long or elaborate scenes, or to bridge between episodes or seasons. Sports montages are very common, as viewers of ESPN know. From the daily top 10 plays to season review specials, the network effectively uses montages to tell condensed stories.

Sequencing

Related Interactive Module

CENGAGE **brain**.com

Editing > Sequencing

A **sequence** is a series of shots that relate to the same activity. They can be continuity-driven or a montage. The purpose of the sequence is to add interest and sophistication and provide the viewer with a better understanding of the scene. A sequence of shots can break up the monotony that one shot provides and effectively draw the audience into the scene. In an episode of *Top Chef,* the contestants compete by cooking a variety of dishes. Instead of covering the scene with one wide shot, the scene shows a variety of close-ups to illustrate the process. These shots may include an establishing shot, a close-up of the cooks chopping vegetables, a reverse angle of their faces, and another close-up of the process. A montage of individual shots of ingredients is another way to edit this scene.

Pick 2 Productions plans to use this technique for a scene in the music video where a scientist sits in a lab with vials, microscopes, and other lab equipment. A cut from the wide shot to a close-up of his hands turning the microscope to a shot looking through the scope and back to the wide shot helps the audience understand the complexity or simplicity of the task.

TECHNIQUE

For a writer, it's a word. For a composer or musician, it's a note. For an editor, it's the frame, and two frames off is the difference between a sweet note and a sour note.

QUENTIN TARANTINO, DIRECTOR

Cutting

A **transition** is the change from one shot to another. It is the fundamental action that advances a story line from shot to shot and scene to scene.

The Cut A cut is an instant change from one image to another. Careful observation of the typical transitions used in a film or television program reveals that the cut is the overwhelming choice for most transitions. It is easy for the audience to follow the story line if the cuts are done effectively. In fact, the audience may not be aware that a transition has occurred if the cut advances the story without drawing attention to itself. Likewise, a cut at the wrong time can cause confusion.

When the cut occurs is also important in creating an effective scene. It takes a good eye and proficiency to develop the expertise for cutting at the right time.

Besides that, there is also the skill and patience necessary for making frame-accurate edits. This is achieved by careful consideration of each frame while assessing when an edit should occur. An editor works with frames, not seconds. If you advance frame-by-frame through the 24 or 30 frames in a full second, you will have a greater sense of the importance placed on individual frames than if you simply play through that same second in real time. This is easy to visualize if you advance frame-by-frame, or **jog** through several frames before or after a potential edit point. While doing this, you will likely see frames you might not have noticed. For example, you may see talent as they begin to open their mouths to speak or their eyes blink just before delivering their lines. You might also notice subtle camera bumps, or a few frames while the camera was being focused or finalizing the composition. Just varying the edit point by a few frames can make a huge difference in the results.

The **cut on dialogue** is easily recognizable. Using a cut and reverse cut between two people talking is common. Narrative scenes use this technique so that the audience can see which actor is delivering his or her lines. It can also be used to show a reaction shot of another person or object in the scene. It is usually important to establish the relationship between actors with a wide shot of both before cutting between individual medium or close-up shots. During the shooting, the director and videographer frame shots with the focal length they want in the final edit. A wise director will provide the editor with as many choices as possible so that the editor will have flexibility in the cutting. In other words, there might be several shots from various focal lengths and angles. This may also provide better reaction shots than staging additional shots after the master scene is completed. The acting is usually more credible since most amateur talent perform better in a linear real-time fashion than when asked to react after the scene is over.

> For me, I'm always having problems cutting long scenes where people talk to each other because you've got an unlimited amount of choices and opportunities when you just have two talking heads. The scene can go many, many different ways; the drama can become comedy, pathos can become tragedy…. [I]t can become a grilling session or a deposition if you cut it really fast, or it can be very leisurely and introspective if you use a lot of thought and a lot of the breaths and air and pauses, not just the words. And that's where a great film editor can really help a director.
>
> STEVEN SPIELBERG, DIRECTOR

Editors love having choices, including multiple focal lengths or camera angles of each actor. While this might make the editing session more complex, it also allows more flexibility, letting the editor cut for the emotion required in the scene. Starting a two-person dialogue scene with an establishing shot, then cutting to a medium shot of each person as the conversation begins, and ending with close-up shots can continue to draw the audience into the scene. Cutting the same scene by only using close-up shots on one of the actors and medium shots of the other gives the illusion that one person is more important than the other.

Related Interactive Module

CENGAGE brain.com

Editing > Motivation > Dialogue

Cutting dialogue with similar camera angles and focal lengths also reinforces the goal of maintaining continuity within a scene. It will look odd if one person is in profile and the other has a three-quarter view. Likewise, differences in focal length will be noticeable due to dramatic changes in depth of field. In other words, if the framing for one person has a very shallow depth of field, then the reverse angle shots should have similar depth.

Cutting sound bites from a single interview and assembling them together poses potential issues since each cut produces a spatial jump cut. It is almost always necessary to find appropriate b-roll footage to cover the jump cuts. If the interviewee is discussing the construction of a new apartment complex, the audience should see visuals of the complex being built.

Dialogue cuts are not always that easy for an editor. Sometimes the specific frame where the audio needs to cut does not work well. Cutting at the end of a sentence may be easy if the speaker leaves a short pause between sentences, but in many cases, the cut is not quite so easy. In these cases, the editor must carefully try the cut using several different in-points and then listen to determine which sounds the best. Unfortunately, there are times when even the most careful work yields poor results. A decision must then be made whether to use the clip with the slight cut on a word or not use the clip. It also takes patience to make the cut with a natural pause between statements. Should that pause be four frames? Twelve frames? Two seconds? The answer depends on the emotion of the scene and the effect the cut will provide.

When properly executed, the **cut on action** creates a wonderful synergy in action scenes. It is virtually impossible for an editor to achieve this without the appropriate footage that creates a dynamic flow of action. A good example would be a scene where a person puts a backpack in a car. The camera could cut from a shot outside the car to a second position from inside the car. The cut would occur during the motion of the person's arms moving the backpack (see Figure 8.7).

During one verse of the music video, Pick 2 Productions has been given a storyboard for a scene where one member of the band reaches for a piece of paper on the counter in a gas station. According to the storyboard, shot one is

Related Interactive Module
Editing > Sound Bites

Related Interactive Module
Editing > Motivation > Action

FIGURE 8.7
A cut on action is achieved by cutting midway through the action of the man putting the pack in the car.

an establishing shot of the inside the gas station, while shot two shows the paper with the writing visible to the audience. It is important that the production team shoot the scene so that it can be edited on the motion of the hand reaching for the paper. The editing team hopes the production crew will shoot full-length versions of each shot. This will give the editor the flexibility to cut at any time during the movement of the band member's hand towards the paper. To achieve a fluid motion, the actual edit point must occur somewhere during the action of the hand moving. If it happens just before or after the action, you will jar the audience because your cut will occur between a dynamic and static shot.

Cutting on the beat is effective when the image should change on specific beats, usually music. While music is the most obvious, the transitional device may be motivated by sounds from things such as a piece of machinery or a clock ticking. In *Intimate Stranger,* filmmaker Alan Berliner uses the sound of a metronome to show the monotony of his elderly father's day-to-day life. Each click of the metronome initiates a cut to different personal items in his father's apartment. These cuts, ranging from a pair of glasses to a knickknack and so on, are powerful in advancing the story.

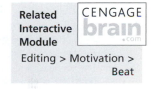

While cutting on the beat seems easy, it takes a patient editor to cue the sound to the exact frame. Looking at the audio waveform in your edit system will assist in finding a specific frame (see Figure 8.8). Many inexperienced editors listen to the audio track, pause when they hear the beat, and mark this as the frame to change the visual. The problem this presents is that the editor has already heard the beat when pausing or marking the spot. With practice and attention to detail, you will be able to hit the proper frame. While cutting on the beat is common, it is also acceptable to vary the cut and edit off the beat to draw attention to the rhythm.

Some programs are edited in such a way as to draw attention to the edit. These are those magical moments when the audience may become aware of the technique or react in a way that goes beyond the effect of the story content. During the children's science program *Bill Nye, the Science Guy,* the audience is continually exposed to techniques that assist in keeping the viewer's attention. A variety of special-effect transitions or a jump in action may have been used to change from one theme to another. Many editing techniques in TV commercials also draw attention to themselves as they try to reinforce the product or service they are promoting.

© 2014 Mark Mosrie, Cengage Learning

FIGURE 8.8

The audio waveform can be used as a cue for making precise edits.

STORY 8.3 It's Not Just Technical

Sometimes the hardest part of editing is getting started. Oftentimes, you want to know where you're going before you start to cut. But sometimes it doesn't matter. Take editing a musical montage.

There are so many ways to edit to music. On the beat, off the beat, to the action, counteraction, building to a climax, or driving to utter chaos. I tend not to think in terms of right or wrong edits, but more to the idea of edits that work well and edits that don't work as well.

For just about any cut of music, you can place pictures in a random order and eventually moments in the music will align themselves with moments in your footage. It is surprising how the mind, in its quest to find order or ascribe meaning to the world, will find a way to make links between seemingly random or unrelated things. Of course, not every cut or every action will align itself to your music. But you can take moments that are working and use them as anchor points to build the rest of your track. You will be surprised by edits that will unexpectedly reveal themselves to you. Something subtle in the background action or a

part of the scene you would normally cut off resonates with the track, taking on a new meaning and sending you in a particular direction.

As well, once a piece is finished, you can try editing a new piece of music and find entirely new moments of synchronicity. A lull or crescendo draws attention to action or pace. A moment that was a struggle with another track is suddenly and magically working in unexpected ways.

A notable example of how powerful this can be is watching the movie *The Wizard of Oz* to the album *Dark Side of the Moon* by Pink Floyd. Were these works intended to be collaborations? Of course not, but when you watch them together, your mind makes all the necessary adjustments to create mysterious connections.

Random editing is not a solution, but it can serve as inspiration. Open yourself to the possibility and prepare yourself for unexpected results.

SOURCE: Jon Dilling, Editor

Other Transitions Besides the cut, transitions include mixes, wipes, and digital effects. No one transition is right for any specific application, but each presents an outcome that should be considered before selecting.

Mix is a generic term for a gradual transition where one image appears to fade away while another begins to appear. It is much more common to use the terms "fade" or "dissolve." A **fade** has black or another solid color as either the incoming or outgoing image. The mix at the beginning of a program or a dip to black between segments is called a fade. The speed of the transition and the amount of time that the screen is black will influence the audience in determining the meaning of the fade. A slow fade out at the end of a program of approximately 2 seconds forces the viewer to consider the last image and its relative importance, as opposed to a four-frame fade that can be used to soften a cut to black.

A mix between two images is called a **dissolve**. Since a mix is a transition that is unnatural to our eyes, we psychologically interpret the action to denote the passage of time or location in the story. A dissolve is inappropriate while cutting a dialogue scene shot for continuity. On the other hand, using a dissolve between shots of a person in a variety of locations allows the audience to understand that the scenes are not taking place in real time. The amount of time that the dissolve takes is similar to the fade. Some very long dissolves last for several seconds or longer and should be considered a special effect more than a transition. Short dissolves of two to four frames are used to soften a harsh cut without the mix being apparent.

Another type of transition is a wipe or digital effect. In these transitions, one image replaces another with an effect or pattern. A **wipe** is when one image moves across the screen, replacing the previous image as it progresses. In some cases, the transition may pause or stop partway across the screen to present both images as in a split screen. This might be an effect to show both people in a telephone

conversation or two unrelated scenes happening at different times or places. Digital effects accomplish the same general result that wipes do. The sophistication and flexibility they offer make them more common choices than a wipe. In the documentary *Terminal Bar,* numerous video windows appear on-screen simultaneously. These images change regularly, motivated by the music playing at the time.

Regardless of the transition, the key to successful editing is using good judgment and asking yourself how the effect supports the story. Like every element of a production, transitions should not detract from the program.

The Magic of Editing

The power an editor has in altering reality is enhanced with numerous techniques and tricks developed through years of experience. For every problem, there is usually a creative solution.

A simple yet highly effective technique is the use of on-screen movement and vectors to advance from one shot to the next. This can be as simple as the talent turning his head to look in another direction or as complex as a bystander jumping away from the curb as an automobile chase scene approaches her. Using these natural cues can help create logic and symmetry in the editing.

Another simple but very effective editing technique is the use of an L cut. A **split edit**, or **L cut**, occurs when the picture and sound start at slightly different times (see Figure 8.9). This is an effective technique used to create

Related Interactive Module

Editing > Techniques > Split edit

FIGURE 8.9

This time line shows a split edit with the audio leading the video.

SOURCE: Courtesy of author, Joe Hinshaw.

interest or suspense. While watching a shot of a city park, we hear the sounds of kids screaming for a few seconds and then there is a visual cut to several kids playing and chasing one another. While the sound piques our interest in where the sounds are, the image satisfies that curiosity. Sometimes the L cut is cued by talent delivering a line or a voice-over. A sound bite mentions the construction of a new fire station and we hear the sound of a fire truck a second before the visual cut to the fire engine. The effectiveness of this technique should not be overlooked since it adds interest with the staggered cut and influence on pacing. While the technique is technically easy to execute manually, many editing programs have a built-in feature to guide you.

A **reveal edit** can startle the audience because the logic of the sequence is technically correct but the editor has achieved a change in time or location. This is accomplished through shrewd framing and cutting. Consider cutting from a wide shot of a man looking at a road sign to a close-up of the sign. The next cut is a close-up of the man's eyes and then back to the sign, but this time the sign is written in a different language.

Flashback and flash-forward are powerful narrative techniques in a visual medium like film or video. If the visuals are planned and shot with this in mind, the editor can easily incorporate the correct shots that make the time shift believable. Advancing a story line in this fashion can keep the audience alert and can retain interest in trying to solve the disjointed time frame. This result can be accomplished through the script or through the edit with the use of special effects to make the time shift easier to comprehend. Some techniques for this might be lowering the intensity of color, or giving the overall image quality a certain softness.

Imagine a story that cuts back and forth between two different scenes. This **parallel editing** technique allows the editor to contrast or build the story from multiple story angles and add suspense or a comedic flair. In some cases, two unrelated stories build with strikingly similar plots. In others, the action in one story seems to create a cause–effect with the other story. When two narrative threads are being presented by cutting back and forth, the action in each scene should have progressed accordingly. This parallel editing technique is an effective method used to advance related story lines. By the very nature of the technique, continuity is relaxed because each of the cuts is from the opposite scene.

Effects and filters can be helpful in certain situations. It is always tempting to include these extras since they are readily available and fairly easy to use. As with any production technique, you need to evaluate how the technique advances the objective of the story before randomly adding these extras.

A **filter** is an effect that can be applied to a clip or entire program. A filter added to an individual clip can alter the perspective, color, or other attributes of the clip. A specific filter that allows the editor to lower color saturation to give a black and white effect might add to a story with a flashback or dream scene, but may confuse the viewer if used randomly throughout the story.

Clip speed can be modified if slow-motion or sped-up clips are desired. This is a powerful tool that can assist in technical challenges where a clip does not fit the exact time required. For example, if the project has a voice-over that is 4 seconds long and the accompanying video is 4 seconds and 20 frames, the video can be slightly sped up to make the duration 20 frames shorter. In this case, the difference may not be noticeable to the viewer and the problem has been solved. If the accompanying video is only 2 seconds long, the result would probably be noticeable, since the clip would be playing at approximately 200 percent speed. Another use of clip speed is to create a motion effect of a shot in slow-motion, or faster than normal. This approach might be to create a visual mood that reinforces a calm scene or adds to the humor of a slapstick scene.

Compositing is the layering of tracks on top of one another. This is accomplished by modifying individual clips so that more than one source can be seen on-screen at the same time. Using scaling tools to make an item smaller than screen size or turning down the opacity so you can see through it to the layer below it are two examples of how it can be accomplished. It is not uncommon for a TV series to introduce central characters through a series of images layered on top of one another. These images include text, still frames, and motion media. Some images are moving on screen, while others have a variety of textured filters placed on them. The technique of compositing can sometimes be accomplished within your digital editing system, but using compositing software like Adobe After Effects is preferred.

Many of these effects are accomplished through the use of key frames. A **key frame** is a reference to a specific frame in the time line (see Figure 8.10). Adding a key frame allows the editor to trigger an action at a specific time. The range of technique is only limited by your imagination.

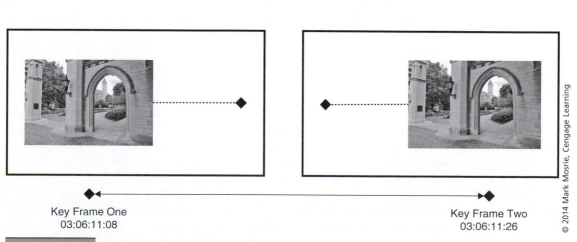

Key Frame One
03:06:11:08

Key Frame Two
03:06:11:26

© 2014 Mark Mosrie, Cengage Learning

FIGURE 8.10

Key frames reference a specific point in the time line and allow an action to take place at that time. In this example, two key frames are used to move the image horizontally across the screen from left to right, beginning at time code 03:06:11:08 and ending 18 frames later at 03:06:11:26.

The use of key frames is usually more complex than just having two points. It is much more common to have multiple key frames through a clip. These key frames may cause continual and subtle changes. Having text slide partially across the screen, pause, then drop down and slowly fade out would require five or six key frames at a minimum. Combining the use of layers and key frames provides very powerful technique capability. Like many effects, certain trends make these effects popular today but outdated tomorrow.

CONCLUSION

Editing is the third and final time a story is told during the production process. Editors input original footage and other assets, then assemble and manipulate the shots to form a meaning. Contemporary editing was developed through historic conventions and experimentation. Stories are edited with continuity or through montage.

The cut is the most common transition, but numerous transitions and effects can be used effectively. Many techniques are available with low-cost digital editing software, and this allows editors to experiment with style. More important than technique is the ability to use the tools to assemble a good story. Experience and attention to detail are two important attributes of a good editor. With patience and skill, the editor can convey emotion and clarity in a program.

Story Challenges: Editing

The editing staff at Pick 2 Productions was involved in some initial planning meetings with the producer and director. Like many editors, they prefer not being on-location with the production crew. Some of them learned long ago that their level of frustration would increase if they knew what actually happened at the shoot. Seeing missed footage opportunities during the production stage always frustrated them as they began the edit session. Their current motto is to work with the material delivered to them.

The edit staff screened all the footage and checked the footage log against the script to make sure all shots were accounted for. In some sections of the documentary script are long passages of interview without footage to cover the sound bites. While this may not be a problem in some cases, in others they will have spatial jump cuts to cover. An intern has been assigned to secure still photos and documents that might fit the content in those places where footage is needed. They are also pleased that clear natural sound is available for most shots, and room tone was recorded in each location.

The green screen interviews turned out to be excellent in content and technical quality. A test of a chroma key was impressive and will become an important technique in the story.

The live concert was shot with five isolated cameras that will allow lots of options in showing master shots or close-ups of individual musicians. In addition, a master cover shot that ran the entire length of the concert provides a framework to begin editing.

In discussions with the director, an editing style has been agreed upon that will advance the importance of the story and retain interest for the diverse audience the program hopes will view it. All in all, the story line seems to be falling into place.

Post Production

You don't know what storylines you have going until you get in the editing room.

ZORAN JEVREMOV, EDITOR

OVERVIEW

After the excitement of completing the shooting, the post production process is where the script and the story line finally come together. What may have seemed like an abstract idea finally comes to life after many long hours of planning, writing, and shooting.

Whether shooting in a studio or on location, post production is an important step in the storytelling process. Editing can be as simple as the linear assembling of clips, or it can be complex, including special effects, graphics, audio sweetening, and color correction. The joy of manipulating individual frames to get just the right blend of timing and pacing is very rewarding. It is hard to conceive of a production that does not require some editing. Live newscasts almost always contain edited field packages. Many studio-based television shows that seem to have been shot live have probably relied on some editing to fix problems with the dialogue, to tighten up the timing, or add elements that could not be added during the actual taping.

Picture yourself in a dimly lit and eclectically furnished edit suite at a professional post production company. Along with the editor, there might be a producer, advertising agency representative, or a client in the room. In some cases, all these people might be present. In other settings, the editor works alone and is heavily involved in making the creative and story decisions. In each case, planning decisions must be considered before the edit session begins. While many programs are shot and edited by the same person, others use separate, specialized crews for shooting, editing, sound, and graphics. Some programs are quickly edited within hours of the shoot, while others take months or even years to complete. Because of these diverse situations, numerous methods are used to facilitate

the edit session. However, certain basic planning considerations can make the edit session a more pleasant and cost-effective experience.

Reviewing the initial story idea is critical as the post production process begins. While editing techniques can enhance and support the original story, the editing process cannot offset confusion in the story structure or shooting problems. It is not uncommon to hear professionals say that editing is the most important part of the storytelling process. Regardless, consider this phase as the third stage of creating or adapting your story. Attention to the details of continuity, pacing, sequencing, and the use of transitions will help you create an effective story that audiences will appreciate.

Before beginning an edit session, it is wise to evaluate the technical, aesthetic, and project management considerations that impact your workflow and the end result.

Story Challenge: Editing

Pick 2 Productions has reserved an edit bay as the footage has been delivered and ancillary materials acquired. The director is negotiating last-minute details with the editing team and has several questions that need clarification.

- How will the edit team transfer the few scenes that were shot with an analog camcorder?
- Since the music video was shot at 24 frames per second (fps), what potential issues might there be for the footage?
- How will still images be stored and edited into the documentary?
- What workflow will be used for assembling the documentary?
- How will the footage from the live concert be kept in sync, since five isolated cameras were used?

Minimal problems should arise if good communication exists between the production crew and the editing team. A sit-down meeting between these two groups is a good idea. The participants can help brainstorm ideas and provide the production team with some specific requests that can make the editor's job easier.

MANAGEMENT OF THE EDITING PROCESS

Before the actual editing begins, a number of organizational checks should be completed. Begin by reviewing pertinent documents and ensuring that the editor has access to master tape footage and other assets. Time spent at this point can save hours later in the process.

Organizing

It is important for the editor to review scripts, storyboards, footage logs, and edit decision lists, even if the editor was present during the field shooting.

Script Most editors would like to have some sort of script available as the post production phase begins. For narrative stories, this should be a detailed script, while a documentary may only have an outline or a sequential list of sound bites. While most editors enjoy a creative challenge, they become frustrated when the challenge includes confusion and disorganization on the part of the director.

Footage Logs The **footage log** contains organizational information for each tape or media card, and specific information for each shot (see Figure 9.1). As an editor, it is nice to have accurate time code numbers, as well as the number of takes for each shot. The reviewing and logging of acquired footage should be completed for each individual shot. This may not seem necessary at first, but in fact, it is the only method you can use to determine the length of each shot, the quality of the images and sound, and any other information that might be useful for the editor. It may not make sense to create elaborate footage logs for every program, but a minimal log should be completed for even the simplest production. The more complex or the longer a program is, the more detailed the log should be in order to manage and organize the edit session.

© Cengage Learning

FIGURE 9.1

Footage logs may provide columns for shot and scene numbers. Shots are the order the material will be on the tape, and scenes are the order they are in the script.

FIGURE 9.2

The time code numbers are superimposed over the video in a window burn.

SOURCE: Courtesy of author, Joe Hinshaw.

Logging can be easier if a window burn is available. A **window burn** is a copy of the original footage that has the time code numbers superimposed over the image (Figure 9.2). Typically, a producer will make a copy on an easily accessible medium, such as a DVD or a QuickTime file. It is also possible to log using the time code displayed on the time line while using your desktop or laptop computer. In this way, you can pause and write down the exact time code number for each entry. Another option is to use third-party logging software programs that provide efficient and accurate information without requiring your computer to have nonlinear editing software.

Most editing systems allow you to electronically log your footage during the ingest or capture process. While this may be efficient and save time, it is still important to add text notes and print the logs for ease of use, especially in those situations where an assistant editor captures the footage before the editor begins cutting the project. This type of logging can also be costly if you are paying an hourly rate for use of the editing system.

Along with footage logs, the editor will need any transcriptions from interviews. While the most desirable transcriptions will be detailed word-for-word descriptions, others may be abbreviated due to time or expense. Having a transcript with the interviewer's questions and paraphrased responses might be all that is necessary. In this case, it is wise to put in as much detail as possible and include the time code for the best sound bites.

During the editing process, a list of every action is saved as a part of the project file. The list is commonly referred to as an **Edit Decision List (EDL)**. This list is transparent for most users, but it is helpful if the editor needs to find data about a specific edit or if the project must be conformed for an online edit. Today's nonlinear edit systems generate the list every time the editor makes a

keystroke. The list differs from a script since it is ordered as each keystroke is completed instead of the linear format common in a script. In other words, the original script and the EDL will not be in the same order.

A good analogy for an EDL would be the step-by-step instructions on a box of cake mix. In a similar way, the EDL tells the editor what to do step by step. The steps follow the order of actual button pushing and not necessarily the script order. For example, the opening music in a show may be the first line on a script, but the last item on the EDL if the music will be added after all visuals are completed.

Physical Assets

It would not make sense for a production team to go into an edit session without accounting for most, if not all, production elements. Besides video clips, these assets include sound effects, music, graphics, titles, animations, and so on. Some of these items may not be completed when editing begins; however, the production crew and editors would have planned and discussed them. Other elements of the production may be acquired from a third-party vendor. Sometimes these acquisitions are less expensive to purchase than to produce yourself.

Licensing/Purchasing Assets

Numerous companies and archives provide footage, music, graphic elements, and still images. These assets can have a positive impact on your production because they provide materials that you may not have been able to create or produce. Besides these companies, some elements can be found in the public domain or are available for free download. It is always critical to check sources and to clear and document rights. It is important to understand that this process can take a substantial amount of time.

Stock Footage An entire segment of the industry provides film and video footage for almost any need. While stock footage may seem expensive, those costs should be compared with the costs of shooting your own shots. For example, consider the cost of purchasing 30 seconds of aerial footage of the Grand Canyon versus flying a crew with camera to the location and renting a helicopter with the proper camera mount. The stock footage should prove a significant cost savings. Historic footage and photos can also be purchased, but often these or similar items are also available for free through state and federal agencies. Almost all media materials produced by the federal government are available without cost and are considered in the public domain. The trick lies in locating and acquiring these materials. Access to the National Archives is available online, but the process of finding specific material can be time-consuming. In addition, getting your own copy of the material may be complicated or include additional expense, such as a dubbing fee. Certain individuals and small companies specialize in the research and acquisition of these types of materials. Smaller-scale archives can be easier to access. For example, the U.S. Geological Survey has a

listing of video clips that are free for nonprofit use after filling out a simple application. NASA has a very impressive catalog of still and video images available. Pick 2 has hired an archivist to search databases for media related to alternative fuels. The director knows the importance of getting enough footage to tell a good visual story.

Royalty-Free Music Finding copyright-free music for your production is easy since there are hundreds of companies selling and leasing everything from classical to hip hop. Some companies have sophisticated libraries with online searching and multiple versions and instrumentation of individual cuts. Some libraries sell you unconditional rights to the library, while others stipulate additional costs depending on the use of the item. Another popular method is to pay what are called per-use fees for any music you use in your project. The costs vary by the number of cuts, the length of cuts, and the intended use. Thirty seconds of music for a program to be played on a local cable show is considerably different than the cost of the same 30 seconds to be broadcast nationally. Most music libraries provide music on CD and/or through digital libraries that allow local servers to host the music to all editing stations in a facility simultaneously.

Graphic Elements and Animations Just like music libraries, there are companies that specialize in generic graphic elements and animations. It can sometimes be cost effective to purchase preproduced graphics of common symbols, shapes, and icons. Images of flags from several countries may be cheaper to purchase or lease than to design and produce in-house. If the flags need to wave as if being blown in the wind, an animated version may be available as well. As with any acquired assets, producers and editors must use good judgment to keep from overusing these elements.

WORKFLOW

Workflow is a systematic procedure that includes planning, file management, file storage, and archiving. It may not seem important, but seemingly mundane tasks such as choosing a file naming scheme and storage location and deciding which codec will be used should be considered during preproduction. Actual workflow decisions must be dealt with before any physical editing begins. On the technical side, having a strategy for selection of an appropriate codec and adhering to it is essential. A **codec** is a compression/decompression engine that is used to modify the amount of data or bandwidth. While many nonlinear editors will support a timeline with multiple codecs, the best practice is to work natively with the original files or to transcode your assets to ensure that each one uses the same codec. **Transcoding** is the process of converting from one codec to another. An important factor is whether you acquired most, or all, of your assets in a tapeless or tape-based recording method.

With the increased popularity of shooting 2K or 4K resolution, editors are forced to make a tough decision on how to incorporate these raw files into the workflow. A **raw** workflow uses uncompressed files in their native codec. Because the files are so large, they make the editing process slow and cumbersome, and many editors will chose to transcode the raw files into a more manageable codec for editing.

Tape or Tapeless Workflow

"Tape is dead" is a common adage among some of those working in the production community. There certainly is some truth to the statement, as the industry continues to move towards a tapeless environment. On the other hand, tape will continue to play a part in many productions for years to come. An important consideration for tapeless systems is where and how to save original files. In a tape-based workflow, the videotape itself serves as the backup of all the materials. In a tapeless workflow, you must devise a system to create and maintain backup files. One solution is to archive the original media cards if your system uses removable media. Saving a copy to a cloud service or on hard drives helps protect the media by providing a redundant copy. In any case, make certain that you maintain multiple copies of the media. Preferably, a second copy would be kept in a different location than the first copy.

Tape

It is enlightening to tour the tape library of a television station, production house, or archive. The amount of analog tapes catalogued and sitting on shelves or in boxes is staggering. In many organizations, efforts are underway to evaluate these tapes and transfer them to a digital format. For others, the process is overwhelming, too expensive, or given a low priority. The end result is that some analog tapes may still need to be played and edited for years to come. Although digital tape is a much more recent medium, it shares many characteristics with analog tape. Since one purpose of editing is to transfer specific clips into a new program, it is evident that transferring these archival pieces is a form of editing. While some transfer directly to a digital file or optical disk, others simply copy the older tapes to new tapes, since the physical life expectancy of any recorded media has limitations and tape is no exception. A drawback to this duplicating process is that analog signals lose quality each time they are copied. This phenomenon is known as **generation loss**. Digital tape does not experience generation loss. The quality of each duplicate version is theoretically the same as the original.

Tapeless

There is no shortage of tapeless options ranging from hard drives, media cards, and solid state drives (SSD). There can be considerable time saving when using file-based recordings, but paying attention to proper workflow planning is

STORY 9.1 A Historical Look at Linear Editing

Historically, linear tape editing was similar to film splicing. The difference was that while the film editor could visually see the images on the celluloid, the tape editor could not actually see the pictures before making a splice. A process was developed whereby a chemical solution would be applied to the tape and the electronic signal would appear while looking through a microscope. By carefully observing the magnetically arranged particles, the editor could cut the tape at a precise position that would allow the synchronizing pulses to stay aligned after the new splice. The process of electronic analog editing has existed since the 1960s, when crude videotape recorders allowed an electronic splice at a predefined point. The editor would pause a video player and a video recorder at the point in the program where the edit should occur. Next, the editor would reverse, or **back time**, each tape as close to the same amount of time as possible, usually 5 to 7 seconds. The editor would then simultaneously start both machines and press the edit button at the appropriate time. During the 5 to 7 seconds that the tape was playing, the editor had to gauge whether the timing was close or not. Even in the best situations, it was extremely hard to be that accurate. Pressing the button committed the actual edit and there was no undo command, as is common in nonlinear editing systems. In the early 1970s, the technique became more sophisticated and the back timing was automated by a simple remote control that was connected to each machine. Upon selecting the edit point and pressing the edit button, the video machines reversed the 5 to 7 seconds, paused, and played to the edit point, and then the edit would occur. Linear editing advanced technically as multiple players, or **feeder** VTRs, were programmed to start at a marked time and cause an effect to be triggered through a switcher. This technique was called **AB roll editing**, and it eventually allowed more sophisticated techniques involving more than two feeder players.

© Cengage Learning

essential if you hope to achieve this efficiency. On location, the **data wrangler** should carefully make backup copies of all the original recordings. It is possible that the data wrangler might also need to transcode the clips to the codec selected for editing. This will save the editor or assistant editor time when transferring the assets into the nonlinear editor. Once the data are prepared, the wrangler assures prompt and careful delivery of the files and production notes to the appropriate person.

THE NONLINEAR PROCESS

The concept of nonlinear editing is second nature to a generation of editors growing up using computers and word processing programs (see Figure 9.3). Most people know how easy it is to fix mistakes such as a misspelled word or remove an unwanted paragraph in a written document. Correcting those same problems on a typewriter is not so easy. This is the perfect analogy to highlight the difference between linear and nonlinear editing. While the technical ease of altering the story makes editing powerful, it does not make you a better editor. If you think about it, the computer did not necessarily make you a better writer or speller. In fact, it may make your structure less organized, since you are not so worried about making a mistake or having to continually undo and redo your work. In addition, because it is so easy to make changes, there is a tendency to keep making revisions and never actually complete the program or document. While editing tools certainly allow flexibility and a chance to try multiple options, the planning process can unfortunately be overlooked.

FIGURE 9.3

In addition to computers, low-cost editing software can be found on tablets and smart phones.

SOURCE: Avid Technology

Most edit systems are software driven and require a fairly robust computer. Besides fast processors, these systems require additional amounts of RAM and significant hard drive space. Today's laptop computers are efficient solutions for editing video and they add the convenience of editing and screening while on the road. Underpowered computers or those without enough storage for video files can frustrate an editor. In addition, numerous peripherals and software enhancements can improve a system. These may include accelerators that allow for more sophisticated graphics, video output boards that allow up or down conversion between high definition and standard definition, and transcoders that translate signals from one digital format to another.

While editing typically offers elaborate techniques, the goal is always to tell a good story. The concept is to select shots and place them in a specific order for eventual output. This is a basic concept that can be accomplished by splicing film with a razor or cutting with a digital razor blade.

File Management

Professional nonlinear editing software programs include an electronic organizational structure similar to a file cabinet with drawers and folders. Although the

FIGURE 9.4

Nonlinear editing programs provide a powerful database for organizing a project.

SOURCE: Avid Technology

terminology differs from manufacturer to manufacturer, all systems have a **project** folder that contains a variety of additional folders and files. Most projects have folders called **bins** that contain all the various assets for the project (see Figure 9.4). An **asset** is a video clip, a sound file, a graphic, or other piece of media. A bin may have been created for interview clips or for all shots from a specific scene. Graphics and sound files are usually placed in their own bins as well. The more you can organize your project in bins, the more efficient you will be when trying to find the clips during editing.

Files are copied from the acquisition format to the computer. The actual audio and video are called **media files**. What shows up in your bin is called a clip. **Clips** are reference links to the actual media files. Think of the clip as a set of directions or a road map that tells the computer to retrieve certain media files and play them back in a certain way. As you edit on a nonlinear system, you are actually writing directions for the computer to execute. The computer is not really altering the media files.

This concept is what creates the great power and flexibility of nonlinear editing. You can have hundreds of different sets of directions, or clips, all based on one media file. This is an important concept to understand and will aid in a better understanding of the software, especially when technical difficulties arise. Every mouse click or keystroke becomes part of a linear file that is written for each action. This file is the electronic EDL, also called a **project file**. As you can imagine, this is the most important file you will deal with. One common

problem is the error message "**Media Offline**." At first, a message like this can cause great concern that the files have been deleted. Most of the time, the message is caused by a break in the link between the clips and the media files. A simple process reconnects the two.

A feature that continually runs in the background is **auto save**, a function that saves your work on a regularly set schedule. While it is rarely needed, it is impossible to be without when you need it. If a file becomes corrupt or gets deleted, the auto save feature will be appreciated. Within the preference settings for most nonlinear editing software is a selection for auto saving the project file at predetermined lengths of time.

TIME CODE

Time code is important in the production process for batch capturing, for editing, and for linking multiple pieces of equipment together. **Time code** is a unique number assigned and recorded for each frame of video. The way it works is quite simple. Time code is composed of an eight-digit number measured in hours, minutes, seconds, and frames. A typical time code number might be 01:12:22:07 (1 hour: 12 minutes: 22 seconds: 7 frames).

We commonly refer to video as having 30 or 24 fps, but the actual frame rate is 29.97 or 23.98 fps. Because the signal is not exactly 30 or 24 fps, time code numbering is not accurate and the error in the numbering increases as the program gets longer. In a 30-fps environment, at the end of a 1-hour program (00:00:00:00 to 01:00:00:00), the time code reading would be 01:00:03:18. The program is 1 hour long, but the time code has added 108 frame numbers. This type of time code is called **nondrop frame** time code. A second standard called **drop frame** time code was developed to keep the numbering system more accurate. With drop frame, the numbering system is almost always correct. This is accomplished by having the numbering system drop the first two frame numbers for every minute except each tenth minute. As an example, time code numbers would read 05:00:03:28; 05:00:03:29; 05:00:04:02; and 05:00:04:03. Frame numbers :00 and :01 have been eliminated (see Figure 9.5). Television and cable networks commonly require that drop frame time code be used. They find this important because of the very specific time allotments for half- and full-hour programming. Even though the program is accurate in length using nondrop frame time code, the programming and engineering departments will only know the real length by using a time code calculator to convert the nondrop frame numbers to the actual time. For example, PBS 30-minute shows usually run 26 minutes and 46 seconds (00:26:46:00). With nondrop frame time code, this time would have a time code reading of 00:26:47:18. Some camera manufacturers do not allow drop frame time code when recording at 24p. The timing errors can be corrected through the use of time-code calculators or special features of your editing software.

Nondrop frame

05:00:03:28 05:00:03:29 05:00:04:00 05:00:04:01 05:00:04:02

Drop frame

05:00:03:28 05:00:03:29 05:00:04:02 05:00:04:03 05:00:04:04

FIGURE 9.5

A look at the representative frame numbers illustrates the difference between nondrop and drop frame time codes, but the actual running time of the program stays the same.

Most professional cameras allow the user to change the time code to one of several positions. A seldom-used setting allows the time code to mimic a clock and actually record numbers that correspond to the specific time of day. This is useful for productions that would benefit from having the real time recorded. **Preset** time code allows you to set a specific number, for example 1:00:00:00, before beginning to record. For projects with multiple shoots or different media cards, the videographer can organize files by changing the hour for each event. **Regenerating** time code is matched to the previous time code on the recording media. If you stop recording one day at 3:05:12:24, the time code picks up at 3:05:12:25 the next time you record. It is common practice to use time code numbers during field recording as a labeling mechanism for programs with multiple media cards or tapes. Using this technique, the first media card would have time code numbers that begin with hour 1 (01:00:00:00), card 2 with hour 2 (02:00:00:00), and so on.

Time code is also necessary for those productions that acquire sound on a separate audio recording system, such as DLSR. Synchronizing the audio recorder and the video recorder is essential to keeping the sound and picture in sync. Synchronized time code is also used to lock the time code numbering system between two or more field cameras shooting the same scene. This allows the editor to choose any shot from a number of camera angles and have the luxury of all shots being synchronized with one another. This is especially useful for those programs requiring lip sync. Finally, synchronized time code is essential between the two cameras used to create stereoscopic 3D images. This ensures that the stereographer has both cameras set to record and relink the images in post production on exactly the same frame.

STORY 9.2 Stereoscopic 3D Editing

When planning to do any stereoscopic 3D (S3D) post work it is smart to allocate more time than usual for managing double the amount of media and for conforming and adjusting the stereo pairs. It is imperative to back-up of all of the principal photography and then make back-ups of the back-ups. Just like in any good post workflow it's also important to properly label and organize all of the media being processed, but when working with S3D media it is even more important for grouping and muxing, that is, mixing the two video streams together.

Stereoscopic 3D post work was once reserved for dedicated high-end editorial and finishing workstations such as Quantel Pablo, Assimilate Scratch, Autodesk Flame, or Avid DS. With these methods the editorial process is much like the traditional off-line / on-line workflow of any 2D job. The editor must transcode all of the media into a low bit rate, offline codec and edit the 2D version in an NLE such as Avid Media Composer, Final Cut Pro or Adobe Premiere Pro. Once the cut is approved and locked, the timeline is sent via XML or AAF to a dedicated finishing system where the two angles are matched and any necessary adjustments are made to the stereo pair. Recently, software providers have updated their software to support stereoscopic 3D workflows, bringing S3D to the masses.

When off-lining a S3D project in 2D it is important to remember that the audience will be viewing this in 3D. In general it is better to slow down the pacing of the sequence and use fewer cuts. It's more interesting for the viewer to watch longer clips with more movement within the shot, to notice and enjoy the visual parallax. If the footage is available, wider shots that show the floor and ceiling of the environment also help accentuate the 3D plane.

The main element to consider when finishing a S3D program is determining where the point of convergence exists in the shot. The convergence point is the point in Z space where the two angles, or eyes, intersect and the stereo pair match if superimposed on top of one another. It is also important to think of the convergence point as the screen plane. When a viewer is looking at the screen, whether it be a television or in a theatre, they are focusing their eyes on the screen plane. It is easier on the audience if the focus point and the convergence point is one in the same. Adjusting the convergence point in post is also referred to as performing "Horizontal Image Translation" on the stereo pair. This is done by adjusting the two images along their X axis, creating a new point in Z space where the two eyes intersect. If the convergence point is animated throughout a shot it can seriously screw with the audience and cause their eyes to see-saw, because when pulling the convergence point, you are in effect moving the screen plane.

Another procedure that the finishing editor often performs is what's known as a "floating window."

In order to understand what a floating window is, it is important to understand the difference between positive and negative parallax. While the convergence point is the screen plane, any objects in the shot that are behind the point of convergence are considered to be in positive parallax. These objects will appear to the viewer as being behind the screen plane, as if they were watching a play and all of the actors and props are located behind the edge of the stage. Conversely, any objects in the shot that are in between the camera lens and the point of convergence are considered to be in negative parallax. These objects will appear to the viewer as being in front of the screen plane, commonly thought of as objects flying out into the audience.

Objects that are in negative parallax must be completely within the frame; if they are partially in the shot, it will be flagged as a "window violation" during quality control. Window violations are very difficult to avoid in production but they can be fixed in post by implementing a floating window. Simply add a small black edge wipe to one of the eyes, only one eye is necessary to clean the disparity of the occlusion, and the problem will resolve itself. It essentially moves the edge of the screen further towards the audience. Keep in mind that this is only necessary to fix left and right edge violations, the viewer isn't affected by edge violations on the top or the bottom of the frame. Be sure to check the Network Operations Standard Red Book when determining the appropriate delivery format for Stereoscopic 3D projects. It is common for networks to require separate HDCAM-SR master tapes of the left and right eyes. If the delivery medium is straight to DVD or Blu-ray the best method is simply outputting a single side-by-side master. In a side-by-side master the left and right eyes are squeezed to half of their horizontal resolution and placed next to each other, containing the entire stereo pair in a single stream. The 3D television then resizes the two eyes to produce the stereo image.

SOURCE: Matt Wildes Senior Editor | Post Production Supervisor

PREPARING YOUR MEDIA

One of the first tasks in the editing process is to make sure all assets are available in the proper format for the editor. The process is slightly different depending on the format of the asset, but one thing that remains consistent is having all assets stored on the editing computer drive, a **RAID** or a server designed to share assets with multiple work stations.

Ingesting **Ingesting** is the process of transferring digital video files from the camera recording media into the computer. While there is not a standardized set of terms from manufacturer to manufacturer, the process is the same. A tool within the editing software allows the editor to review and select clips, and then transcode clips into a designated storage folder. During this process, the clips can be marked so that only selected segments of the footage are transferred. Besides saving valuable hard drive space, the editor will only have the selected clips to work with. Some editing software works natively with the file type that is being ingested and does not require transcoding. This is a benefit in time and storage savings.

Digitizing **Digitizing** is the conversion of an analog signal to a digital file. While rare for narrative work, historic documentaries may benefit from video assets that are archived on analog tapes. **Capturing** is the conversion of digital tape to digital files. While these terms are sometimes used interchangeably, they are indeed two distinct actions. The end result is the same since the editor now has the original media stored on the computer as digital files.

During the capture process, the editor or assistant editor must make a decision regarding how much of the information will be transferred from the source tape to the computer drive. It is not uncommon for the digitizing or capturing to be completed during off-hours by the assistant editor. The process is straightforward but time-consuming, as clips are transferred in real time. It is important to capture a few extra seconds at the beginning and end of each clip. These extra seconds are known as **handles**, and they become critical when performing effects in a nonlinear editor, since that extra media may become part of the transition.

A number of file management tasks can be completed during the capture session. Using the built-in database, reel numbers, clip names, and shot descriptions can be easily typed and entered for future reference (see Figure 9.6). In addition, clips can be organized into specific bins. Pick 2's editors expect to rely heavily on the shot descriptions column and have spent a substantial amount of time logging and entering these data.

The practice of capturing all the contents from an entire tape as one clip is usually a poor practice, as was explained above in the ingesting section. On the one hand, it is an easy process and you will have all the original media available during editing. The downside is the large amount of disk space that you will occupy and the potential lack of thorough preparation as the edit session begins. With a shooting ratio of 10:1, you will need ten times the hard drive space for the project. At 30:1, the number increases dramatically to 30. In addition, you

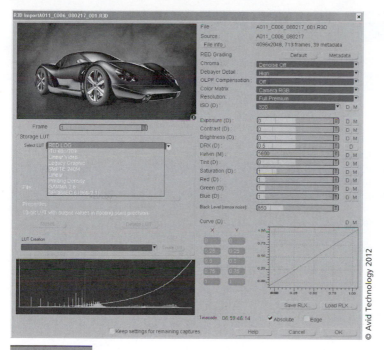

FIGURE 9.6

During the capturing process, editors add text information and organize clips into bins.
SOURCE: Avid Technology

will need to sort through all the footage while monopolizing an edit system. This process is not a good alternative for logging your clips beforehand, as you will still need to log the footage. Some nonlinear editing packages have a feature that places a reference mark on the captured file at every point in time when the camcorder trigger was pressed. This may be a small consolation to the editor trying to sift through a large amount of useless footage.

Batch capturing is a process used to capture multiple clips from an individual tape in one action. First, the tape is logged while viewing and marking clips by title, in- and out-points, and editor comments. Once the tape is logged, the editor can select the batch capture option, and the computer and video player will work together to convert the marked clips to the hard drive. This process allows the editor free time to take a break or work on other tasks.

Batch capturing is also used to recapture clips for those who will perform an **online** edit at full resolution after a low resolution, or an **offline** edit that was approved by a client. The offline edit is normally captured using a lower resolution signal to save time and hard drive space. It also saves the production company valuable time assembling sophisticated graphics, adding effects, and mixing the sound track. After client approval, the original project file is sent to the online edit suite and the online editor reassembles the program in high resolution

STORY 9.3 Batch Capturing

The batch process requires detailed attention during the shooting and logging steps. As mentioned earlier, the time code can be set to a different hour for each tape in a production, and this is critical for a batch capture. As capturing begins, the editor can choose to electronically log each clip without performing the actual transfer process. After each individual tape is logged, or after all the tapes are logged, the editor can select the batch capture tool and the computer will ask what tape is currently in the feeder VTR. If the time code had unique numbers for each tape, it is an easy task of selecting the correct reference and clicking the batch button. The computer takes over and finds each in- and out-point for the entire tape. This process can also cause problems if the time code was not set to unique numbers for each tape. For example, if every tape starts with 00:00:00:00, the computer will not know which tape is loaded and will capture the clips on that tape according to the selection made on the computer. One way to avoid this problem is to assign a reel number to the tape when you capture the footage. The computer will keep track of the reel numbers and know that a shot at 04:25:36:17 on reel 4 is different from a shot with the same time code on another reel. While you are labeling your tape during the shoot, add the reel number on the label so that you can keep track of these numbers as well.

Sometimes, the time code numbers create confusion during the capture process. This problem occurs when the tape has more than one of the same time code numbers on a specific tape. This happens if your camera resets the time code number to 00:00:00:00 every time it is turned off or the battery is changed. When trying to capture, the computer cannot distinguish between the multiple clips with the same number, and thus will capture the clip in the string of numbers where the video player is parked at the time of capture. If the player continues to struggle with this, a manual record feature is usually available to override the automated process.

and adds the graphics and other elements to the final version. Batch capturing is also advantageous if a program will be re-edited at a future date. Having the original media and project files makes this task easier if the proper time code was originally recorded.

Importing Besides the media files, most systems accept a wide variety of file types for use in the project. These files may be created in third-party software packages ranging from graphics files created in Adobe Photoshop and animations created in Adobe After Effects to MP3 music files and still photograph files such as JPEG. They may also be video clips that have already been transcoded and reside on your hard drive. To input these files into your project, a process called importing is used. **Importing** is the simple process of creating media files of your assets and placing the files in the project bins. As when video files are transferred to edit software, the files remain in the original location and the pointer file lets the software know where the file is located.

Time Line Editing

Every nonlinear editing software package performs the same basic task, but the interface and terminology will be different. Nevertheless, the objective is to assemble the segments of clips that the editor plans on using in the logical order. Once all the media files are ingested and other assets are imported, time line editing takes place. The process is quite easy as individual clips can be marked with in and out-points and added to the time line. An **in-point** is a

FIGURE 9.7

The editor works in the timeline to build and refine the project.

mark added to a captured clip that becomes the first frame seen or heard when the clip is placed on the time line. An **out-point** is the last frame. Referring to the word-processor analogy, the time line is where clips are moved around, deleted, copied, and modified (see Figure 9.7).

There are different theories on the most efficient workflow during the editing process. Most editors begin by placing the base layer clips in linear order. As these clips are added, the editor can check carefully for potential problems that can be easily solved at the time. This might be related to awkward story flow or the pacing between two clips. Once this is completed and the story line begins to make sense, b-roll and other secondary footage can be added. At this stage, it is wise to play back and critically view and listen for story structure problems or technical issues related to pacing.

With a solid story in place, the process of selecting and applying appropriate transitions or effects can begin. If a few extra seconds of media were captured or digitized at the head and tail for each clip, the transition will work properly. These handles are necessary for some effects and most transitions. It may be difficult to understand without experiencing the frustration that the lack of hidden media causes. Consider a 10-frame transition from shot A to shot B. If the dissolve is centered or placed to use equal parts of shot A and shot B, the outgoing clip needs 5 additional frames beyond the marked out-point, or **tail**, of the action. The incoming clip needs 5 frames prior to the marked in-point, or **head**, of the clip for the dissolve (see Figure 9.8). If this

Edit Point

Shot A ———————— Shot B

Actual

Hidden

10 Frame Dissolve

© Cengage Learning

FIGURE 9.8

This 10-frame dissolve requires 5 hidden frames from each clip, since the dissolve starts 5 frames before the center and ends 5 frames after.

extra media is not available on the clip, the transition cannot be completed. Another problem can be caused when the handle media does not match the content of the actual media being used. Consider marking a clip of a static wide shot of a pastoral farm scene. If the clip has an out-point marked right before the camera is zoomed or moved, it is quite possible that this movement will be seen during the dissolve. These problems are not limited to dissolves, however. The same problem can occur with any transition other than a cut.

Other timeline tasks related to modifying clips are using motion control, freezing the frame, or applying filters to modify the image. Titles, graphics, and animations may be added within the editing software or completed in third-party programs. The sound-track levels will be set, as will the initial sound mix. After completion of this rough cut, the project is ready for finishing.

Special Issues Regarding 24p Productions The use of 24-frame, progressive-scan (24p) formats is a popular choice for those producers who want to emulate the look of film. Using the same frame rate as film is one way you can attempt to achieve the so-called "film look." There are, however, some special considerations if shooting in 24p.

While 24p is one of the options available on some camcorders, not all 24p systems are the same. With some systems, the camera shoots at 24p and the recording medium records at 24p. In other systems, the camera shoots at 24p and the recording medium records at a different frame rate, usually 30 fps interlaced (30i). **Pulldown** is a process that is used to convert video from 24 frames to 30 frames (see Figure 9.9). Consider the following issue: you need to change a scene that occurs 24 times a second and make it appear 30 times in that same second. To create the proper number of frames, the pulldown process will create duplicate fields. So, for every four frames of 24p material, the pulldown process will generate 10 fields, or 5 frames of 30i video.

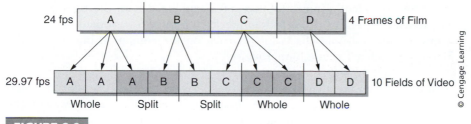

© Cengage Learning

FIGURE 9.9

Video shot at 24 frames can be converted to 30 frames through a technique called 3:2 pulldown.

STORY 9.4 Editing 24-Frame Video

I often work with material that originates at 24 frames per second but delivers at 29.97 frames per second. This might be a DVE move, an animated name key, or a flying box. The standard way to adjust footage is to add what is called 3:2 pulldown. The complaint I usually hear when I do this is "that move looks like video." What they are noticing is that the frame rate of the effect running at 29.97 fps looks different or smoother than the footage that is running at 24 fps.

This is unfortunate and difficult to work around. One way to circumvent this would be to remove the 3:2 pulldown for the footage that needs to be affected. Then, add whatever effects you need in a 24 fps environment. Finally, add the 3:2 pulldown to the effected footage and bring that back into your project.

Another option would be to manually add hold key frames to any effect you have created in the 29.97 project. This would simulate the slower frame rate of film or animation.

SOURCE: Jon Dilling, Editor

Another related issue occurs when you are trying to mix sources during an editing session. This can occur if you have material shot at 24p and 30i. Depending on your final output, you may elect to convert the 24p as mentioned above or you may do a reverse pulldown and convert the 30i to 24p. This may be a difficult process to conceptualize, but the end result is having all your material in the same format.

Finishing

As a project nears completion, a final finishing pass takes place. These tasks are sometimes referred to as the online edit and usually occur after a rough cut screening or approval by clients. Finishing tasks are time-consuming and tedious, and are only completed as the last step in the post production process.

Rendering Rendering is similar to saving your work in any computer program. It is the process of building a special effect, filter, or other complex transition frame by frame. That build creates its own media file, which is saved with the other media files. Often it is necessary to render some of your work in order to view it in real time. Because many of the processes completed during an edit session require significant time to render, editors normally render effects only when necessary. This might be when a scene is complete or an effect needs to be screened to judge its impact on the story. Since rendering is software and

hardware dependent, a powerful computer, combined with the right software, may lessen the need to render before previewing the work. Some software programs include real-time effects for playback on the computer, but require the files to be rendered before outputting.

Audio Sweetening The process of audio sweetening occurs after all audio elements have been selected, acquired, and recorded. Using a variety of techniques and tools, the sound engineer creates a sound track that matches the video or is the catalyst for the story. Audio sweetening will be covered in Chapter 10.

Color It is not uncommon for original footage to be given to an editor with a variety of color and brightness issues, or because a producer wants to apply a specific color effect to the finished video images.

Color correcting is the manipulation of a variety of signal attributes to modify an existing video clip. Color correction is done during the **digital intermediary** stage, the time when final adjustments are completed before distribution. These tools are built into most professional editing software and also allow adjustments for dark shadows and underexposed footage (see Figure 9.10). All these capabilities range from simple adjustments to sophisticated manipulation of the entire picture or a specific segment of what is on screen.

At times, color correcting is a reaction to problems created by improper white balance, poor exposure, or weather-related inconsistencies. By referencing the color white, the range of colors in a shot can be manipulated and hopefully adjusted to an acceptable image. This is accomplished by adjusting primary controls across the entire image. A second step allows adjustment of specific colors or

FIGURE 9.10

Color-correction software helps create a professional look for your stories.

SOURCE: Courtesy of Blackmagic Design.

STORY 9.5 Basic Color Correction

As a colorist, I work to enhance the beauty or mood of images by altering colors, adding visual effects, and matching shots together. Our tools include the ability to isolate particular areas of pictures for separate color changes, reduce grain or noise, and sharpen images.

Most often, my job is to enhance and match scene colors in order to "smooth" the piece. In our market, we handle long-form documentary work that often involves sequences shot over long periods of time. In one recent chase scene for a nature documentary, a leopard chases a gazelle for a total of about a minute in the program, yet the segment encompasses material shot over two years' time. My job is to match the differences in lighting, time of day, and skin tones to convince the viewer that the chase happened in real time. In this instance, a successful color correction would enhance but not distract from the drama of the scene.

For another client, I corrected hunter safety spots that were shot in the spring but were to air in the fall during the hunting season. This meant "killing" a lot of grass and leaves by changing the various springtime greens and yellows to reds and browns, thus simulating fall foliage. Isolating colors was important in this situation, so as to retain normal skin tones and the orange safety-vest color.

Whether matching scenes for beauty, or heavily manipulating color for "attitude," color correction is a necessary finishing touch to make the finished project stand out.

SOURCE: Lauren Meschter, Colorist

areas of the screen. In many cases, the colorist can guarantee consistent color across an entire production.

Color grading is manipulating color for creative reasons, such as adding a bleached or washed-out look, or deciding to remove specific colors from a scene. These techniques are time-consuming, but can give the production a custom look that is easily recognizable. While most digital editing software includes a color-correction tool, many professional editors turn to a specialist to help achieve the best results.

STORY 9.6 Color Correction Troubleshooting

On a recent advertising agency session, I was sent footage that the agency and editor were worried about. They were working with dailies (a quick film transfer done each day) so that the director and agency could be confident that images were actually on the film. As it happens, this was the first TV commercial the client had ever done, and it was also the first time I had ever worked with the agency. These kinds of situations always cause extra stress in the color suite, but in this case it was worse because of the quality of the film. As I screened the film, my stomach sank. The film was very overexposed, but not in a normal way. This film was flat, with very little exposure in the blacks, meaning most detail was gone and unrecoverable. The director informed me that they "flashed" the film.... I knew what flashing was, but had never run across it on a commercial spot for air. Flashing is something done in camera, either pre- or post-exposure. It's literally attaching a strobe housing and firing a "flash" at every frame of film. This technique is usually used for feature films, knowing they will be projected in theaters. It creates a fog on the film and lifts the exposure so everything looks a bit milky. This really helps in something like a night scene where there's almost nothing to be seen, but there is a blue "glow" in the blacks—there's a perception of detail, but none in reality. After coming back to my senses, I asked why they had chosen to use this technique.... [T]he answer was, "Well, we've seen colorists create this flat desaturated look in other spots. We don't want too much pure black. Instead, we want a milky gray black."

Now, I understood the intent of the look. In the end, the client was happy, and I was reminded again that as a working craftsman and creative person in the process, sometimes I really need to look deeper into what visual "problem" I am facing and consider prior intent—no matter how much my experience and wisdom might suggest otherwise.

SOURCE: Craig Leffel, Senior Colorist

CONCLUSION

Editing follows preproduction and production as the third stage in the storytelling process. Understanding the video signal and time code, along with attention to detail during the planning stage, is vital to making your experience a positive one. Having a working knowledge of analog and digital terminology and techniques is essential for today's editor. Good project management is necessary for organization before and during the post production phase. Technological advancements may make the editing experience easier by providing efficient tools that allow additional time to be spent on the creative process.

Story Challenges: Editing

The staff at Pick 2 Productions finished the editing with few problems because the edit session was organized and time was allocated for thorough preparation. During the initial stages of the edit session, an assistant editor ingested footage by referring to a clearly marked footage log. Another assistant reviewed scripts, outlines, and storyboards to ensure that all assets were available. During this time, the editor screened clips and read interview transcripts. Lastly, an extensive search for stock footage was concluded.

During the actual edit session, the base story for the music video was edited to the time line and reviewed for continuity and clarity. The documentary was edited on a second system, based on a detailed outline that included a number of sound bites arranged in the order of the tentative story line. The concert footage was transferred as one clip, and subclips were created to assemble the music.

Aesthetic style was discussed as transitions and effects were tested for audience interest and understanding. Once these decisions were finalized, the edited programs were screened as rough cuts and sent back to the edit bays for finishing.

CHAPTER

10

The Sound Track

A good mix can fix less-than-perfect elements and mask awkward edits. But no matter how good your individual tracks are, they won't survive a bad mix.

JAY ROSE, AUDIO ENGINEER

OVERVIEW

The sound track for your project might include narration, dialogue, natural sound, sound effects, and music. Like the visual elements, planning, acquiring, and managing these audio elements precedes the mixing stage. During the post production stage, the assets are shaped and mixed into a cohesive sound track that supports or drives the story. This chapter focuses on using techniques and tools in the editing and mixing of the video sound track.

Story Challenge: The Sound Track

Pick 2 Productions' post production audio team has received the final audio elements and edited sequences from the editors. There is some concern since a new editor worked on the music video and her style is unknown. Although the editor of the documentary has worked with the team for years, some have begun worrying about the process used to acquire audio during interviews, since some used lavalieres and others used a shotgun. As the sweetening phase begins, the team has several questions.

- Were Foley effects delivered in the proper audio file format?
- Has the decision been made on a Spanish language version of the lead-in to the concert?
- Did the sound engineer who recorded the voice-over (VO) for the documentary use the script to mark the good takes or are these only available on a cue sheet?

- What freedom does the team have in modifying sound elements through the use of audio filters?

- Because different microphones were used, what can be done to make the interviews sound the same?

- Have counterpoint music selections been made?

- Will the music video track be replaced with the original master recording?

SOUND DESIGN

Cut to: *A young man sitting on a park bench staring in the distance. He has a content look in his eyes. There is no sound in the scene.*

Throughout the preproduction and acquisition stage, the sound track is being designed. The design included all the sound track elements that were planned and recorded for the story. During post production, a variety of tasks such as defining the space, determining the narrator style, and deciding how music and other elements fit the story theme are considered and executed (see Figure 10.1).

One of the first considerations in sound design is understanding if the sound drives the visual or if the visual drives the sound. Consider the scene of a man

© 2014 Mark Mosrie, Cengage Learning

FIGURE 10.1

Sound editors use tools found in nonlinear editors or specialized software to shape and mix the sound track.

sitting on a bench, staring into the distance. Without sound, it may be difficult to interpret what his thoughts are, but they become clear with the addition of the sounds of the environment, a romantic song, or an off-screen voice. This is the power of sound.

The overall feel of a scene can be dramatically changed with the addition of a simple sound. The sound of a person dropping and breaking a dish can be serious if we hear the shattering of the glass, or it can be funny if a laugh track or silly sound effect is added.

Another consideration is whether the sounds are diegetic or nondiegetic. **Diegetic sounds** are actual sounds within the story. They include dialogue, natural sound related to a scene, and music initiated by such things as the talent listening to music or turning on a TV. **Nondiegetic sounds** include voiceover, sounds added for effect, and most music.

Watching a program with the sound turned off confirms just how important sound is to a production. Preparing the sound track elements as sound editing begins is as critical as having the visual elements ready for the editor. While many audio elements will be recorded during the production phase, some elements will be completed during the post production process.

SOUND TRACK ELEMENTS

Voice

Most voice elements, such as interviews, have been recorded before the post production process, but it is not uncommon to record narration during the editing stage. **Voice-Over Narration/Voice-overs (VO)** are common in nonfiction pieces and are also sometimes incorporated into narrative plots. At times, these tracks are recorded before post production begins, but it is more common to record them at some point once editing has begun. Recording the VO too early in the process may cause potential editing issues if there is no visual information to enhance the narration. In the HBO documentary series *When It Was a Game*, the VO clearly directs the cutting of the visuals. It would seem that the script was written and recorded as a VO with visuals specifically matched to each line of the script. This technique is common in "how to" programs and infomercials as the visual action matches the narrator. An alternative would be to have a narrator view the edited visual story and add a commentary, similar to the process used by filmmakers to add commentary tracks to a DVD.

Before recording a voice track, it is wise to rehearse for delivery, style, pacing, and pronunciation. Time should be spent making sure that the narrator or actor understands specific word emphasis, inflection, and pacing. A good producer will spend time with talent to make sure that she or he understands the style and delivery for the project (see Figure 10.2). Just as when working with actors, a director should make a narrator feel comfortable and encourage input.

Alternate language tracks on DVDs and video may broaden the market for a program, but also pose the unique challenge of matching the new narration

| Related |
| Interactive |
| Module |

CENGAGE
brain
.com

The Soundtrack

© 2014 Mark Mosrie, Cengage Learning

FIGURE 10.2

This studio microphone is fitted with a pop filter to eliminate the unwanted problems associated with "B" and "P" consonants.

to the existing visuals. One challenge is that it may be difficult to find appropriate matches for words that are unique to a specific culture. It should also come as no surprise to realize that the same sentence spoken in, for example, English, Spanish, and Chinese will not be the same length in each language. The alternative-language replacement can be a challenge if these differences were not planned for.

STORY 10.1 Creating a Multilanguage DVD

The Asia Compassion Project fund-raising video was initially designed as an English-language video. Months after it was completed, the client asked for a Burmese-language version for a time-sensitive presentation in the country of Myanmar. The first challenge was finding, auditioning, and selecting a narrator who could both translate and speak the language. This proved to be difficult both aesthetically and technically. As an English-speaking editor, it was difficult to match up the images in the video to the corresponding audio. In addition, it was difficult to find a native speaker who spoke the language at voice-over quality. Technically, it was a challenge to match the second audio track to the existing video since the new Burmese language track was

18 seconds longer than the original. With some careful editing of the narration, the track was cut by 17 seconds. In Final Cut Pro, the fade in and out on the time line were extended by 15 frames each to make up the additional 30-frame difference. The project was then exported and burned as a second language option on the final DVD. Months later, another request was made for a Thai-language version. The same process was followed to add the third language. While the technical work was challenging, reaching a larger audience proved to be worth the extra effort.

SOURCE: Mickey Seidenstein, Associate Producer and Editor

In preparation for sound track construction, transcoding audio files might also be required. This might entail changing an MP3 file to another format or digitizing an older audio format. These processes are not difficult, but may be time consuming. As discussed in Chapter 6, recording the sound on a dedicated audio recorder for DSLR production requires syncing the sound to the visual. Some shooters use a clapboard method and try to sync the sound during post production by lining up the audio spike in the waveform. Others add a software solution that matches the audio recorded with the built-in camera mic to the audio on the external audio recorder (see Figure 10.3). Sophisticated systems can lock the time code from multiple devices, creating a smooth transition during post production.

(A) (B)

FIGURE 10.3

Software can help synchronize sound and picture that were recorded separately (A), such as using an external audio recorder while shooting with a DSLR camera (B).

Replacing dialogue is not uncommon in large-budget projects. The technique of **automated dialogue replacement (ADR)** requires the actor to screen existing scenes and lip sync as the sound is replaced or added to the existing picture. This process is used so that the dialogue tracks can be rerecorded to fix problematic location sound recording due to environmental problems or to add sounds to scenes that were impossible to capture with live sync sound. ADR is not common in low-budget projects because it is laborious, requiring significant time working with the talent. It is also often difficult to match scenes where the talent can be seen talking in a medium or close-up shot. For situations where the director knows that a scene will use ADR and is concerned about matching sync, a simple trick is to have the talent face away from the lens or to use wider shots.

Music

The emotion and pacing that music provides is a powerful element used to connect an audience with the story. Because of the personal connection an audience

has with music, the sound designer or music editor needs a clear idea of music style. This includes the instrumentation and tempo of the piece. Providing enough lead time may be necessary if you are seeking copyrighted music licenses.

Most music used in film and video production is nondiegetic, as it is not heard by the actors in the scene. Theme music and **music beds** that play at a low volume under the main audio in a scene are common uses of nondiegetic music. Diegetic music is music that is actually playing in the scene. It occurs when someone in the scene turns on the radio or we watch a band performing in a club.

Music can also be **counterpoint** and used to show irony or to add a comedic twist to a scene. Counterpoint music is designed to conflict or contrast with the visual story. Hearing Louis Armstrong singing "What a Wonderful World" during a visual montage of bombing and explosions in the classic film *Good Morning Vietnam* (1987) is a good example; the sound adds to the film's message about the irony of war.

Ethnic and regional locations can be enhanced with appropriate music. Hearing Cuban salsa music during a scene from *CSI: Miami* adds to the intensity of the city streets, while natural sounds of an emergency room enhance each episode of *House*. Historic settings are much more believable when we hear period music or the sound of a horse and buggy during a scene taking place on the streets of a town set during the American gold rush. If you listen carefully to the sound track of some TV series, you might hear unique music for specific actors. It is also common to change the music or tempo when a villain or hero appears on-screen.

Selecting music from sound libraries is a quick and easy method for adding music. For some projects, this is convenient and acceptable. Many times, the style or mood is just not what you need, and compromises must be made. In these cases, original music may be an alternative.

Original music can be created for your project before editing and mixing begins, or it can be completed after the dialogue is edited through a process

STORY 10.2 Music as Story

The best productions that I've worked on have used music to echo the three-act development of the story in the script: exposition, development, and resolution. Usually, this thematic build is handled by a composer who can craft the score specifically for the demands of the project, but even when using prerecorded music, playing a track early on and then reprising it near the end can make for a very satisfying payoff. Early in *Tenacious D: The Pick of Destiny*, the Kyle Gass character shows Jack Black's character a video clip of The Who performing "Won't Get Fooled Again" in which Pete Townshend does a "power slide," a classic rock stage move. Toward the end of the movie, Jack and Kyle perform the power slide to make their escape from the Rock and Roll History Museum. We spent a lot of time temping the escape scene with a big western score cue (from *Silverado*), which served that moment pretty well. But Jack's idea was to pay off the earlier scene by having "Won't Get Fooled Again" play under the escape, as well. That's what we did in the final mix, and by recalling that earlier scene, we made the escape not just fun and exciting, but also a subtle nod to how far the characters had come in their "training." It also became one of the most exhilarating and crowd-pleasing moments in the film.

SOURCE: Mike Baber, Music Editor

called **post-scoring**. During a post-scoring session, the composer works with the visual image to customize the music to the scenes.

Historically, post-scoring music has been out of reach for those with small budgets. Today, with the availability of low-cost software and the abundance of musicians, there are efficient methods for creating a custom music score for your project. In these types of applications, you can select instrumentation, sound loops, and previous audio recordings to shape the sound through various techniques.

STORY 10.3 Using GarageBand

One of the toughest parts of creating music for a project is selecting a style. This was no different while I was writing music for a Red Cross promotional video. Our client wanted to tap into the enormous college student body of potential blood donors and I had to present the piece in a fast-paced "MTV" style. I needed to write pop music that would stand the test of college-student scrutiny, a difficult challenge considering the piece was to have a 3-year shelf life.

A powerful music production tool that allowed me to accomplish this was Apple's GarageBand. I used several synthesizer, guitar, and drum virtual instruments to write each song track by track. I played each part with my midi-controller keyboard and edited the notes with my mouse to fix any performance mistakes. A midi-controller looks just like a piano keyboard that is hooked up to a computer and used to play and record Virtual Instrument performances. Virtual Instruments are sample libraries of real instruments carefully organized to create lifelike performances. For example, every sound that a violin can make can be created and mapped to keyboard keys, which allow for extremely convincing synthesized performances. After sketching out my song ideas, I was able to import a QuickTime file of the video to arrange the music more accurately. The video turned out to be quite effective and the client was very pleased.

SOURCE: Marc Carlton, Audio Recordist

Natural Sound

While music normally provides the emotion, **natural sound** adds realism to the scene. Natural sounds are usually part of the video file or assets that are acquired through shooting. In most cases, the natural sound is added to the time line when an edit is performed. The editor selects the specific audio and video tracks and performs the edit. These sounds can be raised, lowered, or eliminated. Selecting only the video track for an edit is possible, but rare, and is only used if the editor is absolutely positive the sound will not be used. In almost all cases, it is best to lay natural sound on the time line and only eliminate it if it will be replaced with sound effects or a different natural sound track. If the audio or video was not originally added to the time line, you may be able to use the match frame function of your nonlinear editing system. **Match frame** lets you select a clip on the time line and open the master clip at the exact same frame. With this process, the editor can easily add the sound back on any video clips that do not have the sound attached on the time line.

Physical space and environment help direct sound perception. Characteristics of distance, position, and movement can all be manipulated for the desired result. Environmental sounds that add to the overall feeling of a winter scene might include howling wind or low-volume holiday music coming from a nearby home or store. A race car moving across screen from left to

right can be highlighted with a **pan** of the sound from the left to right speaker. A shot of a farm tractor in the distance may be barely heard, while the same tractor has a different presence when the camera shot is from the point of view of the farmer driving the tractor, as audience members feel like they are on the tractor.

TECHNICAL CONSIDERATIONS

While many editors rely solely on software applications for the majority of their post production audio work, some situations may require additional equipment. These additional pieces of equipment can range from a specialized computer to a sophisticated control room with an audio board and ancillary equipment.

An audio booth that can isolate external sounds and control the liveliness of the room sound is useful for recording voice-work or music. A good speaker system to monitor production sound and another speaker system to simulate the sound in the same acoustic quality in which the audience will listen are important.

Patching external pieces of electronic hardware is easier and more efficient through the use of a routing switcher or patch panel. **Patching** simply means connecting the output of one piece of equipment to the input of another. A **patch panel** (see Figure 10.4) is usually a wall plate with jacks that provide a convenient place to connect equipment together. A **passive switcher** is an electronic switch that serves the same purpose. Working

© 2014 Mark Mosrie, Cengage Learning

FIGURE 10.4

A patch panel is an efficient way to connect permanent equipment to other devices.

with sound in this manner requires a basic knowledge of signal flow, audio level, impedance, and sampling.

Some nonlinear edit systems utilize hardware out of necessity or to achieve a specialized technique. Transferring analog audio from vinyl records and audio-tape formats such as reel to reel and cassette may be necessary in the production of a historical documentary. Ingenious sound engineers sometimes create electronic circuits or sound baffles to assist in modifying an audio signal that cannot be replicated through software options.

Like video file formats, audio assets may be recorded with a variety of compression options. Most of these files are compatible with nonlinear editing and sound track mixing packages. If there is a compatibility issue, the files can be converted to another format.

AESTHETICS OF AUDIO SWEETENING

Sound Editing

Initial sound editing occurs as clips are marked and dropped in the time line. In a narrative driven story, most of the shots will be placed in the time line before any mixing or sweetening begins. **Audio sweetening** is a generalized term that encompasses enhancing, editing, and mixing your sound track. In a music-driven story, the audio is placed in the time line first and the **gain**, or volume level, is set at an approximate level.

During the sound mixing and editing stage, the audio signal can be viewed visually as a waveform. A **waveform** is a graphical representation of the signal. The editor can actually see the relationship between the waveform and the sound by observing the waveform as the time line indicator plays through a clip. This is important for editing segments out of interviews since it is easier to edit between sentences or words while looking at the waveform (see Figure 10.5). It is also used for cutting a segment from a song or looping ambient sound tracks for placement throughout a scene.

Effectively editing sound bites together is a critical and time-consuming task. Cutting or adding one frame may be the solution to keeping a word from being cut off or an audio pop from occurring. Leaving the appropriate amount of pause between cuts to create a natural feel or intended dramatic moment may take time, but the results are worth the effort.

Sound Editing Tools

The sound editing process requires the use of a tool to mark points in a clip between words or notes. The tool places a cut on the actual clip that allows the editor to manipulate the attributes on either side of the cut. Marking a second spot allows you to lower the level of the marked section or lift the section out of the audio track. Once the section is removed, it can be placed somewhere else in the story or disregarded. This is the process that is used when removing an

© 2014 Mark Mosrie, Cengage Learning

FIGURE 10.5

A digital waveform is helpful for analyzing and editing a soundtrack.

"um" from the middle of a sound bite. Once it is removed, you can close the gap in the time line. Care should be taken to make sure the pause between sentences or words sounds natural. If a pause is too short, the audience will intuitively sense the audio cut. If it is too long, the story will begin to drag.

Audio and video post production software applications include a tool that allows the editor to mark points on the time line and raise or lower the time line from those anchors. Adding several additional points on a track allows greater control in modifying detailed sound elements. Unlike the cutting tool mentioned earlier, you cannot cut and paste with this tool.

Signal Processing

Shaping, or modifying, the signal is accomplished through a number of different tools available in software applications, the use of a specific piece of equipment, or a set of features included with an audio mixer.

Besides adjusting and cutting out portions of clips, oftentimes the signal needs to be shaped. Shaping can be used to fix problems with an existing track. It can also be used to modify the tonal quality of a signal, for example, to add reverberation or modify the dynamic range so that the signal sounds like a telephone call, or to give a room the acoustic sound of a concert hall. **Dynamic range** is the range between the quietest and loudest sounds.

Some editors use the mixing tools embedded in the nonlinear editing software, while other editors send or import the files to specialized applications

FIGURE 10.6

Professional sound editing software offers powerful audio editing and mixing tools.

with more robust features. Pick 2 Productions has both Adobe Premiere and Avid editing stations. The decision has been made to edit the documentary with Premiere and the music video with Avid. The Avid editing team uses DigiDesign's Pro Tools (see Figure 10.6) for audio work.

Most sound editing software includes a good variety of sound processing tools that provide methods for manipulating individual sounds or mixed tracks to enhance the overall sound in your story.

Equalization　**Equalization (EQ)** is the process of boosting or reducing specific frequencies within the signal. It is one of the most common effects used because of the broad range of adjustments that can be made. EQ lets the editor shape the sound of an individual clip by adjusting selected frequencies.

A **graphic equalizer** offers adjustments to multiple frequencies. By selecting a frequency, you can raise or lower that frequency's level. A graphic equalizer can have a variety of predetermined frequencies set to raise or lower the level of a specific or range of frequencies. This is useful if you are attempting, for example, to increase the high frequencies of a signal or need to filter out a frequency in the midrange. The disadvantage is that a graphic equalizer only works with the specific frequencies it is designed for.

Parametric EQ is similar to a graphic equalizer, but has continuous frequency adjustments to allow for more control and precise adjustments. This is a good way to eliminate specific frequencies within the entire frequency range. A narrative scene with an annoying low-frequency rumble coming from a piece of machinery in an adjacent room may be a good candidate for selective adjustment.

© Avid Technology 2012

FIGURE 10.7

A wide range of filters and effects can be added during post production.

Filters A **filter** is a device that attenuates specific bands of frequencies. A high-pass filter is a simple EQ circuit. When it is set at 2 kHz, it will only pass frequencies higher than the 2 kHz while cutting off the frequencies below. This can be useful for mimicking the sound of a telephone conversation. Likewise, a low-pass filter only passes frequencies lower than the setting. A notch filter can be used to cut out a very specific frequency. The notch filter is sometimes used to filter the 60-cycle hum induced from AC power circuits. An AC circuit is the power circuit that produces 120 volts from wall outlets (see Figure 10.7).

Reverb Reverb is a filter that replicates the sounds of different environments. This might be used to simulate the tone of an arena or a concert hall. Reverb can also be used to create special effects, like the imagined tonal quality inside a Martian spaceship.

Compression A **compressor** is a signal processor that affects the amplitude of the signal as it is being output. The purpose is to bring down the overall level of a signal based on a predetermined level, or threshold. A compressor can be set to increase the signal 1 dB for every 2 dB increase in signal input. A compressor is useful for smoothing out variations in audio levels and maintaining more constant signal strength.

A **limiter** is a compression circuit with a predetermined output level that does not vary. It is useful for situations where the sound levels will vary greatly and the

STORY 10.4 Music Editing

A common problem for music editors and composers is a thing we call "temp love." As the project is coming together in post, the music editor or picture editor creates a temporary music track so the filmmakers can get a sense of how the show will flow with music, and over the course of watching it over and over during editing, people can get quite attached to these temp tracks—to the point where nothing else seems to work. This creates a challenge when the temp music is unavailable (if, for instance, it is from the sound track of a movie) or beyond what the budget will allow.

This issue seems to crop up a lot with the Sci-Fi Network's critically acclaimed *Battlestar Galactica* series. Fortunately, the show is usually temped with Bear McCreary's original music from the show, and since the production company owns those masters, it's easy enough to just reuse those cues. But the "Valley of Darkness" episode in Season 2 had made extensive "temporary" use of a Philip Glass piano piece, which was going to be expensive.

We first attacked this by having Bear write a "soundalike"—a composition that is close enough to the temp to give the same effect, but not so close as to become a copyright issue. Unfortunately, it was not close enough for the producer, and the ultimate solution was to have Bear rerecord the Glass piece, thereby saving the production about half of the license fee.

SOURCE: Mike Baber, Music Editor

videographer cannot adjust the sound during the recording. Although it is not common to use a limiter in post production, Pick 2's editing team was concerned that the live concert would be shot with the limiter turned on due to the range of instruments and sound levels that the band is known for. Fortunately, the decision was made to keep the limiter turned off during production and have the on-location sound technicians carefully observe recording levels during the concert.

Sound Mixing

The craft of mixing sound elements is one of the more important and time-consuming activities completed during the post production process (see Figure 10.8). Like the patience required in selecting a specific video frame, the sound editor meticulously arranges elements at the proper level and quality. Mixing during post production is a completely different experience from live mixing. The post production sound editor has the luxury of a "mulligan" or redo by manipulating over and over until the mix is correct.

A **mixer** allows you to combine more than one sound source simultaneously. A mixer might be a separate electronic device or a specialized software application. Each audio source can be adjusted independently to achieve varying audio levels. When recording with multiple microphones in the field, it is best to record all sources on discrete, or separate, channels. Keeping each microphone on a separate channel allows greater control of the audio in post production. Some professional camcorders have two or four separate channels of audio for this purpose. While most sound mixing is completed during the post production process, on some occasions, multiple sound sources must be recorded simultaneously or mixed during the shooting phase. The flexibility of adjusting individual sources is lost in this scenario.

(A) (B)

© 2014 Mark Mosrie, Cengage Learning

FIGURE 10.8

Besides software mixing, analog (A) and digital mixers (B) are commonly found in production facilities.

Levels and Metering Optimizing audio amplitude, or volume, can only be accurately calibrated by using a meter. Technical quality and levels can be reviewed once the audio files have been ingested. If the level is too low, the problem is that the original sound is too low. If the sound is distorted and too loud, the opposite is true. In either case, you should attempt to reacquire the sound at an optimum level. If reshooting a scene is not possible, the editor must try to maximize the sound by raising the level. With digital audio, the levels can usually be raised if necessary without causing any extraneous noise or distortion, but sounds that are too high and distorted cannot be fixed. This is normally only possible if the noise level was controlled during the original shooting. If not, raising the audio levels will also raise the noise.

Mixing Process While setting record levels is technical, mixing adds an aesthetic element. During post production, the main audio track is set for the optimum level and then the other tracks are mixed in relationship to this track. For example, a voice track may be the main audio element with music underneath at what is called **bed level**. Mixing cannot be optimized by looking at the audio meters. This needs to be accomplished by listening to the mix and ensuring that the overall mix level on the meter is acceptable. You cannot mix a sound track by listening with computer speakers or ear buds, or in a noisy room. The mixing must be done with good quality speakers or closed-muff headphones that completely encase both ears.

Because a sophisticated project may have dozens of audio tracks, a systematic method for designating what is placed on specific tracks is recommended. This may mean that all dialogue is placed on tracks 1 and 2, music on tracks 3 and 4, and sound effects on tracks 5 and 6. In some productions, leaving the first four tracks for dialogue and the next four for music and so on allows the editor to easily manipulate the in- and out-points with fades, without affecting other

FIGURE 10.9

Digital audio interfaces allow modification of multiple tracks on-screen simultaneously.

SOURCE: Courtesy of author, Ron Osgood

clips. The flexibility of having multiple tracks becomes apparent as the sound track becomes more complex (Figure 10.9).

The dialogue mix is normally the initial mix for most projects. It is started once all the clips are placed in order on the time line and the story makes sense. The importance of the dialogue mix is to set base audio levels that can then be used as benchmarks for any additional sounds. Once the story line is clear, other elements can be mixed in. As the other tracks of audio are added, the relative amplitude is measured for the mix based on the dialogue.

One overlooked technique is panning sound to provide more realism to the sound environment or to possibly add suspense. **Panning** is the process of changing the relative balance between two speakers so that the sound balance either moves across the room or is preset for a specialized application.

MIXING/EDITING IN PRACTICE

Many of the concepts used for sound editing and mixing are commonly used for a variety of program genres. At the same time, each format has specific techniques and tricks to optimize the sound track during post production.

Narrative Story

Scene: *A young man and woman are talking to one another as they walk through a park, enter a crowded shopping mall, and walk towards a jewelry store.*

In a narrative story, live dialogue is usually combined with some element of music and natural sounds. After editing the dialogue tracks, the editor hears abrupt changes during each cut in the scene. During several of the cuts, the sound of a lawn mower is in the background. Fortunately, the videographer recorded location tone for 60 seconds. This contains natural sound with the lawn mower running and no dialogue. By placing this sound on another audio track, a bed level track containing the lawn mower is added. Because the scene is more than a minute long, the editor loops the sound a second time on the track and places a 30-frame dissolve between the two lawn-mower clips. In the mall scene, the director had the extras talk quietly as they walked through the mall so that the background noise would not affect the foreground dialogue. Using a technique called walla, a loop of people talking is imported from a sound-effects CD and placed on yet another track at a low level. The term **walla** comes from the technique of having extras continuously saying "walla" in the background of a scene. This sounds like conversation when mixed as a background track. Since music is used in the closing scene in the jewelry store and carried on through the closing credits, the music is **back timed** to cause the music to end on the last note as the credits conclude. This is done by setting out-points at the end of the music track and the end of the credits. An in-point is set at the position where the music should fade in. When the music is inserted, a cutting tool is used to cut the music off and a dissolve is added to the beginning of the music so that it starts with a fade in under other sounds, preferably a voice track so it can be subtly added without jarring the viewer.

Related
Interactive
Module

CENGAGE
brain
.com

Editing > Techniques >
Back-Timing Music

Music Video

Scene: *A prerecorded song is the basis for this music video that will also contain several shots with natural sound.*

The music track is edited onto the time line and the clips are inserted to the beat or story. The band wants to shorten the song by deleting a 40-second guitar solo from the middle of the song. By carefully timing the beat, the editor establishes that a cut on the downbeat of the fourth measure at the beginning of the solo and a cut on the last measure at the end of the solo might work, allowing the song to advance without the solo. Using the appropriate tool and the waveform, the editor cuts the 40-second solo and previews the edit. After several minutes of jogging the edit point by one or two frames, the music plays smoothly through the edit and the band is happy. Later in the song, another short solo occurs and the images shown at this time have a few natural sounds that must be added to the mixed sound track. The natural sound is inserted on a new track and panned to the appropriate channel. An editing tool is used to add reference marks on the music track and the levels are lowered slightly to allow the natural sound to be heard.

Documentary with Narration

Scene: *This historical documentary is a story about the popularity of the first mass-produced pull-string talking toy dolls sold to children in the 1960s.*

This documentary begins with a shot of a pull-string doll as a hand reaches in and pulls the string. We hear "Tell me a story," and there is a cut to a series of still photos of dolls with some children's music playing. After several seconds, the music is lowered to a bed level and we hear the voice of a woman. A few seconds later there is a cut, and we see the person in an interview. Later, there is another montage of still photos of a manufacturing plant where the dolls are being assembled.

The mixing involved in this story is straightforward, with sound bites marked and edited as the first stage. Afterwards, a recording booth is set up to mic the sound of the doll as the string is pulled. When it is added to the time line, it is apparent that the high frequencies were not reproduced as desired, so a parametric EQ is placed on the clip and adjustments made to achieve a desirable sound. During the factory montage, a sound track is added that was created Foley style with the Foley artist using a variety of objects to create mechanical sounds.

OUTPUT

Once the audio sweetening is completed, the tracks can be mixed down for the intended purposes. The output choice(s) should have been considered in preproduction so that elements were produced with final output in mind. The output may be a simple monaural track, a stereo pair, or even surround sound. The mixed-down tracks can be output in a variety of audio file formats or they can be easily replaced in the original nonlinear editing time line. It is a good idea to consider your workflow and be certain to save a copy of the sound track before the mix down in case future changes are required. This will allow individual tracks to be modified or replaced at a later time.

As mentioned earlier, panning sound allows you to change the relative balance between speakers. With **surround sound**, the objective is to have sounds originate from the appropriate direction based on the scene. Similar to stereo, if a train is moving across the screen left to right, we expect the sound to move in that direction as well. With surround sound, the options are multiplied, since several speakers are located around the viewing room. There are a number of surround choices, such as 5.1, 6.1, or 7.1. The first number refers to the total number of speakers, while the decimal and number refer to the sub-woofer in a system. The **sub-woofer** produces low bass sound. Human ears are not able to determine direction with such low sounds. In the 5.1 system there are left front, center channel, right front, right rear, and left rear speakers. The other systems add speakers in the back and on the sides. This added level of mixing borrows the effects from theatrical viewing so that the audience feels like they are in the scene. Vocal tracks are almost always mixed to the center channel, with some modification based on talent movement. The center channel feed is heard through

a speaker that is mounted near the center of the TV or monitor. Surround sound can add to the mystique created by actions that are happening off screen. Music is usually mixed to the front left and right speakers and natural sounds to the side or space dictated by the scene. Mixing surround sound is theoretically the same as stereo, but with more sophistication and options.

The final step is to test the sound track with a playback system similar to the one on which the program will be screened. This may be the average home TV with built-in speakers, or a home theater with 5.1 sound. Only by listening to the sound through these systems can a final analysis and approval be confirmed. At this point in the process, the program is ready for delivery to the client or end user.

CONCLUSION

The process of audio sweetening occurs after all audio elements have been selected, acquired, and recorded. Using a variety of techniques and tools, the sound engineer creates a sound track that matches the video or is the catalyst for the story. Mixing includes adding sound elements to individual tracks at appropriate levels, while editing involves the detailed work of selecting specific sections of sounds and processing specific clips or tracks through the use of filters and technique.

Story Challenges: The Sound Track

Pick 2 Productions' post production audio team has finished audio editing and mixing. The post production audio session went well because considerable time was spent developing techniques to support the stories. For example, the Foley tracks were recorded on an audio file format that was compatible with the editing software. Also, the VO track for the documentary was marked electronically, and a cue sheet listed time code and cut/take numbers. During editing, several EQ filters were applied to smooth out the audio quality differences on interviews shot with different mics. The end result is that the clients are happy with what they have seen and heard. Now, it's on to finishing the titles and graphics.

Graphics

Without aesthetic, design is either the humdrum repetition of familiar clichés or a wild scramble for novelty. Without the aesthetic, the computer is but a mindless speed machine, producing effects without substance. Form without relevant content, or content without meaningful form.

PAUL RAND, GRAPHIC DESIGNER

OVERVIEW

Imagine TV commercials without graphics that support the intended message. How effective would a cooking show be if the ingredients were read by the spokesperson but not superimposed, or **supered**, on the screen? And how would the audience identify a person in an interview without his or her name appearing on-screen? Would the audience be disappointed if full-screen graphics were not used during the credits for a movie? A **full-screen graphic** is one that fills the whole screen. Generally, it has its own background, but it can also be superimposed over other images.

As with other production fundamentals, the use of graphics and effects can be important elements in telling the story. Graphics can provide needed clarity for detailed "how to" programs, illustrate the intricacies of a complex medical procedure in a documentary, or provide closing credits for an episodic narrative series. Text, still images, graphics, and visual effects are integrated into almost every program. These can be as simple and subtle as slow-moving text in a title sequence, or as complex as graphics that encompass the entire screen with multiple layers of integrated text and animation. Both technical and aesthetic guidelines impact graphics work. In this chapter, we begin with a discussion of technical issues and then move to a discussion of some aesthetic elements. Finally, we discuss the incorporation of other media into projects and cover some basic effects.

Story Challenge: Graphics

The team at Pick 2 Productions has several questions to answer and numerous issues to resolve as it approaches the graphic and effects decisions required for the three productions associated with the band. Among the questions and issues are:

- How can the team maintain a consistent style for the graphics within each production?
- What are the technical parameters for the graphics and animation work for each of the productions?
- What is the best way to create the motion backgrounds that will be used behind some of the interview subjects in the historical documentary?
- The band typically has a video wall running at its concerts. The director wants to incorporate images from that wall in the live concert production. What issues are related to that?
- What effects and graphic techniques can be used to help the audience follow the flashback sequences in the music video?

TECHNICAL BACKGROUND

The success of the graphical aspects of any production will depend on a good understanding of technical elements. From the shape of the screen and the shape of each pixel to selecting different graphic elements, an understanding of some technical detail is important to the production of clear and communicative graphics.

Pixels and Screen Resolution

Video images are composed of pixels. For a 1080 high definition (HD) signal, the pixel size of the frame is 1920 by 1080. For a 720 signal, the size of the frame is 1280 by 720, while a standard definition digital video frame is 720 by 480 pixels. Knowing the frame size on which your graphics will be shown is an important first step. The number of pixels and the shape of each pixel determine how graphics will look on screen. An additional related concept is resolution. **Resolution** relates to the quality or detail of the image. The more pixels in an image, the more detail. The standard for judging resolution, though, is not uniform. In video, resolution can refer to the number of lines on the screen or to the quality of the footage being captured in a nonlinear editor. When scanning a printed document, resolution is based on the number of dots per inch (dpi) at which the image is scanned. For the graphics operator, resolution is based on the number of pixels that compose the image. When a scanner converts a printed document to an electronic one, it does so at a certain resolution or dpi, such as 72 or 150. The number of dpi selected when scanning has a direct impact on the number of pixels that document will have when you use it in video.

If you scan a 4 inch by 6 inch photo at a resolution of 150 dpi, your computer will create an image that will be 600 by 900 pixels. That is not enough pixels to completely fill the HD television screen. If you scanned the photo at 300 dpi, the result would be an image that is 1200 by 1800 pixels. That is still not enough pixels to fill the screen for every high definition screen size, however. What is important to understand is that video is all about pixels. An image created at 720 by 480 pixels will fill the standard definition frame. If you wanted to use that same image in a high definition program, there would not be enough pixels to fill the frame. Scaling the graphic up to fit a larger frame results in decreased quality. Creating that graphic at 1920 by1080 pixels, however, will give enough detail for the high definition frame. It is also possible to create the graphic at an even larger size that will allow for a pan and scan, covered later in this chapter. Even without the need for a pan and scan, creating a larger pixel size is not a bad idea, since the pixel dimensions can be scaled down to fit the frame size, and the larger pixel size allows more control of placement on the screen.

Aspect Ratio

The aspect ratio of the screen is another important factor in graphic design. The designer needs to consider the optimum use of screen space and the difference between wide screen (16:9) and standard (4:3) during layout and composition. In addition, you must take into account that the graphic you create for a high definition 16:9 screen might also be used in a 4:3 standard definition version of the program. Typically, this would mean keeping critical information within the 4:3 aspect ratio and allowing background elements or other less important aspects of the design to fill out the 16:9 aspect ratio frame (see Figure 11.1).

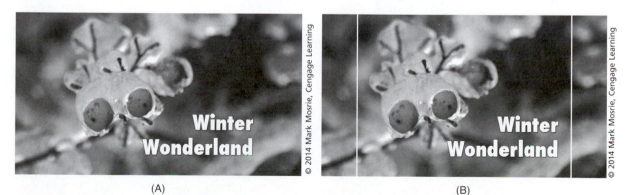

(A) (B)

© 2014 Mark Mosrie, Cengage Learning

FIGURE 11.1

Image A shows the 16:9 frame with graphic content to fit the 4:3 frame so that nothing gets lost as the image is modified to fit the smaller screen. Image B shows the graphic flush with the 4:3 graticule.

Title Safe Area

Because of over-scanning, there is more picture information available than a home TV can display. By contrast, computer monitors underscan. Due to the

underscanning, all picture information, as well as a black border around the edges of your computer monitor, is visible. Because of this, graphic designers must compensate for the overscanned video image. One important procedure is to keep the text inside the title safe area. The **title safe area** is defined as the inner 80 percent of the screen (see Figure 11.2). Keeping the text inside the title safe area ensures that it will not get cut off on the home TV set. Most graphics programs for television have a feature that will place an overlay on the screen that shows the title safe area.

FIGURE 11.2

The overlay shows the title safe area, or inner 80 percent of the frame. All graphics should be placed within this area to ensure that they are not cut off by the home television set.

Pixel Aspect Ratio

Besides image aspect ratio, pixels also have their own aspect ratio. Computers and some video formats use square pixels (see Figure 11.3A). Other video formats use nonsquare pixels (see Figure 11.3B). Many high definition video formats use square pixels. The digital video or DV format and the standard NTSC, HDV, and DVCPRO HD use non square pixels. A potential problem is trying to mix the two pixel aspect ratios in the same program. Suppose Pick 2 does most of its shooting on the AVCHD format. The square pixels from the AVCHD video and the Photoshop full-screen graphics must mix with the rectangular pixels on the historic DV footage acquired for the project. Fortunately, editing and motion graphic programs make the blending of square and nonsquare pixels a seamless process. Software such as Adobe After Effects interprets the square or nonsquare pixels of an image correctly and keeps track of what it needs to be for the output you have selected. It is a matter of making sure that the proper settings are selected during the edit session.

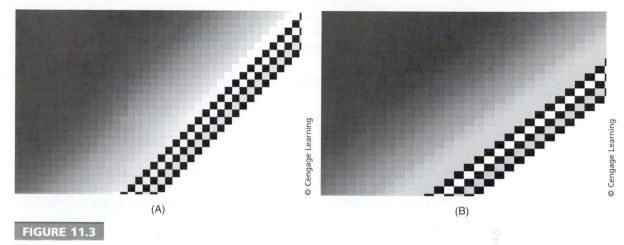

(A) (B)

FIGURE 11.3

(A) Each pixel that makes up this image is square. (B) The pixels that compose this image are nonsquare. The graphics operator needs to be aware of the final output when mixing sources that contain square and nonsquare pixels.

As a part of the historical documentary on alternative fuels, Pick 2 is preparing several graphics of the earth viewed from space. Some of these graphics will be computer generated, while others rely on NASA-acquired videos and photos shot from space. When those images created in graphic software programs are imported into the editing software, the earth will look more like an oval than a circle (see Figures 11.4A and 11.4B). This is the effect of mixing two pixel aspect ratios in the computer. Since the final output is nonsquare, the oval will once again be

(A) (B)

FIGURE 11.4

(A) This computer-generated shape is round, since computers use square pixels. As long as this image is output to a format that supports square pixels, the circle will retain its round shape. (B) This circle, composed of nonsquare pixels, appears more like an oval when viewed in a square-pixel environment.

round. Trying to fix the shape will only create additional problems. It is disconcerting to work with a piece that seems less than spherical, but if you try to fix it, you will end up with unsatisfactory results on the final version of the program.

Raster and Vector Graphics

Computer-generated graphics are either raster or vector. **Raster**, or **bitmap**, images are resolution-dependent graphics and are created at a specific pixel size. While you can scale raster graphics down to smaller sizes without degrading the image quality, it is not recommended to scale raster graphics up to larger sizes. When you exceed the original resolution of a raster graphic, you enlarge the size of individual pixels. This results in **pixelization**, or the degradation of the image as the pixels are scaled larger (see Figure 11.5A). A **vector graphic**, on the other hand, is a resolution-independent graphic. Rather than being composed of pixels, a vector graphic is made up of mathematical formulas. This construction enables the user to infinitely scale the graphic larger and smaller (see Figure 11.5B). Programs like Adobe Photoshop generally produce raster graphics, while Adobe Illustrator creates vector images. If possible, try to use vector graphics. If you cannot acquire vector images, insist on the raster images being very large. That will enable you to size them to the needs of the program without sacrificing quality.

(A) (B)

© Cengage Learning

FIGURE 11.5

(A) A bitmap or raster graphic has been scaled to 2400 percent of its size, resulting in pixelization. (B) A vector graphic is composed of mathematical formulas and will not pixelate even when enlarged to 2400 percent of its original size. Notice the smooth edges and curves in this image.

Luminance Levels

Video is capable of reproducing more than 16 million colors. Each pixel on the screen is composed of a red, green, and blue dot or bit. Each of these respective dots can have 256 different shades of red, green, or blue. This is known as 24-bit color. Typically, these color shades are numbered from 0 to 255. A full range of color values for video would start with pure black at 0 and end with pure white at 255. Many systems, including all the high definition standards, work this way, though some use slightly different numbers for the colors.

A problem that can arise with luminance is if the whites are too bright for the television signal. There may be a buzzing from the TV speaker if the white from a graphic exceeds the legal video limit. Because of this, many editors and graphic artists keep their whites at 235, instead of 255.

Alpha Channels

An **alpha channel** is a black and white channel within a graphic that determines the transparency of the image. Alpha channels can be added during the creation of a graphic. Alpha channels form the backbone for effects as simple as an on-screen title to a complex sequence in which an object flies across the screen. Within any graphic that contains an alpha channel, any area that is black is completely transparent; any area that is white is completely opaque; and gray areas in between black and white have a variable degree of transparency. Even though it is a black–and–white graphic, 256 shades of gray are still possible for an alpha channel (see Figures 11.6A through 11.6D).

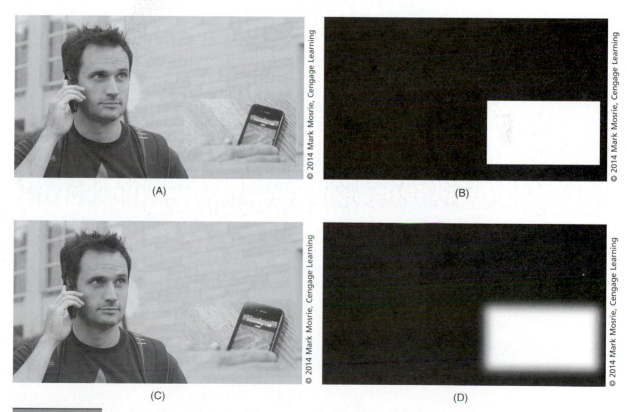

(A) (B)

(C) (D)

© 2014 Mark Mosrie, Cengage Learning

FIGURE 11.6

(A) This picture-in-picture effect shows the hard edges that the alpha channel (B) created. (C) This picture-in-picture effect shows the soft edges that the alpha channel (D) created.

Alpha channels are classified as straight or premultiplied. With a **straight alpha channel**, all transparency is defined by information in the alpha channel. A **premultiplied alpha channel**, on the other hand, uses information from the color channels to help blend the semi-transparent parts. To better understand the difference, consider the idea of using a stencil to paint a shape on a wall. With a straight alpha channel, you paint inside the stencil and the stencil position determines where the edges are. With a premultiplied alpha channel, you would not paint all the way to the edge of the stencil. Instead, you would blend your stencil color with the underlying wall color at the edges of the stencil. In other words, you are using the underlying wall color to help create the transparency.

Adobe After Effects accepts images with a straight or premultiplied alpha channel. Straight is the preferred choice since it does not need to rely on color information to determine transparency. A problem arises if the software thinks you are using a straight alpha channel and the file is premultiplied. If this happens, a color edge is visible around the image. The problem can be rectified by switching the alpha channel type.

File Management

It is easy to get overwhelmed with multiple versions of computer files and then spend unnecessary time finding the correct version of a particular graphic or file. Effective file management depends on using a logical, consistent naming convention for files, such as including a word that describes the graphic. Programs with multiple themes can have the files divided thematically. Keeping original files intact and editing copies provides a sense of security as projects move forward and files are modified.

In a post production environment, it is not unusual to use a program like Adobe Photoshop to create your graphics. Regardless of the type of graphic, you should keep a version in the native Photoshop file format. This will preserve your ability to re-edit the graphic at a later time. The Photoshop file format allows each graphical element to be stored on its own layer. Layers make image manipulation and subsequent editing much easier. Multilayered graphics can be collapsed, or **flattened**, into a single layer for those nonlinear editing systems that require a single-layer graphics file. It is always a good practice to save backup copies of your files at various stages in the process.

Both TIFF, or Tagged Image File Format, and PNG, or Portable Network Graphic, are good choices for the flattened image because you can keep the image uncompressed (see Table 11.1). Suppose that for the historical documentary, Pick 2 interviewed a scientist named Lisa Parker. To identify her on-screen, the editor saved graphics with the file names Parker.psd and Parker.tif. The PSD file is the original that has multiple layers and is easy to edit, while the TIF file is the single-layer flattened version you would import into your editing application. The single-layer graphic, however, would be difficult to edit.

TABLE 11.1 Common File Formats

File Extension	Comments
PSD	Native Photoshop format. Supports all Photoshop features. Used for creation of raster or bitmap graphics.
AI	Native Illustrator format. Supports all Illustrator features. Used for creation of vector graphics.
TIFF	Tagged Image File Format. Can save files without compression. Good format for saving scanned images and importing into nonlinear and compositing software.
PICT	Used by Macintosh computers. Can save files without compression. Good format if all work is done strictly on Macs.
JPEG	Joint Photographic Experts Group. Primarily used as a format to save images in a digital camera and on the Internet. Uses lossy compression.
PNG	Portable Network Graphics. A cross-platform format that uses lossless compression.

© Cengage Learning

STORY 11.1 Budgets Are Always a Factor

In network television, budgets are often low and schedules are tight. This inevitably leads to producers wanting ambitious effects for very little money and in even less time. NBC's *Scrubs* is an example of a series that requires such work on an almost weekly basis. In one show, a scene was written in which the main character was to entertain a patient with an extravagant shadow puppet show that re-created the battle of Pearl Harbor. Immediately, it was assumed that this would quickly become the most expensive and intensive effect shot the show had ever done. The initial ideas pitched on how to complete the shot included full-fledged 3-D animation and even roto-scoping historical footage, a painstaking process of literally cutting out objects from a scene frame by frame. Not wanting to kill ourselves with weeks of all-nighters, and wanting to make sure we offered a competitive bid, our company was tasked with coming up with a much more efficient solution.

As luck would have it, our stock library happened to include various models of battleships and planes that could be passed off as coming from the World War II era. Since everything in the scene would essentially be a flat, black shadow, no texturing or lighting was needed for the models. Wanting to do as little 3-D animation as possible, most elements for the scene were output as still images with alpha channels. These elements were then assembled as multiple layers in After Effects. Their brightness and contrast was pulled back to make them appear as solid black shapes and simple position and rotation key-framing was used to animate them. Explosions were added by bringing in existing stock footage and inverting the luminance, and basic puppy dog and alligator shadow puppets were created through minimal matte animations. Once the sound effects were added, a humorous simulation of the battle was achieved. These creative solutions and work-arounds were able to significantly cut down the time and money needed to complete this lavish effect successfully.

SOURCE: Dylan Chudzynski, Visual Effects Supervisor

AESTHETIC CONSIDERATIONS

Understanding the technical considerations for creating graphics is only one part of the equation. It is equally important to master the aesthetic challenges related to good graphic design and readability to ensure that your graphics make a strong contribution to your visual story. Questions about how much information to

use, the font and color of the letters, as well as the backgrounds, motion, and type of information to include are important aesthetic considerations.

Readability

The single most important factor when producing a graphic is making sure the viewer can read it. This may sound simplistic, but it is surprising how often TV graphics are difficult or impossible to read. As one example, think about a commercial that features a zero percent financing option for an expensive purchase like a car. The interest rate and time to repay are in large, easily readable type. At the bottom of the screen, though, are several lines of very small type with all the disclaimers. The type is so small, and it is on the screen for such a short period of time, that you simply cannot read it. Several factors can help or hinder readability. How much information is contained in the graphic, the font choice, the background, and the color are all major factors in the readability of a graphic.

Information Density It is not unusual to see multiple graphics on-screen simultaneously. It is common for network programs to include layers of graphics in the show opening. Cable news outlets place numerous graphics identifying the content of a particular story on-screen as well as running a crawl of headlines at the bottom of the picture (see Figure 11.7). As a viewer, what should you read? Research shows that this is a very ineffective way to present information because audiences are unable to absorb it. The challenge is to find a way to communicate the message without putting too many words on the screen. If you must present a large amount of information, consider using full-page graphics with multiple pages, similar to a well-designed PowerPoint presentation. You

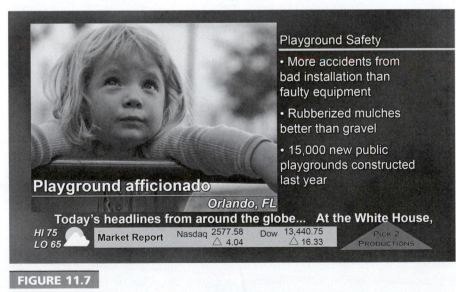

FIGURE 11.7

The audience does not know where to look or what to read on this screen.

SOURCE: Courtesy of author, Joe Hinshaw

can then avoid putting too much information on the screen at once and change the pages at an appropriate pace. In addition, the method used to cluster information together can aid the readability and comprehension of a graphic (see Figures 11.8A and 11.8B). Consider the graphics used on home shopping channels. All the information the viewer needs—the price, the savings, the item number, the telephone number to call, and so on—is typically grouped into one easily readable graphic.

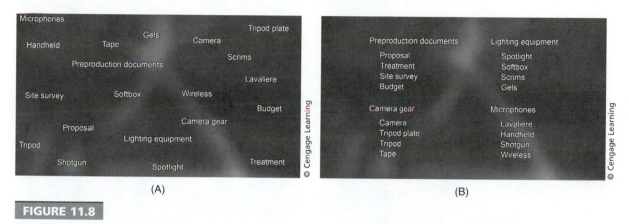

(A) (B)

© Cengage Learning

FIGURE 11.8

(A) Information in this graphic is disorganized and difficult for the viewer to understand. (B) Information in this graphic has been organized and grouped into categories, thus increasing the viewer's ability to read and absorb the data. While the organization does aid readability in this graphic, a better method for presenting this much information is to create multiple pages and have less text on each graphic.

Font Choice The font or the shape of text also impacts readability. Fonts are classified into four basic categories: serif, sans serif, script, and decorative. A serif font (see Figure 11.9A) has small lines at the top and bottom of the letters. These serifs finish off a letter and add readability when there are large amounts of text. Some serif fonts include Times, Baskerville, Bodoni, and New Century Schoolbook. A sans serif font (see Figure 11.9B) does not contain those small lines (the word "sans" means "without" in French). Some examples include Arial, Futura, Franklin Gothic, and Helvetica. A script typeface (see Figure 11.9C) includes fonts that appear to have been drawn by hand with a brush or calligraphy pen. Often, these fonts resemble cursive writing. Examples include Linoscript and Zapf Chancery. Decorative fonts (see Figure 11.9D) are distinctive and can be fun to use. They are usually very different from any other font you see. Some examples include Fajita, Scarlett, and Whimsy Heavy.

Decorative fonts should be used sparingly and only when the story dictates their use because such fonts may be difficult to read. Serif fonts work if the serifs are not too thin. Small serifs do not reproduce very well on-screen. In addition, the delicate characteristics of some serif fonts can get lost in a busy background. The best choice is a large blocky sans serif font because the clean lines of such fonts work well in the limited-resolution environment of television.

Related Interactive Module CENGAGE brain .com Graphics > Font

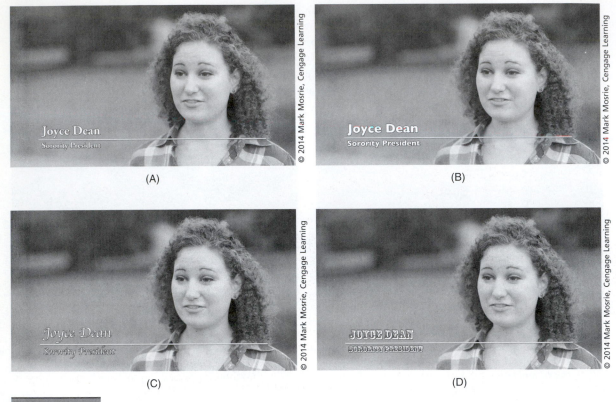

(A) (B)

(C) (D)

FIGURE 11.9

Contrast the fonts used for each of these graphics, (A) serif, (B) sans serif, (C) script, and (D) decorative.

Color The use of color can add to or detract from the effectiveness of on-screen text as well. Color can be manipulated through hue, saturation, and lightness or brightness. The **hue** is the actual shade of the color. **Saturation** refers to the richness of the color, and **lightness** refers to the color's luminance. One strategy to use with color choice is to create contrast. The more contrast between the background of the image and the color of the text, the easier it will be to read the letters. Black letters work well against a bright or white background. White or bright yellow letters work well with a dark background. Ensure that your color choices create a good contrast in the lightness dimension. Even choosing two very different colors like red for the background and blue for the foreground will create readability issues if the lightness value for each of those colors is high. Changing the lightness parameter to make one of the two colors darker helps.

Saturation creates intensity or energy. Highly saturated colors like yellow and red generate high energy and excitement, while desaturated pastels connote low energy. The live concert Pick 2 is producing is a good candidate for

high-energy colors, while the low-energy muted colors may be more suitable for the historical documentary.

Depth Text will be more readable by adding perspective or dimension. Like the name implies, a **drop shadow** is a visual effect that mimics the shape of the characters and is behind and offset from the actual letters. A contrasting color for the drop shadow can make the text stand out as a black drop shadow does with white text. Color, depth, distance, direction, and opacity all influence readability.

A line around alpha-numeric characters can also be used to help the characters stand out. A **stroke** is an outline around the characters and can be used alone or in combination with a drop shadow. Oftentimes the drop shadow and stroke are kept consistent by using the same color (see Figure 11.10).

Background An additional element that affects readability is the background layer. In many cases, the background is the original video. For example, a wide shot of a location is often accompanied by a graphic to identify it. Background

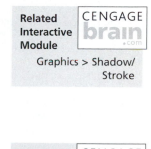

Related Interactive Module

Graphics > Shadow/Stroke

Related Interactive Module

Graphics > Background

(A) (B)

(C) (D)

FIGURE 11.10

The text in image A has no drop shadow or stroke and is difficult to read. Image B has a drop shadow and is easier to read. Image C has both a drop shadow and a stroke to separate the text from the background. Image D has a semi-transparent box behind the text to make it the easiest to read.

SOURCE: Courtesy of author, Joe Hinshaw.

STORY 11.2 Parallax Is My Friend

Parallax is the change in position, or shift, of an object against a background due to the movement of the observer. Parallax can be one of the more powerful visual effects when introduced into what otherwise could be a flat or visually static situation. It occurs when using a virtual camera in computer-generated animation.

I often witness talented motion graphic designers, animators, and effect artists create stunning visuals based in the 2-dimensional world. I usually credit these individuals with having strong traditional fine art or print backgrounds.

Visually stimulating layout, color, and timing can be achieved but often fall flat when left in a 2-D world of modern animation. Introduction of a virtual camera can help these compositions become visually richer, but without proper observance of the camera's effect in the natural world, much effort can be lost.

Truly breathtaking design and realism may be achieved by separating the visual layers of content into the Z coordinates, or depth. Parallax with a virtual camera can be achieved by separating visual layers in 3-dimensional space. Each layer should be placed relative to a position to the natural world. Adjusting your virtual camera to accommodate those positions prior to key-framing will allow for maximum effect. Virtual cameras can be adjusted for alignment, focus, zoom, aperture, and depth of field.

SOURCE: John Michaels, Producer

layers may also be a solid color, a texture, or animation. Besides a drop-shadow or contrasting colors, the use of bold letters can help separate the text from the background. Placing a background shape behind text will make it easier to identify. This may be an opaque or partially transparent rectangle or other shape.

Related Interactive Module

CENGAGE brain .com

Graphics > Animated Text

Motion Motion can be an effective method to move text on–screen or to animate other graphical elements. As with any of the processes covered, supporting the story and providing clear readability should drive the decision to add motion. Some common motion techniques include sliding a graphic on the screen from one side or another or using an animated, moving background for the text. A background graphic for a Fourth of July concert might have a subtle animated flag with moving text of the lyrics of a patriotic song.

Used judiciously and in the right circumstances, animated text and backgrounds can add to the overall theme of the story. The children's science shows *Bill Nye, the Science Guy* and *Beakman's World* use animated text to help create simple explanations of complicated scientific questions. The opening credit sequence for *The Daily Show* uses a number of visual layers, text, and animations to set the stage for this weekly series.

Placement The attributes for creating text on–screen must be supplemented by aesthetic placement considerations. Effective placement forces the viewer's eye across the screen without distracting the background layer. For example, text that covers the talent's face or blocks an important element of the scene will be ineffective. Most nonlinear editing tools allow the editor to move text elements around the screen in an attempt to create an optimum frame.

Key

A **key** is a visual effect in which part of an image is electronically cut out and replaced by another image. A person's name superimposed on the screen during that person's sound bite is a key effect. The key relies on two signals to work (see Figure 11.11). One signal cuts the hole in the video. This is sometimes referred

(A)

(B)

(C)

© 2014 Mark Mosrie, Cengage Learning

FIGURE 11.11

This image shows the parts of a key effect. A is the composited image, B is the fill signal, and C is the alpha channel or cookie-cutter signal.

to as the cookie-cutter signal. The other signal fills the hole. The hole can be created by an alpha channel or differences in the luminance value of an image. Many stand-alone **character generators (CG)** have an output called the "key output." This signal is generally a cookie-cutter signal.

A **chroma key** uses the color on the green or blue screen as its cookie-cutter signal and then replaces the hole with new background video.

A **matte** is an effect that allows you to hide or mask part of an image. You can then use another image to show through the part that has been hidden. In many reality TV shows, a producer may want to hide a prominent clothing logo on a character. The editor will use a matte to blur or pixelate that logo so that a viewer cannot identify it. When that matte moves throughout a scene, it is known as a **traveling matte.**

Types of Graphics

The most common types of graphics used in television include lower-thirds, titles, credits, rolls, and crawls. These graphics might be supered over existing images or be full-screen.

Lower-Thirds Much like its name implies, a lower-third is a graphic that is placed near the bottom part of the screen (see Figure 11.12). The most typical application is to identify a talking head. Besides the person's name, a lower-third might include other information that identifies why the person is included in the story. It is critical that this information be accurate and spelled correctly. The information must not only be accurate, it must also be relevant to the story. Consider a scenario in which you interview the president of a sorority as part of an instructional video for the parking department on campus. Rather than identifying this person through the sorority affiliation, it may be more relevant to identify her as someone who has received several parking tickets. Lower-thirds might also be used to provide guidance for the viewer. In a narrative production that features flashback and flash-forward sequences, it may help the audience to understand the context of a scene if you use a lower-third to indicate the time or day when a particular sequence takes place.

Titles Program titles are usually placed at or near the beginning of a program. Title graphics give you a great opportunity to build on the style or distinctiveness of your story. The title for *24* is simply the number 24, but the font makes it look as if the numbers are coming from a digital clock. In addition, the clock is an ever-present graphic throughout the show. The combination of the title graphic and the other graphics in the show provide a visual unity to the entire program.

The relative proportion of text size should be considered with all graphic elements in a program. Titles are usually larger than other graphics used throughout a program, but not so large as to overwhelm visual continuity.

Calypte anna
Anna's Hummingbird

FIGURE 11.12

The lower-third graphic is frequently used to identify an object or person, but can also function to identify a location or describe something in the image.

SOURCE: U.S. Fish and Wildlife Service.

Credits **Credits** typically come at the end of a program, though major credits may appear near the opening titles. In some cases, a credit can be as simple as a copyright statement, while in others, the credits list the names of the crew as well as the copyrighted material that the producers licensed, the shooting locations, and other elements. Besides recognition, credits serve as an important archival record.

Roll A **roll** is a graphic that moves from the bottom of the screen to the top of the screen. It usually starts off-screen, emerges from the bottom, and ends by going off the top of the screen. A roll can be effective when presenting lots of information, such as the credits in a feature film. A roll can also be used to display lists of information. Consider that the live concert that Pick 2 is shooting is a fund-raiser for alternative fuel research. A credit roll at the end of the concert is a good way to list all the contributors.

Font size and the speed of the roll are the two most important considerations when building a roll. The text should be sized so it fits inside the left and right edges of the title safe zone. Because it will roll into and out of the title safe area on the bottom and top of the screen, we do not worry about that part of the title safe area for this application. The speed of the roll, or how long a particular part of it stays on-screen, is key to the readability of the graphic.

Crawl A **crawl** is a graphic that moves horizontally across the video screen. A crawl that provides up-to-date headlines on cable news networks is an example.

The graphics move from the right side of the screen to the left side. Like the roll, they usually start and end off-screen. In general, crawls are meant to be distracting for the viewer. Because the crawl is used to inform viewers about pending weather issues or breaking news items, the crawl must attract the viewer's attention from the other visuals on the screen. The increasing prevalence of the crawl as a part of the cable news landscape, however, may have decreased a viewer's sensitivity to the information moving along the bottom of the screen. In composing a crawl, you need to keep the text inside the bottom edge of the title safe area. Also, make sure the font and background choices are enough to grab the attention of the viewer.

INCORPORATING OTHER MEDIA

Using still photos, film, or full-screen slides from a Microsoft PowerPoint or Apple Keynote presentation in a production is not uncommon. Each media type requires attention to ensure that its use will be effective.

Pan and Scan

Related Interactive Module

Graphics > Pan and Scan > Overview

A **pan and scan** is a process of animating a still photo in your video. Historical documentarian Ken Burns is an independent filmmaker responsible for the PBS mini-series *The Civil War, Baseball,* and *The Dust Bowl,* among others. He makes extensive use of this effect by animating still photographs and artwork. For example, the photograph of a baseball team slowly zooms in to highlight a particular athlete. It is an effective technique in bringing life to a static composition. It is also effective for photographs that do not conform to the aspect ratio.

The process starts by scanning the visual to create an electronic version of the photo or other document. The size of the scanned image is critical to the success of a pan and scan. Once you have the file, the size can be scaled to simulate zooming, or the image can be moved to simulate panning and tilting (figure 11.13). The image must be larger than 1920 by 1080 pixels if you are working in a 1080 high definition standard. The larger the pixel size, the more pan and scan capability there is. The larger size is required because these are raster graphics and they cannot be resized larger without pixilating. How large you scan the original images will depend on the amount of motion you want. A general rule is that an image for pan and scan should be a minimum of a few hundred pixels larger than screen size or as much as two or three times as large as the frame. For example, the photos should be scanned at 5760 by 3240 pixels to have images that are three times larger than the 1920 by 1080 HD screen size. Recall from the beginning of this chapter that increasing the resolution or dpi at which the scanner creates the image increases the number of pixels.

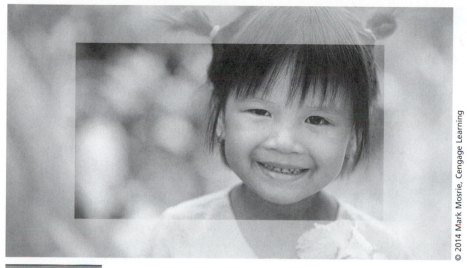

© 2014 Mark Mosrie, Cengage Learning

FIGURE 11.13

To properly pan and scan a photo using a software package, the image must be larger than the screen. Here, the semi-transparent area shows the full photo. The opaque area is what is on the screen. Using key-frames, the editor can pan and scan the photo to see more of it.

Other Media

Photographic slides or negatives can provide rich historic content to a story and can be converted to a digital file by using a slide or negative scanner. The rules regarding pixels and size are the same as those for printed photographs. The use of pan and scan can help overcome mismatched aspect ratios between the slides and the video screen.

Most film is shot at 24 frames per second, so the frame rate will not match the frame rate of video. As discussed in Chapter 9, converting 24 frames per second film properly requires a 3:2 pulldown process. A **telecine** or **film chain** is required to convert a film to video. It will create the video and do the pulldown at the same time. This is not an easily accessible option, so many films are converted by pointing a camera at a screen displaying the image as it plays from a projector. The result is an annoying flicker of the image. Super 8 and 8 mm film present another challenge. These legacy film formats were shot at 18 frames per second, and the film cannot easily be converted for a television frame rate. The best solution is to use a variable frame rate projector.

Microsoft PowerPoint or Apple Keynote presentations can be converted by creating a QuickTime Movie of the presentation. Another option is to grab a screen capture of each slide and import those to your editing application. Other software, such as Screenflow or Snagit, can create a movie of your screen that can include the movement of the mouse on the screen. This can be very useful for both presentations and web pages. Yet another method is to use a video camera to shoot the computer screen. This will work if you are using a

STORY 11.3 Design Inspiration and Efficiency

As a motion graphic artist, you have the opportunity and challenge of creating something from nothing. There may or may not be video footage or storyboards to reference, there may or may not be a full script to read; and yet, you still have to design and you only have so long to do it. So, it is important to learn how to work quickly and effectively to create a cohesive design. Creativity does not exist in a vacuum and professionals cannot afford to wait for inspiration to suddenly strike.

Good design doesn't just manifest itself out of thin air, it takes an understanding of visual communication, time management, and even a bit of psychology in order to create a successful motion graphic. Creativity is mostly a process of deconstruction in the sense of design. Say you are watching your favorite TV show. Can you notice elements in the show's opening that appeal to you? Why do they appeal to you? By taking a moment and reflecting on the meaning and purpose media and design play in your everyday life, you can begin to recognize how design influences your thoughts and feelings. Don't stop with just movies and TV either. Pick up a magazine with an interesting layout. Take a walk outside and notice the patterns and colors in nature. Even listening to new music can spark your mind to make new connections between ideas. Push yourself to design beyond simply "what looks cool" and design for what works best with your audience.

Another important piece of designing is collaboration. If you're feeling stuck, pulling in an outside perspective can be helpful. Taking a step away from your design to look at it from someone else's perspective can not only help you see any flaws in your piece, but can also help you recognize when a design is more successful than you first perceived it. Another form of collaboration can be found in revisiting projects done by your colleagues. Take notice of how they put their projects together in contrast to your own habits. Pay attention to subtle elements that make the piece seem more whole.

In addition to outside resources, also focus on what you are doing with the software to speed up your work time. While working on projects, be conscious of the fact that you are building a library of work that you can pull from later. Repurposing a graphic makes use of the time and effort you initially put into the animation.

All in all there are only so many hours in a workday and you need to fit your creativity into that time frame. Working smarter and building a digital and mental library of designs will free you to be more creative and ambitious in your work.

SOURCE: Tiffany Lewis, Graphic Artist

flat screen monitor for your computer. If you have a CRT for your computer monitor, you will need to adjust the shutter speed of the camera to avoid seeing annoying scan lines.

CONCLUSION

Graphics and effects add a finishing touch to your video productions. To create useful and compelling graphics, you need to understand a number of technical issues like aspect ratio, pixel aspect ratio, luminance levels, and others. Equally important are the aesthetic elements of graphic production. None of those principles is more important than readability. Information density, fonts, colors, and backgrounds all add to the aesthetic complexity of the images. Besides the standard graphics, effects like the pan and scan can help you incorporate still photos, computer information, and other media into your project. A key effect is the primary method by which graphic and text elements are placed on the video screen. The careful consideration of the needs of the story should be the driving force for your decisions regarding graphics.

Story Challenge: Graphics and Effects

Working with the graphics designer and editor, the director was able to define a clean graphic style for each of the three productions. The look added a real element of professionalism to the work. The graphics operator also devised a clever naming scheme for all the graphics that made it easy for everyone to find the correct graphics for each of the productions. Information about pixels, screen size, and luminance information helped the editor create superb animations to place behind the chroma-keyed interviews in the historical documentary. These animations added great depth to the story. In addition, the pan and scan effects used on many of the historical photos helped add life to the documentary. The ability to add some of the video from the video wall during the live concert production enhanced the look of the concert on the DVD. Besides all of the more intricate work on the graphics, the simplicity and readability of the lower-thirds and credits for each production lent a smooth professional look to all the projects.

CHAPTER
12

OVERVIEW

The vision described by Beacham is close to reality, and the popular on-demand, user-driven content of YouTube and Netflix are examples. Being able to search for videos of the latest sports highlight, dance move, gaffe from a politician, or even a whole season of a hit television show is empowering to viewers. In addition, political candidates are flocking to YouTube to announce candidacies, rebut attacks, and communicate directly with voters without the mass media filter. The exploding growth on YouTube, Vimeo, and other sites is part of the larger Internet Protocol Television (**IPTV**) that promises to deliver high-quality professional video programs over the Internet. Other devices, like the iPad and smart phones, are also changing our viewing habits. This chapter will introduce you to the methods used to format your video for these various output channels. Understanding how an audience will view and interact with your program should begin during preproduction and will influence decisions in all phases of the production process. Such decisions can guide field acquisition as well as what editing decisions you might make. Before discussing the various output methods, the chapter begins with an explanation of compression. It then moves on to discuss various output options and how those devices will impact your production work. Finally, the chapter covers repurposing and archiving your work.

Story Challenge: Output and Archiving

As the three productions that Pick 2 is producing enter the final stages, a number of issues must be resolved in terms of output and the way that all the original

footer for each of the shows will be saved and distributed. Among the questions and issues are:

- Did the videographers shoot enough material to complete all of the behind-the-scenes elements for the DVD of the live concert?
- What compression choices will yield the highest-quality video while still producing manageable file sizes?
- What methods will be used to repurpose the various videos to other outlets like MP3 players, smart phones, and the Web?
- Among the many media cards, videotape, and other storage options, what is the best way to archive all the original materials for each of the three productions?

COMPRESSION

As you have read throughout this book, storing and transmitting video and audio is a difficult task. One hour of uncompressed high definition video requires almost 500 GB of storage space. In addition, the **bandwidth**, or amount of space for that data to be transmitted or moved from one computer to another, is overwhelming. **Compression** is reducing the amount of information and/or the bandwidth requirements. It allows for smaller files sizes and bit rates to accommodate both storage and transmission needs.

To understand the need to reduce file sizes and storage space, imagine that you have finished packing your suitcase but you can't get the suitcase to close. No matter how much you push or pull, the suitcase will not zip up. One solution is to refold or stack the clothes more efficiently. Another option is to remove some items. Either way, you need to reduce the total space that your clothes occupy.

Categories for Compression

Compression can be categorized as lossless versus lossy, and intraframe versus interframe. Although there is some overlap in the definitions, they provide a means of differentiating between compression schemes.

Lossless Compression With **lossless compression**, an image that has been compressed and then restored is an exact duplicate of its original. Static images with great similarities in color throughout the frame, such as a wide shot of a grassy field or a clear blue sky, are good candidates for lossless compression schemes. Photographs saved as **TIFF**, or Tagged Image File Format, as well as most native Photoshop documents use a lossless compression scheme known as **run length encoding (RLE)**. With this process, a computer examines each pixel in an image for redundancy (see Figure 12.1). Consider the wide shot of the grassy field as an example. When the computer encounters areas in which

No Compression

1	2	3	4	5
6	7	8	9	10
11	12	13	14	15
16	17	18	19	20

1:White 11:White
2:Black 12:Black
3:White 13:White
4:White 14:White
5:White 15:White
6:White 16:White
7:Black 17:Black
8:White 18:Black
9:White 19:Black
10:White 20:Black

Lossless Compression

1	2	3→	4	5
→6	7	8→	9	10
→11	12	13→	14	15
→16	17→	18	19	→20

1:White
2:Black
3–6:White
7:Black
8–11:White
12:Black
13–16:White
17–20:Black

© Cengage Learning

FIGURE 12.1

No compression has been applied to the letter L in the upper image. Data for each of the 20 pixels have been saved. In the lower image, the lossless compression scheme reduces the amount of information.

the shade of green is exactly the same, it only records part of that information. If there is a run of 40 consecutive pixels that are exactly the same color, there is no need to record the information for each pixel. So instead of saying pixel 1 is green and pixel 2 is green, the computer notes that pixels 1–40 are green. This will reduce the amount of information that must be stored with the file. This lossless scheme is like refolding and rearranging your clothes in the suitcase. When the file is restored, it will be an exact duplicate. Files that use lossless compression tend to be higher-quality images, but the file sizes will be larger than you can achieve with lossy compression.

Lossy Compression Lossy compression means that the restored image is not an exact duplicate. Images with great color variations in the frame, such as a street scene or the texture on a pair of blue jeans, are good choices for lossy compression schemes. Lossy compression schemes rely on the fact that human eyes perceive some aspects of images better than others. Human eyes are very sensitive to changes in luminance levels but not so sensitive to changes in color information. In addition, human eyes are more sensitive to objects in motion than still objects. Many lossy compression schemes take advantage of these facts by compressing the data that fall into these two broad areas. Areas of an image that have lots of motion or convey a great deal of luminance information are not compressed. Still photographs use **JPEG** (Joint Photographic Experts Group), while video uses **MPEG** (Moving Picture Experts Group) for lossy compression (see Figure 12.2). **JPEG compression** divides the picture into luminance and chrominance and then averages a group of pixels to reduce the amount of information. To compress the image, a JPEG scheme samples the color information half as often as it does the brightness information. In this way, the color

No Compression

1	2	3	4	5
6	7	8	9	10
11	12	13	14	15
16	17	18	19	20

1:White 11:White
2:Black 12:Black
3:White 13:White
4:White 14:White
5:White 15:White
6:White 16:White
7:Black 17:Black
8:White 18:Black
9:White 19:Black
10:White 20:Black

Lossy Compression

| 1 | 2 | 3 | 4 | 5 |
| 11 | 12 | 13 | 14 | 15 |

1:White
2:Black
3:White
4:White
5:White
11:White
12:Black
13:Gray
14:Gray
15:Gray

© Cengage Learning

FIGURE 12.2

No compression has been applied to the letter L in the upper image. Data for each of the 20 pixels have been saved. In the lower image, the lossy compression scheme averages vertical pairs of pixels to reduce file size. Notice that pixel 13 is gray, or the average of the vertical pair of 13 (white) and 18 (black).

information is reduced 50 percent. The JPEG compression will then reduce redundant luminance information in a similar manner to RLE.

Intraframe Compression As the prefix implies, **intraframe compression** looks for redundancies inside a frame. It is used more typically on still images but can also be applied to video images. Also known as **spatial compression**, the scheme looks for and eliminates unnecessary information within the frame. The grassy field image described earlier could be highly compressed with the intraframe model. Many similar colors exist and such similarity is not needed to accurately re-create that image. It is discarded when compressed and accurately replaced during decompression.

Interframe Compression By examining changes between frames of video, **interframe compression** reduces redundant information. This **temporal compression** will eliminate information that remains the same between two frames. Consider two shots of a bicyclist riding. In one shot, the rider is set against a clear blue sky. In the other shot, the rider is passing a canopy of trees in full fall color. During the shot of the blue sky, there can be more compression than in the shot with the leaves in the background. The redundant blue color is more easily compressed.

Codecs

Compression is handled by a codec or a compression/decompression engine. As noted in Chapter 9, a **codec** is a computer algorithm that dictates how data will

be compressed and then restored. Such codecs can be software-based or integrated into the hardware. Regardless of whether the compression takes place in software or hardware, there will be some controls for the user to manipulate. Such controls allow you to change things like quality, frame rate, data rate, and other parameters. With the quality setting, your choices are typically high, medium, or low. This relates to the quality of the image and, more indirectly, to the amount of compression. When you select high, little compression is applied; the image quality remains high and the result is a larger file. Choosing low reduces the quality of the image because it will be highly compressed and the resulting file size will be small. The frame rate setting allows you to choose the number of frames per second. The slower the frame rate, the choppier the playback will be. The higher the frame rate, the larger the file size. With **data rate** or **bit rate**, you are controlling how fast the data are allowed to flow through the computer system. A high data rate gives better quality and larger file sizes. Low data rates reduce the quality of the image and decrease the file size.

Probably the most logical consideration when choosing a codec is how you will use the files. There are codecs that are best for acquisition, such as AVCHD or CinemaDNG. Other codecs are more efficient for editing, such as Apple ProRes and Avid DNxHD. Finally, there are a number of codecs that are optimal for output, such as H.264.

MPEG

Many codecs use some form of MPEG compression in shrinking the file size and data rate of video. The MPEG compression model has become a popular choice in the video production industry, from initial recording on a media card to distribution on DVD and outputting for the Web and mobile devices. The basic MPEG standard defines the protocols for compressing, encoding, and decoding data. In addition, the standard dictates the order of the data and what must be included in the data, but it does not dictate the method by which the data are derived. Because of this structure, **MPEG compression** comes in several different types, such as **MPEG 2** or **MPEG 4**, and the system can continue to evolve as technology changes. MPEG compression uses three types of frames—I, P, and B—for its compression (see Figure 12.3).

I Frame The **I frame,** or **intra frame**, contains an image that is sampled in great detail and is used as a reference for surrounding frames. Within an I frame, the pixels are separated into 8 by 8 pixel blocks. These blocks are then placed into larger macro blocks for compression. I frames rely on spatial compression techniques to reduce the amount of data within the frame. Spatial compression is the method used for static or still images. Temporal compression compares movement between images and stores only the data needed to re-create the movement. An MPEG scheme will create I frames as often as needed. If the content is rapidly changing material, then I frames will happen more frequently. Typically, though, there are two I frames per second.

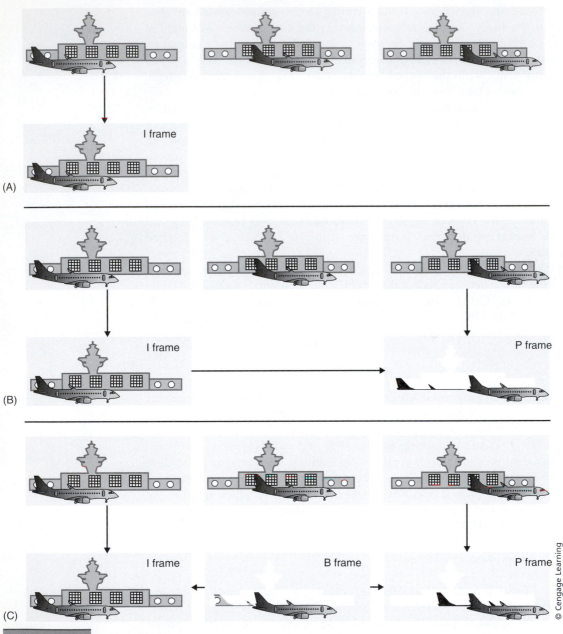

FIGURE 12.3

In Figure A, three frames of a plane passing the control tower are shown as the source video, while an I frame is created with MPEG compression. Using spatial compression, the I frame acts as a reference for the other MPEG frames. In Figure B, a P frame refers back to the I frame and uses motion vectors to determine changes between the frames. It then applies temporal compression to store only data that have changed. This process leaves holes in the P frame (shown in black) that are filled by pixels from the I frame or source video. In Figure C, a B frame functions the same as a P frame, except the B frame can look forward and backward to determine changes over time.

P Frame A second type of frame used in MPEG compression is a P frame, or **predictive frame.** A P frame looks back at the previous frame and attempts to predict how the pixel blocks changed to create the current frame. **Motion vectors** is the term given to a P frame's description of the direction and distance of pixel movement. When a compressed P frame is decoded, it looks back at previous frames and repositions the pixels based on the motion vectors. A P frame is dependent on previous frames and can be greatly compressed because of the reduced data that it requires.

B Frames B frames (**bidirectional frames**) are composed of motion vectors and pixel blocks. The difference between B and P frames is that B frames look both forward and backward to compare pixel blocks. P frames only look backward for such data. When something new enters the picture, the B frame is able to look forward and back and the difference it detects is the data that create the B frame. Both B and P frames contain data that reflect changes in a picture, not the actual picture itself. The pictures can be restored from the information contained in the motion vectors and pixel blocks that make up P and B frames.

The three types of frames—I, B, and P—are compiled together to form a **Group of Pictures (GOP)** within the MPEG scheme. Each GOP starts with an I frame. The number of B and P frames in a GOP will vary depending on the complexity of the video and the amount of motion within it. A video with lots of fast action and detailed content would use a shorter GOP and have more I frames. The general range for the size of the GOP is between 8 and 24 frames. With a larger GOP, you can achieve higher compression with some reduction in quality. Figure 12.4 shows a typical GOP structure for 30 frames of compressed video with I, P, and B frames.

© Cengage Learning

FIGURE 12.4

This shows the typical structure of I, P, and B frames in a standard GOP structure for 30 frames.

Audio Compression

Audio compression uses both lossless and lossy schemes. Primarily, audio compression relies on the notion that most human ears can discern sounds between 20 and 20,000 hertz. By manipulating audio at the fringes of those frequencies, the audio data can be greatly reduced with little quality loss. In addition, compression schemes look for patterns and repetition in the audio and reduce it. This is very similar to how visual schemes reduce redundancies in the pixels. The popular MP3 format is a lossy audio scheme. It allows for a great deal of compression while maintaining a high degree of quality. **Audio Interchange File Format (AIFF)** and **Advanced Audio Encoding (AAC)** are standard lossless

STORY 12.1 DVD Motion Artifacts

A very common issue I run into is DVDs that have very thick motion artifacts. The problem originates from compression software scaling video with fields. Most MPEG 2 works in the 720 by 480 resolution. A lot of professional video equipment conforms to the CCIR-601 standard, which is 720 by 486. The problem arises when the compression software has to scale and interpolate the image (with fields) by 6 pixels in the vertical dimension. It is such a small amount that when the compressor tries to scale the fields, it ends up causing thick heavy scales that won't look correct in the final image. I have seen this happen with several different compression programs.

It has a fairly simple solution to prevent. You need to either crop 2 pixels off of the top of the image and 4 pixels off of the bottom, or vice versa. This can done in the editing or compositing software you are creating your movie in, or some compression programs will allow you to do this during the compression process. If you crop 3 off the top and bottom, it will reverse the fields in the compressed video and you will have even more motion artifacts in your video on the DVD. A simple solution to an annoying problem.

SOURCE: Scott Carmichael, Graphic Artist

compression formats popular in digital video. **Dolby TrueHD** is a high-end lossless compression scheme used in high definition DVD production. Although **MP3** files are common, the level of compression and subsequent quality may or may not be sufficient for your project.

Errors and Artifacts

Compressing and decompressing images can result in some errors in the video. When those errors become noticeable to the viewer, they are known as **artifacts**. **Blocking** is the appearance of small squares in an image that seem to make it look like the image is composed of tiles. One example of this can be very evident on cable or satellite systems with many channels and high compression ratios. Several different types of color-related compression artifacts exist. When colors look like they are blending together in areas of the image, it is generally called a **chrominance smear**. It likely results from low luminance levels or very high chrominance levels. When many colors appear over a finely striped surface in the picture, you often see a **chrominance crawl**. This artifact occurs when the vertical stripes provide a problem for the video and create these colors. The term **mosquitoes** refers to the fuzzy dots you might see around sharp edges after the image is compressed.

OUTPUT OPTIONS

Broadcast Television

Networks and distributors provide a set of specifications that programs must meet for broadcast. The Technical Advisory Committee for the Public Broadcasting System (PBS) is responsible for the guidelines that PBS stations follow. The PBS Technical Operating Specifications contain a list of all the requirements a program must meet for PBS to air the show. For example, a high definition

video program must originate at a minimum frame size of 1280 by 720. Productions produced in standard definition must be upconverted to high definition. **Upconverting** is the process of taking a standard definition production and transforming it to high definition.

Among the other specifications are very exacting requirements for the quality of the video image, the operating level for the program audio, the tape format for submission, time code numbering, and others. If you fail to meet these standards, PBS may refuse to air your program, or potentially charge you a fee. High definition programs must be submitted in the HDCAM videotape format. If you submit your program in the wrong tape format, PBS may also charge you a transfer fee, in addition to the fee for not meeting the technical specifications.

Cable or Satellite Channels

The Discovery Channel, CNN, and other cable or satellite channels have similar technical requirements relating to the format for submission, the length of the program, and many other parameters. For example, the Discovery Channel lists the details for network bug placement in the frame. The **bug** is the graphic that identifies the channel or network. Understanding this is critical as you design your graphics, since you will need to avoid having information in the screen space occupied by the network bug. Discovery's specifications also describe everything from the network's interpretation of the action safe and title safe areas to standards for average, peak, and dialogue audio levels.

DVDs

Although the market is slowly losing its appeal, DVDs may be the main delivery format for your project or a secondary outlet for distribution. Because DVDs can hold a considerable amount of information, you can add extra elements like commentary, alternate endings, deleted scenes, and other features. As with any method of delivery, additional elements should be considered during the preproduction phase.

Standard Definition Standard definition DVDs have traditionally used MPEG-2 compression to fit 4.7 GB, or 2 hours' worth of content, onto a single-sided disc. A red laser writes and reads the information on the disc. To create a DVD, a laser burns microscopic pits onto the surface of the disc. When the disc is played back, the laser then reads those pits to re-create the information on the disc.

Blu-ray **Blu-ray disks** use blue laser technology, which allows more information on a disc. A **blue laser** can write information more densely than a red laser and will support a pixel size of 1920 by 1080, or the full-size standard of the 1080 version of high definition video. Blu-ray supports additional video and audio streams, increased interactivity, and higher data rates than standard definition DVDs.

Internet

The user-centered on-demand method of watching video over the Internet is empowering for the viewer. It is normal to watch videos with a Wifi connection or stream movies through a device such as a DVD player or IPTV.

Streaming video is a method for sending compressed audio and video over the Internet. It allows for near-immediate playback of the video without the delay of downloading a complete file. Several factors should be considered when producing video for the Web. These factors include screen size, frame rate, and data or bit rate. After production is completed, the file is manipulated and **encoded**. Encoding is the process of compressing the production to create the video and audio streams.

Streaming video on YouTube is one example of **IPTV** or **Internet Protocol Television**. IPTV requires a set-top box on your TV that receives Internet Protocol (IP) data packets and translates them to reproduce pictures and sounds on your TV. Unlike today's streaming video, which is subject to sudden and long pauses, the goal of IPTV advocates is to deliver full-screen content without hesitation or pauses.

Downloading is an alternative to streaming. Because the file is copied from the Internet to your local computer, there is a delay before you can screen the program, but the stability of the signal should be better since the file is stored on your computer.

Although technology continues to advance rapidly towards providing higher technical quality for Internet use, there are some tradeoffs that may still affect how the program is delivered.

Screen Size It is common to try to reduce the size of the video to one-half or one-quarter of its original size. For a standard definition 4:3 signal, a pixel size of 320 by 240 or 160 by 120 are alternative sizes. High definition signals can also be streamed, but require higher data rates. With high definition, a 1080 standard would produce sizes of 960 by 540 and 480 by 270 as one-half and one-quarter sizes. The 720 high definition standard produces 640 by 360 and 320 by 180 at those reduced sizes.

Frame Rate The data rate increases with higher frame rates. Many streaming signals work well with as little as 15 frames per second. Programs with more action may require a higher frame rate, while those with limited movement may be able to be streamed at lower frame rates.

Bit Rate Smooth streaming comes down to how much data you can easily transmit through the Internet and how much your end user can receive at any given moment. **Bit rate** or **data rate** are the terms used to define the amount and speed of data that a computer can send and receive. Your choices affect how high the data rate is, while the user's Internet connection determines how much data he or she can receive. Figure 12.5 shows the typical data rates of some video signals, while Figure 12.6 shows data rates for standard consumer Internet connections.

Related Interactive Module — CENGAGE brain.com — Output > Size

Related Interactive Module — CENGAGE brain.com — Output > Frame Rate

Related Interactive Module — CENGAGE brain.com — Output > Bit Rate

Application	Data Rate	
	Uncompressed	**Compressed**
Video Conferencing • 29.97 frames per second • 352 by 288 pixels	36 Mbs	75–900 Kbs
NTSC Video • 30 frames per second • 720 by 480 pixels	248 Mbs	3–8 Mbs
HDTV • 30 frames per second • 1280 × 720 pixels • 1920 × 1080 pixels	0.66 Gbs 1.5 Gbs	20 Mbs

© Cengage Learning

FIGURE 12.5

The data rate for each of these common video applications dictates how much computing power it takes to move that much information. Contrast these numbers to those in Figure 12.6.

Connection Name	Data Rate
56 K Modem	34–48 Mbs
DSL (Digital Subscriber Line)	768 Kbs–6 Mbs Commonly restricted by price; standard 1.5 Mbs downstream and 768 Kbs upstream
Cable Modem	3–105 Mbs downstream and 768 Kbs upstream
Network Connection/Corporate LAN	10 Mbs–1 Gbs
Fiber	3–75 Mbs downstream and 3–35 Mbs upstream

© Cengage Learning

FIGURE 12.6

These data rates for common home Internet connections show that much compression is needed to send a video stream to most houses.

When you are encoding your video for streaming, you can choose from a few possibilities regarding bit rate. A **single bit rate** file will deliver a constant stream at the same speed. For instance, you might encode the video to deliver 128 kilobits (Kbs) per second. Users with DSL or cable modems can easily handle that feed. **Variable bit rate** encoding, on the other hand, dedicates more bits to highly detailed aspects of the video, such as movement in a chase scene. The bit rate will constantly change depending on the complexity of the scene. **Multiple bit rate** encoding produces a file that can scale the bit rate depending on the user's connection speed. Users with higher connection speeds can receive higher bit rate files and can switch instantly to a lower bit rate version to help maintain smooth delivery. This means the encoding software will create multiple files of your project. For example, you might end up with one file that has 128 Kbs encoding, one with 256 Kbs, and another with 768 Kbs. Vimeo suggests that HD streaming files be limited to a bit rate of 5,000 Kbs.

Mobile Devices

Whether it is an iPad, smart phone, or other mobile device, program producers are supplying content for mobile devices. The National Academy of Television Arts and Sciences has given credence to this delivery format, awarding an EMMY for original programming produced for nontraditional platforms. The Academy considers computers, smart phones, iPads, and similar devices as nontraditional platforms. In addition, program providers such as HBO and ESPN have developed specific applications, or apps, for viewers to watch programs on tablet devices. While such platforms provide another outlet for programs, producers must manage certain technical challenges when considering mobile devices as an output choice.

In addition to the screen sizes, many smart phones do not have a conventional aspect ratio. Frame rates can also be problematic as a video shot at 30 frames per second may look much different when played back at the common 15 frames per second that smart phones use. This can be exaggerated if the video has significant movement in the visuals.

Rather than reformatting a show to fit the mobile market, the producers of *True Blood* have settled on a different strategy. They produce a version of *True Blood* specifically for the Web. The episodes, or webisodes, are a few minutes long, and some production techniques are modified for this market. Other productions sometimes produce shows exclusive for mobile devices, known as mobisodes.

Apple's iPhone and iTouch have a resolution of 1136 by 640 when held horizontally. Video on these devices only plays in a horizontal or widescreen format. The iPad has a resolution of 2048 by 1536. Other smart phones have a variety of screen resolutions, with the most popular size being 240 by 320. It is becoming increasingly difficulty to provide one output size that will fit the screens for all mobile devices.

Although it is possible to stream video to a mobile phone, the more reliable method is to use a **TransFlash** chip that can fit in your phone or computer. These chips are similar to the flash memory cards that you might use in your digital camera. A challenge in using mobile phones for video delivery is the sheer variety of manufacturers and video standards that each uses. Each phone manufacturer and network may have different specifications for the way an individual phone interacts with the TransFlash chip or a specific protocol for video.

Regardless of these seemingly complex issues, there are some conventions for mobile phone delivery. Producing the video for a screen size of 320 by 240 will work on most models, and many phones can handle data rates of up to 100 kilobits per second with a frame rate of 15 per second. Audio should be sampled at the rate of 22,500 samples per second (22.5 KHz). Finally, your file name needs the appropriate three-letter extension. Mobile phones send and receive signals in several different bands of frequencies. Video encoded for these phones must select a specific band. Fortunately, with those encoders recommended for mobile phone delivery, you can specify what frequency band you are using. Since a couple of choices exist, the file extension needs to reflect the correct one.

STORY 12.2 Video and Social Media

I started using a nonlinear edit system during my senior year of high school. It was 2004; phones were dumb, the only kind of definition was standard, and my internet connection was dial-up. Facebook had just spread to the big universities, nobody had ever heard of Twitter, and YouTube was "this new website I just discovered." As I began my video production courses in college, I noticed the increasing convergence of video and the Internet.

Today, nearly all of the videos I produce end up online. My job is to manage the Pittsburgh Steelers' online presence through the official website, social media accounts, and video content. Our on-demand video content includes game highlights, on-screen analysis from our team of journalists, and coverage of charity events. We also stream live video throughout the season.

In the early days of online video, I exported a single web file from my editing software. Today, the Steelers export seven different files for each web video we produce. This ensures that every user can access our videos regardless of device, web browser, or connection speed. Though the multi-file encoding process is time-consuming, it guarantees a positive experience for our online fans. Future video production professionals, especially editors, will need in-depth knowledge of web file formats and codecs to effectively perform their jobs. It is far too easy for users to click away from online content. If your content doesn't function well for everyone, you are pushing away a large group of users and potential customers. This is especially true as more and more viewers discover video content via social media apps on mobile devices.

Whereas most companies use social media to build an online fan base, the Steelers already have a massive worldwide following. That means our social media strategy can focus on enhancing the fan experience with great content. I use social media to distribute Steelers content and drive traffic to our website. Our video content must be relevant, well produced, and entertaining, or fans may disconnect from our pages. Good video connects with fans, draws them to the website, and keeps them coming back daily for more. Videos are also effective tools for energizing our fan base. Energized fans attend home games, buy Steelers merchandise, and frequently visit the website. All of these activities generate revenue. In other words, video is more than just entertainment—it is a key part of our business.

Out-of-town fans rely heavily on streaming video because Steelers games aren't usually offered on their local broadcast TV channels. To address this problem, we offer online streaming video of complete games, and we heavily promote these services on our social media platforms. We even target our social media postings based on the user's geographic location and primary language so that each fan receives only the content most relevant to them.

Though more and more video is being delivered exclusively online, many of the traditional rules still apply. Video production professionals must carefully consider the intended audience, especially one as diverse as the online community. I still firmly believe that quality matters—if it doesn't look good and tell a compelling story, people won't watch it (or share it). This is especially true for large organizations. Anyone can produce mediocre video, but viewers expect a big name like the Pittsburgh Steelers to produce a flawless product.

SOURCE: Scott W. Graham, Digital Media Assistant

REPURPOSING

> The best answer may be to create a separate version of your content that delivers your message using less bandwidth.
> CHRIS MEYER, MOTION GRAPHIC DESIGNER AND WRITER

Repurposing is converting one form of media into another. Broadcast programs and movies that are compressed for mobile devices are good examples. From a business perspective, the story gets broader exposure, an increased audience, and more revenue if you can successfully use it across multiple platforms. It should be relatively easy to repurpose the material if these three points were considered throughout the production process.

The idea of reusing a production is not new. Feature films have been providing secondary markets through tapes and DVDs for years. After theatrical

release, and sometimes concurrently, films might be released for television and home video markets. These secondary audiences might access DVD releases, pay per view, cable channels, or the broadcast networks. Foreign markets are also a potential method for distribution. Each of these scenarios presents repurposing issues. For example, a program may need to be reformatted to fit a particular screen size, have subtitles inserted, or be edited for content.

Today's audience becomes increasingly fractured by new distribution options like the Internet and mobile devices. Producers must continually look for ways to increase revenue and audience size by distributing the same content across multiple platforms. The ultimate goal of a converged media environment is "author once, deliver many." Unfortunately, this practice is proving to be much harder than it might have initially seemed. It can be a significant challenge to take a high-bandwidth signal, such as that associated with HDTV, and turn it into a low-bandwidth signal for use in streaming applications. Even if you master the technical considerations, you must consider whether your audience has access to high-speed Internet.

The video industry has experience dealing with the mixing of standard definition and high definition content. Techniques like shoot and protect and the placement of on-screen graphics are strategies meant to meet the challenges of producing for both high definition and standard definition. Unfortunately, these strategies do not exist for all repurposing opportunities, but technology will continue to advance and even make the conversion to mobile devices more practical.

Repurposing Scenario The National Park Service has asked you to produce a promotional video. The organization wants a short high definition video that can be used at a conference for all Park Service employees. It would also like the flexibility to sell DVDs, to use the video within PowerPoint presentations, to stream it on the Internet, and possibly to send to mobile devices. This is not an uncommon workflow scenario in today's production environment. The production process is quite simple—shoot in the 1080 high definition format. This format provides an initial frame size of 1920 by 1080 pixels (see Figure 12.7). During the shooting, remember to consider whether additional elements may be needed, such as close-ups for the mobile device versions or extra material for DVD or behind-the-scenes web video.

After production is complete, down-converting for specific uses may require shrinking the original frame size, dealing with a different aspect ratio, or modifying the compression.

Creating the DVD will require making a decision about a letterbox version (see Figure 12.8) or a pan and scan version. Letterbox requires scaling the video to about 33 percent of its original size. This size will fill the width of the standard definition frame, but will leave black bars at the top and bottom of the screen. The center-cut version will be 45 percent of its original size. This size fits the height of the screen, but leaves extra material on the width of the image, as shown in Figure 12.9. This extra material could be used to create a pan and scan effect. The footage can be compressed with MPEG 2 for the DVD version.

The full 1920 by 1080 high definition version of the National Park Service video shows an image from the Grand Tetons.

SOURCE: U.S. National Park Service.

When shrinking the Park Service video down to a letterbox standard definition version, the entire width of the high definition image is preserved. Contrast this image with Figures 12.7, 12.9, 12.10, and 12.11.

SOURCE: U.S. National Park Service.

FIGURE 12.9

The semi-transparent parts of the image are cut off in this pan and scan version of the Park Service video. The image will be panned to show its entire width. Contrast this image with Figures 12.7, 12.8, 12.10, and 12.11.

SOURCE: U.S. National Park Service.

The other delivery methods are similar to the standard definition model. Table 12.1 shows the frame size, scaling proportions, and recommended compression schemes for PowerPoint, streaming, iPod (see Figure 12.10), and mobile phone outputs (see Figure 12.11).

Repurposing takes time and effort to achieve good results. Without proper planning, the process becomes more expensive and difficult. Understanding output formats when a project starts will assist in developing a budget. Before

TABLE 12.1 Repurposing Schemes

Format	Frame Size	Letterbox Scale Percentage	Pan and Scan Scale Percentage	Notes
HDTV	1920 × 1080	N/A	N/A	30 FPS
SD DVD	720 × 480	33	45	30 FPS/MPEG 2
PowerPoint 1	1024 × 768	53	71	Deinterlace video
PowerPoint 2	800 × 600	41	55	Deinterlace video
Streaming	420 × 270	N/A	N/A	25 percent scale/15 FPS
iPod	1136 × 640	N/A	N/A	59 percent scale/MPEG 4 codec for compression
Mobile phone	320 × 240	16	22	15 FPS/3G codec for compression

FIGURE 12.10

Some of the width from the high definition version is cut off. A pan and scan version can help with that, but too much side-to-side movement on a small device can distract the viewer. Contrast this image with Figures 12.7, 12.8, 12.9, and 12.11.

SOURCE: Grand Tetons image courtesy of National Park Service.

FIGURE 12.11

The mobile phone version of the Park Service video requires a pan and scan technique to see the entire width of the image. Contrast this image with Figures 12.7, 12.8, 12.9, and 12.10.

SOURCE: Grand Tetons image courtesy of National Park Service.

STORY 12.3 Tips for Web Video

The Web doesn't merely offer a second-rate, lossy, low-resolution counterpart to standard and HD video. Web video has its own particularities that should be taken into account when planning a production.

I was shooting and editing a video series for Newsweek.com. The editors expected talking heads with no b-roll, framed in an interactive application. I had to develop a flexible system to record impromptu yet lengthy statements that would be edited for both content and style with little to no setup time.

Avoiding jump cuts and jarring transitions without the aid of b-roll seemed a daunting task—until I took the resolution of the output medium into consideration. I was shooting at standard resolution, but the final video would be displayed on the Web at half resolution. With each interview, I composed the shots loosely with the subject centered. I edited the interviews at 320 by 240, which allowed me to recompose the shot at each edit by zooming and panning the standard resolution video.

This same trick can enhance video that is repurposed for the Web with tight framing for close-ups, text, and graphics. Just don't expand the video past its native resolution and there won't be any loss in quality.

SOURCE: Tom Wade Murphy, Multimedia Producer

production begins, it is important to know if additional material is necessary for DVD extras or if retakes of certain scenes will be necessary to meet the requirements of a mobile device.

ARCHIVING

Archiving is the process of systematically saving all the raw materials from your project. Archiving is done to save the material, to **future proof**, or to preserve the material for historical purposes. How do you save all the raw materials? More importantly, how do you "future proof" your archived materials so that they will still be usable no matter what format or delivery platform you may want to use in the future? Organizations such as the History Channel use a considerable amount of historic footage that has been archived at various private and public storage facilities. It is likely that new versions of programs that were produced in the past will be regularly re-created. As new programs are developed, the archives provide a wealth of material for the new stories. The problem is that most, if not all, of the footage is from lower-quality standard definition formats. In order to future proof, you should shoot at the highest quality possible for additional projects in the coming years.

The issue of future proofing raises questions about legacy video. Most, if not all, video tapes are now **legacy video formats**, as they are no longer used in the production process. Legacy formats provide a wealth of material, but are prone to potential issues as they are incorporated into newer high definition formats. Besides aspect ratio and lower-quality standard definition, other issues to consider include access to working VTRs for playback and videotapes that are in good enough condition to actually play back.

Storage Solutions

It is important to remember that archiving is long-term storage and the materials may need to be used or transferred in the future. Finding the right solution may be difficult, but considering the options is a good start. Archiving in multiple formats is another wise suggestion since it provides more options when you need to use the materials in the future.

Portable external drives are a common method for archiving. The price of such devices has decreased to the point where it is feasible for even individuals to store copies of all original materials on drives that hold a significant amount of material in a small space that can be readily accessed. As with all hard drives, life span is generally short and having only one backup copy on a hard drive is not optimum.

Cloud storage is an increasingly popular archival option, as an entire industry has blossomed that specializes in mass storage. These third-party providers allow access over the Internet.

Magnetic media (videotape) is another archival option, but it has some disadvantages. Tape can become demagnetized over time, causing your archive to

be erased. This demagnetization comes from the magnetic pull of the earth and takes considerable time, but it is a reality. Second, tape can adhere to itself and prevent the playback machine from working properly. Lastly, there is the challenge of finding a working machine to play back a particular tape format years after the format has become obsolete. One solution to this problem would be to continually update the archive to a current tape format. Many companies routinely recopy archival materials to a new format every few years. The life of an archived tape can be prolonged by storing the tape tails out. This means that it is fast-forwarded to the end of the tape. That will require the operator to rewind the tape to use it. Such exercising of the tape can loosen it if it was sticking to itself.

Linear Tape Open (**LTO**) magnetic backup is a safe but expensive option for storing archival material. The system consists of a tape cartridge that can be inserted into the recorder using a lossless data compression scheme.

Optical Media Another method of archiving is the use of optical media, such as DVDs. The advent of double-layer, double-sided DVDs, as well as blue laser technology, has greatly increased the available storage space on a DVD. Double-layer and double-sided DVDs allow you to store more material than a traditional DVD. Compacting the data more closely on the disc greatly increases capacity. In addition, using an optical disc system for acquisition decreases the amount of time it takes to archive your material. On the other hand, converting the files to DVD can take considerable time. Optical media are not immune to long-term problems. One of the issues is file corruption. A file stored today can become corrupt and unreadable tomorrow for no apparent reason.

CONCLUSION

Output and archiving are the last steps in the production process. You need to carefully consider your output needs during the early stages of preproduction. Output and distribution decisions impact the production phase. Understanding the effect that compression has on your video is important. Besides the traditional channels of broadcast or cable release, you can also output your video on DVD, on the Internet, or to a mobile device. Each delivery mechanism has it own methods and rules for delivering the highest-quality sound and picture. Repurposing your work is taking it from one format and delivering it to another output method. The ability to repurpose your project will provide the potential for a wider audience and more revenue. Finally, you must take care to properly archive your work in a way that will enable you to reuse the material in the future.

Story Challenge: Output and Archiving

Because of good planning, the director for Pick 2 Productions had sufficient video for the extras to be included on the DVD. In addition, she followed the

detailed production guidelines for the cable network. This turned out to be a good decision since several specific items were not considered beforehand. Paying close attention to compression settings for the streaming version of the music video was instrumental in having the video play smoothly over the Internet. Finally, Pick 2 decided to use multiple methods for archiving the material of the projects. In addition to keeping all original media, the contents were duplicated to high-capacity hard drives. This redundant backup will be useful should anything happen to either version of the archive.

Glossary

above the line Production costs associated with the creative process, including writer's fees, director's salaries, and story rights

AB roll editing A linear editing system with multiple feeder VTRs

actual malice An additional burden of proof, required of public officials and public figures, that a defamatory statement was published with knowing falsity or with reckless disregard for the truth

additive color Method used to reproduce color for video. The image consists of three primary colors: red, green, and blue, which result in white when mixed together at full intensity

advanced audio encoding (AAC) A standard lossless audio compression format popular in digital video

alpha channel An 8-bit channel in an image that determines the transparency of a graphic, much like a mask

amplitude A measure of volume or loudness

analog Audio or video signal that constantly varies according to the stimulus that creates it

aperture The opening created by the iris that allows light through a camera lens

Apple ProRes A lossy compression codec used in acquisition and post production

archiving The process of systematically saving all the raw materials from a video project

artifacts Noticeable errors in the compression and decompression of video images

aspect ratio The ratio of screen width to screen height

asset As it relates to nonlinear editing, video clips, sound files, graphics, or other media files

audio interchange file format (AIFF) A high end, lossless compression scheme for audio

audio sweetening A step in the post production process in which audio is enhanced, edited, or mixed

automated dialogue replacement (ADR) The process of replacing original voice tracks during post production

automatic gain control (AGC) An audio circuit that averages and controls audio input levels during recording

auto save A function in software applications that makes a backup file of your work at regular intervals

AVCHD A file-based high definition recording format

Avid DNxHD A lossy compression codec used in acquisition and post production

axis of action A compositional rule that dictates camera placement during a scene to ensure consistent screen direction. Also called the 180-degree rule

background light A light placed so that it casts light in the area behind the subject

back light A light used in the three-point lighting scheme to create the illusion of depth by separating the subject from the background

back-schedule A scheduling technique that identifies the completion date of a project and works backward to see how much time can be allotted to different phases of the production

back-story Information that allows the viewer to understand important events that occurred before the story takes place

back time The automatic rewinding of a videotape a specific amount of time before playing the tape to the in-point for a linear tape edit

back timed An editing technique to ensure that the end of a music track coincides with a specific point in time

balanced audio A method of connecting professional audio equipment in which the ground wire is separated from the signal wires

bandwidth Amount of space required for that data to be transmitted or moved from one location to another

barn doors Metal flaps attached to a lighting instrument used to prevent light from hitting certain parts of a scene

bass Lower audio frequencies

batch capturing The process used to capture multiple clips from an individual tape in one action. Also used to replace low-resolution proxy versions of the footage with higher resolution material

bed level A soundtrack element that is lower than the main sound source

below the line Production costs associated with the technical process, such as equipment rental, crew wages, and prop fees

bidirectional frame (B frame) One of three types of frames used in MPEG compression. It is composed of motion vectors and pixel blocks that are derived from previous and subsequent frames

binary code Digital language in which every bit of information is represented by a series of numbers using only the digits 1 and 0

bins An electronic folder located within a project that contain all the various assets for the project

bitmap image A resolution dependent graphic that is created at a certain pixel size. Also known as a raster graphic

bit rate The speed at which data are allowed to move through a computer system. Also known as data rate

blanket license With regard to the use of intellectual property in video production, a fee paid for unlimited use of music, photos, or other material for unlimited use over a specific period of time

blanking A process that turns off the electron beam at the end of each line and at the end of the first field when creating a video image on a video monitor

blocking A procedure in which the director, videographer, and other relevant personnel resolve camera positions, movement in the frame, and other issues prior to shooting a scene. Also a compression artifact that consists of the appearance of small squares in an image that make it look like the image is composed of tiles

blue laser A technology used in video and DVD production that can write information on a disc more densely than a red laser

Blu Ray A standard for high definition DVDs that use blue laser technology to put more information, including higher resolution images, on a disc

blurry wings A method of fitting 4:3 material in a 16:9 aspect ratio frame. The technique uses two layers of video in which the bottom layer is stretched to fit the wider screen and blurred. The top layer is the original 4:3 image

boundary or PZM A microphone that detects sound pressure level changes between direct and reflected sound. Used in situations such as during a meeting when multiple users must use a single mic

breach A violation of a contract

brightness Attribute of color that defines the luminance of a color. Also known as lightness

b-roll Video footage, or shots, that visually describes the story being told by an interviewee or voice-over

bug A graphic that identifies the channel or network, generally superimposed over the lower right corner of the video screen

caching A modern video camera feature in which the camera is constantly storing video data

cameo lighting A lighting technique that isolates the talent from the rest of the frame, causing the viewer to ignore the screen space and concentrate on the talent

capturing Converting digital tape to digital files

cardioid A microphone pickup pattern that picks up sounds in a heart-shaped area around the front of the mic

CG A dedicated graphics computer typically used in a studio environment to produce all graphics for a particular show. Also known as a character generator

character generator A dedicated graphics computer typically used in a studio environment to produce all graphics for a particular show. Also known as a CG

character pov A story told from the perspective of a character in the story

charged coupled device (CCD) A computer chip that converts light to electrical energy

chin room In a video shot, the space from a person's chin to the bottom of the frame

chroma key An electronic effect in which a specific image replaces a colored background in a video shot

chrominance The color portion of the video signal

chrominance crawl A compression artifact in which many colors can appear over a finely striped surface in the picture

chrominance smear A compression artifact that makes colors in an image look like they are blending together

cinéma vérité A film genre popularized in French cinema during the 1950s where attention is placed on

truth in the shot instead of the control usually dictated by the camera crew

CinemaDNG A lossless compression codec used in acquisition and post production

clip As it relates to nonlinear editing, a reference link to the media file

close up (CU) A shot that shows more detail than a medium shot and cuts out unnecessary parts of the image

codec A compression/decompression engine or a computer algorithm that dictates how data will be compressed and decompressed or restored. Can be software or hardware based

color Visual property of an object as defined by three attributes: hue, saturation, and brightness

color correcting The manipulation of a variety of video signal attributes to modify an existing video clip

color grading Manipulating color for creative reasons

color temperature The relative redness or blueness of light as measured in degrees Kelvin. The higher the color temperature, the bluer the light

CompactFlash (CF) A media card used as a storage device

complementary metal oxide semiconductors (CMOS) A computer chip that converts light to electrical energy

complex shot A video camera shot in which the subject moves as well as the camera lens and the tripod head

component Video signal that separates luminance and chrominance information into separate signals

composite Video signal that combines luminance, chrominance, synchronizing, and blanking information together in one signal

compositing The layering of video tracks, resulting in multiple images simultaneously on-screen

compression Reducing the amount of information and/or the bandwidth requirements of a digital audio or video file

compression rate The amount of reduction of information in a video signal applied to original data

compressor A signal processor that reduces the amplitude of an audio signal during output

condenser microphone A powered microphone that uses the movement between two electrostatically charged plates to transduce energy into sound waves

conflicting POV A story told from changing or shifting perspectives

consent form A signed document allowing a production company the use of an individual's image or likeness

continuity Maintaining story consistency from shot to shot and within scenes

contract An agreement by two or more parties that is legally enforceable

contrast The difference between the darkest and brightest part of the video image

cookie A metal pattern such as a window frame, mini blinds, or abstract design placed in front of a light to create that pattern on a set or backdrop. Also known as a cucalorus

copyright An exclusive legal right that protects orignal works of authorship

counterpoint A soundtrack element, usually music, that is in conflict with the visual. This technique creates irony or suspense as it draws attention to the apparent mismatch

crawl A graphic that moves horizontally across the video screen; designed to attract the viewer's attention

credits Graphics used at the beginning or end or a video program that may include a copyright statement, the names of the crew, locations of shooting, and other information

cucalorus A metal pattern such as a window frame, mini blinds or abstract design placed in front of a light to create that pattern on a set or backdrop in a video scene. Also known as a cookie

cut An instant change from one image to another; a verbal signal from the director or videographer that recording has ended

cut on action A series of two edited shots that flow in a continuous and realistic fashion

cut on dialogue A cut during a conversation that keeps the camera shot on the person talking

cutting on the beat A cut timed to a musical beat or sound pattern

data rate The speed at which data are allowed to move through a computer system. Also known as bit rate

data wrangler A person who works on location to ensure digital files are properly recorded, stored, and backed-up

decibel (db) A unit of measurement used for sound levels

defamation A communication that damages or harms the reputation of an individual, or that could cause hatred, ridicule, scorn, or contempt

depth of field The range of distance over which objects in a video shot will remain in critical focus

developing shot A video camera shot that involves subject movement, lens movement, pan and tilt head movement, and movement of the entire camera support

dichroic filter A blue colored glass that mounts in front of a light to match the color temperature of that light to the sun

diegetic sounds The actual sounds within a story, including dialogue, natural sound related to a scene, and music initiated by such things as the talent listening to music

diffuse To soften a light source

digital Audio or video signal composed of data using binary code

digital audio transmissions For purposes of copyright law, webcasts and audio streaming materials

digital intermediary The stage in the production process when final adjustments are completed before distribution

digital use rights Fee paid to a music publisher to make a video production containing copyright protected music available on the Internet

digitizing Converting an analog signal to a digital file

direct cinema A documentary style that concentrates on the story, and where less importance is placed on the equipment and crew

dissolve A gradual transition between two images

DolbyTrueHD A high-end lossless audio compression scheme used in high definition DVD production

downloading A method for playing audio and video over the Internet. Using this method, the file is copied from the Internet to your local computer and there is a delay before you can screen the program

drop frame A time-code numbering system that drops, or renumbers, frame numbers 0 and 1 except for minutes divisible by 10. This adaptation to the numbering system compensates for the real frame rate of NTSC video of 29.97

drop shadow A visual effect that mimics the shape of an image and is generally behind and offset from the actual image

DSLR Digital Single Lens Reflex camera

dutch angle A video shot in which the frame is tilted or canted

dynamic A video camera shot in which either the camera or an object in the frame moves

dynamic microphone A rugged microphone that electromagnetically transduces energy into sound waves

dynamic range The range between the quietest and loudest sounds

edit decision list (EDL) A step-by-step set of instructions of how a program was, or will be, edited

encoding The process of compressing a video production to create video and audio suitable for Internet streaming

equalization (EQ) The process of boosting or reducing specific frequencies within the audio signal

equipment checklist Similar to a grocery list, an advanced organizer used to ensure that all equipment and supplies have been packed for the shoot

errors and omissions (E&O) insurance A safeguard that will protect a production company that infringes a copyright, invades someone's privacy, defames a trademark, or makes other general types of legal mistakes during production and distribution

essential, or safe action, area The inner 85–90 percent of the video frame that will be accurately portrayed on the home television set

establishing shot A camera shot that helps the audience understand the location or time for a scene

extreme close-up (ECU) A shot when the camera lens is zoomed to a very tight shot of the subject, or a long focal length

fade A gradual transition between an image and TV black

fair use A section of the copyright law that may allow a producer to forgo obtaining permission to use someone else's intellectual property

falloff In lighting, the change from light to shadow, generally described by how quickly the change happens

feeder The player or source in an editing system

fill light A light used in the three-point lighting scheme that reduces but should not eliminate shadows created by the key light

film chain The equipment used to convert film to digital video. Also called a telecine

filter An optical device placed in front of the lens that alters the look of an image. Also used to describe a visual effect, such as desaturation, placed on clip. In audio, a device that attenuates specific bands of frequencies

firewire One method for connecting cameras or disc drives to a computer. Also known as IEEE 1394

first-person POV A story perspective in which there is indirect communication from a character to the audience

flag A device used to block or shape light from a lighting instrument

flatten The act of reducing a multi-layer graphic to one layer

flashback An editing technique used to manipulate time as the story moves from the present to past

flooded A condition that exists when a light source is at its widest, least intense position

fluorescent light/fixture A lighting instrument that requires little power, does not get too hot, and can work in 3200 and 5600 degree environments

fluid head A tripod mount that is composed of a sealed system containing a viscous liquid between the moving and nonmoving parts of the head

focus assist A system that aids a videographer in focusing a high-definition camera

focal length The distance between the optical center of the lens to the plane where the image is focused, measured in millimeters

focus puller A person who operates the focus control on the camera during a video shot

fog filter An optical device placed in front of the camera lens that will soften the contrast and sharpness of a video image and add a misty or fog-like quality to the image

Foley A recording technique used to create sound effects

footage log A production form that contains descriptions, time code numbers, and other specific information about each acquired shot

foot-candle A measurement of light, using a scientific standard, one foot-candle is the amount of light a candle emits as measured from a distance of one foot

foreshadowing Hints or clues about what may happen later in a story

frequency (or pitch) The relative tonal quality of an audio signal, measured by the number of waves per second measured in Hertz (Hz)

Fresnel lens A lens permanently fixed to a lighting instrument that allows the light to be focused through the lens

friction head A tripod mount that is composed of a sealed system containing grease between the moving and nonmoving parts of the head

frosted gel A white, translucent material placed in front of a spotlight to diffuse the light source, similar to tough spun and grid cloth

f-stop A number used to indicate how much light is coming through the aperture of a video camera

full screen graphic A graphic that fills the whole video screen

future proof A method of creating video materials today that will still be viable in the future

gain Audio volume level or amplitude; in video an electronic enhancement of the image that allows a camera to operate in lower lighitng conditions but produces a noisy or grainy image

geared head A tripod mount that uses gears and hand wheels to smoothly move the camera

gel A polyester-based material placed in front of a lighting instrument to cast a certain color, to match color temperatures or to reduce light intensity

generation loss The loss in quality that occurs each time an analog tape is copied

genres Identifiers that help group programs into specific categories, such as drama, comedy, or news

graphic equalizer An equalizer that allows variable adjustment of specific frequencies

graphic vectors Stationary objects or elements in a video frame that guide the viewer's eyes in a particular direction

graticule An overlay in a camera viewfinder

grid cloth A white, translucent material placed in front of a spotlight to diffuse the light source, similar to frosted gel and tough spun

group of pictures (GOP) The basic unit of compression for the MPEG scheme. Composed of several frames of video, the GOP starts and ends with an intra frame with a varying number of predictive and bidirectional frames

H264 A lossy compression codec used in production and distribution

handles Extra seconds of audio and video at the beginning and end of a clip this is captured or ingested to help with trimming and transitions during the edit

hard light A illumination source that produces a distinct beam of light with very sharp shadows

head The beginning of a tape or clip

headroom In a video shot, the space between the top of a person's head and the top of the frame

high angle shot A video shot in which the camera is looking down at a subject

histogram A graphical representation of the brightness in an image

HMI light A lighting instrument designed for use outdoors that has a color temperature matched to daylight

hue Attribute of color that defines the actual color, or shade itself, such as a red shirt, a blue ball, or green grass

IEEE 1394 One method for connecting cameras or disc drives to a computer. Also known as firewire

impedance (z) Electrical resistance to signal flow

importing A process for adding media assets into a nonlinear editing software project

incident reading A light meter reading that indicates how much light is falling on a scene

inciting incident The event that causes the story action to begin. It introduces the main conflict and keeps the audience interested in the story

index vectors Lines or directional indicators in the video frame created by people or objects that point in a particular direction

ingesting In post production, the process of transferring digital video files from the camera into the computer

in-point A mark added to a clip that becomes the first frame seen or heard when the clip is placed on the timeline

instructional design A systematic approach to the design of a program, including goals, process, and evaluation

intellectual montage A type of montage that forces the audience to interpret a connection between ideas and camera shots

intellectual property Property that derives from original, creative thought and has commercial value

interactive digital transmission Defined under copyright law as a production, such as a song, that plays only when a user initiates a request, usually through a mouse click

interlaced scanning A process to compose a video picture in which a TV monitor electronically draws all odd-numbered lines first, then it returns to draw the even-numbered lines

interrotron A device used by filmmaker Errol Morris during interviews. The interviewee looks directly into the camera through a teleprompter and sees the interviewer as if he were in front of him

interframe A compression scheme that eliminates redundancies between frames of video. Also known as temporal compression

Internet protocol television A method for receiving content from the internet on a conventional television, known as IPTV

intraframe A compression scheme that looks within a single frame for redundancies that can be eliminated to save space. Also known as spatial compression. In MPEG compression one of three types of frames used as a reference for other frames in the compression scheme

inverse square law A rule of physics that states that as the distance from microphone to talent doubles, the sound level reduces to one-quarter of its intensity. Also applies to the intensity of a light

IPTV A method for receiving content from the Internet on a conventional television, known as Internet Protocol Television

iris A mechanical device that controls the amount of light entering video camera

jib A crane-like device from which a camera can be suspended

jog Advancing a clip one frame at a time

JPEG (jpeg compression) Joint Photographic Expert Group; a lossy compression scheme used mainly for still photos, in which an image is divided into luminance and chrominance and then a group of pixels is averaged to reduce the amount of information

jump cut A series of two shots that lack continuity

key A visual effect in which part of an image is electronically cut out and replaced by another image

key frame A reference point to a specific frame in the timeline used when creating effects at that point in time

key light The main light source in a three-point lighting scheme

kicker A light placed opposite the key light to add a modeling effect on the subject. Can be used in conjunction with a backlight

lavaliere (lav) A clip-on microphone that is attached to the talent

L-cut [or split edit] An editing technique in which the picture and sound start at slightly different times

lead room Space left in the video frame for a person to talk or look in a particular direction. Also known as nose room or look room

leading lines Elements in the video frame that provide a path for the viewer to visually navigate across the frame

legacy video formats Older video tape formats such as one-inch, U-matic, or others that are no longer in use

letterbox A method for fitting wide screen material into a smaller aspect ratio. The wide screen material is proportionally shrunk until it fits the narrower dimension. The resulting image has horizontal black bars at the top and bottom of the screen

light emitting diode (LED) A lighting instrument with all the advantages of a fluorescent light, but in a much smaller size that can easily be powered from a battery

lightness Attribute of color that defines the luminance of a color. Also known as brightness

limiter An audio compression circuit with a predetermined output level that cuts off extremely high amplitude sounds

line level Mid-level audio signals normally found in equipment such as VCRs and CD players

linear perspective A method for creating depth in the video frame in which horizontal lines in the frame are placed along the z-axis rather than parallel to the frame

location agreement A contract that provides the right to shoot video on private property

logline A short summary that describes the story in an interesting manner

look room Space left in the video frame for a person to talk or look in a particular direction. Also known as lead room or nose room

lossless compression A method for compression in which an image is compressed and then restored as an exact duplicate of its original

lossy compression A method of compression in which an image is compressed and data is lost during the

restoration so that the new file is not an exact duplicate of the original

low angle shot A video shot in which the camera is looking up at a subject

luminance The black and white or brightness part of a video signal

lux The metric term for foot-candles. One lux is equivalent to approximately 11 foot-candles

macro lens An optical device that allows a video camera to focus on objects closer than the minimum distance

master use license Fee paid to a record company to use the "master" version, or best quality, of a particular music recording

match frame An editing technique that matches a specific frame in the timeline with the same frame in the original clip

matte A visual effect that allows you to hide or mask part of an image

matte box Attachment for a video camera lens that reduces glare and is capable of holding lens filters

mechanical license Fee paid to a music publisher for the right to record and sell a song the publisher owns

media files As it relates to nonlinear editing, the actual audio and video media

media offline As it relates to nonlinear editing, an error message that occurs when a clip and its associated media file are unlinked and the clip is unable to find the original media

medium shot (MS) A shot that shows less image than a wide shot but more than a close up

metadata Data about data, such as a camera setting used during a recording or the location of the video shoot

metal scrim A device composed of a metal screen that is used for diffusing light

metric montage A type of montage with a series of shots that are varied by the length of time they are on-screen

mic level Low voltage audio signals produced by microphones

mise-en-scene A French term for the designing and staging of the production space

mix A generic term for a gradual transition where one image appears to fade away while another begins to appear. Also, combining multiple sounds together

mixer An audio device that allows you to combine and manipulate more than one sound source simultaneously

mobisode Video programs designed to be viewed on a cell phone or other mobile device

monaural/mono A single channel of audio with no directionality

montage An editing convention that combines unrelated shots to create a new meaning

mosquitoes A compression artifact in which fuzzy dots appear around sharp edges

motion vectors Lines or directional indicators in the video frame provided by movement in the frame. In MPEG compression, a description of the direction and distance of pixel movement in predictive and bidirectional frames

MP3 A common lossy file format used for audio signals

MPEG A lossy compression scheme used for motion video, known as Moving Picture Experts Group

mult box A device that offers a direct audio feed from one source to multiple outlets

multiple bit rate A streaming video file that is encoded at different data rates to accommodate more than one connection speed

music bed Music that plays at a low volume under the main audio in a scene

music clearance company Professional organization that specializes in securing the correct licenses and rights for the use of intellectual property in a video production

national television systems committee (NTSC) The group that developed the current analog television system in the United States

narrative A constructed, fictional story

natural sound Soundtrack elements that add realism to a scene. These sounds are usually synchronous to the visual, like the sound of a bus as it drives through the frame

needle drop fee With regard to the use of intellectual property in video production, a fee paid for a one-time use of a specific piece of music or a photo. Also known as a "per use agreement"

neutral density filter An optical device placed in front of the camera lens that will reduce the amount of light entering the camera without affecting the color temperature of that light

neutral density gel A gray gel placed in front of a light to reduce the intensity of the light while not changing the hardness or color temperature of the light

nondiegetic sounds Sounds not directly related to a visual, such as voice-over, sounds added for effect, and most music

nondrop frame A time-code numbering system that counts each frame and does not compensate for the actual NTSC frame rate of 29.97

non-fiction A factual story

noninteractive digital transmissions Defined under copyright law as a production broadcasting over the

Internet so that users may tune in or out by navigating to the site

nose room Space left in the video frame for a person to talk or look in a particular direction. Also known as lead room or look room

observational approach A documentary style that uses a fly-on-the-wall technique, concentrates on the story, and tries to minimize the use of camera and other equipment

off-axis camera shot Positioning an interviewer close to the side of the camera so the interviewee is looking just slightly off camera

off-line A workflow process where footage is captured using a lower resolution signal to save time and hard drive space. Similar to a rough draft

ohms A measure of impedance

omni-directional A microphone pickup pattern that is sensitive to sounds from all directions

on-axis A process where an interviewee, newsperson or actor talks directly to the camera as if conversing with the filmmaker or the audience

180-degree rule A compositional rule that dictates camera placement during a scene to ensure consistent screen direction. Also called axis of action

on-line A workflow process where footage is captured at high resolution. In addition, final effects are added, color-correction is performed, and final soundtrack mixing is completed. Similar to a final draft

optical disc A video recording medium similar to a DVD that uses blue laser technology to store material on the disc

out-point A mark added to a clip that becomes the last frame seen or heard when the clip is placed on the timeline

overlapping plane A method for creating depth in the video frame by using an object in the foreground of the shot to frame something in the background

overtonal montage A type of montage that combines metric, rhythmic, and tonal montage

PA level High voltage audio signals used to drive speakers

pan For camera, a movement of the camera or tripod from left to right or right to left across the scene. Also a technique to move the soundtrack from one speaker to another, such as left to right or front to rear

pan and scan A method for fitting widescreen content into a smaller aspect ratio in which the widescreen material is cropped to fit and then panned to eventually show the full width of the material. Also a technique for animating a still picture in a video program

panning The process of changing the relative balance between two speakers so that the sound balance either

moves across the room or is preset differently than normal

parallel editing An editing technique that intercuts between two or more different scenes within the story

parametric EQ An equalizer that allows variable adjustment of amplitude, frequency, and bandwidth

passive switcher Specialized software or hardware used to connect inputs and outputs between equipment

patching The process of connecting two pieces of audio or video equipment together

patch panel A device that uses cables to connect equipment inputs and outputs together

PCMCIA Expansion card commonly used to expand the capabilities of many laptop computers

performance royalty Fee paid to a music publisher when one of its songs is performed or played publicly

performing rights society Organization that collects fees and enforces copyrights for music publishers and artists

perspective An audio aesthetic in which the sound matches the framing of a shot. The sound source from a person or object 5 feet away should be distinctly different from the same sound source 100 feet away

per-use agreement With regard to the use of intellectual property in video production, a fee paid to use a specific piece of music or photo for a one-time use. Also known as a "needle drop fee"

phantom power An external power source used to provide voltage to a condenser microphone

physical continuity Continuity problems that occur when items used in a production don't match within a scene

photosite A light sensitive container on a CCD or CMOS chip

pickup pattern The direction from which the microphone will pick up sounds

pillarboxing Vertical black bars that can appear when placing 4:3 images in a 16:9 aspect ratio

pitch A face-to-face opportunity to sell a production idea to a potential buyer or funding agency. Also, the relative tonal quality of an audio signal, measured by the number of waves per second measured in Hertz (Hz)

pixel The smallest unit of visual information. A combination of the words "picture" and "element"

pixelization Degradation of an image caused by enlargement of the pixels that make up the image plot. The events that shape a story

point of critical focus A central object or subject of a video shot that must be in focus

point of view (POV) The perspective used to tell a story

polarizing filter An optical device placed in front of the camera lens that is designed to reduce glare

post-scoring Composing music for a program after the dialogue and visual editing have been completed

predictive frame (P frame) One of three types of frames used in MPEG compression. It looks back at the previous frame and attempts to predict how the pixel blocks changed to create the current frame

premultiplied alpha channel A type of video signal in which transparency is defined by both the alpha channel and the color channels of a particular graphic

preset time code Time code that is set by the user

prime A fixed focal-length lens

production book A binder containing all paperwork and pertinent information regarding the production. Sometimes combined with, or duplicated in, an electronic folder

production design Planning the physical production space, including all the physical objects—such as the location, set, props, and wardrobe—and developing a design through the use of space, color, and lighting

product placement A practice in which a commercial company pays to have its products appear in a production

product placement fees Fee paid to a production company to use commercial products in the context of narrative video

progressive scanning A system of line drawing to compose a video picture in which a TV set starts with line 1 and sequentially scans the image line by line

project The top level folder in a nonlinear edit system where assets are organized

project file Another term for an EDL. A visual list of the edited program

proxies Low resolution versions of video clips

P2 A proprietary media card

public domain Intellectual property that is not subject to copyright or requires no permission for its use

public figures Persons who are in the public eye, such as a sports star or Hollywood celebrity

public officials Persons who serve in elected or appointed governmental positions

pulldown A process that is used to convert video or film from 24 frames to 30 frames

PZM [or boundary] A microphone that detects sound pressure level changes between direct and reflected sound. Used in situations such as during a meeting when multiple users must use a single mic

quantization The precision of digital samples or the number of discrete levels at which a digital sample may be recorded, such as 16-bit audio, which yields 256 discrete levels

rack focus A method for creating depth in the video frame in which the videographer changes focus from one object on the z-axis to another object

RAID A redundant array of independent disks. By spreading data across multiple hard drives, it provides high speed and large capacity for storage of media files as well as greater protection against file corruption

RAM Random Access Memory

raster graphic A resolution dependent graphic that is created at a certain pixel size. Also known as a bitmap image

rate card A list of costs associated with services provided by a production company or equipment rental facility

raw An uncompressed and unprocessed hi-resolution file format

reaction shot Shot of a nonspeaking person used as an alternative shot in a scene; for example, a cut to show the reaction of a person not talking

reflected light A light meter reading that indicates how much light is bouncing back or reflecting back from the scene to the camera

reflector A device that bounces light from a light source toward the subject

regenerate time code Time code that matches previous time code

release form A signed document in which talent agrees to appear in a video production. It informs the talent of their rights and how the recorded video be used

rendering The process of building a special effect, filter, or other complex transition frame-by-frame to enable real-time playback

repurposing Converting one form of media into another, such as a broadcast program or movie compressed for a mobile device

resolution Related to the quality or detail of an image

reuse fee A fee sometimes paid to license motion video clips. Required if the original production involved union workers to cover the loss of income to those persons for the use of the clip, rather than creating new material

reveal edit An editing technique that provides information in the second shot that may startle or confuse the viewer

reverb A filter that replicates the sounds of different environments

rhythmic montage A type of montage that relates to the placement and movement of content within the frame

ribbon microphone A delicate microphone that uses a diaphragm to transduce energy into sound waves

rig A device used to mount a camera, such as a shoulder mount or jib arm

right of privacy A legal protection for individuals from any emotional harm that may arise from commercial exploitation of their name or likeness

right of publicity A legal protection for individuals who may suffer economic harm from an appropriation of their name or likeness

roll A graphic that moves from the bottom of the video screen to the top of the screen

rolling shutter A visual artifact that can cause an image to smear or wobble if it contains movement. More likely to occur with CMOS sensors

royalty-free music Music that, once purchased, has few, if any, restrictions on the way in which a producer may use it

rule of thirds A compositional rule in video that suggests dividing the video frame into thirds vertically and horizontally. Important actions in the frame should be placed on the intersections of these lines. Also, dominant horizontal and vertical elements should follow the lines

run length encoding (RLE) One method of lossless compression

sampling Process by which a continuous analog signal is measured in order to convert the signal to digital

saturation Attribute of color that defines the richness or strength of the color

screenplay format A script format where everything is written in a linear fashion. This includes directions, visual information, and a script

Secure Digital (SD) A media card used as a storage device

second-person POV A story perspective in which there is communication from the talent directly to the audience, usually by having the talent look directly into the lens

selective focus A method for creating depth in the video frame in which one object along the z-axis is in focus while the others are blurry

sequence A series of continuous shots related to the same activity that help tell a story

shoot and protect A video shooting philosophy in which the videographer shoots in 16 X 9, but ensures that all content will fit a 4 X 3 frame

shot list A description of all the shots you wish to capture at a given location

shotgun A highly directional microphone

silhouette A lighting technique in which the foreground is dark, causing the audience to see only an outline of the subject

simple shot A video camera shot in which only the talent in the frame moves

single bit rate A streaming video file that sends data bits at a single constant speed

site survey Advance scouting of a location to review the size, window location, noise, type of lighting, electrical outlets, scheduled events, other personnel you must work around, and clearance into an area. Also, the completed document after the physical site visit is complete

softbox A particular kind of softlight that consists of a spotlight enclosed by highly reflective fabric that diffuses the light

softlight An illumination source that produces a diffused beam of light creating subtle shadows and slow falloff

solid state Device with no moving parts, such as a solid state hard drive

sound bites Quotable statements, usually short, from an interview

spatial compression A compression scheme that looks within a single frame for redundancies that can be eliminated to save space. Also known as intraframe compression

spatial jump cut A jump cut that occurs when the cut between two images is not sufficiently different from the previous shot

spec project A video project that is pitched without having financial support

split edit or L-cut An editing technique in which the picture and sound start at slightly different times

spotlight A lighting instrument that allows a lens to focus the beam and create a directional light source

spotted A condition that exists when a light source is focused to its most intense, narrow position

static A video camera shot that doesn't have any movement in the frame

steadicam A video camera harness with a series of counter-balances that provides smooth and fluid movement

stereo Two linked channels of audio with left and right directionality

story beats Major events in a story

storyboard A visual representation of each shot, possibly including transition and audio information

straight alpha channel A type of video signal in which transparency is defined by information solely in the alpha channel of a particular graphic

streaming video A method for sending compressed audio and video over the Internet that allows for

near-immediate playback of the signal without the delay of downloading a complete file

stroke An outline around the characters of a graphic

sub-woofer Speaker that produces low bass sounds

super A graphic that is superimposed over top of a video image

surround sound A sound system with several different speakers, each placed to allow sounds to originate from the appropriate direction based on the scene

SxS A proprietary media card

synchronization license Fee paid to a music publisher to use a song or part of a song in a video program or other visual media format when the song will be synchronized to visual images

tail The end of a tape or clip

tails out A method for storing video tape in which the tape has been fast-forwarded to the end so that an operator will need to rewind the tape before using it

technical continuity Continuity problems due to technical inconsistency from shot to shot. They can be caused by changes in lighting, audio levels, or quality of the image

telecine The equipment used to convert film to digital video. Also called a film chain

teleprompter A device that mounts in front of a lens and that uses a mirror and video monitor to display text or other images for talent to read or view

temporal compression A compression scheme that eliminates redundancies between frames of video. Also known as interframe compression

3G A type of codec used to create video for mobile devices

third-person POV A story perspective in which the audience is an observer

three-point lighting The basic configuration used for television lighting in which three lights are placed in a triangular shape around the subject. Also known as triangle lighting

Thunderbolt A method for connecting peripheral devices to Apple computers

TIFF A high-quality file format for still images known as Tagged Image File Format

tilt Up and down movement of the camera on a fixed axis

time code A unique number assigned and recorded for each frame of video

title safe area The inner 80 percent of the video screen where all text should be located to ensure that it will not get cut off on the home TV set

tonal montage A type of montage that refers to the emotion the shot creates

tough spun A white, translucent material placed in front of a spotlight to diffuse the light source, similar to frosted gel and grid cloth

trademark A word or symbol that is legally registered to represent a company or product

transcode To convert a digital file from one codec to another

transducer A device that converts one form of energy into another

transflash A computer chip, similar to a flash memory card, used to deliver video and other content to a mobile phone

transition A cut or other action that advances the scene from one shot to another

treatment A detailed summary of a story used to market or sell a production

treble Higher audio frequencies

triangle lighting The basic configuration used for television lighting in which three lights are placed in a triangular shape around the subject. Also known as three-point lighting

two-column script A script format where director commands, instructions, and visual information are in a left column and the actual script and audio are in the right column

umbrella A reflective device, attached to a spotlight that diffuses and reflects the light in a scene

unbalanced audio An audio connection that uses only one wire for the signal and one for the ground

uni-directional A microphone pickup pattern that picks up sounds from a narrow area in front of the mic

upconverting The process of taking a standard definition signal and changing it to a high definition one

USB Universal Serial Bus

variable bit rate A streaming video file in which detailed parts of the video are assigned more data bits, resulting in a constantly changing data rate

vector graphic A resolution independent graphic composed of mathematical formulas

vectors Elements in the video frame that can lead the viewer's eye across the frame

videogram license Fee paid to a music publisher that allows a video producer to sell DVDs or video cassettes of a production containing copyright protected music

voice-overs (VO) A voice recording that has visuals added to help convey the message

walla An audio technique used to create background conversation in a scene. So named because actors continue saying "walla" to create the track

waveform A graphical representation of an audio or video signal used to make adjustments for optimal signal output

waveform monitor A device that displays an electronic representation of the video image. Useful for checking exposure and other video levels

webisode An episodic video program designed to be viewed on the Internet

wide shot (WS) A shot when the camera lens is zoomed out to a wide angle, or short focal length

window burn A copy of the original footage that has the time code numbers superimposed over the images

wipe A transition where one image moves across the screen replacing the previous image as it progresses

wireless microphone A microphone system consisting of a transmitter and receiver and eliminates the need for a cable between the talent microphone and the recorder

workflow During the post production stage, a systematic procedure that includes planning, file management, file storage, and archiving

xdcam A video recording system that uses an optical disc to store images and sounds

z-axis An imaginary line that extends from the front of the camera lens to the horizon

zebras A diagonal overlay on a video camera viewfinder that appears when the image you are shooting is brighter than a preset waveform level

Bibliography

BOOKS

Alten, Stanley. *Audio in Media*. 9th ed. Belmont, CA: Thomson Wadsworth, 2010.

Atchity, Kenneth and Chi-Li Wong. *Writing Treatments that Sell*. 2nd ed. New York: Henry Holt and Company, 2003.

Berger, Arthur Asa. *Seeing Is Believing: An Introduction to Visual Communication*. 4th ed. Mountain View, CA: Mayfield Publishing Company, 2011.

Bernard, Sheila Curran. *Documentary Storytelling*. 3rd ed. Burlington, MA: Focal Press, 2011.

Brown, Blain. *Cinematography: Theory and Practice*. 2nd ed. Burlington, MA: Focal Press, 2011.

Dancyger, Ken. *The Technique of Film and Video Editing*. 5th ed. Burlington, MA: Focal Press, 2010.

Donaldson, Michael C. *Clearance and Copyright: Everything the Independent Filmmaker Needs to Know*. 3rd ed. Beverly Hills, CA: Silman-James Press, 2008.

Gloman, Chuck B. and Tom Letourneau. *Placing Shadows: Lighting Techniques for Video Production*. 3rd ed. Woburn, MA: Focal Press, 2005.

Hurbis-Cherrier, Mick. *Voice and Vision: A Creative Approach to Narrative Film and DV Production*. 2nd ed. Burlington, MA: Focal Press, 2011.

Joyce, Craig, William Patry, Marshall Leaffer, and Peter Jaszi. *Copyright Law*. 7th ed. Newark, NJ: Matthew Bender and Company, 2008.

Katz, Steven D. *Film Directing Shot by Shot: Visualizing from Concept to Screen*. 2nd ed. Studio City, CA: Michael Weise Productions, 2004.

Kohn, Al and Bob Kohn. *Kohn on Music Licensing*. 4th ed. Amsterdam, NY: Wolters and Kluwer Law & Business, 2009.

Leaffer, Marshall. *Understanding Copyright Law*. 5th ed. New York: Matthew Bender and Company, 2010.

Medoff, Norman J., Edward J. Fink, and Tom Tanquary. *Portable Video: ENG and EFP*. 6th ed. Burlington, MA: Focal Press, 2012.

Meyer, Trish and Chris Meyer. *Creating Motion Graphics with After Effects: Essential and Advanced Techniques*. 5th ed. San Francisco: CMP Books, 2010.

Murch, Walter. *In the Blink of an Eye: A Perspective on Film Editing*. 2nd ed. Beverly Hills, CA: Silman-James Press, 2001.

Pember, Don R. and Clay Calvert. *Mass Media Law*. 18th ed. New York: McGraw-Hill, 2012.

Rabiger, Michael. *Directing the Documentary*. 5th ed. Burlington, MA: Focal Press, 2009.

Rose, Jay. *Producing Great Sound for Digital Video*. 3rd ed. San Francisco, CA: Miller Freeman Books, 2008.

Stim, Richard. *Getting Permission: How to License and Clear Copyrighted Materials Online and Off*. 4th ed. Berkley, CA: Nolo, 2010.

Thompson, Roy. *Grammar of the Shot*. 2nd ed. Woburn, MA: Focal Press, 2009.

Ward, Peter. *Picture Composition for Film and Television*. 2nd ed. Burlington, MA: Focal Press, 2002.

Weise, Marcus and Diana Weynand. *How Video Works: From Analog to High Definition*. 2nd ed. Burlington, MA: Focal Press, 2007.

Zettl, Herbert. *Sight, Sound, Motion: Applied Media Aesthetics*. 6th ed. Belmont, CA: Thomson Wadsworth, 2013.

Zettl, Herbert. *Television Production Handbook,* 11th ed. Belmont, CA: Wadsworth Publishing, 2012.

Zettl, Herbert. *Video Basics*. 7th ed. Belmont, CA: Thomson Higher Education, 2012.

ONLINE RESOURCES

cinema5d.com
creativecow.net
creativeplanetnetwork.com
dvxuser.com
lynda.com
provideocoalition.com

RELATED ASSOCIATIONS

Academy of Television Arts & Sciences – www.emmys.tv
Broadcast Education Association – www.beaweb.org
International Documentary Association – www.documentary.org/
National Association of Broadcasters – www.nab.org
University Film and Video Association – www.ufva.org

Index

Page numbers followed by "f" indicate figure.

A

AAC (Advanced Audio Encoding) format, 311
AAF (Advanced Authoring Format), 107
abbreviations in scripts, 41
above the line costs, 35
AB roll editing, 250
acquisition technology, other
 digital cinema, 101
 DSLR, 101, 102
action, cutting on, 234–235
active writing style, 40
actors, working with nonprofessional, 49–50
actual malice, 62–63
adaptation of story, 6–7
additional light, 205–206
additive color model, 89
Adobe After Effects, 239, 258
 alpha channels, images with, 290
 square/nonsquare pixels, interpretation of, 286
Adobe Illustrator, 288
 vector graphics with, 288
Adobe Photoshop, 258
 creating graphics with, 290
 lossless compression and, 306–307
 raster graphics with, 288
ADR (automated dialogue replacement), 269

Advanced Audio Encoding format (AAC), 311
Advanced Authoring Format (AAF), 107
AGC. See automatic gain control (AGC)
AIFF (Audio Interchange File Format), 311
AI format, 291
alpha channels, 289–290
 with key effect, 298
 with picture-in-picture effect, 289
The Amazing Race, 79
ambient sound, recording, 175
American Hollow, 51
American Idol, 75, 79
American Society of Composers, Authors, and Publishers (ASCAP), 75
America's Heart and Soul, 15
amplitude, 152–153
analog audio meter, 157, 157f
analog encoding, 98
analog signals, 91–93
 encoding, 98
analog tape formats, 109
Anderson, Morgan, 21
animation
 of graphics, 296
 pan and scan, 300–301
 preproduced animations, purchasing, 248

aperture, 117–118
 and depth of field, 123–124
Apple
 Final Cut Pro, 255, 268
 GarageBand, 271
 iPad, 316
 iTouch, 316
 Keynote, 301
 QuickTime Movie, 301
Apple Pro Res or Avid DNxHD, 106
approaching the shoot, 56–57
appropriation of name or likeness, 64–66
archiving, 322–323
 cloud storage, 322
 DVD for, 323
 magnetic media for, 322–323
 optical media for, 323
 storage solutions, 322–323
 tails out storage, 323
Armstrong, Louis, 270
Arrested Development, 13
artifacts, 312
ASCAP (American Society of Composers, Authors, and Publishers), 75
Asia Compassion Project, 268
aspect ratio, 94–95, 285
 pixel aspect ratio, 286–288
 and shoot and protect, 127, 128f
 and visual aesthetics, 127